CÉZANNE AND AMERICAN

Gail Stavitsky

Katherine Rothkopf

ESSAYS BY Ellen Handy

Jill Anderson Kyle

Mary Tompkins Lewis

Jerry N. Smith

Jayne S. Warman

MODERNISM

MONTCLAIR ART MUSEUM | THE BALTIMORE MUSEUM OF ART

YALE UNIVERSITY PRESS, NEW HAVEN AND LONDON

This catalogue has been published in conjunction with the exhibition *Cézanne and American Modernism*, organized by the Montclair Art Museum, Montclair, New Jersey, and The Baltimore Museum of Art, Baltimore, Maryland.

Bank of America

This exhibition is made possible by Bank of America.

This exhibition is supported by an indemnity from the Federal Council on the Arts and the Humanities.

Additional funding has been provided by the Terra Foundation for American Art, The Henry Luce Foundation, the National Endowment for the Arts, The Leir Charitable Foundations, and the Thaw Charitable Trust.

Montclair Art Museum
September 13, 2009–January 3, 2010
The Montclair Art Museum is grateful for additional support from The Leir Charitable Foundations, The Blanche and Irving Laurie Foundation, and the Dedalus Foundation, Inc., as well as from Exhibition Angels David and Susan Bershad Foundation, Inc., Bob and Bobbie Constable, Jacqueline and Herb Klein, Lyn and Glenn Reiter, Newton B. Schott, Jr. and Toni LeQuire-Schott, Adrian A. Shelby, Carol and Terry Wall, and Margo and Frank Walter.

The Baltimore Museum of Art
February 14, 2010–May 23, 2010
The Baltimore Museum of Art is grateful for additional support from The Rouse Company Foundation and David L. Warnock and Deidre A. Bosley.

Phoenix Art Museum
June 26, 2010–September 26, 2010

CONTENTS

FOREWORD

Paul Cézanne has been universally acclaimed as the definitive bridge between late-nineteenth-century Impressionism and the modern art movements and key artists of the twentieth century. Nonetheless this is the first time that an exhibition has thoroughly examined the pioneering role that American modernists played in establishing Cézanne's reputation and disseminating his influence through their art, writings, and exhibitions.

Cézanne and American Modernism features a core group of works by the French master that were seen and appreciated by American artists in publications or exhibitions held in the early years of the twentieth century. This story also engages thirty-four important American artists from this time who have been selected to demonstrate the vital impact Cézanne had on the development of modernism in the United States from about 1907 to 1930.

This project would not have been possible without the vision and commitment of Gail Stavitsky, Chief Curator of the Montclair Art Museum, who spearheaded a team of twenty-three scholars, each of whom is uniquely qualified to provide the insights needed on an artist or group of artists in this period. The interconnection of European artistic innovation and American modernism has long been key to Stavitsky's scholarly writings and projects. She first articulated the idea of this exhibition about a decade ago in spirited discussions with longtime MAM Trustee Adrian Shelby, currently Chairman of the Board of Trustees, who shared her memories of trips to Cézanne's home and studio in Aix, as well as her knowledge and intellectual curiosity about the pervasive influence of Cézanne and French culture on American artists.

The Montclair Art Museum formalized the conception of the project in 2002 and initiated the collaboration with The Baltimore Museum of Art given the importance of the BMA's holdings in modern art, most significantly The Cone Collection. As the project director, Gail has worked very closely with Katherine Rothkopf, Senior Curator of European Painting and Sculpture at the BMA, whose expertise in late-nineteenth-century French painting made for a perfect partnership. The show's dual focus on European and American modernism, and its emphasis on groundbreaking scholarship in examining a relatively little researched aspect of the legacy of Cézanne, strongly connects to the complementary collections and missions of both museums. We have joined forces and worked closely together on every stage of the project, from its artistic conception to the complicated arrangements required for the care and shipment of such important works of art. This interactive process has required both intellectual exchange and generosity of spirit. It is truly a case where the whole has become greater than the sum of its parts.

In Montclair and Baltimore, we are fortunate to have dedicated educators, advocates for the needs and interests of our audiences, and talented exhibition staffs, who always find a new and creative way to present each exhibition. Added to these very visible endeavors are the unseen efforts of literally dozens of colleagues at both institutions—those who raise the funds that support museum programs, those who promote and market the exhibition, those who pack, ship, and preserve the art, and, of course those who protect the artworks every day.

Strongly favoring the idea of traveling the show to the West, the staffs of MAM and the BMA were delighted when our colleague James Ballinger, The Sybil Harrington Director of the Phoenix Art Museum, joined us as the show's third and final venue. Jerry N. Smith, Associate Curator of American Art and a catalogue contributor, augmented the scope of the show with astute suggestions of loans by Western artists. We are pleased that *Cézanne and American Modernism* will reach a wider national audience through its presentation in Arizona and thank all the distinguished colleagues at this institution as partners in our undertaking.

It takes a tremendous commitment of financial support to realize the scholarship and planning required for such an ambitious project. We salute Bank of America for making this show possible. We also deeply appreciate the vision of all of those who have so generously supported this exhibition and publication: the Terra Foundation for American Art, The Henry Luce Foundation, The Leir Charitable Foundations, and the Thaw Charitable Trust. This exhibition has received support from the National Endowment for the Arts as part of the American Masterpieces: Three Centuries of Artistic Genius program. The exhibition is supported by an indemnity from the Federal Council on the Arts and the Humanities. Numerous private individuals and foundations have also helped to fund this project.

Finally, the success of an exhibition requires a critical group of artworks to tell a story, and, of course, that means that these treasures—many of them on loan—will be missed from other museums and many private collections.

To each of the funders and lenders to this exhibition, we offer our profound gratitude for their generosity in sharing our vision for a tour that will acquaint our audiences with a new view of Cézanne and his influence on early-twentieth-century American art. Above all, we appreciate Paul Cézanne for his extraordinary artistic genius and legacy.

Patterson Sims Lora S. Urbanelli Doreen Bolger
Director *Director* *Director*
Montclair Art Museum Montclair Art Museum The Baltimore Museum of Art
2001–2008

LENDERS TO THE EXHIBITION

Ackland Art Museum, University of North Carolina at Chapel Hill

The Anschutz Collection

Archives of American Art, Smithsonian Institution, Washington, DC

The Art Institute of Chicago

The Baltimore Museum of Art

Bates College Museum of Art, Lewiston, Maine

Lori Bookstein Fine Art, New York

Brooklyn Museum

The Honorable and Mrs. Joseph P. Carroll

Center for Creative Photography, The University of Arizona

Columbus Museum of Art, Ohio

James Corcoran Gallery, Los Angeles

Warren and Margot Coville

Curtis Galleries, Minneapolis

Dallas Museum of Art

Richard Estes

Solomon R. Guggenheim Museum, New York

High Museum of Art, Atlanta

Fred Jones Jr. Museum of Art, The University of Oklahoma, Norman

Maurice and Margery Katz

Elaine and Henry Kaufman

Library of Congress, Washington, DC

Tommy and Gill LiPuma

The Metropolitan Museum of Art, New York

Marion Meyer Gallery, Paris

Montclair Art Museum, New Jersey

Museum of Art, Rhode Island School of Design, Providence

Museum of Fine Arts, Boston

The Museum of Modern Art, New York

Naples Museum of Art, Florida

National Gallery of Art, Washington, DC

National Portrait Gallery, Smithsonian Institution, Washington, DC

The Newark Museum, New Jersey

New Mexico Museum of Art, Santa Fe

The Henry and Rose Pearlman Foundation, Inc.

Pennsylvania Academy of the Fine Arts, Philadelphia

Gerald Peters Gallery, New York and Santa Fe

Philadelphia Museum of Art

The Phillips Collection, Washington, DC

Phoenix Art Museum

Princeton University Art Museum, New Jersey

Private Collections

Mrs. Henry M. Reed

Sheldon Museum of Art, University of Nebraska, Lincoln

Stetson University, DeLand, Florida

Mr. and Mrs. Eugene V. Thaw

Vaughn O. Vennerberg

Gilbert and Nancy Waldman

Joy S. Weber

Estate of Max Weber

Frederick R. Weisman Art Museum, University of Minnesota, Minneapolis

Whitney Museum of American Art, New York

Williams College Museum of Art, Williamstown, Massachusetts

ACKNOWLEDGMENTS

Many individuals played critical roles in the realization of this exhibition. *Cézanne and American Modernism* had its origins about ten years ago in lively conversations with Montclair Art Museum Trustee and Board Chairman Adrian Shelby. Patterson Sims, then Director of the Montclair Art Museum, immediately embraced the idea for this exhibition, and he approached Doreen Bolger, Director of The Baltimore Museum of Art, in 2005 with the prospect of collaboration. The important advocacy of Lora S. Urbanelli, Director of the Montclair Art Museum since January 2009, is also greatly appreciated. Each has been unfailingly generous and constant in their support with every aspect of this project.

Special thanks are also extended to Emily Schuchardt Navratil, Ph.D. candidate in Art History, The City University of New York, who served so effectively as MAM Research Associate and ably assisted on all aspects of this exhibition, as well as contributing as a writer. Jay Fisher, Deputy Director of Curatorial Affairs and Senior Curator of Prints, Drawings, and Photographs at the BMA, was supportive of the exhibition from its inception, and provided critical guidance. Laura Albans, the BMA's Curatorial Assistant in the Department of European Painting and Sculpture, enthusiastically assisted in many phases of this project.

Twenty-three catalogue authors have contributed illuminating essays and entries that comprise the first comprehensive examination of Cézanne's influence upon American artists during the early twentieth century. Mary Tompkins Lewis, Visiting Associate Professor at Trinity College; Jill Anderson Kyle and Jayne Warman, independent art historians; and Ellen Handy, Associate Professor, The City College of New York (CUNY), all provided enlightening essays. Our colleague Jerry N. Smith, Associate Curator of American Art, Phoenix Art Museum, wrote on the interesting topic of Cézanne and the West. The following scholars have all written informative entries on the individual artists in the exhibition: William C. Agee, Evelyn Kranes Kossak Professor of Art History, Hunter College; Isabelle Dervaux, Curator of Modern and Contemporary Drawings, Morgan Library & Museum; Stacey B. Epstein, Associate Director of Modernism and Research, Hollis Taggart Galleries, New York; Betsy Fahlman, Professor of Art History and Associate Director, School of Art, Herberger College of the Arts, Arizona State University; Roberta Smith Favis, Professor, Stetson University, DeLand, Florida, and Curator, Vera Bluemner Kouba Collection; Ruth Fine, Curator, Special Projects in Modern Art,

National Gallery of Art, Washington, DC; Gregory Galligan, former Project Director, Morgan Russell Archives and Collection Enhancement Project, Montclair Art Museum; Laurette E. McCarthy, independent curator; Patricia McDonnell, Director, Ulrich Museum of Art, Wichita State University; Nancy Mowll Mathews, Eugénie Prendergast Senior Curator of 19th and 20th Century Art and Lecturer in Art, Williams College Museum of Art; Francis M. Naumann, independent scholar and Director of Francis M. Naumann Fine Art, New York; Percy North, Coordinator of Art History, Montgomery College, Rockville, Maryland; and Will South, Chief Curator, Dayton Art Institute. These scholars also participated in an organizational colloquium in November 2006 at the Montclair Art Museum, and each has played an important role in developing this exhibition.

During the past seven years, countless colleagues have generously offered critical assistance with the research and implementation of this project. Early discussions in 2002 with Sylvia Yount at the High Museum (now Curator of American Art at the Virginia Museum of Fine Arts) were pivotal in generating initial ideas for artists and loans. We acknowledge the extremely generous support of Joseph J. Rishel, the Gisela and Dennis Alter Senior Curator of European Painting before 1900, Philadelphia Museum of Art, and his curatorial colleagues Katherine Sachs, Jennifer Vanim, Adrianne O. Bratis, Shelley Langdale, Innis Shoemaker, and Registrar Shannon Schuler. Rishel graciously served as a consultant, shared information, and arranged for the loan of key Cézanne paintings and watercolors from the Philadelphia Museum of Art's collection, in the midst of preparing for the major, complementary exhibition at the PMA, *Cézanne and Beyond* (February 26–May 17, 2009). Michael R. Taylor, Curator of Modern Art at the PMA, generously assisted with identifying and securing loans of paintings by Arshile Gorky during his preparations for the retrospective of this artist's work in fall 2009.

We would like to thank many of our colleagues who have supported this project, including a special tribute to the memory of the consummate museum professionals Anne d'Harnoncourt and Philip Conisbee, who were both early advocates of this project. The following colleagues at museums, libraries, archives, galleries, universities, and elsewhere provided generous and critical assistance: Warren Adelson, Gail Kana Anderson, Philip Anshutz, Bente Arnild, Susan Augustine, Myra Bairstow, Lauren Bakoian, John Benjamins, MacKenzie Bennett, Mark H. C.

Gail Stavitsky

INTRODUCTION

The French painter Paul Cézanne (1839–1906) has been universally acknowledged for many years as the definitive link between late-nineteenth-century Impressionism and twentieth-century modern art. The critical function that American artists played in the establishment of Cézanne's reputation and dissemination of his influence in the United States is a topic that has been never comprehensively examined. The pages that follow are the first attempt to explore fully the pioneering roles that American modernists assumed in the early years of the twentieth century through their works of art, writings, lectures, socializing, as well as their organization of and participation in exhibitions. A number of these artists were also active as advisors to the first American collectors of Cézanne's work and even acquired examples themselves. Thus they played pivotal, vanguard roles in the canonization of Cézanne, especially from about 1907 to 1930. Many of the master's works are in American private and public collections today, and since the mid-twentieth century this country has taken the international lead in the scholarly discourse on Cézanne and his popularization.

Elucidating the myriad ways in which Cézanne inspired the thirty-four artists represented in this project can, at times, be a complex and elusive matter. Not every instance of artistic influence is supported by direct documentary evidence, although in a number of cases, newly discovered primary-source material illuminates the strong connections. Furthermore, the vehicles of transmission are significant, whether by direct viewing of original works or via reproductions, and are compounded by the filters of other artists' styles, especially Matisse's Fauvism, as well as Picasso's Cubism. Another mediating factor is the rich context of coexisting modernist tendencies, including primitivism, orientalism/Japanism, and photography. The challenges of pinpointing Cézanne's influence also derive from the multifaceted aspects of his career and reputation. These ranged from the imaginative, expressionist reworkings of traditional subjects in the 1860s, when he resided in Paris, to the more tranquil Impressionist works of the countryside of the Île-de-France when he was painting with Pissarro in Auvers and Pontoise in the 1870s and on his move back to his native Aix-en-Provence in the 1880s. There he gradually withdrew, creating the late works, infused with a new intensity in which discrete objects are increasingly merged into fluctuating patches of color, inspired in part by his groundbreaking watercolors—which were the first works to be presented in American solo exhibitions of

Cézanne's work, in 1911 and 1916. Thus Cézanne's varied oeuvre offered a variety of liberating options for American artists and others who regarded him both as a formalist and a mystic, who submitted nature to an intellectual/analytic process of organization, and who penetrated beneath the veil of appearances to capture the inner essence or soul of his subjects as well as their fundamental forms.

Shifts in Cézanne's influence, as reflected in the work of many American modernists, reflect the general trajectory of an evolution away from the explosion of radical modern art movements that opened paths to abstraction prior to World War I. While at first regarded as instrumental for breaking through the academic barriers of mimetic representation through his innovative pictorial techniques, Cézanne came to be appreciated for the timeless, architectonic stability of his harmonious compositions during the postwar era of classical values that would rebuild society in the 1920s.

The American artists featured in this project—selected from a multitude of possible candidates—were chosen for the intensity and high quality of their varied aesthetic and intellectual engagements with Cézanne's artwork and philosophy—whether their engagements were of passing, but seminal, importance, or reflected a more lasting devotion. Cézanne's transformative impact on their works is revealed not only by their adaptations of his stylistic hallmarks but also through their choice and serial approach to his subject matter—still lifes, landscapes, figurative works, and portraits. These themes have informed the selection of works for this exhibition. Still-life compositions by Max Weber, Morgan Russell, Charles Demuth, Arshile Gorky, Man Ray, and many others are included, followed by landscapes by several painters, notably Marsden Hartley, one of a number of American artists who traveled to Aix-en-Provence to experience firsthand Cézanne's native environment. Others such as John Marin, Andrew Dasburg, Willard Nash, and also Hartley found native counterparts to Cézanne's landscape motifs in New England, the West, and elsewhere. Figurative subjects, in portraits by Stanton Macdonald-Wright, Alfred Maurer, Weber, and others, are also featured. Cézanne's many variations on the theme of Bathers in landscape settings—among his earliest works exhibited in America—were highly influential for Arthur B. Davies, B. J. O. Nordfeldt, Abraham Walkowitz, Man Ray, Maurice Prendergast, and many others as modern incarnations of this classical, idyllic subject.

These American modernists' range of pictorial responses can be loosely summarized in terms of their individual approaches to Cézanne's alterations of form and creation of complex, architectonic, pictorial structures out of vibrant colors rendered in parallel, constructive brushstrokes, rather than traditional methods of chiaroscuro modeling. They similarly adapted other practices of Cézanne that reinforced and unified the planarity of the support, with shallow, basrelief–like compositions moving downward and outward toward the viewer, rather than into depth: his high horizon lines, tilted perspectives, flattening of ellipses, and *passage,* that is, the opening of objects' contours to allow the colored planes which define them to spill or "bleed" into adjacent areas. Furthermore, they practiced their own versions of Cézanne's controversial incorporation of blank spaces of canvas or paper (his "non-finito," especially appreciated in his watercolors) to suggest volume, form, and highlights, leading to modern pictorial concepts whereby the surrounding spaces are as concrete as the objects/subjects themselves and the

integrity of the composition is the standard for completion rather than the literal re-creation of nature.

This catalogue reflects a range of diverse scholarly perspectives provided by a team of twenty-three scholars. These seminal essays address the relationship of Cézanne to American modernist art criticism, as well as the roles that pioneering American collectors played in furthering his reputation. Cézanne's influence upon American photographers of the early twentieth century is examined for the first time, in recognition of the exceptional importance that Alfred Stieglitz, Edward Steichen, Paul Strand, and others played in introducing modernism to America.

The introductory essay covers the American reception of Cézanne from 1895 to 1930, primarily in terms of artists, critics, exhibitions, and publications centered around New York, with a brief section devoted to the emerging appreciation of his oeuvre in other parts of the country. This is complemented by an essay on the dissemination of Cézanne's influence in the American West—as evidenced by the work of John Marin, Willard Nash, Stanton Macdonald-Wright, Andrew Dasburg, and others. Furthermore, the ongoing impact of Cézanne is extended in one essay beyond the timeframe of this project into the era of Abstract Expressionism and the 1960s.

The essays are followed by shorter texts on each artist, with pertinent information elucidating their specific connections to and appreciation of Cézanne. Discussions of their artworks in the exhibition are provided within the context of the transformative impact that Cézanne's oeuvre had upon their individual aesthetic visions and accomplishments.

American artists' various perceptions of Cézanne's work as modern and abstract yet profoundly realistic and rich in tradition, as well as native/French and universal/transcultural, reveal how his persona and oeuvre were viewed through the complex filters of projected individual aesthetic needs and desires. His work constituted a vital bridge assuring continuity with the past that had been disrupted by the seemingly formless, atmospheric transience of Impressionism and stultification of academicism. Cézanne's complex relationship to various aspects of modernity—science, spirituality, primitivism, classicism, orientalism, abstraction, and realism—illuminate how he remained an all-purpose, relevant guiding spirit for American artists throughout this period and beyond.

Gail Stavitsky

CÉZANNE AND AMERICAN MODERNISM

Cézanne, who had been held in the greatest contempt of them all, was the last to be received into public favour. He still found himself unknown and unappreciated by the general public; [however,] there appeared an increasing nucleus of admirers, composed of artists, connoisseurs and collectors, who formed a kind of sect, penetrated by a sort of fanaticism, in which he was placed in the very front rank.

—Théodore Duret, 1910[1]

With Cézanne's death came his apotheosis. . . . Thousands rushed in and cleverly imitated his surfaces, his color gamuts, his distortions of line. His white wooden tables . . . ruddy apples and twisted fruit-dishes have lately become the etiquette of sophistication. . . . Cézanne's significance lies in his gifts to the painters of the future . . . to those serious and solitary [individuals] whose insatiability makes . . . them explorers in new fields. To such artists Cézanne will always be the primitive of the way that they themselves will take, for there can be no genuine art of the future without his direct and guiding hand. Only today is he beginning to be understood, and even now his claim to true greatness is questioned.

—Willard Huntington Wright, 1915[2]

The impact of the legendary, enigmatic Paul Cézanne upon those who were among the first to appreciate him—modern American artists prior to 1930—is a subject that has yet not been thoroughly scrutinized. As painter-critic Walter Pach observed, "It was the slow, collective pressure of conviction by . . . artists that brought men like Cézanne . . . from their apparent hopeless neglect to their immense prestige of today."[3] American modernists played seminal roles in the dissemination of Cézanne's influence and expansion of access to his work through their writings, artworks, connections with collectors, and the organization of such key exhibitions of the early twentieth century as Cézanne's first American solo shows (1911, 1916), the Armory Show (1913), and the exhibition of Impressionist and Post-Impressionist paintings at The Metropolitan Museum of Art (1921).

For American artists such as the prominent painter-critic Marsden Hartley, Cézanne was a flexible, all-purpose "gateway for our modern esthetic development."[4] Analyzing Cézanne's technical and conceptual innovations, these modernists adapted his clarity of enduring architectonic structures and unified design, as well as the spatial and coloristic complexities of his work. For those who wished to be liberated from the restrictions of their outmoded, academic educations, Cézanne was a challenging beacon of modernity and unhampered self-expression. Their complex range of responses to his work was often mediated by their appreciation of other modern masters such as Matisse and Picasso, for the seminal movements of Fauvism and Cubism had emerged by 1908 as differing pictorial responses to the art of Cézanne. Also vital was their awareness of past cultural and artistic traditions, especially Italian and French old masters and Asian and primitive art. Their interpretations of Cézanne's work as a progressive model for abstract art generally gave way after World War I to the old master concept of him as a paradigm of permanence and classic order.

Cézanne was also a significant model for the synthesis of dualities of form and color, the objective and the subjective, matter and spirit, and abstraction and representation, as he had fused intuition and intellect to achieve "the logic of organized sensations."[5] Therefore, his theories and works were extensively interpreted by artists and critics such as Charles H. Caffin, Willard Huntington Wright, and Roger Fry in terms of mysticism and formalism, as a spiritual antidote to nineteenth-century materialism, with analogies to music, and as a scientific model of rational, formal organization. Furthermore, the mercurial Cézanne was mythologized as the hermit of Aix-en-Provence whose lonely quest for the realization of his art was a potent paradigm for artists such as Max Weber who referred to him as "a saint."[6]

Fig. 1 Maurice Denis, *Homage to Cézanne*, 1900. Oil on canvas. Musée d'Orsay, Paris (RF1977-137)

CÉZANNE'S RECEPTION 1895–1906

Cézanne's transformation within twenty years from an abused eccentric master into the idolized father of modern art could not be foretold during the latter part of his life. Prior to the early twentieth century, there is no firm evidence that any American artists studying abroad were influenced by Cézanne, who was little known before his first one-person exhibition at Ambroise Vollard's Parisian gallery in 1895 (including cat. 10).[7] For these artists, Impressionism was the modern movement of the day. Among the few Americans even aware of the reclusive master was Mary Cassatt.[8] Having acquired one of his still lifes, Cassatt alerted Vollard in 1901 to the impending arrival of her collector friends H. O. and Louisine Havemeyer, who then purchased their first Cézannes from him.[9] Nevertheless, Cassatt was not inspired by his work and even sold her still life when she felt that his reputation had become inflated.[10]

America's first Post-Impressionist, Maurice Prendergast, was formerly regarded as the earliest proponent, perhaps seeing Cézanne's work at Vollard's in 1898–99.[11] However, Prendergast more likely first saw his work in Paris during the fall of 1907 at the Galerie Bernheim-Jeune and

the memorial exhibition at the Salon d'Automne when Cézanne was honored with a retrospective of over fifty oils and watercolors.[12] Exhibitions at these venues provided among the best opportunities for American artists abroad to study the master's work.

By the time American modernists arrived in Paris during the early twentieth century, Cézanne's reputation had been established by the French Nabis Émile Bernard, Maurice Denis, and Paul Serusier. Denis's celebrated *Homage to Cézanne* (fig. 1) was exhibited at the Champ de Mars Salon (1901), where it impressed the American journalist James Huneker.[13] In 1904 he wrote one of the first articles in English on Cézanne—a scathing review of the second Salon d'Automne, which featured thirty works (including cats. 1, 19) by "the god" of "the rebels."[14] This show was visited by Maurice Sterne, who was bewildered by this "mystery I could not [yet] fathom," but who later embraced Cézanne's "new art of modeling form in space by color" (fig. 2).[15]

Although negative, Huneker's review of the 1904 Salon gave readers the impression that Cézanne had a considerable following abroad.[16] That year, Bernard wrote a landmark article, later translated for himself into English by Prendergast (cat. 124), lauding Cézanne as "the only master on whom future art can graft its development."[17] Mentioning the French followers of Cézanne who almost twenty years ago had, at the small shop of Père Tanguy, "consulted [his] works . . . like a religious tract through which a prophet . . . confirmed his sovereignty,"

Fig. 2 Maurice Sterne,
*Dance of the Elements,
Bali*, 1913. Oil on canvas.
North Carolina Museum
of Art, Raleigh, Purchased
with funds from the State
of North Carolina

Bernard distinguished the "Savior" from his Impressionist predecessors.[18] He discussed the salient characteristics of Cézanne's working methods as a "meditative and progressive analysis" of nature, "heightening the color sensations and elevating form into a decorative concept."[19] Citing the opinions of this isolated genius who has "closed his door in order to plunge himself into the absolute," Bernard listed most of Cézanne's key dicta that would be quoted by many subsequent authors and artists, including: "To paint from nature is not to copy an object; it is to represent one's sensations."[20]

Bernard's rather obscure article attracted little attention at the time, nor did Maurice Denis's groundbreaking article, based on his visits with the master, of 1907.[21] The task of facilitating the reclusive painter's reputation as a true innovator would become easier after his death.

AMERICAN ARTISTS IN PARIS: THE STEIN SALON, THE MATISSE CLASS, AND THE SALON D'AUTOMNE CÉZANNE RETROSPECTIVE OF 1907

Max Weber was among many young, receptive artists visiting Paris early in the new century. At the 1906 Salon d'Automne he was gripped "at once and forever" by the work of Cézanne— "this master . . . who brought to an end academicism . . . [who] built up his color to construct the form."[22] Weber had already been prepared for this seminal experience by his frequent visits to Leo and Gertrude Stein, whose cluttered Parisian apartment, prominently displaying their pioneering modern art collection, became the primary gathering place for many American modernists (see fig. 3 in Warman's essay in this volume, included cats. 2, 12, 15, 18).

In 1904, Leo Stein, acting upon the advice of the connoisseur Bernard Berenson,[23] acquired his first Cézanne painting. His newfound interest was reinforced by a visit to the Florentine home of pioneering American Cézanne collector Charles Loeser. Stein's appreciation of Italian Renaissance art paved the way for his understanding of Cézanne, as would soon be the case for such American modernists as Charles Sheeler, Morton Schamberg, and Pach. Stein later discussed his aesthetic vision of Cézanne and classical Italy with his neighbor in Rome, the young painter Elsie Driggs.[24]

Leo Stein shared his discovery with his sister Gertrude, who joined him in the eventual purchase of at least eighteen Cézannes, which could be seen on a regular basis in the context of his successors Matisse and Picasso.[25] During their soirées, Stein expounded on his understanding of modern art, including Cézanne, among "The Big Four," for his "rendering [of] mass with a vital intensity that is unparalleled in the whole history of painting," with color "almost as vibrant."[26]

The first American artist to become associated with the Steins and to practice a Fauve style of painting was Alfred Maurer, who befriended Leo in 1904. Maurer acted as a tour guide of the Steins' collection while Leo and Gertrude were in Florence in the summer of 1905, bringing in groups of Americans visiting Paris and taking delight in their shocked reactions to the pictures.[27] He brought others who became early habitués, including Mahonri Young, William Glackens, and Sterne.[28]

Other Stein congregants were students of Matisse, including Weber, Patrick Henry Bruce, and Morgan Russell. Weber recollected that the Stein salon was an annex to the Matisse

class, which was taught from 1908 to 1911, providing the opportunity to study Cézanne's works, Picasso's drawings, as well as portfolios full of Matisse's work, while Leo Stein moderated lengthy discussions on modern art.[29]

Weber also recalled that his teacher referred "unfailingly to Cézanne's architectonic, masonic plasticity."[30] During occasional visits to his studio, Matisse proudly showed Weber and others his awe-inspiring painting of *Bathers* by Cézanne (reproduced in cat. 150). In notes recorded by his pupil Sarah Stein (who, along with her husband, Michael, received visitors to see their own modern art collection), Matisse discussed Cézanne's primary role in the determination of structured color relations, in terms of the master's use of "blue to make his yellow tell, . . . with the discrimination . . . that no one else has shown."[31]

Thus, as a teacher, collector (who owned at least thirteen works, including cat. 6), and also a frequent visitor to the Steins, Matisse played a major role in the dissemination of Cézanne's influence, as reflected in his own writings in which he discussed his desire to organize his "sensations" to "give to reality a more lasting interpretation."[32] For Matisse, Cézanne was "the father of us all,"[33] and it was his enthusiasm for the master which provided the key introduction for Bruce, one of the charter members of the Matisse class. From 1909 to 1912, Bruce developed a very accomplished Cézannesque style derived from Matisse.[34]

Another Matisse student was Morgan Russell, who joined the class in spring 1908, likely after meeting Matisse through Leo Stein. Through their many discussions and correspondence, Stein incited Russell's appreciation of Cézanne. Filtered through his dedication to the classical quality of permanence and order in such old masters as Michelangelo, Russell's investigations of Cézanne's oeuvre ranged from copies (cats. 94–97) to his own interpretations of the "forceful beauty" of the master's monumental form and contrasting color constructions.[35] Russell was particularly impressed with Cézanne's *Five Apples* (cat. 2), which he and Andrew Dasburg borrowed in 1910 from Stein.[36] Russell's *Three Apples* (cat. 94) was directly inspired by this work. He may likely also have seen Cézanne's watercolors owned by his friend and Stein circle member Stanton Macdonald-Wright.[37] Cézanne's liberation of color from traditional constraints of outline and chiaroscuro modeling would come to form the basis of Russell's and Wright's conception of Synchromism in 1912–13.

Among other guests to the Stein salons was Manierre Dawson, whose pioneering abstractions reflected his observation in 1910 that Cézanne "doesn't take the scene at face value but digs deep into the bones and shows them."[38] Charles Demuth, Arthur B. Carles, Morton Schamberg, Joseph Stella, Sterne, and Abraham Walkowitz were among the many other American artists who visited the Steins.[39] During his visits in 1912, Hartley was especially impressed with Cézanne's watercolors. Not yet acquainted with this medium of the master's work, he found them to be a mystical "revelation . . . a peculiar psychic rendering of forms in space—and from this artistically I proceeded."[40] Another important guest was the painter-photographer Edward Steichen, who in 1909 introduced Alfred Stieglitz to the Steins.[41] Their collection inspired the previously skeptical Stieglitz to embrace Cézanne's oeuvre.[42] Furthermore, Steichen co-organized the New Society of American Artists, formed in 1908 in reaction against the conservatism of the existing Society of American Artists in Paris. Weber, Maurer, and John Marin were among this group

of twelve artists, who would be exhibited at Stieglitz's pioneering Little Galleries of the Photo-Secession ("291") in New York from 1909 onward.[43]

Although the Steins' abode is usually regarded as the primary source for Cézanne, exhibitions at the aforementioned salons and the galleries of Ambroise Vollard and Bernheim-Jeune (cats. 1, 3, 4, 10, 11, 13, 16, 19, 20, 22) were also influential.[44] Leon Kroll later recalled his visit to Vollard's, where he saw the paintings of Cézanne, whom he assumed to be "*still* [thought of as] a young fellow" with "a hell of a lot of talent," alluding to his enduring vitality and significance.[45]

Especially pivotal for the early appreciation of Cézanne was the Salon d'Automne memorial exhibition in 1907 (including cats. 16, 22). As Leo Stein recollected, "At the Autumn Salon of 1905 people laughed themselves into hysterics before his pictures, in 1906 they were respectful, and in 1907 they were reverent. Cézanne had become the man of the moment."[46] Among those who were deeply moved were Weber (for whom it was "the greatest turning point"[47]), Pach, and Prendergast. Declaring his allegiance to Cézanne as his primary influence, Prendergast returned to America, and, from 1910 to 1913, experimented with subjects specifically inspired by the master—still lifes and portraits. Recognized by Pach as probably "the first American to realize the importance" of "his favorite master—'old Paul,' as he called him affectionately" and to be "able to do justice to the broad scope of [his] qualities," Prendergast promoted Cézanne's significance through his conversations with artist-friends, including Hartley, and his participation in the landmark exhibition of the Eight in New York.[48]

THE EIGHT AND WALTER PACH'S ARTICLE ON CÉZANNE (1908)

Prendergast was likely the first artist to be officially recognized as a Post-Impressionist disciple of Cézanne in some reviews of this highly publicized revolt against the National Academy of Design held in 1908 at the MacBeth Galleries in New York, and which then traveled to nine venues across the country.[49] His work was characterized as "a jumble of riotous pigment," the "pure eccentric" Prendergast "brings a later word from Paris than the others" with his "after-Czanne [*sic*] style."[50] A critic also observed, "do not think that Prendergast has spoken the final word with his Czezanne [*sic*] technique. We will hear more of it when the influence of France upon the young artists studying there now becomes better known."[51] Although viewed by critics as relatively conservative in comparison with their French counterparts, the Eight anticipated future independently organized shows. In the opinion of one member, John Sloan, their revolt "against the [academic] corruption of eyesight [Impressionist] painting" was parallel to "the Frenchman who followed Cézanne's lead [only] we just went back to art in the direction of Manet and Goya."[52] The first show of the successor association to the Eight—the Society of Independents—was the occasion in 1910 of the observation that among "those who are wearing the shoes of Cézanne, Prendergast . . . and Schamberg are the most skilful."[53]

The historic exhibition of the Eight was followed by the first informed appreciation on Cézanne to appear in America, written by Prendergast's friend and Stein circle member Walter Pach. Published in *Scribner's Magazine* in December 1908, this five-page article referred to Cézanne as "the strongest of recent influences in continental painting and practically an unknown name in America!"[54] Noting the recent change in critical tone from ridicule to eulogy, Pach provided

a biographical overview that furthered the artist's heroic reputation as an industrious outsider and "constant sufferer" with an unrelenting routine of painting the "'motif.'"[55] Emphasizing Cézanne's importance as a colorist, Pach briefly contrasted the early and later phases of his work, concluding that Cézanne's "high rank" was evidenced by inspired artists "giving less attention to the externals and caring more for what is within—the structural, the significant."[56]

Pach also referred to the problem of access to Cézanne's work, in terms of how infrequently exhibitions of paintings by new artists could be organized, especially in America. Thus his references not only to the writings of Bernard but also to those of Julius Meier-Graefe were especially important. For many artists, reproductions in books such as Meier-Graefe's *Modern Art: Being a Contribution to a New System of Aesthetics* (1908, cat. 125) were essential, since very few opportunities to see original works existed prior to 1910.[57] Meier-Graefe's publications on modern art were especially helpful for Oscar Bluemner (cat. 135), Prendergast, and Hartley. In 1907, Prendergast may have shared both his enthusiasm and his translation of Bernard's 1904 article (cat. 124) with his fellow Boston resident Hartley. Prendergast also owned the *Cézanne Mappe* portfolio (1912), comprising fifteen reproductions of Cézanne's paintings (cat. 137).[58]

Among the few American painters with an opportunity to see significant works by Cézanne was Arthur B. Davies, who saw them in the Havemeyer collection in New York and took Hartley there for his first viewing by 1911–12.[59] Davies' interest had been stimulated by Pach's article. Davies befriended Pach and asked him to translate articles on modern and early Italian art.[60] These complex artistic networks were further stimulated by the return of painters from abroad, such as Weber, who in 1909 brought to New York a group of eighteen high-quality black-and-white photographs of Cézanne paintings taken by the Paris gallery owner-photographer Eugène Druet (cats. 128–33).[61] Weber displayed these photographs on his studio wall as "precious mementos . . . [in which] every touch was so evident" and likely engaged other artists, including Walkowitz and Hartley, in discussions on modern art.[62] In 1910 Weber lent these exceptional documents to Alfred Stieglitz's groundbreaking exhibition at his gallery at 291 Fifth Avenue, the first to publicly exhibit Cézanne's work in America.[63]

CÉZANNE'S DEBUT IN AMERICA AT 291

The pioneering gallery 291 (as the Little Galleries of the Photo-Secession are commonly known) was conceived in 1905–6 by Stieglitz and Steichen as a place to show both progressive photography and paintings—"exhibitions of modern art not necessarily photographic."[64] Both were initially skeptical when Steichen took Stieglitz to see Cézanne's first major watercolor show at Bernheim-Jeune in June 1907.[65] Nevertheless, by spring-summer 1909 they were converted. Their planning of exhibitions of work by Matisse and American modernists at 291 had played an important role in this process.

Matisse's first solo show in America in 1908 was the initial opportunity for drawing attention to Cézanne, although most critics missed the connection.[66] Emphasizing their importance, Steichen observed that Matisse's paintings "are to the figure what the Cézanne's are to the landscape."[67] In Stieglitz's publication *Camera Work,* Matisse was discussed as having painted brilliantly colored works—"pushing to the extreme some discoveries of Gauguin, Cézanne,

and Van Gogh."[68] Connections between Matisse, Cézanne, and emerging American modernists were made in relation to 291's show of Maurer's paintings and Marin's watercolors in 1909. Critic Charles H. Caffin situated Maurer as having "had his eyes opened by Matisse" and Marin as "part of that fermentation which, started by Cézanne and stirred by Matisse, has given new impulse to the artist's old recipe of seeing the world for himself . . . a more abstract way of receiving and rendering the impression of the scene."[69]

In 1910 Marin's first one-person show prompted the following comments by *New York Times* critic Elisabeth Luther Cary, suggesting that the better-known work of Matisse sometimes overshadowed that of Cézanne in discussions of contemporary influences:

> The painter's instinct for recognizing the possibilities of structure by color alone is extraordinary, and we find his color more . . . refreshing . . . than the hot harmonies of Matisse. Although he usually is accepted in this country at least as a follower of Matisse, . . . Marin derives more logically from Cézanne.[70]

This tendency to characterize American modernists as disciples of Matisse, whether appropriate or not, was reinforced by the presentation in 1910 of his next show, which was followed by the landmark exhibition of *Younger American Painters*.[71] The favorable critical response to Matisse's exhibition further established him as the leader of the modern school. Only brief references were made to his mentor, notably by Cary, who observed that to "us he seems to be the final word of that gorgeous hymn to abstract color raised by Cézanne."[72]

Reprinting reviews of the Matisse exhibition in *Camera Work*, Stieglitz observed that the show was held "at a time when the name, Matisse, is being used indiscriminately to explain the influence to which any painter at present may have succumbed whose work is unacademic."[73] The exhibition of *Younger American Painters* was also discussed and the question was raised as to whether the nine artists—which included Carles, Arthur Dove, Hartley, Marin, Maurer, Steichen, and Weber— were Matisse followers.[74] Among the featured paintings was Dove's *The Lobster* (fig. 3), reminiscent of Matisse's Cézannesque still lifes that he saw in Paris.[75] Critic Sadakichi Hartmann combined the names of the two French masters when discussing the "group of younger American painters" who "held a pictorial confab to prove that the Cézanne-Matisse influence has finally crossed the Atlantic," as evidenced by "these latest revolutionary accomplishments in the domain of color."[76]

Huneker designated Cézanne as "the path breaker," singling out Weber's still life with its "treatment of volumes of tone à la Cézanne."[77] Huneker also referred to the artist's celebrated dictum in his comment that "we know . . . Cézanne reduced all forms to the sphere, the cone, and the cylinder, and [Weber's Cubist] study [*Summer*, 1909, Smithsonian American Art Museum] viewed as such reveals plenty of cleverness and research."[78] Included in a 1904 letter to Bernard, Cézanne's misinterpreted admonition to "treat nature by means of the cylinder, the sphere, the

cone" to represent three-dimensional forms in perspective would soon become the focal point of discussions by the American critic Willard Huntington Wright and others on the Cézannian origins of Cubism, as the ordered abstraction of nature into basic geometric shapes.[79]

Younger American Painters was characterized by Cary as offering "a kaleidoscopic vision of that new art for which Cézanne . . . is primarily responsible."[80] Painter-critic Guy Pène du Bois noted that "widespread publicity" had resulted in an unjust focus on Matisse "who, in reality, far from being the originator, the head of a new movement in art, is a simply a disciple" of Cézanne: "Matisse . . . has dissected and divulged the older man's theories, what there is of greatness in his art, so successfully as to have been awarded the spurs that rightfully belong to Cézanne."[81]

In the same *Camera Work* issue as the Hartmann and Huneker pieces (July 1910), Caffin contributed a groundbreaking article in which he agreed that Matisse's "name obscures the movement of which he is only a part. He and not Cézanne has been regarded as the leader of the new thought."[82] Aiming "to set this right," Caffin emphasized Cézanne as having "started the modern painter on a new use of color" and "an abstract realization of the significance of plasticity and construction."[83] In an earlier article alluding to "The New Thought," Caffin discussed Steichen as "the first American painter who, comprehending the example of Cézanne, has been able to fit it into his own personality," even citing one of his photographs of Rodin as "constructively Cézannesque."[84]

In his aforementioned review, du Bois proposed that comprehensive exhibitions of the work of Matisse "and, better still, Cézanne" be held at The Metropolitan Museum of Art, noting that "many of the most promising young Americans have followed one or the other directly."[85] He was likely alluding to the fact that Cézanne's work had not yet been shown publicly in America. Cézanne's official debut at 291, late in 1910, was a modest affair, featuring his lithographs *Self-Portrait* (fig. 4), *Large Bathers* (cat. 15), and *Small Bathers* (fig. 5), in the context of Rodin's drawings, and prints by Manet, Renoir, and Toulouse-Lautrec, as well as works by Henri Rousseau. Weber's photographs of Cézanne's paintings have also been cited as having been shown for the first time as part of this display, however, it seems that they were likely on view even earlier. As Harrington observed in a review of Matisse's show of drawings and reproductions of his paintings, held in February–March 1910, "That the French artist is . . . the product of evolution is shown in a convincing manner by a series of photographs of paintings by predecessors of the present leader of the movement beginning with Cézanne."[86]

Little attention was paid to the first public appearance of Cézanne's work other than Cary's astute description of the *Large Bathers* print and observation of "the progression . . . from the now almost classic Manet and Rodin to the more revolutionary Cézanne, whose vast primitive talent seems to promise a fame even more enduring than that of the others."[87] She also referred to the simultaneous display of the first comprehensive Post-Impressionist exhibition at London's Grafton Galleries, organized by the art historian-painter Roger Fry, who established

Cézanne's "constructive design" as the foundation of modern art.[88] Fry had already published English translations of Denis's important article of 1907 (cat. 134), characterizing Cézanne as "the Poussin of Impressionism" who achieved "a reconciliation of the objective and subjective . . . the just equilibrium between nature and style" as he "assembles colours and forms without any literary preoccupation."[89] In his introduction, Fry asserted that it is "generally admitted that the great and original genius—for recent criticism has the courage to acclaim him as such—who really started this movement" in which "the decorative elements preponderate at the expense of the representative," was Cézanne.[90] On the occasion of the Grafton show, the British critic C. Lewis Hind acclaimed Cézanne—"a recluse, a seer" as "the true parent of Post Impressionism [to whom] the spiritual meaning was everything . . . seeking the soul-meaning behind the bodily forms."[91]

The Post-Impressionist show's in-depth press coverage heightened interest in Cézanne as among "the trinity of masters" who was the "isolated and mysterious . . . guide capable of leading [contemporary artists] out of the cul de sac into which naturalism has led them."[92] The final days of the Grafton show coincided with Max Weber's show at 291 in January 1911. Weber's previous Haas Gallery show affirmed his allegiance to Cézanne, with excerpts of the Frenchman's thoughts on art as expressed by Bernard in his articles of 1904 and 1907 (cat. 127).[93] Now categorized with Fry's new term, Weber the "Post-Post-Impressionist" was savagely attacked by the critics for his "weird works," which ran the gamut from Cézannesque to proto-Cubist.[94] Nevertheless, Weber was positively linked with Cézanne by Sadakichi Hartmann, and his show was characterized by Stieglitz as "a preparation and introduction" to the exhibitions of Cézanne and Picasso he held in March and April 1911.[95]

Thanks to Steichen's negotiations, a loan of twenty watercolors, primarily landscape subjects (including cats. 4, 9, 14), was secured from the Bernheim-Jeune gallery as "a really fine lot . . . as varied as possible."[96] Stieglitz likely prepared a bold introductory statement, possibly available at the gallery, that was later published anonymously in *Camera Work,* in which he characterized "the few touches of color" as "so sure, each stroke . . . so willed, each value so true, that one had [to] surrender to the absolute honesty, sincerity of purpose, and great mentality of him whom posterity may rank as the greatest artist of the last hundred years."[97] The meager reception to this landmark show was, however, largely hostile, with one critic even comparing the master unfavorably to one of his so-called American disciples, Marin, who repeatedly denied his influence:

> The watercolors of Cézanne . . . are certainly a long drop from the inspired color-clairvoyance of Marin. The Cézanne watercolors are merely artistic embryos—unborn, unshaped, almost unconceived things, which yield little fruit for either the eye or the soul.[98]

Others wrote more sympathetically about the suggestive power, freshness, and immediacy of the watercolors, in relation to Asian art "with a very distinctly Japanese . . . power of elimination."[99] The young Man Ray was "terrifically excited" when he saw the exhibition during his first visit to 291 and admired the "unfinished" quality of the watercolors, "as well as the use of the

white of the paper as part of the painting."[100] Photographer Paul Strand was also "tremendously interested" in the Cézanne watercolors, as was Oscar Bluemner, then an architect.[101] Affirming his commitment to Cézanne, Davies made the only purchase from the show, which was not well attended.[102] The notion that Cézanne had not yet been properly shown by representative works took hold; according to one critic "the paradox . . . [is] that this is the first show given to the American public of works of an important artist whose name stands as a sort of historical landmark on the borders of Impressionism and Post-Impressionism, yet it falls flat and insignificant."[103] Later in 1911, Stieglitz wrote a letter to the editor expressing his belief that The Metropolitan Museum of Art "owes it to the Americans to give them a chance" to view "an exhibition, a well-selected one, of Cézanne's paintings."[104] He also observed that without "the understanding of Cézanne—and this one can get only through seeing his paintings, and the best of them—it is impossible for anyone to grasp . . . much that is going on in the art world today."[105]

Stieglitz did not present another Cézanne show, and the immediately following Picasso exhibition did not provoke notable commentary, other than an emphasis upon Cézanne's so-called cylinders and cones as the misconstrued basis for Cubism.[106] Nevertheless, Stieglitz continued to publish pertinent articles in *Camera Work* by Caffin and others. Viewing Cézanne as "the prophet of a new beauty," Caffin asserted that Cézanne "brought to bear upon nature a scientific attitude of mind" through the subjection of "his sensations to logical analysis."[107] For Caffin, it was "this attitude toward art, harmonizing with the scientific trend of the time, which explains the influence he is exerting upon the younger generation . . . working to affect a harmony between two factors that have hitherto been accepted as irreconcilable—materialism and idealism . . . a completer union of art with life."[108] Caffin's reference to the emotional and spiritual appeal of Cézanne's art was reinforced by a passage—avidly absorbed by Hartley, Bluemner, Walkowitz, Weber, and many others—from "Extracts from 'The Spiritual in Art'" by Kandinsky published in the July 1912 issue. Grouping Cézanne, Matisse, and Picasso as "the seekers of the inner spirit in outer things," Kandinsky stated:

> Cézanne knew how to put a soul into a tea-cup, . . . he treated the cup as if it were a living thing. He raised "nature morte" . . . to that height where the outer dead things become essentially living. He treated things as he treated human beings, because he was gifted with the power of seeing the inner life of everything. He realizes them as color expressions, picturing them with the painter's inner note and compelling them to shapes, which, radiating an abstract ringing harmony, are often drawn up in mathematical forms. What he places before us is not a human being, not an apple, not a tree, but all these things Cézanne requires for the purpose of creating an inner melodious painting.[109]

Weber had already written in 1910 for *Camera Work* the first treatise on the fourth dimension in visual art, citing Cézanne's paintings among the key examples "of plastic art possessing this rare quality" of "the consciousness of a great . . . sense of space-magnitude in all directions at one time . . . somewhat similar to color and depth in musical sounds . . . arous[ing] imagination and stir[ring] emotions."[110] Similarly, John Weichsel wrote that the "universal oneness . . .

quivers in every detail of a Cézanne nature-revelation in color and form."[111] Other issues of *Camera Work* (including the June 1913 issue with several reproductions, see cats. 141–44) and exhibitions at 291 (see Chronology), continued to draw attention to the master as "the father of the Post-Impressionists."[112]

THE ARMORY SHOW, INTERNATIONAL EXHIBITION OF MODERN ART (1913)

Among the important visitors to 291 was the attorney and modern art collector John Quinn— closely allied with Arthur B. Davies—who had acquired his first Cézanne painting just in time for its inclusion in the Armory Show in February 1913 (see fig. 5 in Warman's essay in this volume).[113] This large-scale exhibition introduced modern art to America and featured the first representative selection of Cézanne's work, including thirteen oils, one watercolor, and two prints, dating from c. 1870 to c. 1896–98 (including cats. 8, 15). A prototype was Fry's London Post-Impressionist show, followed by a second exhibition in fall 1912. Excerpts from the 1912 catalogue essays by Fry and British critic Clive Bell were published in the guide to Maurer's one-person show at New York's Folsom Galleries in January 1913 in order to situate him within the orbit of the Post-Impressionists, each of whom "owes something directly or indirectly to Cézanne [in terms of] simplification and plastic design . . . the significance of form."[114] More importantly, a monumental international exhibition, the German *Sonderbund* in Cologne from May to September 1912, featured twenty-six paintings and two watercolors by Cézanne.[115]

These shows were important sources for the small group of artist-organizers of the Armory Show in the Association of American Painters and Sculptors, particularly its president Davies and his cohorts Pach and Walt Kuhn. Kuhn's progression from confusion to appreciation of Cézanne (fig. 6) is charted in his correspondence during his whirlwind trip abroad to assemble, along with his mentor Davies, a vast array of works for the Armory Show.[116] Pach assisted with the securing of art abroad and the preparation of pamphlets, translating a critical text on Cézanne by French philosopher Elie Faure (1910) which was published as a seventy-six-page booklet (cat. 140) available for visitors.[117] Full of projections into the mind and "Latin soul" of the artist, "tortured by the pitiless analysis to which he submits his impressions," this poetic statement traced Cézanne's life, influences, and uncompromising desire to "go beyond the superficial relations of man and society, to seize, in his work, the directions of his spirit."[118] Faure also reiterated Cézanne's classic aphorisms, including his desire to "make of impressionism, something solid and durable like the art of the museums."[119] Citing Cézanne's observation that he remained "the primitive of the way that I have discovered," Faure credited the artist with raising "a pedestal of archaic structure and form. It remains to us to erect upon it the final monument."[120] Noting that all "the young men who love painting . . . have more or less consciously solicited the counsel of [his] rough and subtle art," Faure concluded that never "since Rubens . . . has a painter awakened such fervor in the world of artists."[121]

In the midst of the huge exhibition, where Cézanne's works (displayed with those of van Gogh) jostled for attention with the controversial art of Matisse, Duchamp, Picasso, and others, his relatively subdued art was not always noticed.[122] Furthermore, some critics such as Frank Jewett Mather denigrated the selection of Cézannes as "far from superlative; [although] at least it

Fig. 6 Walt Kuhn, *Still Life with Apples and Pitcher*, 1939. Oil on canvas. Hirshhorn Museum and Sculpture Garden, Smithsonian Institution, Gift of Joseph H. Hirshhorn, 1966 (66.2841)

is the fullest America has yet seen."[123] Nevertheless, Mather admired, as a character study, *Woman with a Rosary*, which was reproduced in various reviews and as a postcard for sale (cat. 138) at the show and was cited as "perhaps the best known of all the [nearly] two thousand pictures shown," referring to Cézanne "who . . . reigns as king of the new Art."[124] Recent literature such as C. Lewis Hind's *The Post Impressionists* (1911) was quoted to supply further information.[125]

A study of the Armory Show's reviews illustrates the gradual shift in thinking on Cézanne's reputation to that of a revered father of modern art. In a special issue of *Arts & Decoration*, Davies provided a "chronological chart . . . showing the growth of modern art," with Cézanne listed separately in the "Classicists" and "Realists" categories.[126] Guy Pène du Bois similarly referred to Cézanne as "in a sense a classicist, in a sense a realist . . . the apotheosis of the modern movement in art."[127] Commenting on the "worthwhile" aspects of the American section as inspired by French art, William Glackens noted that the "cubes of the cubists that . . . inevitably give us a sense of weight . . . are derived directly from Cézanne."[128]

Christian Brinton observed that Cézanne liberated art "from the meticulous elaboration of academic practice . . . calmly extracting from . . . natural appearances their organic unity," thus achieving "that structural and chromatic integrity which became . . . the cornerstone of subsequent achievement."[129] He placed Cézanne at the forefront of the "trinity of modern painting," along with Gauguin and van Gogh, "the real pathfinders, the veritable heralds of all that has come after, and in their footsteps . . . should walk, with . . . humility the men of the present."[130]

However, conservative critic Royal Cortissoz decried the "mystery" of "the fuss that has been made over [Cézanne's paintings] as the tablets of a new evangel," given his status as "an off-shoot of the Impressionist School . . . who never quite learned his trade."[131]

The critic and *Camera Work* contributor J. Nilsen Laurvik highlighted Cézanne in a lengthy booklet *Is It Art?* as the "one man who was more radical, more uncompromising in his search of the ultimate reality . . . laboriously evol[ving] the art that was finally to revolutionize the current conception of form."[132] Noting that it "was left for a later generation to pay him the supreme compliment of imitation, obscuring his virtues and exaggerating his faults," Laurvik called Cézanne "a primitive by nature" whose "concrete, matter of fact realism . . . has been converted" into Cubism—"a system of involved geometrics simply because somewhere he said that form is based on the geometric figures of the sphere, cone, and cylinder."[133]

In *Camera Work,* Oscar Bluemner, now a Cubist painter and represented in the Armory Show (see cat. 25), discussed Cézanne's "rapid . . . universal influence . . . with those . . . who feel the pulse of our time," although he felt that Cézanne had been "quite inadequately represented by the number as well as . . . the quality" of his pictures.[134] He observed that "Cézanne substituted for the hitherto imitative effects abstract pictorial elements . . . similar to the poet's measured words or to the musician's rhythmic sounds," employing a musical analogy shared by other modernists.[135]

After closing in New York, smaller versions of the Armory Show traveled to The Art Institute of Chicago (fig. 7) and the Copley Society in Boston. Although the exhibition did not arouse much interest in Boston, its lively reception in Chicago is documented in press coverage prior to and during its run.[136] Among the most supportive critics was *Chicago Tribune* art critic Harriet Monroe, who provided excerpts from the writings of Bell, referring to Cézanne and Matisse who, as creators of "significant form," which "stir our aesthetic emotions," will be "the primitive masters of a movement destined to be as vast, perhaps, as that which lies between Cézanne and the [Byzantine] masters of San Vitale."[137] Wishing to correct the impression that the entire show was composed of "the 'freak' works of the foreign masters," it was noted elsewhere that "Cézanne now looks like an old master compared with the modernists."[138] Given that much of the press was intent on highlighting the perceived abnormalities of modern art, a special pamphlet *For and Against* was issued to provide more background material, referring to Cézanne as the first of "the Titans," who "went beyond Impressionism" and has "come into his own after a life of neglect and even contempt."[139]

Little documented evidence exists that the Armory Show had a direct impact upon specific artists. Nevertheless, it greatly substantiated earlier discoveries of Cézanne and modern art by American artists, many of whom were represented in the show, including Bluemner, Bruce, Carles, Dasburg, Davies, Hartley, Leon Kroll, Marin, Maurer, Pach, Prendergast, Russell, Schamberg, Sheeler, Walkowitz, and Weber.[140]

Although there were few significant sales of Cézanne's work, the Armory Show had a major effect upon the subsequent development of the modern art market and patronage.[141] Lillie P. Bliss, a future cofounder of The Museum of Modern Art, New York, was introduced to modern art during her frequent visits, likely under the tutelage of her mentor Davies, and

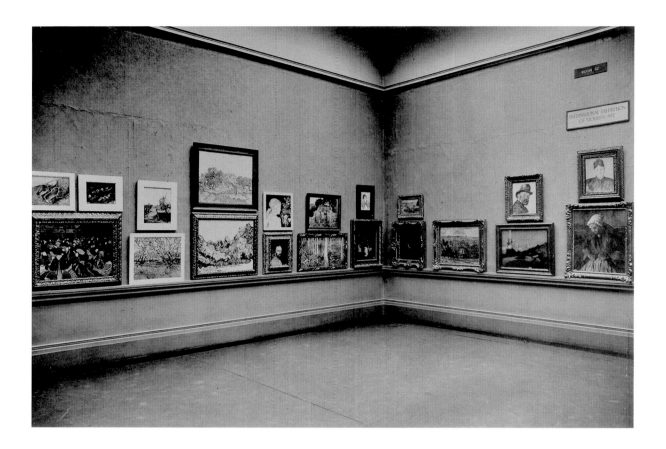

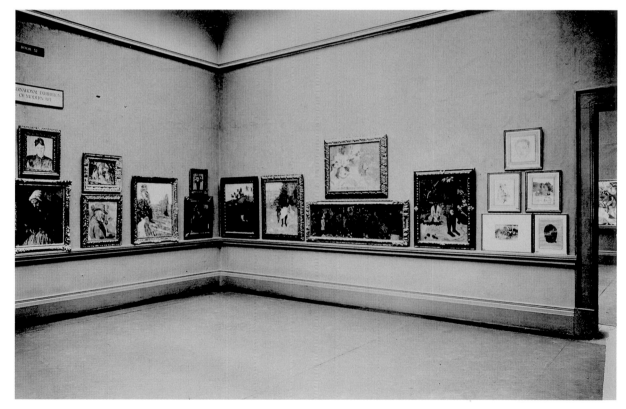

Fig. 7 The Armory Show,
traveling version, The
Art Institute of Chicago:
*Gallery 52, Cézanne,
Van Gogh, and Gauguin
(2 views)*, c. 1913.
Elmer MacRae Papers,
Collection Archive,
Hirshhorn Museum
and Sculpture Garden,
Smithsonian Institution,
Washington, DC, Gift of
the Joseph H. Hirshhorn
Foundation, 1966

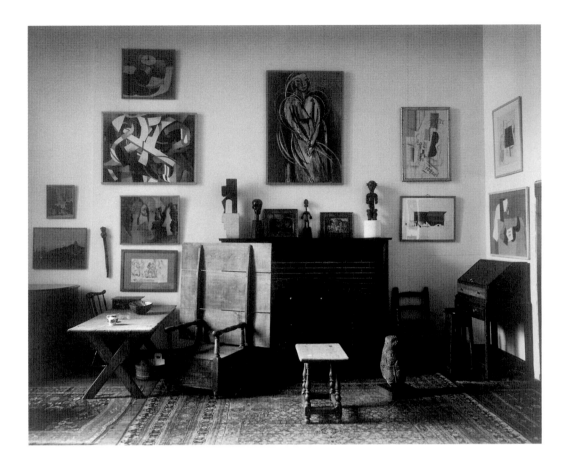

Fig. 8 Charles Sheeler, *Interior, Arensberg's Apartment, New York*, c. 1918. Casein silver print. Philadelphia Museum of Art: The Louise and Walter Arensberg Collection, 1950 (1950-134-989). Cézanne's watercolor *A Forest of Standing Timber* (cat. 4) is visible at lower left.

she acquired two Cézanne lithographs.[142] Walter Arensberg also purchased a Cézanne print. *Large Bathers* was one of five works this New York–based collector owned by 1918, when he had assembled one of America's finest collections of modern art, viewed at his frequently open house for such artists as his close friend-advisor Pach and Sheeler, Schamberg, Demuth, Man Ray, and many others (fig. 8).[143]

The first acquisition of Cézanne's work by an American museum was made by Bryson Burroughs for The Metropolitan Museum of Art. He selected a work that had not attracted much critical attention, Cézanne's relatively noncontroversial *View of the Domaine Saint-Joseph* (1888–90), the only one of his paintings acquired from the show (cat. 8).[144] At the institution, the ground had to be carefully prepared for the purchase, facilitated by Pach.[145] Upon the museum's unveiling of what was then called *La Colline des Pauvres,* the young critic Henry McBride characterized it as neither "dangerous [nor] revolutionary . . . painted with a great simplicity and an honesty that cannot be questioned."[146] Noting the vast amount of literature on Cézanne, McBride stated that it "seems awfully difficult, as Maurice Denis pathetically observes, for anybody to be precise about Cézanne," however, "the essential point is not in dispute."[147] Cézanne "is a great painter. All the fuss is over the descriptive adjectives."[148] The acquisition was also commented upon by Chicago-based collector Arthur Jerome Eddy in a lecture during the run of the Armory Show in his city: "The Metropolitan Museum . . . bought a Cézanne the other day for $8000 [*sic*] that it could have had years ago for $150."[149] Soon

after the show, Eddy wrote the first publication in America to cover its broad contemporary topic, *Cubists and Post-Impressionism* (1914), in which he referred to Cézanne as devoting "his entire life to trying to fathom the secrets of nature and paint her innermost truths" to create paintings that are "*built up* as firmly and scientifically as a builder builds a house."[150]

WILLARD HUNTINGTON WRIGHT: CÉZANNE AND SYNCHROMISM

The growing appreciation of Cézanne as measured by increased prices of his work was a byproduct of the proliferation of modern art galleries and exhibitions after the Armory Show, accompanied by "an avalanche of writings."[151] Critic Willard Huntington Wright (see cat. 61), brother of painter Stanton Macdonald-Wright, played a major role in clarifying Cézanne's position as the father of modern art. Known as "America's first aesthetician," Wright in 1913 observed that Cézanne "has become a fetich [*sic*]."[152] Cézanne had "abandoned the illustrative obstacle . . . [and] explored deeper emotional regions," exerting "an immense influence. . . . To name the men who are and have been his disciples . . . would . . . [comprise] . . . a dictionary of modern painters."[153] Wright regarded this influence as mostly "deplorable" because his "acolytes . . . hurriedly gulped the strange elements in his art, entirely failing to grasp the totality of his genius."[154] He saw, however, that "at the bottom of it all lay a healthy discontent with the old and hackneyed forms . . . the beginning of a renaissance of youth in painting."[155]

At the forefront of this new movement were Macdonald-Wright and Morgan Russell, whose Synchromist works seemed to their critic-advocate Wright "destined to have the most far-reaching effect of any force since Cézanne" with their "mastery over color . . . heretofore unattained."[156] Russell and Macdonald-Wright had positioned their abstractions in the catalogues for their debut exhibitions in 1913 in Paris and Munich as "finally solving the great problem of [the unification of] form and color . . . [to achieve an art] just as capable of music" to "transport us to the highest realms."[157] The Synchromists were further advanced by Wright, who credited them in 1915 with launching "the third and last cycle" which "began with Cézanne" and "resulted in the final purification of painting."[158] By "adding . . . new discoveries in the dynamics of color," the Synchromists, "making use of the achievements of Cézanne, Cubism, and Michelangelo," had "opened up a new vista of possibilities in the expressing of [abstract] aesthetic form."[159] In a review of a group show of modern American painters at the Montross Gallery in 1915, Wright repeatedly referred to the influence of Cézanne in relation to the work of Sheeler, Pach, Samuel Halpert, William Zorach, and especially George Of, whose Cézannesque technique "is not a [superficial] trick . . . [but rather] the inevitable result of far-reaching researches into the dynamics of nature's color translated into pigment."[160]

In 1915 Wright published a landmark article and a book on modern painting (cat. 145) that lucidly characterized the complex nature of Cézanne's achievements and legacy. Asserting that never "has there . . . been a painter of such wide influence so grossly misunderstood [and] canonized for qualities he would have repudiated," Wright attempted to set the record straight by reviewing the artist's biography, based on authentic anecdotes from Bernard.[161] Cézanne's "impetus towards voluminous organization" and "inspiration toward colour," emanating from the masters of the Louvre and Pissarro, were seen by Wright as the foundations of his oeuvre.[162]

assertion coincided with an international postwar avant-garde classicism based on principles of clarity, order, and universality, for which Cézanne was the most important modern source.[281] This concept had been affirmed by Jan Gordon in *Modern French Painters* (1923), which noted that "Cézanne represents a method upon which a new classicism of art can be built."[282] Pach similarly asserted Cézanne's "place in the classic line . . . the sense of measure . . . the laws of picture-making which the haste and confusion of the nineteenth century had obscured."[283] He observed that the "parallel between our conditions and those of a hundred years ago lies in the need to unite the classic, aesthetic principles (seen today in the work of Cézanne, Seurat, and Matisse) with the vision of our time."[284]

Fig. 10 Louis Stone, *Provence Landscape*, c. 1929. Oil on canvas. Courtesy of Michael Rosenfeld Gallery, LLC, New York

Fry's discussion of Cézanne's symbiotic fascination with Mont Sainte-Victoire may well have attracted the attention of Hartley, who painted several versions of this natural landmark during his sojourn in Aix-en-Provence from 1926 to 1928 (cats. 54, 55). For Hartley, the sublime light—"so peculiar to Provence"—and rugged geography afforded insights into Cézanne's absorption in his beloved native locale, as well as a sense of continuity with Hartley's own homeland.[285] In Aix, Hartley befriended the painter Erle Loran, who lived and worked in Cézanne's old studio, and who took pictures of many of the master's landscape motifs, which were published in *The Arts* in 1930.[286] Also painting nearby was Louis Stone (fig. 10), who went in the fall of 1928 to Aix-en-Provence, where he rented (with fellow artist Charles Evans) Cézanne's former home and studio.[287] Other visitors to Southern France included William H. Johnson and Hale Woodruff. As noted by painter-critic Jacques Mauny, "Cézanne became the great leader. . . . Everybody nowadays is painting in the vicinity of Marseilles, Aix, or Toulon."[288]

The publication of Fry's study coincided with that of a profusely illustrated translation of Meier-Graefe's 1910 Cézanne monograph. Both received considerable press coverage as having "gone directly [to the artist's work] for their material, seeking in the mementos left by a great spirit . . . the record of an aspiration drunk with agony of doubts and introspective despair, yet that attained perfection of utterance more often than it knew."[289] A retrospective was held in 1928 at Wildenstein Galleries in New York, and Cézanne's status as a classical old master was affirmed in a catalogue preface by the collector and lender Maud Dale (included cats. 6, 10).[290] In a review, Watson noted how the "great public which ignored Cézanne when . . . Stieglitz began his battles, poured into the Wildenstein Galleries speaking in awed whispers . . . [about] this genius, now so universally recognized" that his art had been buried in bombastic profundities.[291] Nevertheless, another reviewer noted that for all the "exhaustive studies," Cézanne remains mysterious because "of all painters save only the cubists (whom by chance he called into being)," he is the least concerned with representation, painting instead "eternal values" and "a dream of the universe" frequently beyond his reach.[292]

THE MUSEUM OF MODERN ART'S CÉZANNE, GAUGUIN, SEURAT, VAN GOGH EXHIBITION (1929)

Progress in the appreciation of Cézanne was also measured during the Wildenstein show in terms of the presence of many great works in private and some public collections in America.[293] These resources greatly facilitated the organization of the first show at the newly founded Museum of Modern Art, *Cézanne, Gauguin, Seurat, van Gogh* (cat. 151). Represented by an impressive group of twenty-nine oils and six watercolors (including cats. 1, 17), Cézanne was characterized by the museum's director, Alfred H. Barr, Jr., as having exerted an "influence during the last thirty years . . . comparable . . . to that of Giotto . . . or Michelangelo. . . . All over Europe and America fragments of Cézanne's art reappear in a thousand disguises."[294] Asserting that "Cézanne's innovations were so difficult and so little advertised that they were not understood until twenty-five years after he had made them," Barr concluded that his "mannerisms have become academic, but his essential power is inimitable. Men of such stature do not live today."[295] Barr had already developed his interest in "Cézanne's composition [as] founded on Poussin and the old masters"

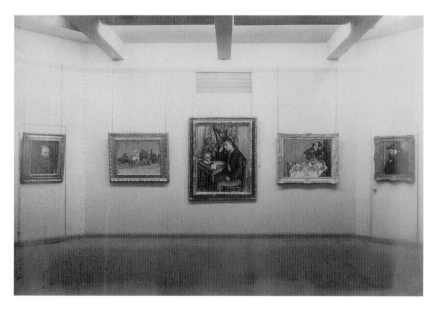

as a graduate student and then as an associate professor at Wellesley College where, in 1927, he taught the first classes in America on modern art.[296] Barr had also presented a series of lectures in 1928–29 discussing "the immediate antecedents of Cubism: . . . Cézanne's natural geometry" and "Modern American Painting . . . The Cézannists."[297]

Acclaimed as the most comprehensive exhibition of its kind in America, Barr's and the Modern's landmark show attracted over 47,000 people, including many artists and students.[298] The display of Cézanne self-portraits in the four corners of the main gallery was especially appreciated by visitors (fig. 11), as well as his *Boy with Skull* (R825, Barnes Foundation, Merion, PA), "a Hamlet-esque composition which attracted much attention."[299] Cézanne's celebrated still lifes were also cited as an artistic genre in which this uncompromising painter could not be surpassed.[300] One critic contrasted the viewing experience of patrons' informal homage to the thrilling adventure of art students who at last "can meet face to face the solved problems of genius," now that all the "tumult has died and the revolutionaries and iconoclasts of yesterday have slipped quietly into the rarer atmosphere of accepted greatness."[301]

It was also observed that Cézanne and the others "have had a greater influence on contemporary American painting than any four American painters of the past century—a convincing argument against the criticism which the inaugurating of a modern American museum with a French group will inevitably call forth."[302] The paintings of Cézanne charted his "growth . . . from the early landscape . . . in which . . . he is already stumbling in the right direction to the post-Pissarro period when he had developed in its greatest amplitude the vision that revolutionized the painting of our day."[303] Among "the giants of XIXth century art," Cézanne was viewed as a child "of the first great development in art since the Renaissance . . . painting the earth and its figures

Fig. 11 *Installation view of the exhibition "Cézanne, Gauguin, Seurat, van Gogh." The Museum of Modern Art, New York. November 7, 1929 through December 7, 1929 (in 1.3), 1929. The Museum of Modern Art, New York*

as never before, boring into mountains, reducing man to his parent clay in order that he might discover the realities of form."[304] Other critics, in reaction to this hyperbolic praise, commented that "we are still living in a period when it is fashionable to consider that no one painted before Cézanne."[305] Similarly, Royal Cortissoz noted that, although it "is in the still life paintings that you come closest of all to the effective Cézanne . . . one may appreciate them without recognizing in [him] an artist of quite the stature assigned to him in some quarters."[306] Noting with pride that the majority of loans in the show were from American collections, Cortissoz observed that "we are only a decade away from the centenary of Cézanne's birth . . . an epoch in which revolution was tinctured by tradition."[307]

OTHER EXHIBITIONS AND THE APPRECIATION OF CÉZANNE'S WORK OUTSIDE NEW YORK

Although the New York art world had taken the lead in the appreciation of Cézanne, Stieglitz had, by 1911, received more than one hundred letters "from art institutions [nationwide] asking about . . . the possibility of arranging [shows] for them of what they and the rest of the world are calling post-impressionism."[308] In 1913 the Newark Museum exhibited Cézannesque and Cubist works by Max Weber. The Cincinnati Art Museum in 1914 presented *Modern Departures in Painting*, featuring work by its organizers Davies, Kuhn, and Pach, as well as Prendergast, Sheeler, Schamberg, and other "insurgents" for whom "Cezanine [*sic*] [was] the father of the movement."[309] Vassar College, in Poughkeepsie, New York, featured the work of Pach, Schamberg, Sheeler, Weber, and others as followers of Cézanne in 1917 (see Chronology).

Among the relatively rare opportunities to see Cézanne's work outside New York prior to 1920 was the Panama-Pacific International Exposition in San Francisco in 1915, which included only one painting (see fig. 1 in Kyle's essay in this volume).[310] A selection of works, including this Cézanne, traveled in 1916 to other cities, including Buffalo's Albright Art Gallery, Pittsburgh's Carnegie Institute, and The Art Institute of Chicago, where a critic noted that "Cézanne's colors are said to have climaxed the efforts of a whole century."[311]

After 1921, in recognition of The Metropolitan Museum of Art's exhibition of Impressionist and Post-Impressionist paintings, other institutions around the country mounted somewhat more comprehensive exhibitions. In 1921 the Dallas Art Association presented an exhibition featuring sixteen Cézannes, primarily works on paper, as well as works by Carles, Dasburg, Davies, Demuth, and others. Organizer Forbes Watson emphasized the need to "recognize [the contemporary American artist] in the prime of his power" now, rather than subjecting him to the "long, hard struggle" in isolation, endured by Cézanne, whose "genius . . . cannot be downed even by an inimical public."[312]

Later in 1921 the Minneapolis Institute of Arts presented an exhibition of modern French art, including works by Cézanne, van Gogh, and others, whose paintings "have been subjected to the extremes of superlative praise and . . . violent abuse," to whom "American art owes . . . a great deal."[313] The Arts Club of Chicago hosted "the most significant exhibition of modern art" since the Armory Show with two paintings that provided an opportunity for Hamilton Easter Field to ruminate on Cézanne's influence:

Then the still life and landscape by Cézanne: as I was standing before the latter . . . a stranger remarked to me, "This is the way Americans should paint! They've begun to do it in writing—Anderson, Sandburg, Dreiser—but American painting will have its beginning only when our young men and women begin to understand Cézanne." Yes, our painters here may learn infinitely from these Cézannes.[314]

In 1922 the Detroit Institute of Arts presented an "exhibit of ultra modern painting," to enlighten "Detroiters [who] have hardly had an opportunity to see anything later than Impressionism."[315] Two paintings by Cézanne, whose "remarkable sincerity and vitality have taken such a hold on the world of contemporary achievement," were exhibited alongside works by Bruce, Davies, Hartley, Man Ray, Schamberg, and others.[316] In 1925, The Baltimore Museum of Art presented an exhibition of modern French art and reprinted an excerpt from The Metropolitan Museum of Art's 1921 catalogue. Among the lenders to this show, which featured three Cézannes, were the Cone sisters, Etta and Claribel.[317]

The exhibition that set the standard for future shows, though, was the Fogg Art Museum's 1929 survey of French nineteenth-century paintings and drawings, largely assembled from collections in the Boston area. Organized by associate director Paul Sachs, mentor to Barr at Harvard, this "superb display" was acclaimed for its exceptional presentation of works by Cézanne (cat. 10), van Gogh, and Degas, which raised expectations for The Museum of Modern Art's opening later that year.[318]

The Museum of Modern Art's first loan exhibition in November 1929, *Cézanne, Gauguin, Seurat, van Gogh*, was regarded as the fulfillment of those hopes. Noting that the show generated "an air of classicism worthy of the Louvre itself," McBride observed that the "bones of Edgar Allan Poe, . . . Cézanne, Charles Baudelaire . . . are disinterred and put in consecrated ground."[319] Barr noted that "several art connoisseurs who had been known for their antipathy to modern painting were 'converted' after seeing the exhibition."[320] This canonization of Cézanne and the other artists was also referred to as "a species of ancestral worship," confirmed by another article proclaiming the museum to be a "Shrine Reared to Modern Art Saints" who were "pioneers of a movement that still follows their leadership."[321]

In the evolution of Paul Cézanne's reputation from neglected, misunderstood recluse to universally revered genius, perceptive American artists played vital roles through their artwork, dialogues, writings, and organization of exhibitions. Several phases of their assimilation of Cézanne's aesthetic principles can be identified. Prior to the Armory Show, the pioneering modernists, including Max Weber, Charles Prendergast, Morgan Russell, Alfred Maurer, Marsden Hartley, Patrick Henry Bruce, and others, often combined their appreciation of Matisse's brilliant Fauve colors with the parallel, constructive brushstrokes, faceted surfaces, and complex, architectonic structures of Cézanne's oeuvre. This tendency to apprehend Cézanne's work through the filter of Matisse and his appreciation of his predecessor can be related to the greater attention initially accorded to the later French modernist. In relation to Cubism, Cézanne's work likely functioned more for Weber, Andrew Dasburg, and others as a starting point and bridge for apprehending the art of Picasso and Braque.

Matisse's initially pervasive influence is less apparent after 1913, with the increase in exhibitions of and writings about Cézanne's work, which was absorbed in increasingly personal, sophisticated ways by a great variety of artists and even collected by some (Arthur B. Davies, Walter Pach, and Stanton Macdonald-Wright). Incorporated into many articles and books, Cézanne's own words about his art were translated, quoted or adapted by Weber, Pach, Prendergast, Russell, Hartley, Bluemner, and others as instrumental to their appreciation of his oeuvre.[322]

Other factors in the complex web of influence were the growing appreciation of Renoir from 1904 onward, and also of van Gogh, Gauguin, and Seurat as pillars of modern art. Cézanne's treatment of form and structure was also associated by artists and critics with earlier traditions in Western art, as well as Nonwestern cultures (i.e., Japanism/Asian art, primitivism). Thus, prior to World War I, American modernists tended to focus on the innovative, radical aspects of Cézanne's work which validated their own experimentation with abstraction and new perceptions of art and the world around them. During the 1920s, a greater concern for more stable arrangements of smoothly rendered, volumetric, essential forms coincided with the international postwar classicism/"return to order," in which Cézanne served as the primary bridge between the old masters and modernism.[323] He continued to play this vital role at a time when many artists turned away from European-derived abstraction toward representation as a way of redefining their relationship to America, their native soil. Thus Cézanne's work served as a vital, enduring touchstone, especially for Weber and also Hartley, who was initially attracted to the "first cosmic" painter's watercolors as purely spiritual renditions of forms in space.[324] When Hartley made "the complete return to [a more objective approach to] nature" in the 1920s, Cézanne, as one of the "great logicians of color . . . [with] the intellectual knowledge of structure upon which to place . . . emotions," was still his guiding spirit.[325] Thus Cézanne's ongoing appeal as a multifaceted, modern role model and old master was related to his mysterious abilities to mediate the complex dualities of two-dimensional art and three-dimensional nature, intellect and intuition, as well as the material and immaterial.

The enigmatic, elusive Cézanne remained important for American artists striving to find national and personal identities because of his transcultural significance, as noted in 1915 by Willard Huntington Wright, who proclaimed him to be "above nationality," and in 1917 by the artist Everett Carroll Maxwell:

> Cézanne embodied the spirit of France in his work, yet he never painted an historical subject in his life. He was the logical result of generations of culture and high thinking. He loved the soil, and his work lives and speaks of a great people. . . . An artist may belong wholly to his country and yet be claimed by the universe.[326]

Notes

1. Théodore Duret, *Manet and the French Impressionists* (London: Grant Richards; Philadelphia: J. B. Lippincott, 1910), 186. This is an English translation of a book published in French in 1906.

2. Willard Huntington Wright, *Modern Painting, Its Tendency and Meaning* (New York: John Lane, 1915), 162–63.

3. Walter Pach, *Queer Thing, Painting: Forty Years in the World of Art* (New York: Harper & Brothers, 1938), 20.

4. Marsden Hartley, "Whitman and Cézanne," in *Adventures in the Arts* (New York: Boni and Liveright, 1921), 36.

5. Paul Cézanne, quoted in Émile Bernard, "Paul Cézanne," *L'Occident* (July 1904), in *Conversations with Cézanne*, ed. Michael Doran, trans. Julie Lawrence Cochran (Berkeley and Los Angeles: University of California Press, 2001), 38.

6. Letter of January 5, 1908, to Abraham Walkowitz, Max Weber Papers, Archives of American Art, Smithsonian Institution, reel NY59-8, fr. 378 (Archives of American Art hereafter cited as AAA), quoted in Jill Anderson Kyle, "Cézanne and American Painting," Ph.D. diss., University of Texas at Austin, 1995, 274.

7. On this first show, see Robert Jensen, "Vollard and Cézanne: An Anatomy of a Relationship," *Cézanne to Picasso: Ambroise Vollard, Patron of the Avant-Garde* (New York: The Metropolitan Museum of Art; New Haven, CT: Yale University Press, 2006), 29–38.

8. For Americans' awareness of Cézanne's presence at Giverny's Hotel Baudy in 1894, see William H. Gerdts, *Monet's Giverny: An Impressionist Colony* (New York: Abbeville Press, 1993), 118–19 ("it is extremely unlikely that his art had any impact because of his visit"), 235n6.

9. John Rewald, *Cézanne and America: Dealers, Collectors, Artists, and Critics 1891–1921* (Princeton: Princeton University Press, 1989), 26–27.

10. Ibid.,163.

11. Pach, *Queer Thing, Painting*, 224; Kyle, "Cézanne and American Painting," 332, 337; and Rewald, *Cézanne in America*, 32. See also Charles Sawyer, "The Prendergasts," *Parnassus* 10 (October 1938): 10.

12. Nancy Mowll Mathews, "Maurice Prendergast and the Influence of European Modernism," *Maurice Brazil Prendergast, Charles Prendergast: A Catalogue Raisonné* (Williamstown, MA: Williams College Museum of Art; Munich: Prestel, 1989), 36–41. See also William H. Gerdts, *Painters of the Humble Truth: Masterworks of American Still Life 1801–1939* (Columbia: University of Missouri Press, 1981), 236–37; in his discussion of Prendergast and other modernists, Gerdts decries the lack of "a definitive study of Cézanne's influence on American art."

13. See Françoise Cachin and Joseph J. Rishel, et al., *Cézanne* (Philadelphia: Philadelphia Museum of Art, 1995), 35.

14. James Huneker, "Autumn Salon is Bizarre," *New York Sun*, November 27, 1904, quoted in Rewald, *Cézanne in America*, 96.

15. Maurice Sterne, "Cézanne Today," *The American Scholar* 22 (Winter 1952–53): 41, 47 (see also 40–59). See also Charlotte Leon Mayerson, ed., *Shadow and Light: The Life, Friends, and Opinions of Maurice Sterne* (New York: Harcourt, Brace & World, 1965), 42–45, 53, 80, 83, 185, 216, 251. The author wishes to thank John Coffey for transcripts of clippings from 1911–36 from Maurice Sterne's papers at the Yale Collection of American Literature, Beinecke Rare Book and Manuscript Library, Yale University, referring to Cézanne's influence, especially on the Bali paintings (Yale Collection of American Literature hereafter cited as YCAL).

16. "If ardent youth sneered at the lyric ecstasy of Renoir . . . their lips were hushed as they tiptoed into the Cézanne sale. . . . Sacred, crude, violent, sincere, ugly, and altogether bizarre canvases. Here was the very hub of the Independents' universe" (quoted in Rewald, *Cézanne in America*, 96). See also James Huneker, *Promenades of an Impressionist* (New York: Charles Scribner's Sons, 1922), 3–4 (reprint of review). For Huneker's claim that he was "the first man to write in America about Cézanne," see Josephine Huneker, ed., *Letters of James Gibbons Huneker* (New York: Charles Scribner's Sons, 1922), 148 (see also 204). On Huneker, see John Loughery, "The *New York Sun* and Modern Art in America: Charles Fitzgerald, Frederick James Gregg, James Gibbons Huneker, Henry McBride," *Arts Magazine* 59 (December 1984): 79–80.

17. Bernard, "Paul Cézanne," 40. This first authentic article was based on Bernard's conversations with the master and excerpts from a few letters.

18. Ibid., 33. For an overview of Bernard and other early sympathetic writers on Cézanne, see Judith Wechsler, *The Interpretation of Cézanne* (Ann Arbor, MI: UMI Research Press, 1981), 6–27; and Kyle, "Cézanne and American Painting," 32–33, 95n15, 96–97, 139–41.

19. Bernard, "Paul Cézanne," 36–37.

20. Ibid., 38, 43.

21. See Rewald, *Cézanne and America*, 92, 114; and Maurice Denis, "Cézanne," *L'Occident* (September 1907), in *Conversations with Cézanne*, 165–79.

22. Max Weber, interview with Carol Gruber, "The Reminiscences of Max Weber," Columbia University Oral History Project, vol. 1, 1958, 118–19 ("the way to paint . . . art and nature reconstructed").

23. In Edmund Fuller, ed., *Journey Into the Self: Being the Letters, Papers & Journals of Leo Stein* (New York: Crown, 1950), 204, Stein asserted with regard to his introduction via Berenson, that he went to Vollard's and "saw some Cézannes. Like others who were saturated . . . in quattrocento Florentine art, Cézanne was easy. This was the time when Piero della Francesca, Pollaiuolo . . . and others of their kind and period were comparatively new and exciting. They formed a direct approach to the appreciation of Cézanne." See also *Four Americans in Paris: The Collections of Gertrude Stein and Her Family* (New York: The Museum of Modern Art, 1970), 24–26, 87–95 (photos of the Stein apartment), 155–56; and Carol Nathanson, "The American Response, in 1900–1913, to the French Modern Art Movements After Impressionism," Ph.D. diss., The Johns Hopkins University, 1979, 74–75, 116, 126–27 (Weber in Italy where he saw Loeser's Cézannes). On the pioneering collections of Loeser and also the American expatriate collector-painter Egisto Fabbri, see Francesca Bardazzi, ed., *Cézanne in Florence: Two Collectors and the 1910 Exhibition of Impressionism* (Milan: Electa, 2007).

24. See Constance Kimmerle, *Elsie Driggs: The Quick and the Classical* (New Hope, PA: James A. Michener Art Museum; University Park: University of Pennsylvania Press, 2008), 24–25, on Driggs in Italy in 1923. On Schamberg in Italy, see Nathanson, "The American Response," 273; and Kyle, "Cézanne and American Painting," 405.

25. See Rewald, *Cézanne and America*, 56, 61. For Stein's importance for artists as an extemporaneous speaker on modern art, see Kyle, "Cézanne and American Painting," 148–59. In 2011, a major exhibition will reunite the collections of Gertrude, Leo, Sarah, and Michael Stein. Entitled *Matisse, Picasso, and the Stein Family Collections* (working title), it will be held in New York, San Francisco, and Paris. Twenty Cézannes are on the working checklist, copy courtesy of Carrie Pilto, San Francisco Museum of Modern Art.

26. The others were Renoir, Manet, and Degas. Leo Stein to Mabel Weeks, early 1905, quoted in Rewald, *Cézanne and America*, 64 and 84n21 (original in YCAL). For more on the Stein salon, see Lee Simonson, *Part of a Lifetime: Drawings and Designs* (New York: Duell, Sloan, and Pearce, 1943), 14–16; Agnes E. Meyer, *Out of These Roots: The Autobiography of an American Woman* (Boston: Little, Brown, 1953), 80–81; and Mabel Dodge Luhan, *Intimate Memories, vol. 1, Background* (New York: Kraus Reprint, 1971), 321. ("Earlier still, he had come upon the Cézannes—and holding forth night after night in the big living room, he had forced people to see their value.")

27. Gertrude Stein, *The Autobiography of Alice B. Toklas* (New York: Random House, 1933), 37. See also Simonson, *Part of a Lifetime*, 16: "Seen for the first time, the Cézannes at the rue de Fleurus seemed startlingly incomplete." On the Steins, Vollard, and American artists in Paris, see also Karin Schick, "The Making of Cézanne—Eine Studie zur amerikanischen Cézanne-Rezeption," Ph.D. diss., Eberhard-Karls-Universität Tubingen, Laupheim, Germany, 2002, 11–17.

28. See Gail Stavitsky, *Gertrude Stein: The American Connection* (New York: Sid Deutsch Gallery, 1990), 7–8. See also Stacey B. Epstein, "Alfred H. Maurer: Aestheticism to Modernism 1897–1916," Ph.D. diss., City University of New York, 2003, 157–70; John H. Cauman, "Matisse and America, 1905–1933," Ph.D. diss., City University of New York, 2000, 29–45; Stacey B. Epstein, *Alfred H. Maurer: Aestheticism to Modernism* (New York: Hollis Taggart Galleries, 1999), 24–30; and William C. Agee, "The Tommy and Gill LiPuma Collection: Exploring American Art, 1906–1946." *High Notes of American Modernism: Selections from the Tommy and Gill LiPuma Collection* (New York: Berry Hill Galleries, 2002), 26–27.

29. Max Weber, "The Matisse Class," presented at the Matisse Symposium, November 19, 1951, Weber Papers, AAA, NY59-6, fr. 159. For the origins of the Matisse class, see Cauman, "Matisse and America," 75–79 (see also 5–48 on the Steins and American artists in their circle). See also Kyle, "Cézanne and American Painting," 159–69; and Phyllis Burkley North, "Max Weber: The Early Paintings (1905–1920)," Ph.D. diss., University of Delaware, Newark, 1975, 12–40 and passim. On Pach as a visitor to the Matisse Academy and informal student, see John Cauman, "Henri Matisse's letters to Walter Pach," *Archives of American Art Journal* 31, no. 3 (1991): 2–3.

89. Roger Fry, trans., "Cézanne I—by Maurice Denis," *Burlington Magazine* 16, no. 82 (January 1910): 213, 214, 219; and Roger Fry, trans., "Cézanne–II by Maurice Denis," *Burlington Magazine* 16, no. 83 (February 1910): 279. For Fry, see Wechsler, *The Interpretation of Cézanne,* 33–45; and Kyle, "Cézanne and American Painting," 61–66, 106–10.

90. Fry, "Cézanne I," 207. See also Rewald, *Cézanne and America,* 132 on the Grafton show and Fry, whose articles were looked at by John Sloan, who wrote in his diary, "A big man . . . his fame is to grow." (136, 153n36.)

91. C. Lewis Hind, *The Post Impressionists* (London: Methuen, 1911), 2, 3, 5, 32. See also 6, 11, 12, 25–28, 30–33, 38, 40, 43–45.

92. "Seen in the World of Art: Interest in a London Show of Post-Impressionists," *The Sun,* January 1, 1911. The other masters referred to were Gauguin and van Gogh. This article also referred to Cézanne as the "deliverer" for "artists who felt most the restraints which the Impressionist attitude toward nature imposed upon them" because he "showed how it was possible to pass from the complexity of the appearance of things to the geometrical simplicity which design demands." See also Frederick Lawton, "Paul Cézanne," *The Art Journal* (London) 1911, 55–60: "After a long life of unpopularity, he has recently been lifted . . . to a pinnacle of fame. . . . [His] vision was . . . partly mystical, partly logical, and always abstract." This illustrated article included (60) an illustration of cat. 5.

93. Percy North, *Max Weber: American Modern* (New York: Jewish Museum, 1982), 27; and *Max Weber* (New York: Gerald Peters Gallery, 2000), 17. For the importance of Bernard's articles in 1904 and 1907 of Cézanne's letters of 1904–6, see Kyle, "Cézanne and American Painting," 141–43.

94. Review by James B. Townsend, *American Art News,* reprinted in *Camera Work* 36 (October 1911): 33. See 31–46 for all reprinted reviews.

95. Stieglitz quoted in *Camera Work,* 29; and Sadakichi Hartmann, "Structural Units," *Camera Work* 36 (October 1911): 18–20.

96. Steichen to Stieglitz, early 1911, BL, quoted in Rewald, *Cézanne and America,* 141. For more on the organization of the show, including Stieglitz's prediction that these "pictures will become the fashion," see Norman, *Alfred Stieglitz,* 105–6; and Norman, "Writings and Conversations of Alfred Stieglitz," 83–84. See also Edward Steichen, *A Life in Photography* (New York: Doubleday, 1963), 67–68, claiming that he had painted a fake Cézanne that was included in the show, which he later burned. "Of all the exhibitions we had at 291, this one was probably the most sensational and the most outrightly condemned. Of course, appreciators of avant-garde art thought it was the best we ever had."

97. "Cézanne Exhibition," *Camera Work* 36 (October 1911): 30. See Rewald, *Cézanne and America,* 129–51.

98. Joseph Edgar Chamberlain, "Cézanne Embryos," *The Evening Mail,* March 8, 1911, quoted in Rewald, *Cézanne and America,* 146. On Marin having likely seen the Cézanne show despite his denials of the master's influence, see Kyle, "Paul Cézanne, 1911," 111; and Charles H. Caffin and Henry Tyrell, reviews reprinted in *Camera Work* 48 (October 1916): 37, 53. On the paucity of reviews, see Phillips, "Cézanne's Influence," 19–22, and on lack of attendance, 23, quoting Stieglitz: "There were fewer people at the first Cézanne exhibition in America

at 291, than at any other of the demonstrations there. And people would not buy Cézannes at $175!" (from Herbert J. Seligman, *Alfred Stieglitz Talking* [New Haven: Yale University Press, 1966], 26). Research in the Stieglitz Archives at the Beinecke Library, box 112, folder 2267, yielded only one additional review that was not reprinted in *Camera Work:* B. P. S[tephenson], untitled, *Evening Post,* n.d. [March 1911]: "There are people, no doubt, who can see some magic in Cézanne's Still Life, both in design and color. We saw only a badly drawn basin and jug lined in blue, with one or two dabs of blue on the surfaces . . . [nor could he appreciate] a Landscape that Stieglitz . . . raved about—'Japanese art never reached such a height.'"

99. See "Watercolors by Cézanne," *The New York Times,* March 12, 1911, quoted in Rewald, *Cézanne and America,* 148; and Rockwell (quoted Fry) in *Brooklyn Daily Eagle,* March 8, 1911, reprinted in *Camera Work* 36 (October 1911): 48. See "Art Notes," *The Craftsman* 20 (May 1911): 237: "The writer found in Cézanne . . . a very delicately beautiful insight into outdoor life, a Japanese feeling imagined upon a modern interest." See also Kyle, "Paul Cézanne, 1911," 109; and Kyle, "Cézanne and American Painting," 225–32 for discussions of Japanism and Cézanne. She quotes Weber as stating that through Cézanne, "I learned to love the archaic. . . . I altered . . . my interpretation . . . of . . . Far Eastern art" (232, 303n84, cited to Weber, "The Reminiscences," 119).

100. See Arturo Schwarz, *Man Ray: The Rigour of Imagination* (New York: Rizzoli, 1977), 25; Man Ray, *Self Portrait* (Boston: Bulfinch Press, 1988 ed.), 25; and Man Ray, "Impressions of 291," *Camera Work* 47 (July 1914): 61 recalling "Cézanne, the naturalist" at 291.

101. Homer, *Alfred Stieglitz and the American Avant-Garde,* 245.

102. Rewald, *Cézanne and America,* 151; and Norman, "From the Writings and Conversation of Alfred Stieglitz," 84.

103. Tyrell, *New York Evening World,* quoted in *Camera Work* 36 (October 1911): 47. Tyrell asserted that "students who know nothing of Cézanne, except what they learn here, will go away knowing even less, because they will have a one-sided and dead wrong idea of the man's real significance."

104. Stieglitz's letter to the editor of the *Evening Sun,* cited in Norman, *Alfred Stieglitz,* 109; and Nathanson, "The American Reaction," 8, who notes that the letter was a response to an article by Charles Fitzgerald in the *New York Evening Sun,* asking for a "fair chance to judge . . . these painters? Mr Stieglitz has shown us some examples of the later things, but, apart from these and a few sweepings from Cézanne's studio, we have seen nothing here."

105. Ibid. (Stieglitz's letter).

106. For reviews of the Picasso show, see *Camera Work* 36 (October 1911): 51–54 (e.g., 52–53, Israel White in the *Newark Evening News:* "Cézanne and his followers progressed to solid and spherical geometry, making the cylinder and the cone the bases of their patterns. Now I find Picasso using cubes and crystals, the very elements of pictorial design . . . to suggest natural forms."); and Cauman, *Inheriting Cubism,* 24.

107. Charles H. Caffin, "A Note on Paul Cézanne," *Camera Work* 34–35 (April–July 1911): 48, 50.

108. Ibid., 48, 51. Caffin also observed (50) that Cézanne's art has "the elements of gravity and greatness that the classic masters . . . share with those of Egypt and the

Orient." See also Kyle, "Cézanne and American Painting," 215–18; Sandra Lee Underwood, *Charles H. Caffin: A Voice for Modernism 1897–1918* (Ann Arbor, MI: UMI Research Press, 1983), 153–55; and Schick, "The Making of Cézanne," 66, 322–23 (on Cézanne as "scientist" in the writings of Caffin, Fry, Barnes, and Phillips). See too in the same issue of *Camera Work,* Marius de Zayas, "The New Art in Paris," 31 (refers to artists today as "officiating at the altars of Greco, Cézanne, and Gauguin").

109. Wassily Kandinsky, "Extracts from 'The Spiritual in Art,'" *Camera Work* 39 (July 1912): 34. On Caffin, see Underwood, *Charles H. Caffin,* 37, 87–88. On American modernists and Kandinsky, see Gail Levin, "Marsden Hartley and the European Avant-Garde," *Arts* 54 (September 1979): 159; Gail Levin, *Theme & Improvisation: Kandinsky and the American Avant-Garde 1912–1950* (Boston: Bulfinch Press, 1992), 10, 22–61; Patricia McDonnell, "'Dictated by Life': Spirituality in the Art of Marsden Hartley and Wassily Kandinsky, 1910–1915," *Archives of American Art Journal* 29, nos. 1–2 (1989): 30; and Kyle, "Cézanne and American Painting," 372–73. See also Bernard, "Paul Cézanne," 40–41 on Cézanne's "mystical nature"; and Wechsler, *The Interpretation of Cézanne,* 41–43.

110. Max Weber, "The Fourth Dimension from a Plastic Point of View," *Camera Work* 31 (July 1910): 25. See also Percy North et al., *Max Weber The Cubist Decade 1910–1920* (Atlanta: High Museum of Art, 1992), 16, 23; and Linda Dalrymple Henderson, *The Fourth Dimension and Non-Euclidean Geometry in Modern Art* (Princeton: Princeton University Press, 1983), 64. See also Max Weber, *Essays on Art* (New York: W. E. Rudge, 1916), 20, 70–71.

111. John Weichsel, "Cosmism or Amorphism?," *Camera Work* 32–33 (April–July 1913): 69–70, see also 71, 76, 77, 79, 82.

112. *Camera Work* Special Number (June 1913): pls. I–III. The three works reproduced were all ones that Max Weber had purchased as Druet prints, so it is interesting to speculate whether they were the source, although Weber and Stieglitz were no longer close at this point (on their falling out in 1911, see Percy North, "Turmoil at 291"): *Portrait of Louis Guillaume* (1879–80; R421), detail of *The Large Bather* (1906; R857), and *Sugarbowl, Pears, and Tapestry* (1893–94; R771). Other references to Cézanne can be found in the following issues of *Camera Work:* no. 34–35 (April–July 1911): 52; no. 38 (April 1912): 18, 37; no. 39 (July 1912), Sadakichi Hartmann, "Once More Matisse," 22: "Cézanne, Matisse, Picasso endeavor to give a new understructure to color."; no. 41 (January 1913): 27, 43; Special Number (June 1913): 30–31, 34, 36; no. 44 (October 1913): 25; no. 45 (June 1914): 17, 41; no. 47 (July 1914): 45, 61; no. 48 (October 1916): 10, 37, 53, 54; nos. 49–50 (June 1917): 35.

113. See Rewald, *Cézanne and America,* 141, 146, 165; and Judith Zilczer, *The "Noble Buyer": John Quinn, Patron of the Avant-Garde* (Washington, DC: Smithsonian Institution Press, 1978), 22, 23, 25–27. Quinn was the biggest lender to and buyer from the Armory Show. For other collectors who lent and purchased Cézannes, see Milton Brown, *The Story of the Armory Show* (New York: Abbeville Press, 1988), 96–97, 126, 130–32.

114. *Exhibit of the Recent Paintings of Mr. Alfred H. Maurer of Paris* (New York: Folsom Galleries, 1913), unpaginated, American Art Exhibition Catalogues, 1817–1945, AAA, reel N-435, fr. 70. See also Epstein, *Alfred H. Maurer,* 246–50.

115. See Walt Kuhn's annotated copy of the catalogue of this exhibition, marked as "one of the inspirations of the Armory Show," Walt Kuhn Papers, AAA, box 9, folder 9. See also Walt Kuhn, *The Story of the Armory Show* (New York: n.p., 1938), reprinted in *The Armory Show International Exhibition of Modern Art, 1913* (New York: Arno Press, 1972), 3:8, discussing the Cologne exhibition as "the model of what we finally did in New York [with] a grand display of Cézannes." On Kuhn's later concentration on Cézannesque still lifes in the 1930s, see Philip Rhys Adams, *Walt Kuhn, Painter: His Life and Work* (Columbus: Ohio State University Press, 1978), 153, 196 (48–51 is about the Armory Show). On Bluemner having seen this show, see Patricia McDonnell, *Painting Berlin Stories: Marsden Hartley, Oscar Bluemner, and the First American Avant-Garde in Expressionist Berlin* (New York: Peter Lang, 2003), 121 (on Hartley, see 72–74).

116. Rewald, *Cézanne and America*, 168–69; and Adams, *Walt Kuhn*, 46–50. See also Milton Brown, "Walt Kuhn's Armory Show," *Archives of American Art Journal* 27, no. 2 (1987): 6–10.

117. Analyzed briefly in Rewald, *Cézanne and America*, 182–83. For Walter Pach's pamphlet *A Sculptor's Architecture* (1913), see also *The Armory Show International Exhibition* 3:16–17, 19 for his discussion of Cézanne as "the great master of these latter years" and "the great realm of possibilities he opens up for succeeding artists by his organization of a work into a structure."

118. Elie Faure, *Cézanne* (New York: Association of American Painters and Sculptors, 1913), 29, 33, 44.

119. Ibid., 41, Faure cites Maurice Denis's article in *L'Occident*, September 1907.

120. Ibid., 63 (Faure noted Bernard, "Paul Cézanne" as source), 64.

121. Ibid., 70. "Most of them have thought they must submit themselves to the letter of his teaching—by voluntarily inflicting twists and fractures on the form, by peopling imaginary landscapes with nudes that look like bursted sausages or by installing on the edge of a table a glass of wine and three onions. Some, penetrated by his spirit, have resolutely approached nature with the sole preoccupation of demanding from her—aside from all literary or moral intentions or tendencies—the secret of pure coloration and the essential structure which will permit the men of to-morrow to bring back her great decorative rhythms." See also Phillips, "Cézanne's Influence," 26 for her analysis of this text.

122. See, e.g, "A Private Collection That Contains Fourteen Examples of the Art of Paul Cézanne, a Great Modern Who Already Is Placed with the Old Masters," *The New York Times,* July 6, 1913, for an illustrated review contrasting the current spacious installation of the Reber collection in Darmstadt, Germany, with "its unparalleled group of Cézannes" to the Armory Show's previous "crowd hasten[ing] by [the] comparatively undisturbing Cézannes" to "gape aghast at the sensational Matisse." Rewald, *Cézanne and America*, 215, believes this was written by Willard Huntington Wright. For more information, including the original intention to have a separate room for Cézanne's work, see Brown, *The Story of the Armory Show,* 79, 117, and passim; "The Armory Show: A Selection of Primary Documents," *Archives of American Art Journal* 27, no. 2 (1987): 21; and "Art at Home and Abroad," *The New York Times,* January 5, 1913.

123. Frank Jewett Mather, Jr., "Old and New Art," *The Nation* 96 (March 6, 1913): 241. For overviews of the show's critical reception, including conservative backlashes by Kenyon Cox and others, see Phillips, "Cézanne's Influence," 28–30, 36; Rewald, *Cézanne and America*, 182–91; and Brown, *The Story of the Armory Show*, 153–86 (see especially 157–61 for negative criticism).

124. Quotes from "The Greatest Exhibition of Insurgent Art Ever Held," *Current Opinion* 54 (March 1913): 231; and C. Owen Lublin, "Through the Galleries," *Town and Country,* March 1, 1913, 24. See Brown, *The Story of the Armory Show*, 93 on the postcards for sale as "a source of some artistic influence," especially for artists in other cities—"for years people in remote areas had only these cards as a source of study." See also Schick, "The Making of Cézanne," 23, on the importance of the postcards for Carl Sprinchorn teaching at the Los Angeles Art Students League. *Woman with a Rosary* (R808) was also reproduced in the special Armory Show issue of *Arts & Decoration* Special Edition Number (March 1913): 167; and in an article by Frank Jewett Mather on "Newest Tendencies in Art," *The Independent* (March 6, 1913): 505, who declared it to be "almost a classic . . . distinguished by less of eccentricity than the work of his successors."

125. Harriet Monroe, "Bedlam in Art: A Show that Clamors," *Chicago Daily Tribune*, February 16, 1913. See also Monroe's *Chicago Daily Tribune* articles of January 19, February 17, and February 23, 1913.

126. "Chronological Chart Made by Arthur B. Davies Showing the Growth of Modern Art," *Arts & Decoration* Special Edition Number (March 1913): 150. The other category, in which he is not listed, is "Romanticists." See also Brown, *The Story of the Armory Show*, 113.

127. Guy Pène du Bois, "The Spirit and Chronology of the Modern Movement," *Arts & Decoration*, Special Edition Number (March 1913): 154: "Cézanne arouses interest by creating disequilibrium and then . . . by the force of his will creates the balance, the equilibrium. He is essentially a classicist; that is, like Ingres, demands last of all, order, measure, the harmonious scheme that is essential . . . to the completion of a musical composition. He insists upon the relation of color to form, as do the Cubists, of forms to each other, of their dramatic play in juxtaposition. He gives the impression of the disorder of nature and by his herculean will of its order."

128. "The American Section (The National Art): An Interview with the Chairman of the Domestic Committee, William J. Glackens," *Arts & Decoration* Special Edition Number (March 1913): 159.

129. Christian Brinton, "Evolution Not Revolution in Art," *The International Studio* 49 (April 1913): XXX.

130. Christian Brinton, "Fashions in Art," *The International Studio* 49 (March 1913): 9.

131. Royal Cortissoz, "The Post-Impressionist Illusion," *The Century Magazine* 125 (April 1913): 808–9.

132. J. Nilson Laurvik, *Is It Art? Post-Impressionism Futurism Cubism* (New York: The International Press, 1913), reprinted in *The Armory Show International Exhibition*, 3:2, 3. See also Brown, *The Story of the Armory Show*, 185–86.

133. Laurvik, *Is It Art?*, 4, 27. See also 5, 6, 7–8 (quotes from Bernard's articles), 8–9 ("Even now, only seven years after his death, he is regarded by many of the most discerning spirits of our age as . . . a demi-classic . . . perhaps the last great painter whose work has in it something of the grand manner, a certain severity of style that inevitably recalls El Greco and the Primitives"), 28, 31, also repro. of *Woman with Rosary* [35].

134. Oscar Bluemner, "Audiator Et Altera Pars: Some Plain Sense on the Modern Art Movement," *Camera Work* Special Number (June 1913): 30, 31. See also 34.

135. Ibid., 36. See also "Art at Home and Abroad," *The New York Times,* July 20, 1913, in which Cézanne is declared the master of the "new school . . . moving [toward] 'pure art' as in architecture and music, not by imitation of nature as in the past." On the relationship between modern art and music in the work of Morgan Russell, Stanton Macdonald-Wright, and others, see *Visual Music: Synaesthesia in Art and Music Since 1900* (Washington, DC: Hirshhorn Museum; Los Angeles: Museum of Contemporary Art; London: Thames and Hudson, 2005), 44–46.

136. For the show's reception in Boston, see Kuhn, *The Story of the Armory Show, in The Armory Show International Exhibition,* 3:21–22; Garnett McCoy, "The Post Impressionist Bomb," *Archives of American Art Journal* 20 (1980): 12–17; "Mamma's Angel Child Has Cubist Nightmare in the Studio of Monsieur Paul Vincent Cezanne Van Gogen Gauguin," cartoon, *Boston Daily Globe,* April 13, 1913; and A. J. Philpott, "Marvels of Modernity in the Name of Art, Post Impressionist, Futurist, and Cubist Exhibition Would Be a Joke If One Could See the Point," *Boston Daily Globe,* April 28, 1913, "There are four phases of the post-impressionist delirium clearly in evidence in this show. . . . The beginning . . . is seen in the work of Cézanne, which is not bad in color, but which is insipid and careless in drawing." See Brown, *The Story of the Armory Show,* 215–19.

137. Harriet Monroe, "International Art to Open at the Institute on March 24," *Chicago Evening Tribune,* March 16, 1913, in The Art Institute of Chicago Scrapbook, microfilm 25, reel 5 (hereafter AIC Scrapbook). The quotes are from Bell's article "Post-Impressionism and Aesthetics," *Burlington Magazine* 22 (January 1913): 227, 229, which Monroe quotes extensively. See also her article "Art Exhibition Opens in Chicago," *Chicago Daily Tribune,* March 26, 1913: "The finest example . . . indeed, the only one which shows his intense power of concentration is the 'Woman with Rosary.' However, in the two self-portraits and the two of his wife, we have further testimony to his direct sincerity of vision and his reduction of a problem to its salient terms. His groups of figures and his landscapes, especially the superb dark 'Landscape' (No. 49) show the same uncompromising power."

138. "Cubists Invade City Today," *Chicago Tribune,* March 21, 1913, quoting this line from a press release by F. J. Gregg, AIC Scrapbook. For other references to Cézanne, see the untitled *Chicago Evening Post* clipping, March 27, 1913. On the show in Chicago, see also Brown, *The Story of the Armory Show,* 187–214; Sue Ann Prince, ed., *The Old Guard and the Avant-Garde, Modernism in Chicago, 1910–1940* (Chicago: University of Chicago Press, 1990), 209–14; and Andrew Martinez, "A Mixed Reception for Modernism: The 1913 Armory Show at the Art Institute of Chicago," *Art Institute of Chicago Museum Studies* 19, no. 1 (1993): 30–57, 102–5.

139. Frederick James Gregg, *For and Against: Views on the International Exhibition Held in New York and Chicago* (New York: Association of American Painters and Sculptors, 1913), 20–22.

140. For Brown's speculations on the general impact on artists, see Brown, *The Story of the Armory Show*, 236–38. For artists' reactions to the show, including Sheeler, Kroll, William Zorach, and Stuart Davis, see Milton Brown, *1913 Armory Show: 50th Anniversary Exhibition, 1963* (Utica, NY: Munson-Williams-Proctor Institute, 1963), 93–97 (the only artists mentioning Cézanne were Paul Burlin, Randall Davey, and Carl Sprinchorn). See also Schick, "The Making of Cézanne," 22–23. For Strand's particular interest in Cézanne's paintings which he saw for the first time, see Homer, *Alfred Stieglitz and the American Avant-Garde*, 246.

141. Judith Zilczer, "The Armory Show and the American Avant-Garde: A Re-Evaluation," *Arts Magazine* 53 (September 1978): 126–30. See also Judith Zilczer, "'The World's New Art Center': Modern Art Exhibitions in New York City, 1913–1918," *Archives of American Art Journal* 14, no. 3 (1974): 2–7.

142. Brown, *The Story of the Armory Show*, 121, refers to the Armory Show as the initial impetus for her collection which would later include 26 Cézannes; her purchases are listed on 254; Kuhn, *The Story of the Armory Show*, in *The Armory Show International Exhibition* 3:17, cited Bliss as a daily visitor. On Davies and Bliss, see Judith Zilczer, "Arthur B. Davies: The Artist as Patron," *The American Art Journal* 19 (1987): 77, 81.

143. Brown, *The Story of the Armory Show*, 254; and Francis Naumann, "Walter Conrad Arensberg: Poet, Patron, and Participant in the New York Avant-Garde 1915–20," *Philadelphia Museum of Art Bulletin* 76 (Spring 1980): 1–32 (see especially 4, 7–9).

144. Brown, *The Story of the Armory Show*, 252–54. The only other purchases were of two lithographs, probably *Large Bathers* and *Small Bathers*. For Cézannes owned by Arensberg, see Rewald, *The Paintings of Paul Cézanne*, nos. R344, R755; and Rewald, *Paul Cézanne: The Watercolors*, nos. RWC151, RWC233 (cat. 4 herein), RWC581.

145. Rewald, *Cézanne and America*, 203–7. See also Bryson Burroughs, "Recent Accessions," *Bulletin of the Metropolitan Museum of Art* 8 (May 1913): 108 (109, incorporation of Cézanne quotes); and Frank Crowninshield, "The Scandalous Armory Show of 1913," *Vogue*, September 15, 1940, 114. For Pach's facilitation of this purchase, see Perlman, *American Artists, Authors, and Collectors: The Walter Pach Letters*, 6, 119–20; and Laurette E. McCarthy, "The 'Truths' about the Armory Show: Walter Pach's Side of the Story," *Archives of American Art Journal* 44, nos. 3–4 (2004): 6.

146. Henry McBride, "Cézanne at the Metropolitan," *The Sun*, May 18, 1913, reprinted in *The Flow of Art: Essays and Criticisms of Henry McBride* (New York: Atheneum 1975), 33.

147. Ibid., 33–34.

148. Ibid., 34. See also the catalogue entry on this painting in *Cézanne to Picasso: Ambroise Vollard, Patron of the Avant-Garde* (New York: The Metropolitan Museum of Art; New Haven, CT: Yale University Press, 2006), 341.

149. Untitled clipping by Joan Candoer, *Chicago Examiner*, March 28, 1913, in AIC Scrapbook. For the actual discounted purchase price of $6,700, see Rewald, *Cézanne and America*, 205. For Cézanne's prices, including $48,600 for the *Woman with a Rosary*, see Brown, *The Story of the Armory Show*, 132, 252–54.

150. Arthur Jerome Eddy, *Cubists and Post-Impressionism* (Chicago: A.C. McClurg & Co, 1919 ed.), 36, 37. See also

25, 26, 28, 35, 38–39, 46; Rewald, *Cézanne and America*, 224–25; and Phillips, "Cézanne's Influence," 38–44 for further analysis.

151. This quotation is the title of Rewald, *Cézanne and America*, Chapter 9, 211.

152. André Tridon, "America's First Aesthetician," *The Forum* LV (January 1916): 124; and Wright, "From Impressionism to Synchromism,"), 763. On this article and Wright, who later became well known as a mystery writer, see John S. Loughery, *Alias S.S. Van Dine* (New York: Scribner, 1992), 76–83. See also Rewald, *Cézanne and America*, 211, 215–19, 237–46; and Phillips, "Cézanne's Influence," 44–49. For Stanton Macdonald-Wright's authorship of this article which was solicited and signed by Willard, see Will South, *Color, Myth, and Music: Stanton Macdonald-Wright and Synchromism* (Raleigh: North Carolina Museum of Art, 2001), 46.

153. Wright, "From Impressionism to Synchromism," 762–63.

154. Ibid.

155. Ibid., 763.

156. Ibid., 768–69.

157. Morgan Russell and S. Macdonald-Wright, "In Explanation of Synchromism," *Austellung Der Synchromisten Morgan Russell, S. Macdonald-Wright*, Der Neue Kunstsalon, Munich, June 1–30, 1913, reprinted in Gail Levin, *Synchromism and American Color Abstraction, 1910–1925* (New York: George Braziller, in association with the Whitney Museum of American Art, 1978), 128–29.

158. Willard Huntington Wright, "The Truth about Painting," *The Forum* (October 1915): 450; and Willard Huntington Wright, "Synchromism," *The International Studio* 56 (October 1915): XCVIII.

159. Wright, "The Truth about Painting," 450, 453 ("These artists completed Cézanne in that they rationalized his dimly foreshadowed precepts"). See also Wright, "Synchromism," XCIX, in which he employed the analogy of music to distinguish Cézanne's "palette . . . necessarily subdued in order to approximate to the attenuated gamut found in nature" versus "the Synchromists' palette . . . keyed to the highest pitch of saturation . . . so that one could strike a chord upon it as surely . . . as on the keyboard of the piano."

160. Willard Huntington Wright, "Modern American Painters—and Winslow Homer," *The Forum* (December 1915): 667. For more on Of, see Betsy Fahlman, "George Of," *The Advent of Modernism*, 143.

161. Willard Huntington Wright, "Cézanne," *The Forum* (July 1915): 39.

162. Wright, *Modern Painting*, 135, 136.

163. Ibid., 137–38.

164. Ibid., 140, 144.

165. Ibid., 141, 145, 151.

166. Ibid., 156–57.

167. Ibid., 154, 240. On Renoir's growing reputation from 1904 onwards, surpassing that of Monet as the most innovative of French Impressionists, see Anne E. Dawson, *Idol of the Moderns: Pierre-Auguste Renoir and American Painting* (San Diego: San Diego Museum of Art, 2002), 11, 21, 23, 32–35, 38, 44–48, 50, 53, 57, and passim. On Cézanne and Cubism see Wright, 240–42, 249–54.

168. Wright, *Modern Painting*, 159.

169. Ibid., 159.

170. Ibid.

171. Ibid.

172. Ibid., 161.

173. Frank Jewett Mather, "Art," *The Nation* 102 (January 13, 1916): 57. On 58 he compares the watercolors to oriental art—"Like Far Eastern drawings, there are merely symbols for swing and spatiality." Cézanne's work was also featured in a show of modern art at the Bourgeois Galleries—see "Art Notes," *The New York Times*, April 13, 1916, 12.

174. Frederick James Gregg, "Paul Cézanne—At Last," *Vanity Fair* (December 1915): 58. See also "The Cézanne Show," *Arts & Decoration* 6 (February 1916): 184, referring to Cézanne as "a solitary divinity" to "particularly avid collectors . . . one of the mightiest forces that have entered the field of art and disrupted its existing traditions."

175. Max Weber, "Cézanne Watercolors," *Cézanne, Montross Gallery, New York*, January 1916, unpaginated. For an overview of the show and its reception, see Rewald, *Cézanne and America*, 288–91, 294–99, 301.

176. Henry McBride, "Cézanne," *The Sun*, January 16, 1916, reprinted in *The Flow of Art*, 96.

177. Ibid., 98.

178. Willard Huntington Wright, "The Aesthetic Struggle in America," *The Forum* (February 1916): 217, review of Weber's Montross gallery show.

179. Ibid., 331, review of Marin show at 291.

180. Walter Pach, "The Cézanne Exhibition of 1916," 2–3, Walter Pach Papers, AAA, copy courtesy of Laurette McCarthy. See also William C. Agee, "Walter Pach and Modernism: A Sampler from New York, Paris, and Mexico City," *Archives of American Art Journal* 28 (1988): 4–5; and Zilczer, "Arthur B. Davies," 65.

181. Leo D. Stein, "Cézanne," *The New Republic* (January 22, 1916): 298.

182. Ibid., 297–98.

183. Ibid. See also Leo D. Stein, "Renoir and the Impressionists," *The New Republic* (March 30, 1918): 259–60.

184. Willard Huntington Wright, "Paul Cézanne," *The International Studio* 57 (January 1916): CXXIX.

185. Willard Huntington Wright, "An Abundance of Modern Art," *The Forum* (March 1916): 326.

186. Anonymous, "A Representative Group of Cézannes Here," *The New York Times Magazine* (January 2, 1916): SM21.

187. Albert Eugene Gallatin, "Notes on Some Masters of the Water-Colour," *Arts & Decoration* 6 (April 1916): 277. See also Gail Stavitsky, "The Development, Institutionalization, and Impact of the A. E. Gallatin Collection of Modern Art," Ph.D. diss., Institute of Fine Arts–New York University, 1990, 1:33–34.

188. Ibid., 1:279. For the possibility that Demuth saw the Montross show, see Barbara Haskell, *Charles Demuth* (New York: Whitney Museum of American Art, in association with Harry N. Abrams, 1987), 125–26.

189. Wright, "An Abundance of Modern Art," 318; and Rewald, *Cézanne and America*, 289. See also Phillips, "Cézanne's Influence," 50–52.

190. Wright, "An Abundance of Modern Art," 318. For reviews of the *Modern French Pictures* show at the Knoedler Gallery, see "Art Notes," *The New York Times,* December 7, 1916; "Art at Home and Abroad," *The New York Times,* January 9, 1916; and Robert J. Cole, "Studio and Gallery," *New York Evening Sun,* January 11, 1916: Cézanne "is thoroughly himself and if some of his many imitators would imitate him in that they would do well." See also Rewald, *Cézanne and America,* 301. See also Cauman, "Matisse and America," 311–12 for his discussion of a group exhibition of modern art held at the Bourgeois Galleries in New York from April 3 to 29, 1916 that included Cézanne's work.

191. Wright, "An Abundance of Modern Art," 325.

192. Marius de Zayas and Paul B. Haviland, *A Study of the Modern Evolution of Plastic Expression* (New York: "291," 1913), 35. For the history of the Modern Gallery, see Marius de Zayas, *How, When, and Why Modern Art Came to New York,* ed. Francis Naumann (Cambridge, MA: The MIT Press, 1996). See also Kyle, "Cézanne and American Painting," 239.

193. *Cézanne Exhibition* (New York: Modern Gallery, 1916), unpaginated. For frequent quotations of the catalogue in the press, see the following clippings in the Francis M. Naumann research papers, Marius de Zayas Research Collection for *How, When, and Why Modern Art Came to New York,* c. 1910–36, Archives, Frances Mulhall Achilles Library, Whitney Museum of American Art, New York, cited with permission of Rodrigo de Zayas: "More Cézanne," *The Evening Post Saturday Magazine* (January 29, 1916): 19, 33; "Art Notes," *The New York Times,* January 29, 1916, 8; *Sunday Sun,* January 23 and 30, 1916; *Arts & Decoration* (March 1916).

194. *Cézanne Exhibition,* unpaginated.

195. [Henry McBride], "What Is Happening in the World of Art," *The Sun,* January 9, 1916, asserts that "the father of modern art" appeared "to have been a genius from the beginning . . . [never] very far from public scrutiny . . . contrary to the general idea . . . [of him] as a [mad] forlorn, old gentleman." See also Royal Cortissoz, "Paul Cézanne and the Cult for His Paintings," *New York Tribune,* January 9, 1916; Gregg, "Paul Cézanne at Last," 106; and "Paul Cézanne, The Misanthropic Don Quixote of Modern Art," *Current Opinion* 60 (February 1916): 121.

196. "Cézanne's Studio" was reprinted in the March 1917 issue of *The Soil,* 13–14. See also the December 1916 issue of *The Soil* for a translation by Enrique Cross of the chapter "Cézanne and Zola." On Coady having "proselytized for Cézanne," see the preface to his letter to the Art Critic, *The New York Sun,* March 12, 1916, 8.

197. R. J. Coady, "Introduction," *Cézanne's Studio* (New York: Washington Square Gallery, 1915), unpaginated. See also Rewald, *Cézanne and America,* 226; and unpaginated pamphlet announcing this publication, copy courtesy of Judith Zilcer. On Coady, see Judith Zilcer, "Robert J. Coady, Forgotten Spokesman for Avant-Garde Culture in America," *American Art Review* 2 (November/December 1975): 77–89; and Judith Zilcer, "Robert J. Coady, Man of *The Soil,*" in Rudolf E. Kuenzli, *New York Dada* (New York: Willis, Locker, and Owen, 1986), 35 and passim. See also the letter from Michael Brenner to Gertrude Stein, February 15, 1916, stating their desire to produce "Vollard's book on Cézanne in English. . . . There would be considerable profit on the sale of an edition of one thousand copies which is not too much to expect

with the Cézanne boom now on in this country." Reprinted in Gallup, *The Flowers of Friendship,* 112.

198. Coady, *Cézanne's Studio,* unpaginated. (On Cézanne, de Zayas, and Primitivism, see also Kyle, "Cézanne and American Painting," 232–46, 307n93, 309n110.)

199. Coady, *Cézanne's Studio,* unpaginated; and Zilcer, "Robert J. Coady, Forgotten Spokesman," 82, quotes a letter to Mabel Dodge in which Coady asserted "Cézanne was not French . . . the Negro blood of his mother . . . gave his canvases most of their qualities."

200. Marius de Zayas, "Cézanne," undated, handwritten essay, 4, in Francis M. Naumann research papers, Marius de Zayas Research Collection, cited with permission of Rodrigo de Zayas. This quotation is related to de Zayas's *African Negro Art: Its Influence on Modern Art* (1916) which does not mention Cézanne. See de Zayas, "African Negro Art," in *How, When, and Why,* 55–70. See 68, 70, for reviews specifically linking the "heroic plastic reforms initiated by Cézanne" as paving the way for the Modernists' appreciation of the "constructive revelations of negro sculptures." (*The Evening Post,* February 2, 1918; and *The Christian Science Monitor,* February 4, 1918). On Cézanne and primitivism, see also Vollard, *Paul Cézanne,* 117, 122; Howard Anthony Risatti, *American Critical Reaction,* 189, 203, 214, 308; Judith Zilcer, "The Aesthetic Struggle in America, 1913–1918: Abstract Art and Theory in the Stieglitz Circle," Ph.D. diss., University of Delaware, Newark, 1975), 132–54; and Jack Flam, "Matisse and the Fauves," in William Rubin, ed., *Primitivism and Modern Art* (New York: The Museum of Modern Art, 1984), 212. On Arensberg adopting de Zayas's juxtaposition of primitive artifacts alongside examples of modern art, see Francis Naumann, *New York Dada* (New York: Harry N. Abrams, 1994), 26–27.

201. See Theresa Leininger-Miller, *New Negro Artists in Paris: African American Painters and Sculptors in the City of Light, 1922–1934* (New Brunswick, NJ: Rutgers University Press, 2001), 117, 133–34; William E. Taylor and Harriet G. Warkel, *A Shared Heritage: Art by Four African Americans* (Indianapolis Museum of Art in cooperation with Indiana University Press, 1996), 63, 88.

202. "More of Cézanne," *Christian Science Monitor,* February 5, 1916, quoted in de Zayas, *How, When, and Why,* 16.

203. Ibid. See also James Huneker, "The Seven Arts," *Puck* (March 4, 1916): 12: "The Cupid still-life is a painter's canvas. I found Robert Henri before it, in almost a patibulary attitude." On Henri's students, see Gail Levin, "Patrick Henry Bruce and Arthur Burdett Frost, Jr.: From the Henri Class to the Avant-Garde," *Arts Magazine* 53 (April 1979): 102–6. On Bruce's previous Cézannesque work shown at the Montross Gallery in 1916, see Willard Huntington Wright, "Modern Art: Four Exhibitions of the New Style of Painting," *The International Studio* (January 1917): XCVIII; "Art Notes," *The New York Times,* November 26, 1916: "After a term of Matisse, he went over to Cézanne and Renoir and his work shows the influences of both. His perspectives recall Cézanne"; and Francis M. Naumann research papers, Marius de Zayas Research Collection, clippings from the *New York American,* March 19, 1917; and *The Sun,* March 25, 1917.

204. Robert Henri, *The Art Spirit* (Philadelphia and New York: J. B. Lippincott, 1960 ed.), 95. See also 96, 192, 226, 238 ("To a Cézanne, all [the] parts [of a still life] will live, they will interact and sense each other"), 268 ("he

correlated things never before correlated. Therefore he was a great artist. His work shows part of a universal existence.") For Henri's mentions of Cézanne in his classes, see Homer, *Robert Henri and His Circle,* 163, 174 (Henri made available to students his extensive collection of postcards and reproductions of the work of Cézanne and others), 263 (growing importance of Cézanne in Henri's thinking after the Armory Show).

205. Henri, *The Art Spirit,* 95.

206. Ibid., 111–12.

207. Rewald, *Cézanne and America,* 158–61, 305. For more on Agnes Ernst and Eugene Meyer, see Douglas K. S. Hyland, "Agnes Ernst Meyer, Patron of American Modernism," *American Art Journal* 12 (Winter 1980): 64–81. On *Vase of Flowers,* see also de Zayas, *How, When, and Why,* 13–17.

208. "Two Cézannes," *Bulletin of the Metropolitan Museum of Art* 11 (May 1916): 117.

209. Forbes Watson, "At the Galleries," *The Evening Post Saturday Magazine,* February 24?, 1917, Forbes Watson Papers, AAA, reel D47, fr. 831. The Arden Gallery was characterized as "a daily point of pilgrimage [for] the flock of students working in the Cézanne tradition [who] will be able to study the fountainhead of their art sufficiently, in spite of the fact that our museums . . . have been so finely oblivious to their needs. Now that Cézannes are hard to buy and very expensive, no doubt our museum-buying committees will find them worthwhile."

210. [Willard Huntington Wright,] "Paintings by Cézanne Now on Exhibition Here," *The New York Times Magazine* (March 4, 1917): 7. On the Arden Gallery show, see Rewald, *Cézanne and America,* 306–7; and Judith Zilcer, "John Quinn and Modern Art Collectors in America, 1913–1924," *Archives of American Art Journal* 14, no. 1 (Winter 1982): 60–61.

211. Robert J. Cole, "Studio and Gallery Cézanne's Inconvenient Variety," *New York Evening Sun,* March 9, 1917.

212. Ibid.

213. Forbes Watson, "At the Art Galleries," *The Evening Post Saturday Magazine* (January 29, 1916): 18, Watson Papers, AAA, reel D47, fr. 785.

214. Ibid. "His work is consequently very big, very broad, very simple, and exceedingly thoughtful, while its mood is tremendous. . . . The far-sightedness which enabled Cézanne to see, before almost anybody else, the limitations of Impressionism, and the infallible concentration that enabled him to work out his discoveries and rediscoveries without applause and without losing faith stamp him definitely as a creative master."

215. Guy Pène du Bois, "Who's Who in Modern Art— Cézanne," *The Evening Post Magazine,* July 13, 1918.

216. Charles H. Caffin, "'Cheating the Coroner' Suggested by Mr. George Moore's Verdict that Art is Dead," *The International Studio* 62 (July 1917): IV–V.

217. Jerome Myers, *Artist in Manhattan* (New York: American Artists Group, 1940), 66. For possibilities as to the identification of the unknown Cézanne painting, see R304, R481, R562, R637.

218. Willard Huntington Wright, "What Is Modern Painting?," *The Forum Exhibition of Modern American Painters* (New York: Anderson Galleries, 1916), 23.

219. Ibid., 16; and Brinton, "Foreword," *The Forum Exhibition,* 27.

220. Ibid., 28.

221. Thomas Hart Benton, untitled statement, *The Forum Exhibition,* unpaginated. On Halpert's role in providing Benton with photographs of Cézanne's work to study and copy, see Diane Tepfer, *Samuel Halpert: Art and Life, 1884–1930* (Millennium Partners, 2001), 9, 36 (Halpert, Cézannesque *Bathers* watercolor). For more on Benton's short-lived experiments with Cézanne, as well as Synchromism, see Thomas Hart Benton, *An American in Art: A Professional and Technical Autobiography* (Lawrence: University Press of Kansas, 1969), 16, 21–23, 30, 33, 35, 374, 376, 181–84, 185, 186.

222. Marsden Hartley, untitled statement, *The Forum Exhibition,* unpaginated.

223. Christopher Knight, "On Native Ground: U.S. Modern," *Art in America* (October 1983): 169. For more on the Forum exhibition, see Anne Harrell, *The Forum Exhibition: Selections and Additions* (New York: Whitney Museum of American Art at Philip Morris, 1983); and Anne Harrell, "America's Coming of Age: The Forum Exhibition of Modern American Painters and American Nationalism," Master's thesis, Florida State University, Tallahassee, 1985.

224. See diary entry by Aileen Cramer, December 1918 or January 1919 in John Baker, *Henry Lee McFee and Formalist Realism in American Still Life, 1923–1936* (Lewisberg, PA: Bucknell University Press; London: Associated University Presses, 1987), 36, 37, and see also passim, chapter on "McFee and the Influence of Cézanne at Woodstock, 1916–1923." See 23 for Dasburg's role in introducing McFee to Cézanne and modern art and his having given McFee one of his copies of Leo Stein's still life of apples (cat. 2). See also 46–85, chapter on "Stages of Cézanne's Influence in America," including the impact of Renoir in the mid-1920s (52–55). McFee's avid study of Cézanne was noted by his fellow Woodstock artist Alexander Brooks in his article "Henry Lee McFee," *The Arts* (November 1923): 257. See also Gerdts, *Painters of the Humble Truth,* 237; and Tom Wolf et al., *Konrad Cramer: A Retrospective* (Ananndale-on-Hudson, NY: Edith C. Blum Art Institute, 1981), 9, 12–14 on Dasburg's influence on Cramer's Cézannesque works.

225. Frank Jewett Mather, "Art," *The Nation* 102 (March 23, 1916): 840. See also Willard Huntington Wright's lengthy review of the show in *The Forum* (April 1916): 464: "Like distant echoes the influence of the Chinese and of Cézanne make themselves felt in his art; but these influences are more in the nature of admiration than of active impulses which have guided him." See also 466 for the influence of Cézanne on George Of. Another review, "Exhibitions in the Galleries," *Arts & Decoration* 6 (April 1916): 292, does not mention Cézanne, however, another section of the review on Paul Manship accuses the sculptor of applying color "as a surface decoration" rather than as "an integral part of the form, as in the . . . paintings of Cézanne." (291)

226. See reviews reprinted in *Camera Work* 48 (October 1916): 37 (Charles Caffin, *New York American,* on Marin), 53 (Henry Tyrell, *Christian Science Monitor,* on Marin); no. 39–40 (June 1917): 35 (Charles Caffin, *New York American,* on Macdonald-Wright "intent on mastering the principles of Cézanne's art" and his "color relations.")

227. "Notes on Current Art," *The New York Times,* February 15, 1920. For more on these shows, *The Evolu-*

tion of French Art from Ingres and Delacroix to the Latest Manifestations (Arden Gallery, April 29–May 24, 1919, organized by de Zayas, also including several prints) and the Montross show, see Rewald, *Cézanne and America,* 306–8, 311. In the Arden Gallery catalogue, de Zayas mentions that the "consequent discovery of new forms was immensely aided by the study of certain primitive painters, such as Greco, as we can see in the work of Cézanne" (unpaginated). On the Arden Gallery shows, see also Zilczer, "John Quinn and Modern Art Collectors," 60–61, 64–65.

228. See Wilford Wildes Scott, "The Artistic Vanguard in Philadelphia, 1905–1920," Ph.D. diss., University of Delaware, Newark, 1983, 43–92. Henri, Marin, Demuth, Carles, Sheeler, Schamberg, and Sayen all studied at the Academy. For McCarter's appreciation of Cézanne as well as his public lectures on him and other modern artists, see 65–69; and R. Sturgis, *Henry McCarter* (Cambridge, MA: privately printed at the Riverside Press, 1944), 26–27, 62–63, 72–73, 122–23. On Breckenridge's and Carles's modern art instruction, see 74–85. See also [Hamilton Easter Field?], "The Pennsylvania Academy," *The Arts* (February–March 1921): 24, 26: "Has any artist of the last hundred years had such an influence upon art as Cézanne? . . . I go to the Pennsylvania Academy, and . . . see scores of canvases which show Cézanne's influence. Hugh H. Breckenridge is probably the most successful of the still-life painters who owe much to the great French-man. He is in no sense an imitator of Cézanne, but has borrowed intelligently from his manner of composition and his palette. Breckenridge has a fine feeling for strong color, a feeling in many ways close to that of the Chinese." See also Joseph J. Rishel, *Cézanne in Philadelphia Collections* (Philadelphia: Philadelphia Museum of Art, 1983), xi–xiv, including a discussion on the painter-collector Carroll Tyson and his work on the major Cézanne show of 1933 at the Philadelphia Museum of Art (xiv); and Sylvia Yount and Elizabeth Johns, *To Be Modern: American Encounters with Cézanne and Company* (Philadelphia: Museum of American Art of the Pennsylvania Academy of the Fine Arts, 1996), 11, 15–17.

229. *Philadelphia Inquirer,* November 12, 1911, quoted in Scott, *The Artistic Vanguard in Philadelphia,* 121.

230. Ibid., 163–64; and Kyle, "Cézanne and American Painting," 262–72, 318nn186–90. See also Morton Schamberg, "Cubist Oils Coming Here, Artists Differ on Purpose," *Philadelphia Press,* March 17, 1913; and "Artist Analyzes Cubist Paintings," *Philadelphia Press,* March 18, 1913.

231. Morton L. Schamberg, "Preface," *Philadelphia's First Exhibition of Advanced Modern Art* (Philadelphia: McClees Galleries, 1916). See also Scott, *The Artistic Vanguard in Philadelphia,* 193–97 and 210 (review of an avant-garde costume ball, mentioning Cézanne's modern spirit).

232. Schamberg, "Preface." The work of Pach, Man Ray, Sayen, Schamberg, and Weber was shown alongside Picasso, Braque, Matisse, Duchamp, and others.

233. Leopold Stokowski, untitled preface, *Catalogue of an Exhibition of Paintings and Drawings by Representative Modern Masters* (Philadelphia: Pennsylvania Academy of the Fine Arts, 1920), unpaginated. For the Cézannes in the show, see Rewald, *Cézanne and America,* 314.

234. Yarnall Abbott, "Modern Artists Represented in Noteworthy Exhibition," *Philadelphia Press,* April 18,

1920, in Pennsylvania Academy of the Fine Arts Scrapbooks, AAA, reel P56, fr. 683. See also Harvey M. Watts, "Radical Art at the Academy," reel P56, fr. 682; and Scott, *The Artistic Vanguard,* 233–35. For the collector-painter Carroll Tyson's significant role in planning the show which "ranges through Cézanne, the true 'master' of the 'Modernists,'" see "Modern Art in Philadelphia," *American Art News* (May 8, 1920): 3.

235. Arthur Edwin Bye, *Pots and Pans or Studies in Still-Life Painting* (Princeton: Princeton University Press, 1921), 135. See also 132–39. See also Rutter, *Evolution in Modern Art (A Study of Modern Painting 1870–1925),* 600–61. Denigrating Cézanne's figure compositions, which have been "most imitated," Rutter praised the landscapes and designated the still lifes as "his greatest achievements . . . nobody yet has painted fruit so *powerfully* as Cézanne. . . . It is this manifestation of worship for the rude vigour of elemental forces which tempts many to see in Cézanne the Nietzsche of modern painting."

236. Helen Appleton Read, "Notable Exhibit [title obscured]," *Brooklyn Eagle,* February 3, 1918, in Brooklyn Museum Scrapbooks, 32/1, microfilm reel 2, 1914/15–1917/18. "Cézanne was a simple, direct painter, who saw beyond the limitations of Impressionism. His rude, primitive simplification of form, his restricted palette, from which he drew the most subtle and resonant harmonies, and his feathery brush work have all started a host of imitators who, in grasping his mannerisms, miss the essential qualities of his work. Cézanne has only come into his own of late years; he was the last of the Impressionists to receive a full measure of appreciation. . . . All lovers of Cézanne will welcome the addition of his beautiful landscape to our, so far, meager knowledge of his work." *L'Estaque, a Village near Marseille* (R390) is listed in the catalogue *The Art of France and Belgium from the Panama-Pacific International Exposition* (Brooklyn Museum, February 5–March 18, 1918), 23, as cat. no. 15.

237. "French Masters in Big Exhibition," *American Art News* (April 2, 1921): 1. See also Rewald, *Cézanne and America,* 319–20. See also Alan Burroughs, "Making History of Impressionism," *The Arts* (April 1921): 16.

238. "Preface," *Paintings by Modern French Masters Representing the Post Impressionists and Their Predecessors* (Brooklyn Museum, 1921), unpaginated.

239. "The World of Art: More French Work," *The New York Times,* April 10, 1921, 51.

240. Ibid.

241. Paul Strand, "American Water Colors at the Brooklyn Museum," *The Arts* (December 1921): 148, 149, 151. On Davies, he observed that he "is aware, too, as Sargent is not, of contemporary French painting and its simplifications, of Cézanne, Matisse, Picasso. More sensitive also is his fresher and translucent handling of the medium-white paper" (149). Marin "is seen struggling . . . to the point where every part of his picture is equally fine, equally meaningful, without dead spots. Here, indeed, is the problem of Cézanne" (151).

242. W. H. Fox, "French Post-Impressionist Paintings and other Groups at the Brooklyn Museum," *The Brooklyn Museum Quarterly* 8 (October 1921): 163–65.

243. B[ryson] B[urroughs], "Exhibition of French Impressionists and Post-Impressionists," *Bulletin of the Metropolitan Museum of Art* 16 (April 1921): 70. See Rewald, *Cézanne and America,* 320–32 for an indepth

Jill Anderson Kyle

CÉZANNE, THE "PLASTIC," AND AMERICAN ARTIST/CRITICS

While considerable scholarly attention has focused on the relationship of Paul Cézanne to European critical writing during the early decades of the twentieth century, the merits of an American early modernist art criticism, formed around close study of Cézanne's works, have gone somewhat unheralded. Original, noteworthy in its range of understanding and addressing Cézanne's art, and, contrary to a generally held view, more dependent upon US sources than European precedents, American early modernist thinking had an important art-critical manifestation, in addition to the better-known artistic one. The role of Cézanne as catalyst to new ideas concerning the function and meaning of art is best seen in the published work of a handful of American artists and writers, most importantly Max Weber, Morton Schamberg, Charles Sheeler, and Marsden Hartley. Others made contributions, yet these four artist/critics were able to approach Cézanne's work with both practical and theoretical insights, and, after they returned from Europe, they formulated the tenets of a uniquely American genre in art criticism, an early modernist one. Central to this emergent field of writing was a use of the pivotal term "plastic" to describe the perceived pliability and solidity of form in Cézanne's pictorial images. Drawing upon theories and foundation insights espoused by forebears Harvard professor of psychology and philosophy William James as well as his students Bernard Berenson and Leo Stein, many American painter/writers understood "plastic" to imply both the flexibility of matter yielding to pressure and the physical property characteristic of a concrete form, such as that found in Cézanne's painting.

That Weber, Schamberg, Sheeler, and Hartley were successful art-critical writers on the subject of Cézanne also hinged, to a large extent, upon their familiarity with the American poets Ralph Waldo Emerson and Walt Whitman, who, along with James, had already established a philosophy/vocabulary for modernism that these artists could apply to Cézanne's work quite easily.[1] Although at times flavored by European ideas, the tradition of early modernist art-critical writing had an authentic American stamp, a sense of genesis in this country, and a daring to articulate original ideas regarding the aim of art. Furthermore, the distinctly American understanding of nature-as-artistic-originator (rather than solely the imagination or consciousness), with emphasis on an empirical, perceptual source for the artistic statement, is closely tied to underlying principles in the works of Emerson,

Whitman, and James, and this exerted an important influence on American artist/critics' views of modernism.

Prior to 1895, the perception of modernism in this country, specifically as it applied to art, had few pre-established principles other than a discontinuity from the didactic, moralistic realism of the American late-nineteenth-century "genteel" tradition. Once the relationship between Cézanne and modernism was established, it finally provided a common frame of reference. Throughout the first two decades of the twentieth century, artists and critics alike established a fundamental consensus by proclaiming Cézanne the precursor of a new "modern" movement and considering his art its definitive example.

The association between Cézanne and modern art by an American audience was developing as early as 1899. That year, the American expatriate collector Egisto Fabbri wrote to the French master regarding the "aristocratic and austere beauty" of his paintings, which Fabbri contended "represent what is most noble in modern art."[2] Fabbri's discernment about the "modern" qualities of Cézanne's art was soon followed by that of other Americans, among them the artist and critic Walter Pach, who in 1908 pointed to Cézanne's "great aesthetic quality—Form" and to the "modern clarity of tone" in his paintings.[3] Two years later, in 1910, Max Weber attested to Cézanne's stature in modern art by proclaiming that among the "modern painter-colorists," Cézanne painted "grey colored forms" that ranked as "a masterpiece."[4] Later, in a 1916 catalogue preface, another key early modernist artist, Morton Schamberg, traced "the whole tendency of the modern movement" to Cézanne.[5] After 1910, growing numbers of American writers on Cézanne relied upon "plastic" to denote the solid, palpable forms that Cézanne achieved through color variations; and, in another sense, the term often described the unified structure and design in Cézanne's pictures. A deeper understanding of "plastic" often included psychological overtones in association with the sense of touch. Many writers found that the flexibility of connotations of "plastic" was particularly pertinent to their art-critical needs, because it was open-ended enough to accommodate individual theories about Cézanne's painting but still allowed writers to share a common discourse. Charles Caffin, for example, an exceptional, early proponent of modern art and critic for Alfred Stieglitz's publication *Camera Work,* plied the term to suit his needs by linking Cézanne, the plastic, and modern art. In 1910, he pointed to the "significance of plasticity and construction" in Cézanne's work and then deemed him an artist who "has started the modern painter on a new use of color."[6]

These and other forward-looking Americans adhered to a formalist base, focusing on paintings as physical objects with formal pictorial problems that the artist individually addressed. For them, modern art was synonymous with simplicity and flexibility of form, liberation from existing traditions, and unhampered self-expression, all salient features of Cézanne's painting. As artists, men such as Weber, Schamberg, Sheeler, and Hartley had learned the basics about structural order and balance of formal elements in terms of design, and they were able to write intelligently and with conviction about the physical qualities of Cézanne's art, a subject that stymied most other critics and nonartist journalists. In the early years of the twentieth century, most American professional journalists faced a virtual roadblock if art was not mimetic and topographical or narrative, deploying a high degree of detail and exactness. Wanting to deal

with modern aspects of Cézanne's works, but lacking visual flexibility and analytical acumen, many fledgling professional critics found guidance in the commentary of these four American early modernists.

Although these Americans went abroad and gained firsthand exposure to Cézanne's art and knowledgeable criticism that addressed it, many had already profited from the particular, imagistic language that Emerson, Whitman, and James had employed. They revered these writers as kindred spirits and as liberating forces within the US intellectual scene. They also found that the vocabularies of these literary icons provided a terminology specifically suited to discussing Cézanne's art and, in some cases, the subjects and style of Emerson, Whitman, and James were influential in shaping artists' aesthetic ideologies. Marsden Hartley, for instance, writing to Alfred Stieglitz in 1913, singles out William James as a source of inspiration for initiating changes and experimentation in his [Hartley's] artistic expression.[7] In another instance, Hartley linked Cézanne to Whitman on several counts:

> I have felt the same gift for life in a still-life or a landscape of Cézanne's that I have felt in any of Whitman's best pieces. The element in common with these two exceptional creators is liberation. . . . Both Whitman and Cézanne stand together in the name of one common purpose, freedom from characteristics not one's own. . . . Cézanne's fine landscapes and still-lifes and Whitman's majestic line with its gripping imagery are one and the same thing.[8]

Celebrating ties to and perceptions of the animate world, Emerson, Whitman, and James were skilled in expressing concepts of form and touch and deployed language that was highly suggestive of form and form characteristics. Whitman's concern with form is evidenced in the narrator in *Leaves of Grass,* who symbolizes the common American working man, albeit one with an abnormally developed sense of touch. Throughout the work, Whitman valorizes tactile and visual sensations by emphasizing the narrator's physical flesh and form and by invoking sensuous images. Even though they differ markedly in approach, Emerson, Whitman, and James constantly refer to nature and the external world or forces in nature and frequently use words such as "elastic" and "plastic" in their published writings as a particularly immediate way of phrasing a concept of physicality. For instance, Whitman, in *Leaves of Grass,* refers to youth as "ever-pushed elasticity," and Emerson says of man's ability to harness forces in nature, "We build a mill in such a position to set the north wind to play upon our instrument, or the elastic force of steam, or the ebb and flow of the sea."[9] James, who maintained that the mind can better understand a concept if it is related to a form or object, refers to a clock spring's "elasticity" to indicate its potential movement, to the "elastic quality of this india-rubberband," and to a football in terms of "elasticity, leathery integument, swift mobility."[10]

In critical discourse on Cézanne, however, "plastic" was the most significant word commonly used by American modernist artist/writers to discuss unusual, evocative aspects in his painting. Emerson and James frequently invoked that particular word, or variations of it, to describe physical phenomena either in relation to an individual's powers or in association with an individual's awareness of an external reality. Emerson argued that "such is the *plastic* power

of the human eye, that the primary forms, as the sky, the mountain, the tree, the animal, give delight *in and for themselves.*"[11] James, who stated that the "felt object has a *plastic* reality and outwardness which the imagined object wholly lacks," determined that form was a psychological factor vital for cognition and that tactile perception and "touch images" were essential to mental processes.[12] This same emphasis on perceptual experience and knowledge would also characterize early modernist art-critical writing, in which American artists revealed that creative impulses, theirs and Cézanne's, depended upon interaction with or observation of forms and objects in the natural, external world. Benefiting, then, by a knowledge of these writers' works, Americans were naturally very responsive to criticism or verbal discussions they encountered abroad, especially in Paris, that linked ideas of "plastic" form, "plastic relations," or "plastic expression" to Cézanne's painting.

Another part of the American cultural legacy that served early modernists well in discerning formalist directives in Cézanne's painting was an emerging native tradition in progressive, forward-looking art theory. Since many of the Americans who championed Cézanne relied to some degree on European art-critical models—chiefly writings by the French Nabi artist Maurice Denis, the English artist and critic Roger Fry, and the German art critic Julius Meier-Graefe—the general consensus has been that central phraseology and formal analyses associated with Cézanne were derived solely from foreign sources. What is not always recognized is the crucial role played by a trio of American art teachers and theorists who, at the turn of the last century, provided a foundation for the evaluation of modern art, Cézanne's most notably. These three scholars—Ernest F. Fenollosa, Arthur Wesley Dow, and Denman W. Ross—who, like Emerson and James, maintained an active affiliation with either Harvard University or other Boston-area institutions, were as instrumental as the Europeans in providing ideas vital to an American tradition of early modernist art theory and criticism.

Earliest of the art theorists central to formulating a progressive artistic vision pertinent to both Cézanne and modern art was Ernest F. Fenollosa, who argued that art should express formal values rather than imitate nature. Incorporating sophisticated design concepts derived from East Asian art with aspects of European traditions into an original philosophy of art, he maintained that a work of art must be seen as a "concrete image," its wholeness dependent upon "clear visual relations."[13] Fenollosa presented the artistic image as an autonomous entity with an internal organization, where its elements must "be *plastic* and sensitive."[14] Not only did he refute the strict realism dominant in American art at the end of the nineteenth century, but Fenollosa also served as mentor to both Arthur Wesley Dow, also a painter-printmaker, and Denman W. Ross, perhaps the two most influential art teachers in America in 1900.[15]

Dow's book *Composition: A Series of Exercises in Art for the Use of Students and Teachers* (1899), largely a tribute to Fenollosa, argued that quality in art depends upon design, or the combining of formal features (lines, masses, colors) in a way that clarifies the relations between the parts. He emphasized originality in art and cited nature as a "storehouse of facts," facts not to be imitated, however, for "mere accuracy has no art-value whatever."[16] Taking the formalist orientation further, Ross's *A Theory of Pure Design* (1907) emphasized the importance of human agency in design through selecting and organizing the facts of nature. Ross wrote, "By Design

I mean Order in human feeling and thought. . . . By Order I mean, particularly, three things—Harmony, Balance, and Rhythm. These are the principal modes in which Order is revealed in nature, and, through Design, in works of art."[17] Thus, the premises of design, coherent order, and clarity of relations in art, upheld by these three New England figures, set precedents in "modern" thought that would later inform a number of Americans' investigations of Cézanne in Europe, as well as their artistic efforts and discussions of Cézanne's painting upon their return to America.

During the first two decades of the twentieth century, when many American modernists either lived or spent time in Paris, numerous French critics analyzed Cézanne's chromatic inventiveness, often characterizing some aspect of his color usage or the depiction of form in his art as "plastic." One of the most important French publications on Cézanne, one known to many Americans, was issued in 1907 in the form of an article by Maurice Denis, which Roger Fry translated into English and which was published in 1910 (cat. 134).[18] While acknowledging Cézanne's passion for nature as the basis for his art and regarding Cézanne as "a primitive who returns to the sources of his art," Denis underscored how Cézanne "taught us to transpose the data of sensation into the elements of a work of art"—a concrete object or "plastic expression."[19] Moreover, Denis explained Cézanne's technique of constructing paintings solely in terms of "plastic equivalents," or color relationships, and wrote that "[Cézanne] composed his *nature-mortes,* varying intentionally the lines and the masses, . . . avoiding the accidents of chance, [and] seeking plastic beauty."[20] Denis's view that Cézanne was unequaled in creating formal consonance and coherence kept the emphasis on aesthetic features of the work of art itself, and his diction demonstrated the aptness of "plastic" in describing Cézanne's art in terms of formalist design. Because of its prevalence in the literature of American laureates and professors, "plastic" thereby more effectively placed Cézanne's art within the intellectual grasp of Americans. Furthermore, from an early modernist perspective, Denis's commentary on Cézanne was highly accessible because he analyzed Cézanne's art with an eye to its concreteness, physicality, and design, which would seemingly be in concert with the views of Fenollosa, Dow, and Ross which the American artist/critics knew and highly prized.

Paris in the first two decades of the twentieth century was home to a number of expert interpreters of Cézanne's art. One of the most important was the American expatriate Leo Stein, whose "talks" on the intricacies of Cézanne's compositions made an impact on many young American converts to modernism, among them Morgan Russell, Max Weber, and Morton Schamberg—Schamberg wrote to Walter Pach in 1908 that "the visits to [the] Steins' are . . . like pills for the artistic liver."[21] Stein's expertise in modern painting was partially influenced by another American expatriate, the Renaissance art connoisseur Bernard Berenson, who espoused an objective, psychological, and analytic approach to art. Likewise, Stein focused on the physical, formal properties in painting and harbored a passion for composition, for the arrangement of pictorial elements that constitute the single design entity, and, as with Denis, "plastic" was a central term in Stein's discussions of Cézanne's work. Frequently referring to Cézanne's paintings as "plastic presentations,"[22] Stein emphasized Cézanne's calculated color structuring in the interest of mass and volume and routinely used a painting, *Five Apples* (1877–78, cat. 2), in his

and his sister Gertrude Stein's collection, to demonstrate the artist's unique rendering of tactility and volume in the painted forms. Attempting to clarify form perception through art-historical relationships that bridged different eras, Stein once wrote to Morgan Russell that "nowhere on the ceiling [of the Sistine Chapel] has Michelangelo attained to the sheer expression of form that is often achieved in his drawings. I believe that nowhere is it as complete as in those apples of Cézanne."[23]

Indeed, a line can be traced from James through Berenson and Stein, and in the last-named's cogent aesthetic perceptions of Cézanne's pictorial achievements, the line extends directly to the American artists who gathered at the Steins' rue de Fleurus apartment in Paris and absorbed perceptions of "tactility" and "plasticity" in the way Cézanne depicted form. Stein, who, like Berenson, had attended Harvard and studied psychology under William James, often laced his discussions on art with excerpts from James (who, by one account, once visited the Steins' apartment to see the art, looked, and gasped, "I always told you that you should keep your mind open"[24]).

James had determined that form was a psychological factor vital for cognition and that tactile perception and "touch images" were essential to mental processes, stating that "the felt object has a *plastic* reality and outwardness which the imagined object wholly lacks."[25] The impact of James's theories about cognitive sensations of tactility on the aesthetics of Berenson, who was an even earlier product of James's teaching than Stein, is clearly evident in portions of text in Berenson's landmark book on Renaissance art (1907).[26] In his chapter on "Florentine Painters" (originally published in 1896) Berenson stated that the first business of the artist is "to rouse the tactile sense, for I must have the illusion of being able to touch a figure."[27] A year later, in 1897, in his chapter "The Central Italian Painters," Berenson specified that an "intimate realization of a [painted] object comes to us only when we unconsciously translate our retinal impressions of it onto ideated sensations of touch, pressure, and grasp," sensations that he maintained were linked to movement.[28] These ideas of Berenson are directly traceable to theories that James had earlier set forth in *The Principles of Psychology* (1890).[29]

Described in 1911 as "the American writer on art who proclaims he would sooner have Cézanne's pictures on his walls than those of any other painter," Berenson once acknowledged James as the source for his system of aesthetics.[30] He wrote, "I owe everything to William James, for I was already applying his theories to the visible world. 'Tactile values' was really James's phrase, not mine, although he never knew he had invented it."[31] According to Berenson, "tactile values," meaning sensations of touch and movement in a painting, are "the essential qualities" and are what give "life-communicating" power to a picture.[32] Berenson gave examples of these values not only in Renaissance art but also in a landscape by Cézanne, quite possibly *The Gulf of Marseille Seen from L'Estaque* (1878–79, R390, fig. 1).[33] He wrote about the "essential qualities" in the painting which evolve from "the exquisite modeling of Cézanne, who gives the sky its tactile values as perfectly as Michelangelo has given them to the human figure."[34]

That Berenson, in *The Italian Painters of the Renaissance*, often ascribed tactile connotations to the term "plastic" or "plasticity" was well known to a number of Stein protégés, Morgan Russell prominent among them. Mulling over Berenson's ideas, undoubtedly brought to his

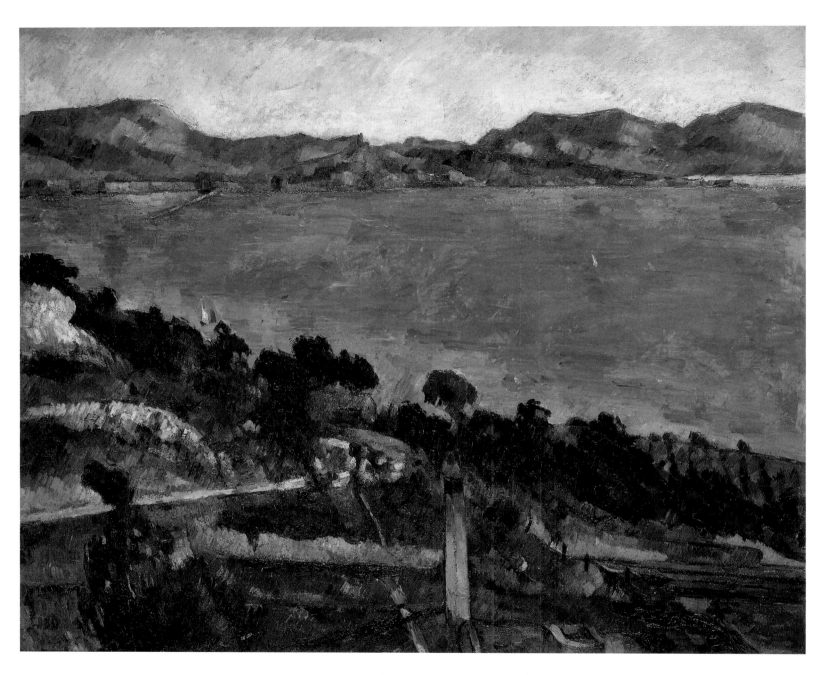

Fig. 1 Paul Cézanne, *The Gulf of Marseille Seen from L'Estaque*, c. 1878–79. Oil on canvas. Musée d'Orsay, Paris (RF 2761)

attention by Leo Stein, Russell recorded in an unpublished notebook annotations on Berenson's descriptions of a Renaissance Venus. Russell's handwritten fragments describe Venus as a figure "possessed of all plasticity" and appealing to the "tactile imagination."[35] During the same period, around 1910, Russell, still preoccupied with tactile features in the depiction of form, wrote to his friend Andrew Dasburg about how Cézanne achieved tactile features of form in his oil paintings, explaining that "all [Cézanne's] colors are translations of one and the same light . . . feel form if you will just paint light."[36]

The relationship between tactile perceptions in form cognition and Cézanne's art recurs prominently in the writings of another Stein protégé, Max Weber, arguably the most articulate

Fig. 2 Paul Cézanne, *Rocks Near the Caves above the Château Noir,* 1895–1900. Watercolor and graphite on paper. The Museum of Modern Art, New York: Lillie P. Bliss Collection (21.1934)

art writer of the early modernists and the one drawing on the widest range of sources, both American and European. Describing Cézanne's watercolors in 1916, *Rocks Near Caves above the Château Noir* (1895–1900, RWC435, fig. 2), among them, Weber betrayed a debt to James's theories on movement and tactile responses when he claimed that Cézanne "succeeds to a rare degree in making the static to vibrate."[37] In the same catalogue prologue, Weber stated that "in these watercolors can be seen and felt his [Cézanne's] power of synthesis in transforming the chaotic into the purely architectural plastic."[38] These statements followed an earlier article Weber wrote in 1910, "The Fourth Dimension from a Plastic Point of View," for Stieglitz's *Camera Work.* In it, he indicated that the three-dimensional physicality of tactile and "plastic" forms in Cézanne's art had the power to evoke an ideal "fourth dimension," which Weber described as "the consciousness of a great and overwhelming sense of space-magnitude."[39] According to Weber, this "fourth dimension," a "dimension of infinity," although not a physical entity in itself, is somehow tangible, "is real, and can be perceived and felt."[40] Further, Weber explains that "Cézanne's or Giotto's achievements are most real and plastic" and are "splendid examples of plastic art that possesses this rare quality."[41]

Although Weber's "The Fourth Dimension" was a watershed in early modernist writing because it linked matter with the ideal, old with new art, and art with science (the fourth dimension) through the physicality of Cézanne's tactile, "plastic" forms, the actual source of Weber's insight is unknown. He could have been inspired by passages he read in Julius Meier-Graefe's essay "Paul Cézanne" in *Modern Art: Being a Contribution to a New System of Aesthetics* of 1908 (cat. 125). Writing of effects in Cézanne's art which appeal to the "latent tactile impulses," Meier-Graefe had stated about an image by Cézanne accompanying his text, "there is no movement; the subject before me is a simple still-life; and yet I feel something in the pupil of my eye

quivering, as if set in motion by some movement taking place in a higher dimension."[42] Closely related to the still-life image Meier-Graefe used, painted in the same year and with the same wallpaper background, is Cézanne's *Still Life: Flask, Glass, and Jug* (c. 1877, R326, fig. 3) with characteristics that also could be said to evoke "tactile impulses." It could be argued, too, however, that an American source provided Weber with ideas about a fourth dimension, and again in the forefront is the thought of William James. A year before Weber wrote his piece, James had published an article in a widely read journal calling the fourth dimension "a transmundane experience" or "superhuman consciousness," and explaining that "abstract concepts, such as elasticity, voluminousness, disconnectedness, are salient aspects of our concrete experiences."[43]

Other parts of the "Fourth Dimension" essay also manifest Weber's debt to native literary sources. According to Weber, "The greatest dream or vision is that which is *regiven* plastically through observation of things in nature."[44] His concept of the artist as mediating agent, one who observes nature and filters sensations derived from experience of the natural world, is quite compatible with Emerson's belief that "This is art, a nature passed through the alembic of man."[45] Likewise, Weber's thought concerning art and nature and an ideal fourth dimension that "envelops a tree, a tower, a mountain, or any solid" recalls Emerson's composite reality of nature, form, and matter. Emerson wrote, "As the world was *plastic* and fluid in the hands of God, so it is ever to so much of his attributes as we bring to it . . . in proportion as a man has anything

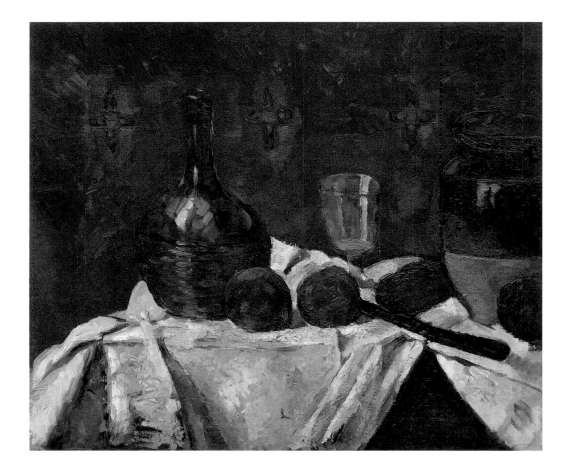

Fig. 3 Paul Cézanne, *Still Life: Flask, Glass, and Jug*, c. 1877. Oil on canvas. Solomon R. Guggenheim Museum, New York, Thannhauser Collection, Gift, Justin K. Thannhauser, 1978, 78.2514.3

Cézanne and Whitman, "They are most of all, the primitives of the way they have begun, they have voiced most of all the imperative need of essential personalism, of direct expression out of direct experience."[64]

Cézanne's art was, from Hartley's perspective, a technical, aesthetic feat, first and foremost, "a removal of all significance from painting other than that of painting for itself."[65] This was particularly true of the watercolors, which, according to Hartley, were "so rich in form as well as radiant with light" and were like new instruments for "the realization of finer plastic relations."[66] Although Cézanne often left his watercolors "unfinished," Hartley wrote, they were unique because even "at the half-way point . . . the design [was] always locked."[67] Reasoning with a formal, analytical power more natural to a painter than to a non-artist writer, Hartley considered Cézanne one of "the greatest logicians of color" and "certainly the most logical analyst of light the world has ever known."[68] When Hartley wrote about Cézanne's art, he was usually motivated to do so by the watercolors, in which he saw an expression of the artist's self: "Who will not, or cannot, find that quality [the autographic aspect] in those extraordinary and unexcelled watercolors of Cézanne, will find nothing whatsoever anywhere."[69] In association with Whitman's celebration of the self as a means to escape inhibitions and conservative forces dominant in America prior to the early modernist era, Hartley equated Cézanne's watercolors with the same kind of liberation and daring. While Hartley and the other American early modernist artist/critics discussed here spent time abroad and learned about Cézanne in a European environment, still they retained an American dimension inclined towards the experiential rather than the conceptual and based upon the same sense of place and tradition to which Emerson, Whitman, and James belonged.

Notes

All of the material in this essay has been adapted from my dissertation, "Cézanne and American Painting, 1900–1920," University of Texas at Austin, 1995.

1. James continued to write both books and articles throughout the first decade of the twentieth century; however, his *The Principles of Psychology* published in 1890 is the work of most importance in this essay.

2. From a letter Fabbri wrote to Cézanne from Paris, dated May 28, 1899. For the complete text of the letter in French, see Mabel La Farge, *Egisto Fabbri, 1866–1933* (New Haven, CT: privately printed, 1937), 29.

3. Walter Pach, "Cézanne—An Introduction," *Scribner's* 44, no. 6 (December 1908): 768.

4. Max Weber, "Chinese Dolls and Modern Colorists," *Camera Work* 31 (July 1910): 5.

5. Morton Schamberg, "Preface," *Philadelphia's First Exhibition of Advanced Modern Art* (Philadelphia: McClees Galleries, 1916), unpaginated.

6. Charles Caffin, "The Art of Eduard J. Steichen," *Camera Work* 30 (April 1910): 35.

7. Patricia McDonnell refers to two letters written to Stieglitz in 1913, in February and September, in which Hartley claims that James has influenced his art ("'Dictated by Life': Spirituality in the Art of Marsden Hartley

and Wassily Kandinsky, 1910–1915," *Archives of American Art Journal* 29, nos. 1, 2 [1989]: 33, 34n44).

8. Marsden Hartley, "Whitman and Cézanne," in *Adventures in the Arts* (1921; New York: Hacker Art Books, 1972), 34, 35–36.

9. Walt Whitman in *Walt Whitman's "Leaves of Grass," The First (1855) Edition* (New York: Penguin Classics, 1986), 78, italics mine; Ralph Waldo Emerson, "Art" in *The Early Lectures of Ralph Waldo Emerson, 1836–1838*, vol. 2, ed. Stephen E. Whicher, Robert E. Spiller, and Wallace E. Williams (Cambridge: Belknap Press of Harvard University Press, 1964), 45.

10. William James, "Pragmatism's Conception of Truth" (1907) in *Pragmatism*, ed. Bruce Kuklick (Indianapolis: Hackett, 1988), 92; James, "Discrimination and Comparison," in *The Principles of Psychology*, 2 vols. (1890; New York: Dover, 1950), 1:528; James, "Association" in *The Principles*, 1:579.

11. Emerson, "Nature" (1836) in *The Selected Writings of Ralph Waldo Emerson*, ed. Brooks Atkinson (New York: Random House for The Modern Library, 1950) 9, author's italics except for italics on "plastic," which are mine.

12. James, "Imagination" in *The Principles*, 2:70, italics mine.

13. Ernest Fenollosa, *Imagination in Art* (Boston: Boston Art Student's Association, 1894), 6.

14. Ibid., 9. Italics mine.

15. The three writers on art commonly cited as being the most influential in Roger Fry's codification of ideas concerning form and formal relationships in modern art are the American Denman Ross, the German critic Julius Meier-Grafe, and the French artist/critic Maurice Denis.

16. Arthur Wesley Dow, *Composition: A Series of Exercises in Art Structure for the Use of Students and Teachers* (1899; Garden City, NY: Doubleday, Page, 1920), 49–50. Comparable to Dow's words are those of Emerson: "Insist on yourself; never imitate" ("Self-Reliance," in *Selected Writings*, 166).

17. Denman Ross, "The Meaning of Design" in *A Theory of Pure Design* (Boston and New York: Houghton, Mifflin, 1907), 1.

18. Maurice Denis, "Cézanne," *L'Occident* 12 (September 1907): 118–33; trans. Roger Fry, "Cézanne—I," *Burlington Magazine* 16, no. 82 (January 1910): 207–19, and "Cézanne—II," *Burlington Magazine* 16, no. 83 (February 1910): 275–80.

19. Denis, "Cézanne—I," 219; Denis, "Cézanne—II," 275.

20. Denis, "Cézanne—I," 214.

21. Morton Schamberg in Paris to Walter Pach in New York, November 5, 1908, Walter Pach Papers, Archives of American Art, Smithsonian Institution (hereafter AAA), reel 4216, frs. 856–57.

22. Leo Stein, *The A-B-C of Aesthetics* (New York: Boni & Liveright, 1927), 86.

23. Gail Levin, *Synchromism and American Color Abstraction, 1910–1925* (New York: Whitney Museum of American Art, 1978), 12.

24. "The Autobiography of Alice B. Toklas" in *Selected Writings of Gertrude Stein*, ed. Carl Van Vechten (New York: Vintage Books, 1962), 75.

25. James, "Imagination" in *The Principles*, 2:70, italics mine.

26. Bernard Berenson, *The Italian Painters of the Renaissance* (1907; Ithaca, NY: Cornell University Press, 1980). In "The Florentine Painters" chapter, Berenson expounds upon Giotto's ability to stimulate the tactile consciousness, thereby triggering feelings of a three-dimensional form in space, 40; and in the "Central Italian Painters" chapter, Berenson specifies that sensations of "touch, pressure, and grasp" combine with movement to translate our retinal impressions into a realization of an object, 94.

27. Bernard Berenson, "The Florentine Painters " (1896) in *Italian Painters of the Renaissance*, 40.

28. Berenson, "The Central Italian Painters" (1897) in *Italian Painters of the Renaissance*, 94.

29. Berenson had a rich source of information regarding tactile impulses in form cognition in the writings of William James, especially two chapters in volume 2 of *The Principles*. Portions of "Sensation" explain that sensations of movement enhance the visual and tactile reality of an object or image (41–42); and in "The Perception of Reality," James writes, "Tactile and muscular sensations [are] 'primary qualities'. . . . Tangible qualities are the least fluctuating. . . . Then, more decisive still, the tactile properties are those most intimately connected with our weal and woe" (305–6).

30. Frederick Lawton, "Paul Cézanne," *Art Journal* 63, no. 871 (February 1911): 55.

31. Henry Fitch Taylor, "The Summons of Art: Conversations with Bernard Berenson," *Atlantic Monthly* 200, no. 5 (November 1957): 124.

32. Berenson, "Central Italian Painters," in *Italian Painters of the Renaissance*, 94.

33. John Rewald reasoned that this was the painting by Cézanne that Berenson wrote about. Rewald in *Cézanne and America: Dealers, Collectors, Artists and Critics* (Princeton: Princeton University Press, 1989), 19–20.

34. Berenson, "The Central Italian Painters," 122.

35. From a tattered, unbound notebook in the Morgan Russell Archives, Montclair Art Museum, Montclair, NJ.

36. Morgan Russell to Andrew Dasburg, October 27, 1910, Morgan Russell Papers, AAA, reel 2803, fr. 193.

37. Max Weber, preface to *Cézanne* (New York: Montross Gallery, 1916), unpaginated.

38. Ibid.

39. Max Weber, "The Fourth Dimension from a Plastic Point of View," *Camera Work* 31 (July 1910): 25. Linda D. Henderson gives a comprehensive analysis of Weber's essay in *The Fourth Dimension and Non-Euclidian Geometry in American Art* (Princeton: Princeton University Press, 1983), 168–72.

40. Weber, "The Fourth Dimension," 25.

41. Ibid.

42. Julius Meier-Graefe, "Paul Cézanne" in *Modern Art: Being a Contribution to a New System of Aesthetics*, trans. Florence Simmonds and George Chrystal (New York: G. P. Putnam Sons, 1908), 1:267. The still-life painting reproduction in Meier-Graefe's 1908 essay "Paul Cézanne" is *Compote and Plate of Biscuits* (c. 1877, R325).

43. William James, "On a Very Prevalent Abuse of Abstraction," *Popular Science Monthly* 74, no. 5 (May 1909): 485.

44. Weber, "Fourth Dimension," 25, author's italics.

45. Emerson, "Nature," in *Selected Writings*, 25.

46. Emerson, "The American Scholar," in *Selected Writings*, 58, italics mine.

47. See Matthew Baigell, "American Landscape Painting and National Identity: The Stieglitz Circle and Emerson," *Art Criticism* 4, no. 1 (1987): 27–47.

48. Morton Schamberg, "Post-Impression Exhibit Awaited, Large and Very Important Show, Which Will Open in New York February 15 Excites Preliminary Interest," *Philadelphia Inquirer*, January 19, 1913.

49. Morton Schamberg, "Artist Analyzes Cubist Paintings," *Philadelphia Press*, March 18, 1913.

50. Morton Schamberg, "Post-Impression Exhibit Awaited."

51. Ibid.

52. Charles Sheeler, "Autobiographical Notes," Charles Sheeler Papers, AAA, reel NSh1, frs. 60–61.

53. Emerson, "The American Scholar," in *Selected Writings*, 61.

54. Sheeler, "Autobiographical Notes," reel NSh1, frs. 60–61.

55. Sheeler, "Explanatory Statement," *The Forum Exhibition of Modern American Painters* (New York: Anderson Galleries, 1916), unpaginated.

56. Emerson, "Art," in *Selected Writings*, 307.

57. "Sheeler on the Tradition of Still-Life," Forbes Watson Papers, AAA, reel D56, fr. 1094.

58. Sheeler, "Talk Given to a Symposium on Photographers," The Museum of Modern Art, 1950, Sheeler Papers, reel NSh 2, frs. 8–9.

59. For a detailed discussion of primitivism, as well as Japanism and photography, as artistic contexts important to the Americans' understanding of Cézanne, see my dissertation, "Cézanne and American Painting, 1900–1920," 219–46.

60. "Cézanne—I," 219.

61. [Roger Fry and Desmond MacCarthy], "The Post-Impressionists," in *Manet and the Post-Impressionists* (London: Grafton Galleries and Ballantyre & Company, 1910), 10. The emphasis on "design" suggests that Fry was at least familiar with if not drawing upon Denman Ross's theories of design in an attempt to formulate new principles to apply to the Post-Impressionists.

62. Marsden Hartley, "The Red Man," in *Adventures in the Arts*, 18. Hartley felt that both the native Indian and the land the Indian inhabited were immanent portrayals of life and art bound together as one and, hence, the Southwest provided "primal significance" as subject matter. See Hartley, "Aesthetic Sincerity," *El Palacio* 5, no. 20 (December 9, 1918): 332.

63. Hartley, "Cézanne and Whitman," in *Adventures in the Arts*, 16.

64. Ibid.

65. Hartley, "Arthur B. Davies," in *Adventures in the Arts*, 80–81.

66. Hartley, "Some American Watercolorists," in *Adventures in the Arts*, 96.

67. Hartley, "On the Persistence of the Imagination, The Painting of Milton Avery" (1938), in *On Art*, ed. Gail R. Scott (New York: Horizon Press, 1982), 202.

68. Hartley, "Impressions of Provence from an American Point of View," in *On Art*, 143.

69. Hartley, "Artist's Statement" in *The Forum Exhibition*, unpaginated.

discussion of the show and Cauman, "Matisse and America," 358, 360 (regarding Burroughs's statement that the "only person we will not cut down will be Cézanne.") For Quinn's role as lender and advisor, see Zilczer, *The Noble Buyer,* 54–55; and Zilczer, "John Quinn and Modern Art Collectors," 63–64.

244. Bryson Burroughs, "Introduction," *Loan Exhibition of Impressionist and Post-Impressionist Paintings* (New York: The Metropolitan Museum of Art, 1921), vii.

245. Ibid., xii–xiv. On xv Burroughs observed that "Cézanne's famous saying that all forms in nature can be reduced to spheres and cubes, cylinders and cones, appears to have been the *fiat lux* of the Cubists." On xiii he quoted Cézanne as wishing "to make of Impressionism something lasting, like the art in the Museums" and "to do again what Poussin did but from nature."

246. Harry B. Wehle, "Loan Exhibition of Modern French Paintings," *Bulletin of The Metropolitan Museum of Art* 16 (May 1921): 95, quoted in "Modern French Pictures," *Boston Transcript,* May 23, 1921, in Metropolitan Museum of Art Historical Clippings and Ephemera Files, box 19, folder 1, reel 6 (hereafter MMA Files).

247. "Museum Opens Its Modernist Show," *American Art News* (May 7, 1921): 5.

248. "Impressionists and Post-Impressionists," *Outlook* (June 15, 1921): 280. See also [Hamilton Easter Field], "The Metropolitan French Show," *The Arts* (May 1921): 2.

249. Walter Pach, *The Freeman* (July 13, 1921): 424. Pach was referring to Cézanne's *Bather and Rocks* (1867–69, possibly earlier; R29) or *The Large Bather* (c. 1885; R555).

250. See Rewald, *Cézanne and America,* 328–31; Cauman, "Matisse and America," 366–71; and in MMA Files, *Brooklyn Standard Union,* May 1, 1921; *The New York Times Book Review* (May 29, 1921); *Arts & Decoration* (June 1921): 30, 62; as well as David Lloyd, "Modern Art Shown at Metropolitan," *New York Evening Post,* May 2, 1921.

251. Circular quoted in Rewald, *Cézanne and America,* 330. Samples of the considerable amount of negative criticism to be found in the MMA Files are: Royal Cortissoz, "Some Leading Types Shown at the Metropolitan," *New York Herald Tribune,* May 8, 1921; "Art Exhibit at Metropolitan Is Condemned as Neurotic," *New York Evening Sun,* September 6, 1921; "Call Modernistic Art at Museum Form of Insanity," *New York Evening World,* September 7, 1921; "Modernist Art Denounced," *Boston Evening Transcript,* September 7, 1921; "Degenerate Art," *Outlook,* September 21, 1921, 85; "Plea for American Art. Foreign Modernistic Works said to have the Preference Now," *New York Morning Herald,* September 10, 1921; and "Out to Kill Modernist Pictures," *The Literary Digest* (September 24, 1921): 25.

252. See Anna Warren Ingersoll, "Modern French Art," letter to the editor, *Philadelphia Public Ledger,* September 10, 1921, MMA Files (asserted that there "is no question whatsoever of the permanence of [his] work or . . . its logical development from the old masters"). See also "Vilified Art Lures Throng to Museum," *New York Morning Herald,* September 7, 1921; "Artists Rise in Aid of Impressionists," *The New York Times,* September 7, 1921; and Alfred Stieglitz, "Changed Art Standards," *New York Morning Herald,* September 11, 1921, in MMA Files. See also Alfred Stieglitz, letter to Hamilton Easter Field, *The Arts* (August–September 1921): 61.

253. [Hamilton Easter Field], unsigned and untitled article, *The Arts* (January 1922): 1.

254. Forbes Watson, untitled statement, *Loan Exhibition of Works [of 19th- and 20th- Century French Art]* (New York: Museum of French Art, 1921), 12, 14.

255. Marsden Hartley, "Cézanne and Whitman," in *Adventures in the Arts,* 36. For more on this connection and Hartley's relation to Cézanne, see also Marsden Hartley, *On Art,* ed. Gail Scott (New York: Horizon Press, 1982), 35–36; and Kyle, "Cézanne and American Painting," 249–56.

256. Hartley, "Cézanne and Whitman," 30.

257. Hartley, "Some American Watercolorists," in *Adventures in the Arts,* 96. For other Hartley comments on Cézanne, see also 32, 57, 60, 65, 81, 108, 124, 138.

258. A. E. Gallatin, *American Water-Colourists* (New York: E.P. Dutton, 1922), 17. See also A. E. Gallatin, *Charles Demuth* (New York: William Edwin Rudge, 1927).

259. Clive Bell, *Since Cézanne* (New York: Harcourt, Brace, 1922), 14–15. See also 57–65. Gallatin owned a copy of this book (see Stavitsky, "The Development," 1:54–55. See also Bell's earlier article "Post-Impressionism and Aesthetics," *The Burlington Magazine* 22 (January 1913): 227–29 on Cézanne's work as possessing the one quality common to all great art—"significant form." In his book *Art* (1914), Bell wrote extensively about Cézanne, designating him as "the Christopher Columbus of a new continent of form" (171).

260. Duncan Phillips, "Revolutions and Reactions in Painting," *The International Studio* (December 1913): CXXVI, CXXVIII. See also Erika D. Passantino et al., *The Eye of Duncan Phillips: A Collection in the Making* (Washington, DC: Phillips Collection, in association with Yale University Press, New Haven, CT, 1999), 13.

261. Duncan Phillips, "Fallacies of the New Dogmatism in Art," *American Magazine of Art* 9 (December 1917): 103.

262. Duncan Phillips, *A Collection in the Making* (Washington, DC: Phillips Memorial Gallery, 1926), 8, 34–35, italics mine. See also Passantino, *The Eye of Duncan Phillips,* 262 (on the first Cézanne, acquired in 1925, *Mont Sainte-Victoire,* 1886–87), 80–81, 89 (reference to Phillips's writings on Arthur B. Davies' reverence of the master), 90–97. On Phillips, see also Schick, "The Making of Cézanne," 152–60.

263. Katherine S. Dreier, *Western Art and the New Era: An Introduction to Modern Art* (New York: Brentano's, 1923), 62. The review was in the December 4, 1920, issue of *The Arts,* 34.

264. Dreier, *Western Art and the New Era,* 63.

265. Ibid., 64. See also Katherine S. Dreier and Christian Brinton, *Modern Art at the Sesqui-Centennial Exhibition* (New York: Societe Anonyme, 1926), unpaginated.

266. Andrew Dasburg, "Cubism—Its Rise and Influence," *The Arts* (November 1923): 280. "In its inception Cubism was unconsciously a geometric definition of a state of feeling induced by Picasso's preoccupation with the tactile sensations of mass and movement in the work of Paul Cézanne. . . . Picasso, through the contemplation of Cézanne's achievement, found a method that created a new school. In one of his letters, Cézanne writes, 'I see the planes criss-crossing and overlapping and the lines sometimes seem to fall'—a sentence . . . bearing within it the germ of Cubism."

267. Forbes Watson, *The Arts* (January 1923): 13, 22. See also Forbes Watson, "The Barnes Foundation," *The Arts* (February 1923): 142, 144, 147. Watson also discusses Renoir as "the other great pillar of the edifice of modern art . . . represented in the Barnes collection" and concludes that Cézanne, "in the effect that he has had on subsequent painting, [was] a greater innovator" (144).

268. Betsy Fahlman, *Chimneys and Towers: Charles Demuth's Late Paintings of Lancaster* (Fort Worth: Amon Carter Museum, 2007), 69–71. In Gallery XX of the Barnes Foundation, Merion, PA, six Demuth watercolors are juxtaposed with four Cézanne works on paper. See Mark Mitchell, "A New Tradition: Cézanne, Demuth, and the Invention of Modern Watercolor," in *Cézanne and Beyond* (Philadelphia: Philadelphia Museum of Art, 2009), 288–89.

269. Albert C. Barnes, "Cézanne, A Unique Figure Among the Painters of His Time," *Arts & Decoration* (November 1920): 40. In *The Art in Painting* (1925), Barnes provided detailed, formal analyses of works in his collection by Cézanne who "ranks with the greatest painters of all ages because, by the use of means purely plastic and by a new use of the most difficult of those means—color—he realized a form of the highest conviction and power."

270. [Hamilton Easter Field], "The Kelekian Collection," *The Arts* (1921): 132–48; Forbes Watson, "American Collections No. II—The John T. Spaulding Collection," *The Arts* (December 1925): 321–44; Forbes Watson, "The John Quinn Collection," *The Arts* (January 1926): 5–22, 77–92; Forbes Watson, "American Collections No. III—The Adolph Lewisohn Collection," *The Arts* (July 1926): 15–48, especially 41–44 on Cézanne as having "produced a long list of portraits, landscapes, and still lifes, painted with so true a sense of his medium, with such rare understanding of the inseparability of form and color that they have won for [him] a position apart from all other masters and made him *chef d'école.*" *The Arts* also reported on collections and shows abroad. See Jacques Mauny, "The Charles Pacquement Collection," *The Arts* (January 1928): 5–17: "The tumultuous sincerity of Cézanne is always bracing, and though his influence has been salutary, on the whole, it could have been far more so if his followers had followed his spirit instead of misusing his weaknesses" (12).

271. Forbes Watson, "The Birch-Bartlett Memorial Collection," *The Arts* (June 1926): 303–12 [R800]. See also Courtney Graham Donnell, "Frederic Clay and Helen Birch Bartlett: The Collectors," *Museum Studies* 12, no. 2 (1986): 94 and passim.

272. "The Summer Exhibition," *Brooklyn Museum Quarterly* 8 (October 1926): 135 (reprint of a review by Elisabeth Luther Cary in *The New York Times* on July 4, 1926). Cary noted that Cézanne's "expansion of mind in the region of elemental relations is the characteristic differentiating [him] from the other painters of his generation. No one else tried so hard to master as much of cosmic philosophy as belonged to the artist's field of thought." The Brooklyn Museum scrapbook, reel 3 does not contain any reviews.

273. A. E. Gallatin, "The Gallery of Living Art, New York University," *Creative Art* IV (March 1929): xlii. See also Stavitsky, "The Development," 1:84–85, 88–96, 134–40; and Gail Stavitsky, "The A. E. Gallatin Collection: An Early Adventure in Modern Art," *Philadelphia Museum of Art Bulletin* 89 (Winter/Spring 1994): 8–20.

Jayne S. Warman

CÉZANNE CROSSES THE ATLANTIC
VOLLARD AND AMERICAN COLLECTIONS

Nearly one-third of Paul Cézanne's oil paintings are currently in public and private collections in the United States, a phenomenon that belies the almost visceral repudiation by many critics and observers when his art was first seen on American soil. Indeed, Cézanne's painting was long misunderstood and reviled even in his own country, and it was only after continued, almost dogged praise by his few admirers that the artist's reputation would become secure both in Europe and in America. A good many of these early enthusiasts were artists who influenced critics and motivated collectors to buy Cézanne's works. And in the center of it all was Ambroise Vollard, who was encouraged by several of the French Impressionists to introduce Cézanne to Paris in 1895 with his first one-person show. From then on the artist's work was never to be out of public view. As a result, many notable American collections with Cézanne represented—Loeser, Fabbri, Havemeyer, Stein, Cone, Barnes, Quinn, Meyer, Bliss, Phillips, and others—were created from the advice of American artists who were living or studying in Europe in the late nineteenth and early twentieth centuries and who frequented Vollard's rue Laffitte gallery and Parisian exhibitions.[1] But the public's appreciation of Cézanne's art in America was slow to take hold, just as it was in the artist's native France—and it would be several decades before the painter's work would be known, let alone exhibited, in the United States.

The first Cézannes to cross the Atlantic were a pair of still lifes[2] (R426, The Museum of Modern Art, New York, fig. 1) brought to Chicago in September 1891 by Sara Hallowell, who was a friend of Mary Cassatt's and an agent in Paris for American collectors and museums. She had hoped to stimulate interest in the two canvases but, receiving little or none at all, sold them in 1894 to the Durand-Ruel Gallery in New York, who sold them to their Paris branch for similar reasons.[3] In other words, Cézanne's debut in America came without fanfare and left no mark but for a few gallery records.[4]

Cézanne's lackluster reception in America was not much different from the one in Paris. The artist was virtually unknown except to his colleagues, like Camille Pissarro, who recognized Cézanne's rare and "precious qualities" even though at the Académie Suisse "his figure drawings were ridiculed by all the important artists."[5] By 1894 a mystique had developed around the artist in the French capital: "[Cézanne] might be described as a person at once unknown and famous, having only rare contact with the public yet considered influential by the reckless seekers in the

Katherine Rothkopf

THE CONE SISTERS
DISCOVERING CÉZANNE AND MODERN ART

Over the course of more than fifty years, the Cone sisters of Baltimore bought more than 3,000 objects, including paintings, drawings, prints, illustrated books, sculptures, books, medals, jewelry, textiles, and furniture. Their greatest passion was for contemporary French art, and they acquired one of the finest collections of European modernism in the United States during the first half of the twentieth century. Many of their acquisitions were made directly from the artists they befriended, making their collection extremely personal and unique. Claribel Cone (1864–1929), the older sister, was a distinguished medical doctor at a time when women did not regularly attend medical school (fig. 1). Etta Cone (1870–1949), the younger sister, did not have a professional career but dedicated most of her life to collecting art (fig. 2). They are best known for their comprehensive holdings of works by Henri Matisse, with over 500 objects acquired over more than forty years. Etta Cone first met Matisse in 1906, and she and her sister went on to become his most important and loyal patrons. In the 1920s, while gathering an impressive group of Matisse's works, Etta and Claribel Cone also began to acquire important paintings and drawings by his predecessors, in order to provide context for the artistic milieu from which Matisse came. This included a small but significant collection of paintings, drawings, and prints by Paul Cézanne, the artist whom Matisse considered his greatest inspiration. It was partly because of private collectors like the Cone sisters that Cézanne's work became better known in the United States during the first half of the twentieth century and beyond.

The Cone Collection began somewhat modestly in 1898, when Etta Cone was given three hundred dollars by her eldest brother, Moses, to decorate the sitting room of their family home in Baltimore. Rather than purchasing something traditional, such as antique furniture or oriental rugs, Etta chose to spend the funds on a group of five paintings by the American Impressionist artist Theodore Robinson (1852–1896) at his estate sale. Robinson was not very well known in Baltimore, so it was a daring and unexpected choice for Etta, who had no history of buying any kind of artwork. Most Baltimore collectors at the turn of the twentieth

Fig. 1 *Claribel Cone as a resident physician at the Philadelphia Hospital*, 1891–92(?). Dr. Claribel and Miss Etta Cone Papers, Archives and Manuscripts Collections, The Baltimore Museum of Art, CC.2

Fig. 2 *Etta Cone, wearing a riding outfit*, late 1880s. Dr. Claribel and Miss Etta Cone Papers, Archives and Manuscripts Collections, The Baltimore Museum of Art, EC.1

Paul Cézanne, *Mont Saint-Victoire Seen from the Bibémus Quarry* (detail, cat. 16)

century were interested in works by French Barbizon artists or American painters of the Hudson River School. Etta's light-filled paintings by Robinson were probably the first Impressionist examples to come to Baltimore, and must have been considered very modern and unusual at the time of their purchase. They were the start of a long and fruitful career of collecting modern art for Etta and her sister. There is no evidence that their parents had any interest in art, and it can be easily construed that Etta's newfound curiosity was a direct result of a close friendship developed the previous year.

In 1897, Gertrude and Leo Stein arrived in Baltimore to study at The Johns Hopkins University. They had first met the Cone sisters several years earlier during a stay with extended family in Baltimore,[1] but it was not until this later foray in the city that the siblings became particularly close. The Cones and the Steins both lived in Reservoir Hill, a Baltimore neighborhood known for its tightly knit German Jewish community. Gertrude attended medical school while Leo completed his undergraduate degree and then began taking graduate courses in biology, and the two were soon befriended by the Cone sisters. The Steins were not serious, active art collectors in the 1890s, with only a modest collection of Japanese prints at the time, but Leo's burgeoning interest in art history and aesthetics in general must have prompted many discussions with the Cones in the late 1890s.[2] It is hard to imagine that Etta's decision to purchase works by Theodore Robinson was not the subject of much conversation with the Steins both before and after the choices were made.

A few years later, the Steins left Baltimore in order to pursue new intellectual interests in Italy, England, and New York, finally settling in Paris in an apartment on the rue de Fleurus. The two sets of siblings continued their close relationship during the first years of the twentieth century. Etta traveled to Europe for the first time in 1901, and she met Leo in Italy, where he toured her around many important museums and sites throughout the country. They went on to Paris, where Gertrude joined them, and Etta experienced the beauty and excitement of the city for the first time.[3] Two years later, Etta and Claribel went to Europe together, and Gertrude met the sisters in Florence (fig. 3). In 1904, Etta and Gertrude journeyed to Europe together, spending time with Leo and Claribel. During the winter of 1905–6, Etta rented an apartment in Paris in the same building as Gertrude and Leo's brother, Michael, his wife Sarah (known as Sally), and their son Allan.[4] Etta was introduced to Pablo Picasso in 1905 by Gertrude, who was sitting for her portrait by the artist, when she asked her friend from Baltimore to join her at his studio. Etta immediately became interested in his work, and she and her sister went on to collect more than one hundred works by the artist over the course of more than forty years. Michael and Sally were equally important to the development of the Cone Collection: it was Sally who introduced Etta to Henri Matisse in 1906, and Michael often helped the sisters with their financial and shipping arrangements for their new acquisitions.

The Cone sisters' interest in the work of Paul Cézanne can be easily traced back to the Stein family. In the fall of 1904, Gertrude and Leo received an unexpected bonus of funds from their brother Michael, and they went on a buying spree at Vollard's gallery, acquiring two paintings by Cézanne, *Group of Bathers* (R753, The Barnes Foundation, Merion, PA) and *Bathers* (cat. 18),[5] which Etta later purchased from Gertrude in 1926. In 1906, Etta Cone purchased her

first work by Cézanne, a lithograph entitled *Small Bathers* (see fig. 5 in Stavitsky's essay in this volume). This significant early acquisition was the first of five works by the French artist to be purchased by Etta or her sister Claribel.[6] Cézanne's lithographs played a major role in the dissemination of his daring and original vision to a broad audience, and Etta was quick to make this inexpensive but important acquisition. During the critical period in 1903 when Leo Stein first discovered Cézanne's work and became one of his greatest proselytizers, Etta was spending large amounts of time with the Steins. In fact, three different members of the Stein family introduced Etta Cone to the three most important artists of the day during the first decade of the twentieth century: Gertrude introduced her to Picasso in 1905; Sally introduced her to Matisse in 1906; and Leo introduced her to the work of Cézanne by 1906. Etta responded enthusiastically by acquiring examples of their work soon after learning of their importance, and subsequently supported their artistic vision with more purchases in the following decades.

The first phase of the Cone Collection was completed in 1908, when Claribel and Etta's eldest brother, Moses, died unexpectedly in December. After his death, Etta remained in North Carolina with his widow, Bertha, for an extended period. Her relatively modest collection, consisting largely of five paintings by Robinson, one painting, a watercolor, and drawing by Matisse, a group of drawings and prints by Picasso, a Cézanne lithograph, two Manet prints, and a group of Japanese prints, remained relatively static for the next fourteen years.[7] Although Etta traveled abroad several years later, she did not resume her focus on collecting until after World War I. Claribel did not begin collecting fine art until after the war ended.

Fig. 4 *Marlborough Apartments, apartment of Claribel Cone (8B), View into front back room with Cézanne's "Mont Sainte-Victoire Seen from the Bibémus Quarry" by window*, 1941. Dr. Claribel and Miss Etta Cone Papers, Archives and Manuscripts Collections, The Baltimore Museum of Art, CECHOMES 14

When the sisters returned to Europe in 1922, after an extended hiatus from collecting, they bought with a new sense of eagerness. Their enthusiasm for Matisse was evident, with at least thirty-two paintings and sculptures by the artist acquired between 1922 and 1929. They became more confident of their choices and clearer in their direction as the decade wore on. Their interest in Matisse's work led them to his nineteenth-century predecessors, artists who provided him with the greatest inspiration. On June 26, 1925, Claribel purchased Cézanne's *Mont Saint-Victoire Seen from the Bibémus Quarry* (cat. 16) from the Bernheim-Jeune Gallery for Fr410000 (about $18,860). It was the most expensive work that either sister had ever bought, and it made a significant statement about Claribel's commitment to acquiring magnificent works by the painters of her time. Although this was to be her only purchase of Cézanne's work, Claribel was well aware of his importance in the pantheon of modern artists. In the fall of 1924, Claribel wrote her sister during a trip to Aix-en-Provence about seeing Cézanne's house: "Interesting to have seen the home of Cezanne. It makes him more real—less a myth—somehow."[8] The following year, Etta acquired Cézanne's painting *Bathers* from Gertrude Stein's collection (cat. 18), a subject that also appeared in the lithographs by the artist that she acquired. Although much smaller than Claribel's choice, Etta's decision to add this canvas to her holdings proved to be equally wise. Leo Stein had purchased it from the dealer Ambroise Vollard in 1904, and it hung in the Stein apartment on the rue de Fleurus for many years. In the first decade of the twentieth century, the Stein home was the only place in Paris where one could see paintings by Cézanne, Matisse, and Picasso installed side by side.

Back in Baltimore in the 1920s, the Cone sisters played much the same role as the Steins, providing a place for modern art to be seen and discussed in their apartments (fig. 4). The Cone papers are filled with thank-you notes from artists and collectors, museum professionals, and amateur art lovers, with many references to their acquisitions, including their two paintings by Cézanne.[9] As their collection grew, Claribel and Etta were in high demand as speakers on art. In 1923, the sisters gave a lecture together on Matisse and Cézanne in their apartments,[10] and they both began taking classes on aesthetics at The Johns Hopkins University with philosophy professor George Boas.[11] Although there is no surviving document where the sisters directly discuss their many collecting decisions, the manuscripts, lecture notes, and correspondence of the Cone sisters do provide some insight into their preferences and philosophies. In the 1920s, Claribel Cone delivered several lectures in public and on the radio that celebrated the revolutionary nature of the artists that she admired. Her self-assurance as an art authority in her lectures is quite extraordinary, and clearly indicates her confidence as a collector as well. She had a clear sense of progression in modern art, with Cézanne playing a central role. In her notes for a lecture in 1929,[12] she wrote: "PAUL GAUGUIN has said: "In all Art there are only <u>Revolutionists</u> and <u>Plagiarists</u>. The <u>REVOLUTIONISTS</u> are

those who have broken away from the Traditional Form of Art—the Academic. In each Generation these have been the Path-Finders. [Handwritten addition: "They Produce Something new. They Create"] The PLAGIARISTS are the Artists who calmly accepted the TRADITIONAL—the Academic Form of Art, with-out some Original Contribution of their own. Among the REVOLUTIONISTS we have such Men as: Il Greco [sic], Rembrandt, Velazquez, Goya, Courbet, Manet, Monet, Renoir, Cezanne, Matisse, Picasso, and others." [Handwritten addition: "Derain."] In her typewritten remarks for a radio program on modern art in April 1929,[13] Claribel explained the difference between the old and new in art, starting with Ingres, Delacroix, and artists of the early nineteenth century through the modern day. When referring to Cézanne, she clearly understands his role as a revolutionary figure. She writes: "The work of the IMPRESSIONISTS was rather Superficial and Flat. [Handwritten addition: "as was that of Neo-Impr."] Cezanne wanted more Solidity, more Structure, more substance to his Pictures—as did also Renoir."[14]

Etta Cone also evolved into a highly regarded art authority in Baltimore. In 1931, she presented a lecture entitled "The Development of Modern Art."[15] Her introduction began: "This paper was written by an amateur and is intended to trace the influences which led up to the modern art of today. The following remarks are based on what can be gleaned from museums, galleries and casual reading of the critics and other authorities." Her humble and modest preface belies the immense challenge that she takes on in her lecture—outlining the history of art, from prehistoric cave paintings in France, through the Renaissance, the Baroque, Neo-Classicism, Orientalism, Realism, Impressionism, and Post-Impressionism to Matisse and Picasso. Like her sister, Etta was well aware of the importance of Cézanne's role in the advent of modernism: "Paul Cezanne of this period was the most independent of them all, limiting his palette to no more than four colors. His landscapes were remarkable examples of impressionism."[16]

Etta's overriding interest in Matisse and his creative process frequently appears in her notes and manuscripts for lectures. In her notes for a possible lecture on modern art, Etta profiles the biography and stylistic evolution of Matisse.[17] She describes his work during his Fauvist period, and the significant inspiration he received from artists of the late nineteenth century, including Cézanne: "His technique was his own, and he resorted to a complete suppression of detail and subjugation of natural representation. There is no loss of intelligibility, rather an enhancement of expression. By using large flat areas of pure color, connected by heavy outlines, he started what became the tenets of associates and followers. This was the direct influence of Cezanne, Gauguin and Van Gogh."[18]

As part of her extensive notes about modern art that are now housed in the Cone Papers, Claribel Cone compiled a multipage list of artists that she considered important and revolutionary. Although predominantly featuring European artists, on the last page of the surviving document she also mentions a group of American painters that she considered part of this modernist trajectory.[19] Among the artists listed are Leon Kroll, Arthur Dove, Marsden Hartley, Max Weber (twice), John Marin, Alfred Maurer, Oscar Bluemner, Morgan Russell, Stanton Macdonald-Wright, and Patrick Henry Bruce. These are the Americans most influenced by Cézanne's masterly touch, and it is clear that the Cone sisters recognized their inspiration and rewarded several of them (Kroll [cat. 60], Weber [cat. 116], Marin, and Bruce [cat. 30])

with support and patronage. Although the majority of The Cone Collection features work by European artists, their holdings in works by Americans are significant and dominated by artists with an interest in color, structure, and volume—a legacy of Cézanne and his influence on American modernism.

In the surviving manuscripts and notes for her lectures, Claribel frequently mentions her sources—often recently published and highly regarded texts on modern art. She cites Frank Rutter's *Evolution in Modern Art (A Study of Modern Painting 1870 –1925)*[20] in her manuscript for a lecture in 1927, and her well-used copy of this survey of modern art includes her notes regarding the text, notably in the sections on Cézanne, van Gogh, Gauguin, and Matisse.[21] She mentions C. Lewis Hind as a source for two lectures in 1929, and her copy of his book *The Post Impressionists* of 1911 is filled with her marks in the margins highlighting important passages about his views on Cézanne, van Gogh, and Gauguin as pioneers of modernism.[22] For two sisters from Baltimore who were self-taught art enthusiasts, there is a document in the Cone Papers that reveals a great deal about their confidence as collectors and authorities on modern art. In her notes about Matisse, Claribel tries to identify the various reactions that different people have to his work. Among these papers is a handwritten list entitled "5 Types of Connoisseurs (Types of mind which re-act to Matisse paintings)" which divides people into five categories: "intuitive, intelligent/open minded, prejudiced, blank mind, and primitive mind/unsophisticated."

Fig. 5 *Claribel Cone on boat, looking at shore,* n.d. Dr. Claribel and Miss Etta Cone Papers, Archives and Manuscripts Collections, The Baltimore Museum of Art, CC.15

Under "intelligent/open minded," the author has included five names: "E.C. [Etta], C.C. [Claribel], Walter Pach, Roger Fry, and Lewis Hind."[23] Of course, Pach, Fry, and Hind were well-respected scholars of modern art, critics that the Cones relied on for their information. Claribel felt very comfortable allying herself, and her sister, with this very distinguished group of art historians.

The Cone sisters were dedicated readers, and their library consisted of books on their favorite artists, travel guides, and general texts on art styles and movements. They acquired an impressive selection of surveys of modern art, including Willard Huntington Wright's *Modern Painting, Its Tendency and Meaning* (1915; cat. 145),[24] Clive Bell's *Since Cézanne* (1922; cat. 150), and several issues of Alfred Stieglitz's *Camera Work.* Cézanne is the artist who is best represented in their library, an acknowledgment of his importance as the inspiration for the artists they collected and supported for decades. There are more than twenty monographic texts and exhibition catalogues about Cézanne, several with more than one copy.[25] Each sister often had her own copy of certain books, and some are marked with notes and checkmarks in passages that they found particularly interesting.

In 1929, while vacationing in Lausanne, Switzerland, Claribel Cone died unexpectedly at the age of sixty-five (fig. 5). Although she had only been a serious collector for just over seven years, she had made many bold and adventurous choices, including the major acquisition of Cézanne's *Mont Saint-Victoire Seen from the Bibémus Quarry* in 1925. She left her collection to

Fig. 6 Paul Cézanne,
*Sketch after Puget's
"Milo of Croton,"* c. 1890.
Graphite on laid paper.
The Baltimore Museum of
Art: The Cone Collection,
Bequest of Frederic W.
Cone, BMA 1950.12.657

her sister, with the understanding that if the city of Baltimore could learn to appreciate modern art, her holdings would be given to The Baltimore Museum of Art.

Etta Cone's interest in modern art continued unabated for the next twenty years, with hundreds of new works by both European and American artists added to the collection. In 1938, she purchased Cézanne's *The Poplar,* a graphite drawing of a single tree, during one of her final trips to Paris. Frederic W. Cone, the youngest sibling in the family, probably received the powerful and dramatic drawing *Sketch After Puget's "Milo of Croton"* (fig. 6) as a gift from Etta in the late 1930s, and upon his death, it became part of her collection. This was to be Etta's last acquisition of the artist's work. Although she continued to purchase works until the end of her life, she stopped traveling abroad in the late 1930s because of safety concerns due to political unrest, thus limiting her acquisitions only to those made from New York dealers (fig. 7). Upon her death in 1949, Etta Cone left the Cone Collection to The Baltimore Museum of Art. This extraordinary gift has made the museum a major repository of modern art in America for almost sixty years, providing scholars and museum visitors alike with a unique view of the prescient collecting tastes of two philanthropic sisters from Baltimore.

Fig. 7 *Etta Cone in her apartment next to a vase of flowers,* 1930s. Dr. Claribel and Miss Etta Cone Papers, Archives and Manuscripts Collections, The Baltimore Museum of Art, EC.23

Notes

1. According to Ellen B. Hirschland, "The Cone Sisters and the Stein Family," in *Four Americans in Paris* (New York: The Museum of Modern Art, 1970), 75, the Cone and Stein siblings met in 1892 before the Steins went to college in Cambridge, MA.

2. Leo Stein's trip to Europe in 1895 was an enormous inspiration to him, as he spent a great deal of time in the museums in Dresden and Paris. See Brenda Wineapple, *Sister Brother: Gertrude & Leo Stein* (Baltimore: The Johns Hopkins Press, 1996), 86–87.

3. *Four Americans in Paris*, 75.

4. Ibid., 76.

5. Wineapple, *Sister Brother*, 217. For more information on Stein's introduction to Cézanne's work, see ibid., 209–12. Also see James R. Mellow, *Charmed Circle: Gertrude Stein & Company* (New York: Praeger, 1974), 62–63, for more information on the purchases of works by Cézanne in 1904.

6. The first work by Cézanne to enter the Cone Collection was listed simply as "Cézanne lithograph" in Etta Cone's records from 1906, and it has since been identified as *Small Bathers* (BMA 1950.12.605). In 1929, Etta Cone subsequently purchased a second lithograph, *Large Bathers* (BMA 1950.12.681.1). For more information about Cézanne's lithographs and the dating of the multiple states of his prints, see Douglas Druick, "Cézanne Lithographs," in *Cézanne: The Late Work* (New York: The Museum of Modern Art, 1977), 119–37. Claribel Cone acquired *Mont Saint-Victoire Seen from the Bibémus Quarry* (cat. 16) in 1925, and Etta Cone bought *Bathers* (cat. 18) from Gertrude Stein in 1926. In 1938, Etta purchased *Poplars*, a graphite drawing (BMA 1950.12.667). Frederic W. Cone, the youngest brother in the family, owned Cézanne's *Sketch after Puget's "Milo of Croton,"* a graphite drawing (BMA 1950.12.657). Adelyn Breeskin, the former director of The Baltimore Museum of Art, recalled that Etta Cone had told her that she had given her brother the drawing as a gift. Although Etta acquired the drawing after her brother's death, it was accessioned as part of Frederic Cone's bequest to the museum per Etta's wishes upon her death.

7. For detailed information about the artistic acquisitions of the Cone sisters, see Brenda Richardson, *Dr. Claribel and Miss Etta* (Baltimore: The Baltimore Museum of Art, 1985), 167–94. For more information about their interest in nineteenth-century French drawings, see Jay McKean Fisher et al., *The Essence of Line: French Drawings from Ingres to Degas* (University Park, PA: Pennsylvania State University Press, 2005), 46–49; and Jay McKean Fisher, "Drawings from the Collection of Claribel and Etta Cone at The Baltimore Museum of Art, *Drawing* 17, no. 1 (May–June 1995): 1–6. According to Ellen B. Hirschland and Nancy Hirschland Ramage, *The Cone Sisters of Baltimore: Collecting at Full Tilt* (Evanston, IL: Northwestern University Press, 2008), 89, Etta asked Michael Stein to buy her a Renoir lithograph in 1910.

8. Claribel Cone to Etta Cone, September 10, 1924, Dr. Claribel and Miss Etta Cone Papers, Archives and Manuscripts Collections, The Baltimore Museum of Art (BMA).

9. For example, Stephen C. Clark to Etta Cone, December 1, 1929, Cone Papers, BMA, where the noted collector mentions the "little Cezanne," probably *Bathers* (cat. 18 herein). Also Florence M. Levy to Etta Cone, August 4,

1926, Cone Papers, BMA, where the director of The Baltimore Museum of Art mentions wanting to "see your new Cezanne," probably *Mont Saint-Victoire Seen from the Bibémus Quarry* (cat. 16).

10. See A. R. L. Dohme to Claribel Cone, February 9, 1923, where he makes arrangements for the talk for the Art Forum, "a group of about twenty art lovers," Cone Papers, BMA. Also discussed in Hirschland and Ramage, *The Cone Sisters*, 99.

11. Hirschland and Ramage, *The Cone Sisters*, 99.

12. Claribel Cone, Notes for a lecture on Modern Art, March 28, 1929, Cone Papers, BMA. The quote from Paul Gauguin at the start of her notes is also cited in Frank Rutter, *Evolution in Modern Art (A Study of Modern Painting 1870–1925)* (New York: The Dial Press, c. 1925), 11.

13. Claribel Cone, draft of a radio talk on modern art, April 10, 1929, Cone Papers, BMA.

14. Ibid.

15. Etta Cone, paper on "The Development of Modern Art," 1931, Cone Papers, BMA.

16. Ibid.

17. Etta Cone, notes for a lecture on modern art [?], undated, Cone Papers, BMA.

18. Ibid.

19. Claribel Cone, list of modern painters for lecture [?] on "Modern Art," spring 1927, Cone Papers, BMA.

20. Rutter's *Evolution in Modern Art* is cited in Claribel Cone's notes for her lecture on modern painting, Tuesday, March 15, 1927, Cone Papers, BMA.

21. Rutter's text credits Cézanne as one of the pillars of Post-Impressionism, along with van Gogh, Gauguin, and Matisse, and he refers often to the solidity and structure apparent in Cézanne's works. These same ideas appear in Claribel Cone's manuscript notes for lectures. Rutter openly preferred the still-life compositions of the French master, and felt that Cézanne's Bather compositions were often unsuccessful attempts to paint like Poussin. See Rutter, *Evolution in Modern Art*, 48–68. Claribel Cone's copy of the book is full of notations in the margins from pages 11 to 79. The second half of the book, which discusses Cubism, Futurism, Expressionism, Post-Impressionism in England, and design, does not contain any notes from its owner.

22. In her notes for lectures on March 28, 1929, and April 10, 1929, Claribel Cone cites full quotations from C. Lewis Hind, *Art and I* (New York: John Lane, 1921); and C. Lewis Hind, *The Post Impressionists* (London: Methuen, 1911). Cone Papers, BMA. There are extensive notes in Claribel Cone's copy of Hind's *The Post Impressionists* in The Baltimore Museum of Art's E. Kirkbride Miller Art Research Library. In the book, Hind describes his personal discovery and admiration for the works of Cézanne, van Gogh, Gauguin, and Matisse, and criticizes the English public for their lack of understanding of these Post-Impressionist masters when they were on view in London at the famed Grafton Galleries show of 1910.

23. Claribel Cone, "5 Types of Connoisseurs (Types of mind which re-act to Matisse paintings)," undated, Cone Papers, BMA. These notes may be associated with a lecture given about Matisse by both sisters, as they are labeled "Matisse EC CC."

24. Although now less well known than Bell or Stieglitz, Wright played an essential role in furthering the case for Cézanne's importance to the modern art movement. For information about Wright's opinions about Cézanne, see Stavitsky's essay in this volume.

25. The exhibition catalogues and monographic texts about Cézanne in the Cone sisters' library published by 1930 are: Émile Bernard, *Souvenirs sur Paul Cézanne: Une conversation avec Cézanne: La méthode de Cézanne* (Paris: R. G. Michel, 1925); Gustave Coquiot, *Cézanne* (Paris: A. Michel, 1919); Roger Fry, *Cézanne: A Study of His Development* (New York: McMillan, 1927); Léon Leclère [pseud. Tristan L. Klingsor], *Cézanne* (New York: Dodd, Mead, 1924); Julius Meier-Graefe, *Cézanne* (New York: Scribner, 1927); Julius Meier-Graefe, *Cézanne und Sein Kries* (Munich: R. Piper, 1922); Eugenio d'Ors, *Paul Cézanne* (Paris: Éditions des chroniques du jour, 1930); Kurt Pfister, *Cézanne: Gestalt, Werk, Mythos* (Potsdam: Gustav Kiepenheuer, 1927); Ambroise Vollard, *Paul Cézanne* (Paris: Galerie A. Vollard, 1914); Ambroise Vollard, *Paul Cézanne: His Life and Art* (New York: N. L. Brown, 1923); Ambroise Vollard, *Paul Cézanne: Huit phototypies d'après Cézanne* (Paris: Crés, 1924); and Hans V. Wedderkop, *Paul Cézanne: mit einer Farbigen Tafel und 32 Abbildungen* (Leipzig: Klinkhardt & Biermann, 1922).

Ellen Handy

CÉZANNE AND MODERNIST AMERICAN PHOTOGRAPHY
HOW A FEW CORKING CÉZANNES HELPED RESHAPE PHOTOGRAPHIC ART IN AMERICA

Moments and photographs: a sturdy young woman's worn bathing costume clings as she raises her arm to grasp a branch rather than look toward the energetic man whose large camera and heavy tripod stand at the water's edge (cat. 103). Three under-ripe pears from a garden in Voulangis patiently flank an apple as another photographer works to render them solid as rock formations amid shadows (cat. 102). An earnest young man watches sunlight angle through the railings of a cottage's porch before tipping a small, round table to rest against the floor, and adjusting the camera to a tight close-up (cat. 108). Each moment is a point of entry for exploration of the possibility that American photographers as well as painters may claim Cézanne as inspiration.[1] Photography's history recognizes that Alfred Stieglitz, Edward Steichen, and Paul Strand each evolved modernist practice from factors including personal inspiration, other photographers' ideas, Cubism, and the innate qualities of their medium. Adding Cézanne's influence to that already fertile compost of explanations is introducing a hypothesis considerably easier to declare than to confirm as fact. Whether Stieglitz thought of Cézanne, or of his desire for the radiant bodies of young women as he photographed Ellen Koeniger at Lake George; whether Steichen honored Cézanne or pondered the rival claims of painting and photography while ministering to his plate of fruit; and whether Strand aspired to follow Cézanne's example, or simply to win the approval of Stieglitz for his experiments in abstraction—all are unknowable. None of these men ever set pen to paper to announce an explicit intention to emulate Cézanne in photography.

As we accept that we cannot definitively know the intentions of artists, that not every plausible story told within the history of art comes supported by dense webs of letters, memoirs, and verifiable claims, the concept of influence remains a slippery one. Identifying the transmission of styles from Europe to the United States, from paintings to photographs, from one artist to many, only ramifies the complexity. Asking whether the pattern of Cézanne's influence upon American painters is paralleled among American photographers raises questions specific to photographic history. How did Strand suddenly arrive at his subjects and tensions between stasis and motion in still life composition in 1916? What models did Steichen have for sudden transformation from the painterly remains of Pictorialism to a modernist manner in 1921? Why did he choose still life as his preferred genre in that transition? What are the origins of Stieglitz's extended serial

projects, and why did he produce so many images of bathers at Lake George? What did he see in Anne Brigman's decidedly retardataire work, whose Pictorialist idiom he increasingly abjured? What inspired Clarence White to abandon the costumey quasi–Pre-Raphaelitism of his early images of women in gardens in favor of sun-dappled sylvan nudes? How did White's advocacy of modes of composition more modernist than his own shape the work of a generation of students at his school of photography? These questions all concern stylistic change in the works of early-twentieth-century American photographers close to Stieglitz.

Stieglitz's circle served as a kind of modernism assimilation and production machine.[2] Energetically adopting the most advanced currents of thought and stylistic innovations emanating from Europe, Stieglitz-circle artists also rivaled the products of European modernism by generating indigenous forms expressive of American consciousness. Largely through Stieglitz's crusading efforts, photography had come into its own, after proving itself capable of Symbolist, Tonalist approximations of painting that rapidly gave way to bolder, often semi-abstract images. These came to be called "straight" photography.[3]

Painterly versus purely photographic aesthetics are only part of the story. When photography and abstraction partner each other, the modernist impact is enhanced, owing to the twist of the camera's identity as a machine. But just as Cézanne's images never quite relinquish representation, so too do most strongly modernist photographs retain elements of mimesis. In building a comparison between these photographs and Cézanne's paintings, however, we must ask just which Cézanne is it whose influence we seek. The "wild man of Aix" of early criticism?[4] The recondite formalist who "appealed first and foremost to the eye, and to the eye alone"?[5] A colorist? A constructor of timeless harmonies? Merleau-Ponty's figure of existential tension?[6] Part of the challenge in seeking his influence upon Stieglitz-circle photographers lies in recognizing that they might have construed Cézanne as a model in terms differing from those most familiar today.

Certainly by the fall of 1911, when *Newark Evening News* critic Israel White announced that "already the name of Paul Cézanne has become familiar," many others in the United States also recognized Cézanne's importance in the emergence of a new twentieth-century style of art. Stieglitz called attention to White's pronouncements, reproducing his review in *Camera Work*.[7] A few months later, Stieglitz himself wrote a letter to the *Evening Sun* advocating for an exhibition of Cézanne and van Gogh at The Metropolitan Museum of Art because "without the understanding of Cézanne—and this one can get only through seeing his paintings, and the best of them—it is impossible for anyone to grasp, even faintly, much that is going on in the art world today."[8]

Photographers in Stieglitz's circle were intensely aware of the mechanisms and strategies of avant-garde activism, given the Photo-Secession's crusade to establish itself as the leading voice in fine-art photography, and photography itself as a form of fine-art expression. Having cultivated heroic outsider status for the photographic medium as a whole, the Secessionists were able to identify with an individual apostle of the new art like Cézanne. Yet few accounts of modernist photography in America have considered Cézanne to be central in its evolution. Subdivisions within the practice of art history may have obscured circumstances previously more apparent

to contemporary audiences, but history "presents no isolated facts," as John Rewald noted; the "often invisible threads that link events" encourage reconsideration of Cézanne's importance to American photography.[9] In addition to the transmission of avant-garde leadership in the arts from Europe to America during the early twentieth century, there are complicated subsidiary questions about the ways in which photography came to follow the example of painting and, at times, to take the lead.[10] What relationship is there between painting's embrace of abstraction, and photography's redefinition as a fine-art medium in its own right? Is it possible to extend to photography what Christopher Lloyd called Rewald's "history of taste" by marshaling the documents of the social history of art to reveal the cultural framework surrounding the reception of Cézanne by American photographers?[11]

Three main paths to modernism are evident in early-twentieth-century American photography; the first comprises Alfred Stieglitz's activities as impresario of the arts and as photographer. Subsequently, Steichen and Strand each came briefly to favor jumpy oscillations of space and truncations of form in abstract composition. And thirdly, the Clarence White School disseminated a philosophy of photography based on principles of semi-abstract design at the expense of virtually all other elements.[12] There are fewer primary source documents concerning the evolving relations of American photographers to Cézanne extant than those illuminating the corresponding situation of American painters.[13] The most comprehensive such narratives are the recollections of famous men regarding heroic episodes of their early careers, polished to glowing patinas probably quite different from the original texture of those experiences.[14] Though literal accuracy is relatively unlikely, the importance of these anecdotes as codifications of values is inestimable. A few key occurrences supplement these accounts in framing the story of Cézanne's impact upon American photography: two exhibitions of Cézanne's work (and reproductions of it) at "291" (as the Little Galleries of the Photo-Secession came to be known); critical texts about Cézanne published (or republished) in *Camera Work*; Stieglitz's advocacy of a Cézanne exhibition at The Metropolitan Museum of Art; Steichen's supposed creation of a fake Cézanne; Steichen's acquisition of Cézanne's *Still Life with Apples and Peaches* (cat. 21) for Eugene and Agnes Meyer; Strand's pioneering composition of photographic abstractions in the summer of 1916; and the curriculum at the Clarence White School of Photography.

Each of these three currents within the movement of American modernist photography had its roots in the Photo-Secession, an international Pictorialist movement which Alfred Stieglitz localized to the United States at the turn of the century. Stieglitz successively cultivated confidants and protégés among photographers, including White, Steichen, and Strand, each of whom he eventually accused of personal or aesthetic betrayal, and cast off decisively.[15] Yet in the best years, he was the genial center of a band of artists and writers who enthusiastically lunched daily at his expense, then visited the gallery where he held forth upon art, life, and photography. Alfred Kreymborg lovingly captured a vignette of the group in action:

> Laughing among themselves, the artists arose, while their host attended to the waiter. Then, with Steichen and Walkowitz in advance, they started down Fifth Avenue. People stopped and stared at the parade of men so dissimilar, chatting,

fooling and calling to one another: Steichen, lanky and boyish, Walkowitz, diminutive and dignified, Caffin, erect, aristocratic, Weber, volatile, gesticulating, Marin, with his long lean face and roving dark eyes, Hartley, with the aloofness of Hamlet, the stocky mercurial Strand, the stocky genial Dove, the grave, silent Haviland, the quick-witted, sharp-faced De Zayas, and bringing up the rear, the nervous dynamo in gray. . . .[16]

The photographers and associates of the Photo-Secession had been trained to respect what Stieglitz put on the walls at 291, and reproduced in the pages of *Camera Work*.[17] When Stieglitz's interests turned toward painting and modernist art in general, it was as inevitable that his cadre would turn with him as it was that he would use the polemical tools at his disposal to promote the new causes. By November 1910, this emphatically included the work of Cézanne, with three lithographs and a group of Eugène Druet's copy photographs of Cézanne paintings exhibited as part of a group show. This was closely followed in March by the ambitious Cézanne watercolor exhibition.[18] The story of how that exhibition came about has been told repeatedly, then codified in Stieglitz and Steichen's variant versions. Stieglitz's tale, reprised by Dorothy Norman, opens with the artists and their wives sheltering from a summer storm in the Bernheim-Jeune gallery in 1907. Stieglitz incongruously cast himself as an ignorant viewer, contrasting initial incomprehension of the work with his later partisan embrace of it, an internalized parable of the challenge that European avant-garde work presented to American audiences.[19]

The story continues to a stranger twist in Steichen's mocking offer to paint one hundred watercolors for Stieglitz to pass off as Cézannes, to which Stieglitz ostensibly replied: "Steichen, I have never laughed before at anything I did not understand. I have a sneaking idea the joke is on us."[20] Steichen (whose wife Joanna wrote that "he demanded truth from others but manipulated his own. He never could repeat a story without embellishing it a little more each time") recalled the Stieglitzes' summer visit to Paris as occurring in 1910. He described the two men laughing "like country yokels" at the Cézannes, though Steichen soon decided to ship some of them to New York for the 291 show. In his telling, the faux Cézanne was painted and successfully exhibited.[21]

The denouement of Steichen's account is the burning of his "Cézanne" after receiving various offers to purchase it, which left him "petrified." At this date it is impossible to be sure whether he ever painted and exhibited that watercolor; the important point is rather the severe anxiety about Cézanne's abstract vision on the part of two of the most advanced thinkers in the American fine-art community that these stories demonstrate. For Stieglitz, it was essential that the Paris encounter happened early enough that he could cast himself as having been temporarily philistine in the face of an unimaginably bold innovation in art, yet reconsider in time to appear as a prescient connoisseur of Cézanne. His conversion narrative supplied a template that audiences in New York could be expected to emulate when he then presented Cézanne's work. For Steichen, who was a painter as well as photographer, the challenge was to *become* Cézanne, at least for the space of one short-lived watercolor. The fraught emotionality of both their encounters with Cézanne suggests that the impact of those watercolors was deep,

powerful, and dislocating—exactly the sort of experience which would lead to response in their own work, whether or not they acknowledged it openly.

The unsigned *Camera Work* review of 291's Cézanne watercolor show rhapsodized that:

if one gave oneself a chance, one succumbed to the fascination of his art. . . . The artist's touch was so sure, each stroke was so willed, each value so true, that one had to surrender to the absolute honesty, sincerity of purpose and great mentality of him whom posterity may rank as the greatest artist of the last hundred years.[22]

It's impossible to assess how many of the photographers reading *Camera Work* and visiting 291 thus succumbed to Cézannesque aesthetics, though surely the numbers were not negligible. Yet the accepted explanation most current today for how American photographers invented a new visual language in the teens and twenties instead emphasizes the role of Cubism.[23] Although a stimulating hypothesis, there is virtually no way a camera lens can directly adopt the multiple viewpoints of Analytic Cubism, whereas Cézanne's push and pull of planes is more congenial to the camera; his restless, subtle compositing of perceptions may be suggested by the camera's capture of changing conditions of light or motion during a lengthy exposure.[24]

John Pultz's and Catherine Scallen's landmark study *Cubism and American Photography* discusses many works characterized by a struggle to apprehend objects lying behind the shifting veil of appearance rather than by Cubism's yet greater dislocations and destabilization of form.[25] Gestures toward abstraction, such as Strand's 1916 still lifes and Steichen's transitional fruit pieces, are striking in so essentially mimetic and perspectively monocular a medium as photography. The problem with Pultz's and Scallen's argument is its breadth: it comprehends a swath of early-twentieth-century American photography so wide that highly disparate works lacking even formal cohesion are categorized together. The period notoriety of Cubism as an avant-garde style does, however, make it easy to establish evidence that virtually all the photographers encompassed by the argument were at least familiar with their supposed source. A similar, if much narrower, case for Cézanne's influence is in fact more challenging to make.

The most immediate answer to the question of who introduced the American photographic community to Cézanne must be Stieglitz, through 291 and *Camera Work*. But he didn't conduct those enterprises alone, and he didn't form his views in a vacuum. As is well documented, Edward Steichen, Leo Stein, Max Weber, and Marsden Hartley all played roles in bringing Cézanne to Stieglitz's attention, and keeping him there. Of these, Steichen is the most important.[26] While Stieglitz was the celebrated impresario whose gallery and journal presented Cézanne to American audiences for the first time, Steichen was 291's man on the spot in Paris, making critical evaluations of contemporary art as he discovered it.[27] As early as 1910, Charles Caffin confidently proclaimed that Steichen was "the first American painter who, comprehending the example of Cézanne, has been able to fit it to his own personality, in such a way that the latter has been not only preserved but strengthened."[28] Caffin referred exclusively to Steichen's paintings, but described a transformation of Steichen's very personality, an influence which would logically pervade of all his mediums. Steichen's advocacy of Cézanne's work, his selection and instigation of both exhibitions of Cézanne, and his agency in Agnes and Eugene Meyer's

1912 purchase from Vollard of the majestic *Still Life with Apples and Peaches* (cat. 21) all indicate passionate commitment to Cézanne.[29]

Writing from Montparnasse on an unspecified Tuesday in January 1911, Steichen sent glad tidings to "My dear A.S.":

> Well, the Cezannes are out at sea on the Savoie. It meant a certain amount of "manoeuvre" to get them so they did not get off as soon as I hoped. . . . The Cezannes are a really fine lot the cream what the Bernheims have.—And I managed to get the collection as *varied* as possible in that way I did sacrifice a few corking things I might otherwise have included. . . . —I should liked to have had some Cezanne watercolors that Vollard has but it was impossible to make the show up from two houses.[30]

While the credit for discovering much of the European art shown at 291 belongs to Steichen, his praise for other avant-garde manifestations was decidedly equivocal. A serious painter for more than twenty years before he turned exclusively to photography, Steichen slowly evolved from his early Tonalism to a modified Fauvism. If his own deepest affinities lay first with Rodin, Whistler, and Matisse, Steichen had nonetheless been stimulated and preoccupied by Cézanne for more than ten years by the time he reached the great turning point in his strikingly episodic career. By 1921, Steichen was disillusioned by the war, on the verge of leaving his beloved studio and garden in Voulangis, bitterly divorcing from his first wife, and moving closer to an inevitable personal and aesthetic break with Stieglitz. A superb photographic technician and brilliantly facile image-maker, he sought a new direction for the photography to which he was now wholly committed, having foresworn painting. His photographic still life experiments of that period wrestle with problems of essence, existence, and form. This series recalls old-master still-life meditations upon mortality. Despite the strikingly unfinished qualities of the watercolors he'd selected for the 291 show, Steichen evidently preferred Cézanne's oils, like the Meyer still life that he praised so eloquently in a letter to Stieglitz.[31] Apparently Steichen found gravitas rather than faceted immateriality in Cézanne, and his affinity was with the painter's Poussinesque rather than proto-Cubist aspect.

Steichen's still lifes—the work of a forty-two-year-old man who could see both ends of the spectrum of life from his vantage at a midpoint—address the tensions between reality and the image of a thing. They embrace the weighty corporeality of existence with tragic overtones like those of many Cézanne still lifes. *An Apple, a Boulder, a Mountain* (fig. 1) demonstrates his renunciation of Pictorialism's flattened, veiled forms and ghostly luminosities in favor of the mass and inherent gravitas of the solitary fruit, which nonetheless slips loose from the demands of accuracy of scale in representation to assume an almost geological, rather than botanical, form. The rocky weight and mass with which he invested the fruits before his camera approaches Cézanne's struggle with the Heraclitean variations of a motif. The photograph's title echoes Cézanne's own protean mountain, Mont Sainte-Victoire, while the apple's texture is somewhere between that of human flesh and roughly hewn granite.

Paul Strand's transitional still lifes, by contrast, are relatively unemotive explorations of compositional form. Unconcerned with life and death, their bold abstraction is triumphantly

Fig. 1 Edward Steichen, *An Apple, a Boulder, a Mountain,* c. 1921. Gelatin silver contact print. The George Eastman House, Bequest of Edward Steichen by Direction of Joanna T. Steichen, neg. 38889 (1979:2024:0004)

Fig. 2 Paul Strand, *Ceramic and Fruit,* 1916. Platinum print. The Museum of Fine Arts, Houston; Museum purchase with funds provided by the Brown Foundation Accessions Endowment Fund, 94.62

original. Both photographers found the discipline of still life essential to essaying new directions, but those transitions were very different in nature. When Strand began his famous Twin Lakes, Connecticut abstractions in 1916, he created a laboratory setting for experimentation with still life. His close-up composition, coupled with the strong lighting effects and unusual subject matter, attains a greater degree of abstraction than ever suggested by Cézanne, but only by taking his characteristic means to logical conclusions (fig. 2).[32]

Maria Hambourg has suggested that Strand imitated Stieglitz in his admiration of Cézanne (among other ways), and that he was more affected by discussions of Cézanne than by actual images.[33] Sarah Greenough has argued that just as Picasso and Braque worked as a team to invent Cubism, so too did Strand and Stieglitz push each other toward photographic modernism, a characterization suggesting the two men's provisional allegiance based on mutual need, potential rivalry, and latent antagonism.[34] If Strand and Stieglitz invented modernist photography while tied together like mountaineers (as Picasso famously described partnership with Braque), they shared with the painters not only an ambivalence about partnership and dominance, but also the foundation of a new pictorial structure based on Cézanne's composition.

Stieglitz, Steichen, and Strand's tight nexus of personal relationships and artistic dialogues provides the most clearly documented model for the dissemination of Cézanne's influence among American photographers. But in terms of quantity and breadth of diffusion, the White School is equally significant. As a former disciple of Stieglitz's, White veered onto his own path in opening his school in 1914. Supporting his family by making teaching a business, and teaching photography as a business, he violated more than one tenet of the affluent, independent Stieglitz's purist credo of art. Emphasizing principles of design at the expense of other elements of instruction, according to Bonnie Yochelson, "abstract still life became the foundation for teaching design at the White School."[35] Directed toward commercial ends, that design made fluent use of essentially abstract pictorial construction, much as the brilliantly successful Steichen was doing in his magazine work. White's vision of photography as profession rather than spiritual calling was sufficient grounds for Stieglitz to sever ties, but his constitutional openness to multiple approaches and practices was also problematic to Stieglitz, who recognized but a single path (his own) toward any goal. White's flexible eclecticism made his school an extraordinary success, however, and the striking range of styles of the school's alumni is a triumphant tale often told.[36] White gravitated toward the influence of Arthur Wesley Dow, for whom he had taught at Columbia University's Teachers College, and whose teachings quickly pervaded the school, augmenting Max Weber's art theory.[37]

At the White School, the talented and extremely competent Margaret Watkins served as major domo and the go-to figure for students regarding practical and technical matters, while White's encouraging presence and the avant-garde teachings offered by Weber were keys to the school's success in training a new generation of distinguished photographers of all kinds.[38] Weber's role at the school can scarcely be overestimated. As a prophet of modernism, specifically as an ardent devotee of Cézanne, he introduced students to ambitiously modernist pictorial thinking later employed by them in advertising, photojournalism, or portraiture.[39] White sought figures from all positions on the spectrum of photography as visiting speakers at the school. In

1923, Strand—now a doctrinaire representative of the Stieglitz camp from which White had departed—spoke on "The Art Motive in Photography," exhorting students to renounce White's late Pictorialism, and warning against excessive emphasis on composition and design: "Perhaps you will say: But wait, how about design and composition, or, in painter's lingo, organization and significant form? . . . These are words, which, when they become formulated, signify, as a rule, perfectly dead things. . . . When a veritable creator comes along, he finds the only form in which he clothes his feelings and ideas."[40] Dead or alive, the word "form" was in potent circulation at the White School, and still life was *the* genre in which to explore form.

The nude is also a genre in which echoes of Cézanne may be detected, however. That most classical of pictorial subjects came to play an important role in determinedly modernist art in the early twentieth century. Just as Cézanne's Bathers are ancestors of *Ma Jolie*, so too do they haunt the pedigrees of American photographic nudes. Cézanne Bathers are not merely nudes, they are heroic, impersonal, remote figures set in indeterminate, often sylvan, settings. Ranging from minimally sexual to coldly erotic, they are almost akin to Easter Island *moai*. Only a few photographic nudes approach those qualities, yet outdoor nude photographs suddenly became surprisingly plentiful in a still very conservative era. Were photographers modeling themselves after Cézanne in subject, if not always in style?

Anne Brigman's daring nude and self-portrait studies must have astonished contemporaneous viewers.[41] Yet the images are decidedly chaste, more athletic allegory than documentation of sensuality. While Brigman's work in no way matched the style and ambition of Stieglitz's aesthetic program circa 1910, its unfettered physicality captivated him. Given as he was to the mixing of personal and aesthetic responses, he may simply have been taken by lithe female bodies atop mountains. Yet Stieglitz maintained his cordial support for Brigman far longer than he sustained a working relationship with any other photographer. It's difficult to see how his regard for her work would have continued so unabated had it not meant more to him than that. Brigman is unlikely to have modeled the cloying juxtapositions of her own lithe body with rugged, if softly focused, settings in the Sierra Nevada after Cézanne's Bathers deliberately; indeed, Maxfield Parrish is a nearer analog. But it's not inconceivable that her work elicited Stieglitz's support because it recalled to him Cézanne's quite different use of the unclothed figure in nature as a beacon of modernity and innovation. Indeed, Stieglitz himself was to make a number of photographs of bathers at his family's summer home on Lake George. These include his sharply sexualized, emotionally manipulative studies of Strand's wife Rebecca naked in the lake (1923), his disquieting nude study of his nubile niece Georgia Engelhard (1920), and unusually candid 1916 images of Ellen Koeniger in soaking-wet swimming costume, all of which address the monumentality of bodies in nature (cat. 103). The figures from the lithograph and the Druet photograph of Cézanne's *Large Bathers* (cats. 15, 131) almost seem visible beyond the frame as these bathers posed for Stieglitz's camera.

Stieglitz's own work had for the most part been placed on hold during his years of involvement with *Camera Work*, the Photo-Secession, and 291. As those enterprises concluded, his involvement with painting and his promotion of American art grew. By the time he fell in love with Georgia O'Keeffe as muse and lover, he had traveled far from his earliest photographic

work. The vast O'Keeffe Portrait begun in 1918 amounted to hundreds of images, including many nudes. Tightly composed, resoundingly erotic, and intimate in their personification, they were photographed in indeterminate spaces, like the small East 59th Street studio the lovers shared. There, nature is found within O'Keeffe's body, rather than being a setting in which that body reposes. The extraordinary serial composition Stieglitz borrowed or invented for himself in photographing O'Keeffe is very close to Cézanne's passion for his ever-changing motif, sustained throughout numerous renditions of Mont Sainte-Victoire.[42]

Stieglitz's passionate variations on a theme found ultimate culmination not in the O'Keeffe Portrait, however, but in his Equivalents, small abstractions derived from sky studies. Clouds and skies suited him better than a mountain or a body; his Symbolist-Expressionist approach needed their protean qualities to contain the ultimate content, his volatile emotional states. Subjects more enduring or less abstract might have distracted him from himself. Cézanne's struggle to render three-dimensionality on flat surfaces emphasized gestures of hand and brush which direct attention to the actions of the eye, skimming from motif to canvas in a kind of "fort-da" game, as Freud called it. By contrast, Stieglitz's Equivalents disembody the viewer, and detach the images from the process of their making.[43]

Likening Stieglitz's Equivalents to Cézanne, despite dissimilarities of scale, color, and facture, presumes that influence can exist in conceptual rather than compositional terms—and that profound influence may result in transformation of that inspiration into very different forms (figs. 3, 4). So the question is not merely whether American modernist photographs *look* like Cézannes, but whether they *are* like them.[44] Strand's upturned table and disordered vessels brought photography as close as literally possible to Cézanne's restless eye and tumbling forms, while Steichen's mountainous fruits best approached the painter's monumentality of representation, and the White School photographers found the widest range of applications for lessons learned from Cézanne's pictorial language. Yet it is Stieglitz's remaking of aspects of Cézanne that most deeply reflects the painter's influence upon modernist American photographers. Ralph Flint asserted the connection in 1934, writing that "Stieglitz brings to his camera work much the same sense of veracity and pictorial penetration that Cézanne brought to painting."[45]

Though differences between painting and photography seem obvious, the particularities of materials and processes, and the object qualities of the images under discussion, repay attention. Maria Hambourg remarked Strand's use of orthochromatic film for the 1916 photographs, a negative material which causes red to register as black in a less than usually literal rendition of the world's tonalities.[46] This optical defamiliarization helped his camera to produce abstractions, thus giving the photographer advantages normally more available to the painter. Turning from negatives to reproductions, Sarah Greenough pointed out that "because *Camera Work* reproduced everything—paintings, prints, drawings, sculpture, and photographs—the same size and in the same limited tonal range, it allowed photography more easily to engage the other arts in a serious discourse that Stieglitz could then push in other directions."[47] The magazine page was thus the level playing field on which all media could meet. These specific material qualities, photographic practices, and objects are part of the story of Cézanne's influence on American photography. Ironically, it was a group of humble copy photographs, mere aides-memoires,

Fig. 3 Alfred Stieglitz,
Equivalent Y, 1925–27.
Gelatin silver print. The
Museum of Modern Art,
New York. Anonymous
gift (993.1943.2)

Fig. 4 Alfred Stieglitz,
Equivalent E, 1925. Gelatin
silver print. The Museum
of Modern Art, New
York. Anonymous gift
(92.1943.5)

which played a starring role. In 1909, the homeward-bound Max Weber purchased a suite of photographic facsimiles of Cézanne canvases from Eugène Druet. Intended as personal touchstones to keep alive his Parisian experiences, some of them became public and historical documents, exhibited at 291 (1910) and published in *Camera Work* (1913)(cats. 128–33).[48]

The influence of Cézanne on American photographers is most visible in Strand's and Steichen's photographs that resemble the smallish, close-tonal range Druet photographs, which proudly announced the look and feel of Cézanne's oil paintings to American audiences not yet able to see the real thing. Cézanne's influence mediated by a Druet photograph, a Caffin review, the talk around Stieglitz's luncheon *Stammtisch,* or Roger Fry's polemics upon American photographers—each would logically deviate somewhat from what the paintings offered directly.[49] Strand actually spoke of the power of such reproductions of paintings in his address to the White School:

> Compared with this so called pictorial photography, which is nothing but an evasion of everything truly photographic, all done in the name of art and God knows what, a simple record in the *National Geographic Magazine,* a Druet reproduction of a painting or an aerial photographic record is an unmixed relief. They are honest, direct and sometimes informed with beauty, however unintentional.[50]

While to painters and colorists they afforded but a hint of what was yet to come, to American photographers (operating in an essentially monochrome world) they offered revelations of compositional innovation. The photographs reduce Cézanne's paintings to small schematic works dominated by the raw power of form, not mere placeholders for the original works which would soon follow, but eloquent emissaries whose messages could be read and used differently by photographers than by painters.

Looking at the history of emerging abstraction in American photography in relation to Cézanne shifts perspectives. Not only direct transmission of style ideas from individual paintings to specific photographs may be present, but also a looser influence based upon photographers' readings of reproductions or criticism of Cézanne's work. So how will we know the influence of Cézanne upon photography when we see it? Would it require total abstraction or total fidelity to a motif? Would it privilege dissolving space or solid form? Must we find a patchily colorful rendering of a vast basalt pile on the horizon? Could it be instead a corking photographic still life of objects upon a vertiginously tilting table top? Or a monumental nude in indeterminate sylvan space? An applelike portrait subject immobilized by a long-held pose before the camera, cramped with lack of movement? Surely all are possible. Cézanne's originality of vision communicated itself to Stieglitz, Steichen, Strand, and to members of the White School, all of whom sought to use the camera to see anew. Meyer Schapiro described Cézanne's desire to paint nature "as if no one had ever painted it before" and said that "we can understand better his deformations of perspective and all those strange distortions, swellings, elongations, and tiltings of objects that remind us sometimes of the works of artists of a more primitive style who have not yet acquired a systematic knowledge of natural forms, but draw from memory and feelings."[51] We can also understand, now, how the camera's own radically empirical vision reflects the inspiration of Cézanne.

Notes

I am indebted to Gail Stavitsky for raising the question of Cézanne's role in the arrival of modernist style in American photography, and to all the curatorial team involved. Several esteemed colleagues in the history of photography community took time to discuss the problem of discerning Cézanne's traces in American photography with me at some length, some of them all the more generously given their skepticism regarding this thesis; I owe warm thanks to John Pultz, Joel Snyder, and Mary Panzer for insightful dialogue with me on this topic. Thanks also to Samuel Claiborne for thoughtful comments on an early version of this essay.

1. As Daniel Robbins astutely noted, "The present is always reinterpreting the past. . . . One measure of the greatness of Cézanne is the extent to which diverse artists of later movements have claimed a portion of his art as stimulation and ancestor to their own." Daniel Robbins, *Cézanne and Structure in Modern Painting* (New York: Guggenheim Museum, 1963), unpaginated.

2. This is a figure of speech which many of the circle's members would have approved. See, e.g., Pepe Karmel's "Francis Picabia, 1915: The Sex of a New Machine," in Sarah Greenough et al., *Modern Art and America: Alfred Stieglitz and His New York Galleries* (Washington, DC: National Gallery of Art; Boston: Bulfinch Press, 2001).

3. "Straight" photography suggests the directness and immediacy of "straight talk," thus emphasizing photography's autonomy from painting's subjectivity. Stieglitz didn't so much make a *volte face* as subtly alter and realign himself within the basic direction of his original aesthetic. Indeed, according to John Pultz, in 1910, Stieglitz's softly focused but boldly composed *City of Ambition* was straight photography by his present standards. John Pultz and Catherine B. Scallen, *Cubism and American Photography* (Williamstown, MA: Sterling and Francine Clark Art Institute, 1981), 3.

4. "What Is Happening in the World of Art," *The Sun*, January 9, 1916.

5. Roger Fry, "Preface," *Manet and the Post-Impressionists* (London: Grafton Galleries, 1910), 10.

6. Maurice Merleau-Ponty, "Cézanne's Doubt," trans. Hubert L. Dreyfus and Patricia Allen Dreyfus, in *Sense and Nonsense* (Evanston, IL: Northwestern University Press, 1964).

7. Israel White, *Newark Evening News*, reprinted in *Camera Work* 36 (October 1911): 33–34. Similarly, the critic Charles Caffin noted that the significance of Cézanne's work "is beginning to percolate through American consciousness." Charles Caffin, "A Note on Cézanne," *Camera Work* 34 (April/June 1911): 47.

8. Alfred Stieglitz, letter to the editor, *Evening Sun*, December 14, 1911.

9. John Rewald, *Cézanne and America: Dealers, Collectors, Artists, and Critics, 1891–1921* (Princeton: Princeton University Press, 1989), 129.

10. The Photo-Secession was the first American art movement to achieve international leadership, and to reverse the transatlantic flow of cultural influence to run from the New World to the old. Although postwar New York School painting is often cited as the first expression of a change in the balance of power, in fact the new medium of photography saw the first such "triumph" of American artists, to borrow Irving Sandler's phrase.

11. Christopher Lloyd, book review of John Rewald's *Cézanne and America, Apollo* 130 (December 1989): 431.

12. Unlike Stieglitz, Steichen, and Strand, White did not produce an autobiography, burnish dramatic anecdotes through repeated retellings, or attempt to control historical accounts of his work. As Bonnie Yochelson noted "to the dismay of Stieglitz and Strand, straight photography, like modern art, had mutated from an avant-garde ideology into an advertising technique." Bonnie Yochelson, "Clarence H. White, Peaceful Warrior," in Marianne Fulton, ed., *Pictorialism into Modernism: The Clarence H. White School of Photography* (New York: Rizzoli, 1996), 98.

13. While Leo Stein described the trajectory of the French public's developing response to Cézanne ("At the Autumn Salon of 1905 people laughed themselves into hysterics before his pictures, in 1906 they were respectful, and in 1907 they were reverent. Cézanne had become the man of the moment."), we unfortunately have no such overview of the American photographers' response. Leo Stein, *Appreciation: Painting, Poetry, and Prose* (New York: Crown, 1947), 174.

14. Among the central texts for assessing how Cézanne shaped the thought and practice of American photographers are Edward Steichen's *A Life in Photography* (New York: Bonanza, 1984); *Paul Strand, Sixty Years of Photographs* (New York: Aperture, 1976); and Dorothy Norman, *Alfred Stieglitz: An American Seer* (New York: Aperture, 1970), this last a biography of Alfred Stieglitz compiled by his lover and amanuensis, Dorothy Norman, from Stieglitz's reminiscences.

Sarah Greenough astutely noted that late in life, Stieglitz had a tendency to suggest that his "varied activities were inevitable." In "Alfred Stieglitz, Facilitator, Financier, and Father Presents Seven Americans," in Greenough, *Modern Art and America*, 277.

15. As John Szarkowski trenchantly described Stieglitz's leadership style at the time of the dissolution of the Photo-Secession: "The Photo Secession had been effectively dead since the Buffalo show. (It had not been necessary to call a meeting of the board to dissolve the club; it was only necessary for Stieglitz to stop thinking about it.)" John Szarkowski, *Alfred Stieglitz at Lake George* (New York: The Museum of Modern Art, 1996), 18.

16. Alfred Kreymborg, *Troubadour: An Autobiography* (New York: Boni and Liveright, 1925), 164.

17. This is evident from the numerous accounts of his pedagogical, quasi-messianic style of discourse as well as the somewhat unattractive manner in which he recruited submissions from the circle for the "What '291' Means to Me" issue of *Camera Work* of July 1914 (no. 47), which consisted wholly of doctrinaire tributes couched in almost unvarying terms so suggestive of Stieglitz's own views as almost to amount to an official party line.

18. As an unsigned piece in *Camera Work* proclaimed, "During the month of March the Secession gave the American public its first opportunity to become acquainted with Paul Cézanne." *Camera Work* 36 (October 1911): 29–34.

19. Norman, *Alfred Stieglitz*, 104.

20. Stieglitz continued, "But if you want to stick to your bargain I'll go ahead. Meanwhile, the storm ceased, the sun broke through the clouds, the ladies were talking about dresses, and Steichen, very subdued, said 'I guess

I had better not.'" The breaking storm is a nice touch, typical of Stieglitz's grand mythologizing style. Ibid., 105.

21. Joanna Steichen, *Steichen's Legacy: Photographs 1895–1973* (New York: Knopf, 2000), xxxii. The propensity for embellishment Joanna Steichen mentioned did not, in fact, substantially differentiate Steichen from Stieglitz, who was a dedicated self-mythologizer and rhetorician. According to Steichen, he was "haunted for some time by the idea of testing some of our public, so I painted a fake Cézanne. It was not an imitation of one picture but a landscape in the style of the Cézanne watercolors. These were all as abstract as anything we had seen in Paris up to that time. In spite of my attempt to make it exactly like the Cézannes, my fake was probably a little more naturalistic. When the exhibition hung in New York, my fake Cézanne attracted particular attention, possibly because it was more literal." Edward Steichen, *A Life in Photography* (New York: Bonanza, 1984), unpaginated. Note Steichen's mention of "*our public*" (emphasis added). At the time, he and Stieglitz functioned as a tight team with shared goals, bringing modern art from Europe to America.

22. Unsigned review of Cézanne exhibition, possibly penned by Stieglitz himself, *Camera Work* 36 (October 1911): 29–34.

23. Pultz and Scallen, *Cubism and American Photography.* I am much indebted to John Pultz for extensive and warmly collegial correspondence discussing the question of Cézanne's significance to photographers in this period.

24. The exception to prove this rule would be Alvin Langdon Coburn's Vorticist photographs made through a prism, which quite uncannily approximate Cubist form. Paul Strand's *Pear and Bowls*, 1916 (cat. 110), on the other hand, has just the swing and vibration of form most characteristic of Cézanne.

25. Pultz's and Scallen's ambitious work remains a valuable foundation for understanding the evolution of modernist photography in America. But since their arguments are not based on extended readings of individual images, or documentation of the context of the contact each photographer had with particular works by Picasso, Braque, or other Cubists, it's not apparent exactly what manner of influence is being attributed to Cubism, or precisely which Cubist images might have been at issue. Cubism, in Pultz's and Scallen's usage, effectively stands in for modernist, potentially abstractionist European art ideas in general. One could almost replace the word "Cubism" with "Cézanne" throughout the text. Indeed, Pultz speaks of Cézanne's importance to the critic Charles Caffin, saying Caffin "cited Cézanne's greatest contribution as his effort to remove art from natural representation and sentiment and to intellectualize it. . . . For Cézanne, to intellectualize was not to involve story or literary allusion but to make concrete his 'sensations and perceptions' by means—as abstract as possible—that required submission to an intellectual process of organization and realization." Pultz and Scallen, *Cubism and American Photography*, 5.

Another important account of the evolution of American modernist photography is David Travis's essay in *Photography Rediscovered,* which attributes the evolution of the medium to its own intrinsic properties, and suggests a continuity between nineteenth-century documentary and twentieth-century avant-garde photography, complemented by the response to Bauhaus and other European work. In describing the American

"disciplined photographic vision," he quotes Cézanne: "One must make an optic, one must see nature as no one before has seen it before you." David Travis in *Photography Rediscovered* (New York: Whitney Museum of American Art, 1979), 148.

26. Rewald, *Cézanne and America*; James Timothy Voorhies, ed., *My Dear Stieglitz, Letters of Marsden Hartley and Alfred Stieglitz, 1912–1915* (Columbia: University of South Carolina Press, 2002); and Jill Kyle, "Paul Cézanne, 1911: Nature Reconstructed" in Greenough, *Modern Art and America*, 101–16.

27. Rewald, *Cézanne and America*, 129. Jill Kyle has suggested that Stieglitz's decision to exhibit Cézanne's work at 291 in 1910 derived largely from 1909 conversations with Leo Stein, but this view fails to take into consideration Stieglitz and Steichen's close working partnership in 291 and *Camera Work* at this time. Kyle, "Paul Cézanne, 1911," 104–7. But as Anne McCauley astutely asserted, "Stieglitz played Dante to Steichen's Virgil." Anne McCauley, "Edward Steichen: Artist, Impresario, Friend" in Greenough, *Modern Art and America*, 55. According to Richard Whelan, "For nine months in 1910, Weber was the leading member of the Stieglitz circle. His important contribution was to stress the centrality of Cézanne." Richard Whelan, *Alfred Stieglitz: A Biography* (Boston: Da Capo Press, 1995), 258.

28. Charles Cafffin, "The Art of Eduard J. Steichen," *Camera Work* 30 (April 1910): 35.

29. Douglas K. S. Hyland, "Agnes Ernst Meyer, Patron of American Modernism," *American Art Journal* 12, no. 1 (Winter 1980): 70. The National Gallery of Art cites its provenance as follows: (Ambroise Vollard [1867–1939], Paris). Edward Steichen [1879–1973] purchased 1912 for Eugene [1875–1959] and Agnes Ernst Meyer [1887–1970], Mount Kisco, New York, and Washington, D.C.;[1] gift 1959 to NGA. www.nga.gov/collection/gallery/gg80/gg80-45986-prov.html (consulted 15 July 2008).

30. Alfred Stieglitz Collection, Beinecke Library, Yale University, YCAL MSS 85, box 46, folder 1095. Steichen's exuberantly colloquial style is a refreshing counterpoint to Stieglitz's often ponderously brooding missives. "Corking," for instance, is a frequent term of high praise by Steichen in the correspondence preserved in the Stieglitz archive at Yale. Steichen evidently was empowered to make aesthetic as well as financial decisions on Stieglitz's behalf; the letter contains discussion of the shipping costs Steichen was incurring and for which Stieglitz would be liable.

Anne McCauley has raised a fascinating point about the hair's-breadth margin separating Cézanne's avant-garde moment from his rapid rise as a commercially viable modern master in the art market, a transition she suggests was already under way by the time of the 291 exhibition. Anne McCauley, "Edward Steichen: Artist, Impresario, Friend," in Greenough, *Modern Art and America*, 67.

The theme of money arises constantly in Steichen's correspondence with Stieglitz, e.g., in his unhesitating October 1903 request for financial assistance, which is strikingly juxtaposed with rhapsodies about nature: "My dear Stieglitz: I had the cussed luck to loose a *twenty dollar* bill and find myself dead busted up to a dollar for tomorrows dinner.—I am going to write to Glaenzer for a check but that will take several days to get here and then to cash.—so please help me out with a *V* in the mean time. Its cold—but glorious—The brilliant glare of autumn is wearing off and now comes that gorgeous

'autumn tone' dignified and noble"—(Alfred Stieglitz Collection, Beinecke Library, Yale University, YCAL MSS 85, box 46, folder 1093).

31. In January 1912, Steichen wrote to Stieglitz that "It is the finest still life Cézanne ever painted I am sure—and I don't know if anyone but Chardin ever painted as good a one—and I'd rather have a Cézanne than a Chardin." Alfred Stieglitz Collection, Beinecke Library, Yale University, YCAL MSS 85, box 46, folder 1095.

32. The spatial distortions which Strand achieved primarily through lighting and camera angle are easier to understand when compared with Erle Loran's diagrams of multiple perspectives, spatial distortions, and other mannered compositional devices employed by Cézanne. Erle Loran, *Cézanne's Composition* (Berkeley and Los Angeles: University of California Press, 1963). Or, as Jan Gordon put it, "Cézanne's drawing is not a drawing of outline, it is a drawing of space." As Strand's still lifes could also be described. Jan Gordon, *Modern French Painters* (London: Ayer, 1923), 33.

33. This makes an interesting distinction of Strand from Steichen, whose 1921 still lifes represent great attention to the look, feel, and weight of Cézanne's paintings, but show lesser concern for critics' discourse about Cézanne. Maria Morris Hambourg, *Paul Strand, Circa 1916* (New York: The Metropolitan Museum of Art, 1998), 32. Hambourg's account of Strand's involvement with Cézanne is the most thoughtful and nuanced account to date of any of the American photographers' engagement with his work. Bonnie Yochelson has hypothesized that Strand's Twin Lakes still lifes are essentially extensions of White School space-filling exercises, noting that Strand had attended a print-critiquing session with Max Weber in 1915 not long before beginning this series. Yochelson, "Clarence H. White, Peaceful Warrior," 66.

34. Greenough, "Alfred Stieglitz, Facilitator, Financier, and Father," 283. Greenough additionally suggests that Stieglitz rivalrously recommended photographing in 1915 after his long hiatus "as if to reclaim his rights to a subject" that the young Strand had just then begun to explore. In "Paul Strand, Unqualified Objectivity," in Greenough, *Modern Art and America*, 381.

35. Yochelson, "Clarence H. White," 66.

36. White's open-mindedness was also apparent in his selection of faculty, ranging from the technically proficient, aesthetically conservative photographer Paul Anderson to the radical avant-garde painter Max Weber.

37. Yochelson, "Clarence H. White," 31–32.

38. The White School's curriculum is further discussed in Kathleen A. Erwin's "'Photography of the Better Type': The Teachings of Clarence H. White," in Fulton, *Pictorialism into Modernism*, 120–91.

39. Weber's high-toned lectures from the White School are couched in very general terms as art history and theory. Yet when White School students crowded round him with their portfolios after his lectures, what did he tell them? Surely, he would have mentioned his passion for Cézanne. Likely a man who, upon first seeing examples of Cézanne's work, said to himself "this is the way to paint" would have shared this enthusiasm with his students. "The Reminiscences of Max Weber," interview with C. S. Gruber, Columbia University Oral Research Project, 1958, 249. Weber's lectures were privately published as Max Weber, *Essays on Art* (1916), and

recently reprinted (New York: Gerald Peters Gallery, 2000).

40. Strand challenged the students to understand photographic uniqueness of means as embodied in the work and institutions created by Stieglitz. Elsewhere in the lecture, he said that photographers imitate Whistler, Japanese prints, bad German and English landscape painting, and Corot, but find it too hard to imitate the greater artists: Rubens, Michelangelo, El Greco, Cézanne, Renoir, Marin, Picasso, or Matisse, whose work "cannot be so easily translated into photography." Yet how would he know of that difficulty if he had not tried? Already he was moving away from his own dazzling abstractions of 1916, and the painting which inspired him at that time. Paul Strand, "The Art Motive in Photography" (1923), reprinted in Nathan Lyons, ed., *Photographers on Photography* (Englewood Cliffs, NJ: Prentice Hall, 1966), 150. According to Sarah Greenough, Strand began as a White School–style Pictorialist; in a sense, therefore, in this lecture he was a convert returning to spread the gospel to his people. "Paul Strand, 1916: Applied Intelligence" in Greenough, *Modern Art and America*, 250–51.

41. Kathleen Pyne provides a very sympathetic reading of Brigman's work and Stieglitz's appreciation of it. Kathleen Pyne, *Modernism and the Feminine Voice: O'Keeffe and the Women of the Stieglitz Circle* (Berkeley and Los Angeles: University of California Press, 2008). In her essay on the emergence of Strand's full-fledged modernist style, Maria Hambourg lucidly explored the curious overlapping of outmoded pictorialism and the first glimpses of more modernist practice. Hambourg, *Paul Strand, Circa 1916*.

42. The mountain named for a woman and a woman named for a place seem to have functioned very similarly within these artists' oeuvres as inspiringly elusive subjects. Sarah Greenough noted a visual correspondence between an O'Keeffe portrait and Cézanne's *Madame Cézanne with Hydrangeas* (1882–86, RWC 209, private collection). The comparison is as plausible as the better established links between other O'Keeffe photographs and Rodin drawings, but Greenough's suggestion that what Stieglitz learned from Cézanne was "how a simple pose could suggest not only the deep love but also the comfortable relationship that existed between two people" seems seriously awry. The precocious student Stieglitz's portrait of his lover, *Paula, Berlin*, 1889, already vividly demonstrated that knowledge, and that notorious cold fish Cézanne was no model for Stieglitz in matters of love and desire. Greenough, "Alfred Stieglitz, Facilitator, Financier, and Father," 283.

43. Just as Stieglitz himself cultivated open-endedness of interpretation regarding the *Equivalents*, so have critics and scholars derived it in varying terms. Rosalind Krauss's groundbreaking article "Alfred Stieglitz's 'Equivalents,'" *Arts Magazine* 54, no. 6 (February 1980): 134–37, introduced the question of Stieglitz's Expressionism, and these works are frequently associated with Kandinsky. But other authors have sought to elucidate the *Equivalents* in relation to Jacob Burckhardt, Clive Bell, Van Wyck Brooks, Martin Buber, Ernst Bloch, Swedenborg, and Gurdjieff, to name but a few. According to Jill Kyle, Stieglitz saw Cézanne's work as "an approach to the concrete, objective world, one centered on freedom of expression of form and the material object that was not unlike his own." Kyle, "Paul Cézanne, 1911," 103. Interestingly, Steichen also undertook serial projects late in life. He repeatedly photographed a single beloved

shadblow tree on the grounds of his Connecticut home, and he also worked to perfect actual delphinium flowers through hybridization. These functioned for him as art; a selection of them were actually exhibited at The Museum of Modern Art in 1936.

44. Speaking literally, few photographs actually do look like any paintings, given the obvious differences in materials, media, and binocular vs. monocular perspectives of vision.

45. Ralph Flint, "Post-Impressionism," in Waldo Frank, ed., *America and Alfred Stieglitz* (1934; reprint, New York: Aperture, 1979), 89.

46. Hambourg, *Paul Strand, Circa 1916,* 32.

47. This is a point of subtle Benjaminian sophistication. Sarah Greenough, "Alfred Stieglitz, Rebellious Midwife to a Thousand Ideas" in Greenough, *Modern Art and America,* 34.

48. For the exhibition, see the Chronology herein; *Camera Work* 42/43 (April/July 1913).

49. Jill Kyle has pointed out the increasing prominence of copy photographs, starting in 1904 when the Salon d'Automne included a section specifically for copy prints of paintings, including some by Cézanne. Kyle, "Paul Cézanne, 1911," 103.

50. Strand, "The Art Motive in Photography," in Lyons, *Photographers on Photography,* 147.

51. Meyer Schapiro, *Paul Cézanne* (New York: Harry N. Abrams, 1952), 19.

Jerry N. Smith

CÉZANNE AND THE AMERICAN WEST

Paul Cézanne's bearing on art in the western United States is remarkable, especially given that knowledge of his work came largely through second-hand sources, as exhibitions of his works prior to 1930 were extremely rare. Yet despite the absence of first-hand examples and predominantly conservative artistic environments, Cézanne's influence still proved significant. Artists who never traveled to Europe or even to eastern American cities where they could see his paintings learned of Cézanne and the subsequent offshoots of Fauvism and Cubism primarily through reproductions. Perhaps most importantly, students were made aware of Cézanne from other, better-traveled artists and instructors. This is evident in small artists' colonies in northern California and Santa Fe, New Mexico, and in association with teachers at the artistic institutions in San Francisco, Los Angeles, and Denver, Colorado.

The initial exhibition of Cézanne in the West took place in Portland, Oregon, in November 1913. Exhibited were Cézanne's lithographs, shown alongside reproductions of Post-Impressionist paintings. Prepared by Frederic Torrey, then owner of Marcel Duchamp's infamous Cubist painting *Nude Descending a Staircase (No. 2)* (1912, Philadelphia Museum of Art), the exhibition, which Torrey remounted in San Francisco a few months later, introduced many on the West Coast to Cézanne.[1] The first painting by Cézanne shown in the West, *The Gulf of Marseille Seen from L'Estaque* (c. 1878–79, Musée d'Orsay, see fig. 1 in Kyle's essay in this volume), is an exceptional example but was just one of the 11,403 works exhibited at the 1915 Panama-Pacific International Exposition in San Francisco. It received no special attention in accompanying catalogues.[2] Cézanne was included in a few private California collections, but apparently only two other oil paintings and two watercolors were exhibited publicly in the western part of the country prior to 1934, each in San Francisco.[3]

In California, Cézanne's effect on painting is first recognizable among artists in the Bay Area. The Society of Six (1918–29) in Oakland was the first group of modernists in a region otherwise known artistically for its Tonalist landscape painters. Their work demonstrated a variety of influences, with the architectonic treatment of motifs associated with Cézanne most fully realized by members Bernard von Eichman (1899–1970) and August Gay (1890–1949), while Louis Siegriest (1899–1989) broke most freely from the traditional use of perspective as learned from Cézanne's example.[4]

Fig. 1 Yun Gee, *Man with Pipe (Head of Man)*, 1926–27. Oil on paperboard. Hirshhorn Museum and Sculpture Garden, Smithsonian Institution, The Joseph H. Hirshhorn Bequest, 1981 (86.2199)

Otis Oldfield (1890–1969), a California native, studied and lived in Paris for fifteen years, working through Impressionism to Cubism and exploring Dada before returning to America and accepting a teaching position in 1924 at San Francisco's California School of Fine Arts.[5] His knowledge of European modernism in general and of Cézanne in particular proved momentous to several students, perhaps none more so than Yun Gee (1906–1963), who had emigrated from China in 1921. First discovered through Oldfield's instruction, Gee's appreciation of Cézanne would last throughout his career (fig. 1). As a student, he painted in a constructive, Cubist manner that recalls Orphism in its use of blocks of strong color to define subjects, a result of Oldfield's "color zone" teaching method.[6] Gee began to create an allegorical style of Cubism while in San Francisco, which he fully developed into the theory of Diamondism while in Paris in the 1930s, finally having the opportunity to study Cézanne's work in person.[7] "A painting by Cézanne or Courbet became as close to me as any of the scrolls by the Chinese masters with which I was so familiar," he recalled in 1944.[8]

Stanton Macdonald-Wright, creator of Synchromism with fellow American painter Morgan Russell during their years in Paris, was the most important instructor in California to share knowledge of Cézanne with his students. Synchromism's blend of color theory with the structure of Cubism grew directly from Macdonald-Wright's initial and immense appreciation for Cézanne. "Without Cézanne," claimed Macdonald-Wright, "there never would have been any devolvement of modern painting."[9] Having been raised in California, he returned in 1918, teaching at the Art Students League of Los Angeles and heading the program from 1923 to 1930. The influence of Macdonald-Wright is evident in the Synchromist-inspired canvases by several students, including James Redmond, John Gerrity, and Vivian Stringfield.[10]

Prior to Macdonald-Wright's arrival, the art exhibitions organized by the Los Angeles Modern Art Society in 1916 and 1918 were rather conservative in nature, dominated by California Impressionists and the loose brushwork of Robert Henri and his followers.[11] In 1920, Macdonald-Wright organized the *Exhibition of Paintings by Modern American Painters,* held at the Los Angeles Museum of History, Science and Art (forerunner of the Los Angeles County Museum of Art) in Exposition Park, which marks a more progressive stand for modernism. Seeking assistance from Alfred Stieglitz in New York, Macdonald-Wright brought together works of several artists, including himself, Russell, Charles Demuth, Konrad Cramer, Andrew Dasburg, John Marin, and Man Ray, all of whom showed the effect of Cézanne's example in their imagery. The exhibition was the first of many spearheaded by Macdonald-Wright, who remained on the coast for the rest of his life and continued to promote modern painting in the hope of making Los Angeles "a great art center of the world."[12] Adding to the cultural environment in Los

Angeles was the arrival from New York of prominent collectors Louise and Walter Arensberg in 1927. Their collection included works by Cézanne, though it centered on Marcel Duchamp and other French artists, many of whom shared an artistic lineage to Cézanne.

In Denver, the sway of Cézanne was limited, although not entirely absent. John Thompson (1882–1945), originally from Buffalo, New York, settled in Denver in 1917. He had studied in Paris at the turn of the century, attended the salons held at the home of Leo and Gertrude Stein, and visited the 1907 Cézanne retrospective, which had a profound effect on his art.[13] Thompson's landscape paintings demonstrate his appreciation for Cézanne through the broken brushwork he used to define compositional space. The influence of his teaching can be found in his students, most notably Józef Bakoś. In 1919, Thompson exhibited alongside his students in what was called a mini-Colorado "Armory Exhibit" that shocked the Denver community.[14] Denver also became home to Arnold Rönnebeck (1885–1947) in 1926, who served as director of the Denver Art Museum until 1930. German born, he adopted a painting and print style composed of fractured planes while still in Europe, and he considered Cézanne "the greatest master at the end of the great tradition."[15]

Rönnebeck first came west at the invitation of Marsden Hartley, who was then staying in northern New Mexico. Like many artists who visited the area, Rönnebeck admired the crisp, dry clear sky that accentuates the rugged terrain, and seeing "nothing but landscape for some time."[16] The geometric quality of the land is found in the mass of the mountains, mesas, and rocky canyons. The region's traditional architecture of blocky, adobe houses and stacked pueblo dwellings further added to the appeal, especially for modernists already inspired by Cézanne. The area has often been noted for its topographical similarity to Provence and southern France, which provided artistic challenges for artists more accustomed to working in a moister climate. When Hartley first visited New Mexico in 1918, for example, he was overwhelmed by the "magnificently sculptural country,"[17] and was tentative in his first attempts at landscapes, working in pastel, "copying nature as faithfully as possible."[18] Only after familiarizing himself with the terrain did he approach the landscape with greater freedom. John Marin met similar challenges during his first trip in 1929.

"This country is more magnificent than I ever expected," wrote Andrew Dasburg upon his arrival to Taos, New Mexico, in 1918.[19] He had been one of the few American exhibitors at the Armory Show already demonstrating the influence of Cézanne and Cubism in his work. Starting in 1920, Dasburg returned to New Mexico annually, and settled permanently in Santa Fe a decade later. Most importantly for the development of modernism in the Southwest, Dasburg continued to teach, influencing many younger artists who also painted in a linear manner stemming initially from Cézanne. They included Willard Nash, Kenneth Adams, Gina Knee, Ward Lockwood, and Cady Wells.[20]

Dasburg came to New Mexico as the first guest of the newly transplanted social maven Mabel Dodge.[21] Known for avant-garde salons held in her New York apartment, she settled in scenic Taos in late 1917. There, Dodge routinely had her artist-friends visit, such as Hartley, Marin, and, perhaps most famously, Georgia O'Keeffe, and this played a major role in the development of modern painting in the Southwest. There were, however, already artists

knowledgeable of Cézanne on hand even before Dodge's arrival. Paul Burlin (1886–1969) moved to Santa Fe in 1913, shortly after exhibiting at the Armory Show, where he had taken special note of Cézanne, particularly *Woman with Hat* (National Gallery, London), which he described as "the most romantic" and structural of all paintings in the exhibition.[22] The compositional qualities found in Cézanne's work would inform Burlin's art, which he combined with an expressive use of color. William P. Henderson (1877–1943) also moved to Santa Fe in 1916. Both were modern, expressionist painters who demonstrated aspects of Cézanne's means of representation in their work and were crucial for introducing to the area Fauvist interest in using color to define form.

The establishment of the Museum of Fine Arts (now the New Mexico Museum of Art) in 1917 proved instrumental in bringing modern artists to New Mexico (fig. 2). The founding director, Edgar Hewitt, took the advice of the visiting Robert Henri in creating non-jury installation policies, establishing an outlet for many younger artists to exhibit. As a result, were it not for the liberal hanging policies of the museum, the influence of Cézanne on art in the Southwest would be significantly different than we currently know it. B. J. O. Nordfeldt was one of the artists who arrived shortly after the museum opened and frequently exhibited there. Nordfeldt's expressive use of color and geometric shapes demonstrate knowledge and admiration for Cézanne that developed during trips to Paris. In *Antelope Dance* (1919, fig. 3) we find an American scene directly inspired by Cézanne's Bathers, with dancers framed beneath a canopy of trees, while

the imaginative mountain rising in the background recalls Cézanne's many paintings of Mont Sainte-Victoire.

Other early arrivals to Santa Fe included Thompson's student from Buffalo, Józef Bakoś, who, in 1921, formed New Mexico's first modernist organization, *Los Cinco Pintores* (The Five Painters), joined by Dasburg's student Willard Nash.[23] They mounted traveling shows and exhibited regularly at the Fine Arts Museum until 1926. Bakoś was also a member of the New Mexico Painters in 1923.[24] They were described at the time as representing "the progressive or radical conservative element in the art of today."[25] The interest in modernism expressed in paintings coming from the Southwest, a significant number of which showed a marked Cézannesque quality, was apparent to outsiders, and in 1927 the *New York Times* described New Mexicans as possessing an "inherent fascination in modern art."[26] At the close of the 1920s, Cézanne's influence in northern New Mexico remained strong, particularly because of the presence of John Marin. He stayed in Taos in 1929 and again the following year; his dry-brush watercolor technique indebted to Cézanne had a lasting effect (cats. 67, 68). This can be seen perhaps most fully realized in paintings from the early 1930s by Victor Higgins (1884–1949) and Dasburg's student

Fig. 3 B. J. O. Nordfeldt, *Antelope Dance*, 1919. Oil on canvas. Collection of the New Mexico Museum of Art, Museum purchase with funds from the Archaeological Society & Friends of Southwestern Art, 1920

Mary Tompkins Lewis

For almost a third of a century Paul Cézanne has been the most influential figure in modern paint-ing. . . . Today he is enthusiastically hailed as one of the three greatest artists of all time—and vigorously debunked as the bungling subject of a colossal myth. Between the extremes is the usual appreciation, from rational doubt to hysterical faith. Out of this chaos of opinion one fact comes clear, that of his influence. . . . The ultimate realization of Cézanne's contribution remains with the artists of the future.

—Clyfford Still, 1935[1]

As both this exhibition and the essays in the pages preceding these have established, Paul Cézanne's presence was etched in vanguard American culture from the very outset of the twen-tieth century. Although he never left his native France and met, at most, only a handful of Ameri-cans in his lifetime, in the aftermath of the Armory Show of 1913 the exhibition and acquisition of his paintings by American museums, dealers, and collectors gradually whetted the appetite of Americans for modernist culture as a whole.[2] Not only painters but early-twentieth-century sculptors, photographers, and writers in America traced some of their transgressive approach to their respective mediums to an early exposure to Cézanne's art.[3] In the 1930s consideration of his work by American scholars became part of a heated debate about the trajectory of mod-ernist European painting, while in the 1940s and 1950s it fueled speculation among American critics as to whether the explosive art of the New York School was an inevitable part of a for-malist continuum or represented instead a defiant rupture with Europe and the past. Cézanne's countless innovations were not only debated in the context of his own work but projected into a much larger and impassioned dialectic about the notion of an avant-garde, a national school, and the role of art in post–World War II society. Equally, his celebrated persona—the fierce autonomy, provincialism, solitude, and persistence in the face of repeated rejection and con-suming self-doubt, which had long made him a paradigm of the modern painter—was captured anew for American readers in John Rewald's translations of Cézanne's letters, which appeared in 1941, and more fully in his biography of the artist of 1948.[4] Finally, a large exhibition of his oil paintings and watercolors in 1947 at the Wildenstein Galleries, New York, and a wildly suc-cessful retrospective in 1952 in Chicago and New York assured Cézanne a prominent place in

Fig. 1 Mark Rothko, *Beach Scene,* c. 1928. Oil on canvas board. Gift of Louis and Annette Kaufman, Reed College Art Collection

Fig. 2 Roy Lichtenstein, *Portrait of Madame Cézanne,* 1962. Magna on canvas. Estate of Roy Lichtenstein

chain they projected. Mark Rothko, who studied briefly with Max Weber and whose first paintings often bear the imprint of Cézanne's influence (fig. 1), argued as early as 1940 that Cézanne's constant aim, despite his abstraction of particular forms, had been "the reaffirmation of the visual reality of the world."[17] This objective, Rothko argued, made him "the exact opposite of the painters who came after him."[18] Likewise, in his review of Thomas Hess's 1951 *Abstract Painting: Background and American Phase,* which drew on formalist precedents, Barnett Newman protested that the narrow historical view of Cézanne the book espoused had no more than "a verbal construction at its basis." Cézanne's greatest discovery, he argued, had been the use of distortion as a formative principle, and this had opened it to a range of meaning that did not find, or need, validation in Cubism.[19] Even more pointed—and ironic—were the Pop artist Roy Lichtenstein's later re-creations of Loran's outlines, such as his *Portrait of Madame Cézanne* of 1962 (fig. 2), which hews closely to one of Loran's diagrams but parodies its intent. Though Loran had stressed in his text that the whole of Cézanne's painting could not be reduced to such expository profiles, his overarching emphasis on line and structure in the artist's work clearly struck a nerve.[20] "It is such an oversimplification trying to explain a painting by A, B, C," Lichtenstein later noted, "particularly the idea of diagramming a Cézanne when Cézanne said 'the outline escaped me.'"[21] However, though they took on directly some of the most prominent formalists of their day, Newman and Lichtenstein, like Rothko before them, were hardly the first painters in America to argue for Cézanne's complexity. Resisting both Barr's tidy modernist grid—and, even more, becoming part of it—and related formalist critiques, a number of vanguard painters had already sought precedents in Cézanne's art for

their own artistic experimentation, thus articulating a broader modernist spectrum in which his art, and theirs, could figure.

The German painter Hans Hofmann, who studied in Paris before immigrating to America in 1930, played a prominent role in the United States in relocating Cézanne's painting outside a stringent formalist continuum. One of the oldest of the Abstract Expressionists, Hofmann is also remembered as one of the great art teachers of his age.[22] In the tumult of the Depression and World War II, when many art students were unable to travel abroad, Hofmann's early contacts with Matisse, Picasso, and other European modernists made his voice a uniquely authoritative one.[23] And at the Art Students League in New York, where the conservative leanings of the Social Realists predominated, Hofmann's informed vision of modern art was exhilarating. Although, like many of his generation, Hofmann interpreted Cézanne's geometric form as crucial for later Cubist painting, he also drew new attention to the formal role of color in Cézanne's art.[24]

As a student in Paris Hofmann absorbed early on the brilliant chromatics of his classmate Henri Matisse, but he also studied closely the work of Cézanne and saw the large posthumous retrospective of 1907.[25] He later credited the Aixois master's command of color as one of the key elements in his own search for "plasticity" in painting. Hofmann used the now celebrated term "push-pull" to describe "the transference of three-dimensional experience into [the] two dimensions" of the picture plane, at one point explicitly linking the concept to Cézanne and emphasizing the sense of movement that color brought to Cézanne's surfaces:

> At the end of his life and at the height of his capacity, Cézanne understood color
> as a force of *push* and *pull*. In his pictures he created an enormous sense of volume,
> breathing, pulsing, expanding and contracting through his use of color.[26]

The later Abstract Expressionist Clyfford Still also studied Cézanne's art in his formative years, and its influence on his work is unmistakable. Growing up in rural Washington and southwestern Canada, Still may have been drawn, at first, to Cézanne's painting by a kindred attachment to his own dramatic terrain and a shared sense of being a provincial outsider in an unforgiving, cosmopolitan art world.[27] Also, like Cézanne and many of his own, less-traveled peers, Still's exposure to art in his student years was largely limited to grainy, black-and-white illustrations in art journals, especially the *Cahiers d'art,* which frequently reproduced the work of the French moderns in the 1910s and early 1920s.[28] In 1925, however, at the age of twenty-one, he traveled to New York to "visit the Metropolitan Museum of Art and see at first hand the paintings I had learned to love through my study of their reproductions."[29] Still also enrolled briefly at the Art Students League in New York. Ever petulant, the artist later claimed to have been disappointed by what he saw at the museum, and to have realized quickly that there was little he could be taught by the faculty. But the effect of Cézanne's palette and labored brushstroke on Still's art would be lasting. By 1928 Still was back in New York, enrolling again at the Art Students League and studying with Vaclav Vytlacil, a former student of Hofmann's in Munich and one of the few progressive voices to be heard then in the school.[30] At this point Vytlacil was deeply engaged in a study of Cézanne's art, and had earned the clear animosity of his colleagues. As

he later recalled: "I brought Cézanne and I brought charts with a dozen or more paintings . . . whereupon Kenneth Hayes Miller and Reginald Marsh started an argument and a movement against me because I was misleading students. In 1928!"[31] Though Still soon after rejoined his family in Alberta, he could hardly have missed the controversy sparked by Vytlacil's veneration of Cézanne, one on which the League's students and faculty seemed to thrive.[32] By the time Still again came east in 1934, to spend a summer as a guest artist at the Trask Foundation in Saratoga Springs, New York (now known as Yaddo), his interest in Cézanne was palpable.

Although most of his first paintings are known at present only through photographic archives, the few that have come to light suggest the depth of Still's early interest in Cézanne's work, and especially in the dense facture of his surfaces.[33] The *Row of Grain Elevators* of 1928–29, for example, can be likened to countless Regionalist and Precisionist scenes of an industrialized American landscape, but its ponderous, planar forms are troweled with thick swaths of paint, and "amassed, Cézanne style," as David Anfam has described, "like building blocks across [its] surface."[34] Likewise, broad and roughly parallel strokes of a palette knife figure in his *PH 323* (*Untitled*) of 1934, a painting of an immense, atavistic nude who strides through a turbid landscape scattered with pools of cobalt water and again bears comparison with Cézanne's work.[35] By the following year, in fact, Still had completed his master's thesis, entitled "Cézanne: A Study in Evolution," where, as Newman would later, he highlighted the importance of distortion in Cézanne's art. And, like Hofmann, he drew attention to Cézanne's structural use of color. As Still saw it, Cézanne's "repeated working of contours, that frequently occasioned a heaping of paint," his "ability for rhythmically synchronizing rugged volumes" and for "building form in terms of color planes" were key to "the triumph of his color synthesis of line as well as form."[36] By alluding to both the physicality of the paint substance and the formative value of color in Cézanne's art, Still not only defined his vision of the artist's modernity—which bore little relation to Cubism—but suggested the extent to which he saw Cézanne's art as a mirror to his own.

Still's considered appraisal of Cézanne's methods, moreover, bore immediate fruit: his painting of 1936, *Untitled* (*Indian Houses, Nespelem,* fig. 3), closely echoes the images that had figured in his research.[37] Like Cézanne's *Oil Mill* (fig. 4), for example, Still's image is constructed of synchronized, relieflike planes of textured pigment applied with broad, thick strokes of a palette knife and likewise features the dense, impacted background and blackened doors and windows that portend gloom in so many of Cézanne's landscapes.[38] By 1946 Still's signature style had emerged in a series of expansive, abstract canvases of densely impastoed pigment—tectonic fields of color in which some critics have seen further reflections of his study of Cézanne.[39] Although in his later years Still remained virtually silent on the subject of Cézanne, assuming an isolated stature and independence with which some critics were complicit, both his early painting and writing place him clearly in Cézanne's critical continuum.

Few of Still's fellow Abstract Expressionists would undertake such a painstaking study of Cézanne's painting, but many were critically engaged with his work, notably among them, Willem de Kooning.[40] Like Newman, de Kooning decried the idea that art could be systematically plotted and emphasized instead the power of the artist's will to escape the teleological constraints of historical graphing. The painter argued as well that great innovators could come

Fig. 3 Clyfford Still,
*Untitled (Indian Houses,
Nespelem)*, 1936. Oil on
canvas. Private Collection

Fig. 4 Paul Cézanne, *Oil
Mill*, c. 1872. Oil on canvas.
Private Collection

at the end, not just the beginning, of a period. "Cézanne," de Kooning wrote in 1951, "gave the finishing touches to Impressionism [or ended it] before he came face to face with his 'little sensation.'"[41] Later, in an interview with the critic Harold Rosenberg, de Kooning argued that "Cubism went backwards from Cézanne because Cézanne's paintings were what you might call a microcosm of the whole thing, instead of laying it out beforehand."[42] In a string of oracular and sometimes provocative pronouncements that punctuate his career, de Kooning suggested a number of alternative chronologies for modernism, as much to liberate his art from the "tidal flow of history" as to part company with the critics and constructs he disdained.[43] And Cézanne figured in them all.

Fig. 5 Willem de Kooning, *Two Figures*, c. 1946–47. Pastel on paper. Private Collection

Cézanne, as well as Picasso, was much on de Kooning's mind in the late 1940s, a period in which the artist struggled with questions of figuration and abstraction in his painting. By that time Barr had installed at The Museum of Modern Art two of the later master's great figurative canvases, *Les Demoiselles d'Avignon* (1907; itself influenced by Cézanne) and *Guernica* (1937). And in a series of drawings from about 1946–47 in which de Kooning labored to come to grips with the monumental *Demoiselles*, the artist also signaled his debt to aspects of Cézanne's painting that formalist critics had all but ignored. While Picasso's squatting, rightmost figure must count among its progeny the seated nude in de Kooning's drawing *Pink Angel* of 1947 (private collection), in the related drawing *Two Figures* (fig. 5), de Kooning looked back pointedly to Cézanne.[44] His struggling, recumbent nude recalls the fraught figure at the center of so many of Cézanne's inscrutable compositions of bathers, while de Kooning's standing nude, who leans toward her but also twists, full-faced, to confront the viewer, is even more overtly Cézannesque. Cézanne's *Four Bathers* of about 1880 (fig. 6), which was exhibited repeatedly in New York in the 1940s, may figure specifically, in fact, in de Kooning's drawing.[45] Not only are his palette and composition reminiscent of Cézanne's, but the nervous, hatched lines, scribbles, erasures, and emphatic, retraced limbs of his drawing become graphic echoes of Cézanne's pulsating surface of tangible strokes. In another of his inventive chronologies from this period, de Kooning described a history of great art that consisted of canvases "trembling," one that stretched from the paintings of Michelangelo to El Greco, the Impressionists, . . . and culminated with Cézanne, who, in such tactile, ordered canvases, "is trembling but very precisely."[46] Additionally, the viridian greens, flesh-toned pinks, and brilliant yellows and blues in paintings such as the radiant *Four Bathers* may have led de Kooning to contemplate the impact and origins of the artist's palette. As a summer professor at Black Mountain College in North Carolina in 1948, de Kooning delivered a lecture entitled "Cézanne and the Color of Veronese." Although the text has not survived, the topic itself suggests yet another focus and historic framework for the artist (and perhaps for himself?) that dislodged prevailing Cézanne criticism.[47]

Long after his stay in North Carolina, de Kooning was still trumpeting the impact of Cézanne on his art, distancing himself from formalist constructs, and also from Greenberg,

Fig. 6 Paul Cézanne, *Four
Bathers,* c. 1880. Oil on
canvas. Private Collection

who years before had turned away from de Kooning's painting to embrace abstraction as the
most eminent American mode of the moment. After a period of near despair in the late 1960s
and early 1970s, in which he produced almost nothing, de Kooning returned to the studio with
a burst of enthusiasm and again contemplated his debt to Cézanne. Describing his own method
of painting in thick, tangible strokes that were wedged now onto his canvases as a kind of "fitting
in," he told Rosenberg, who had become his champion and Greenberg's rival, "I never made a
Cubist painting. . . . The way I do it, its not like Cubism, it's like Cézannisme, almost."[48]

 In his early criticism, Greenberg had focused on Cézanne's tactile, blocklike brushstrokes
as a means of affirming the painting's tactility, flatness, and even its rectangular format, and saw
them as crucial to the self-reflexive quality and objectification that situated his art in a historic
continuum with Cubism and contemporaneous abstraction. Yet Cézanne's dense, impacted
paint surfaces encompassed only one aspect of the artist's manifold oeuvre, whose diversity and
breadth across a range of media were celebrated at the massive 1952 retrospective. In both Chi-
cago and New York, a large selection of watercolors and drawings shared space with the painter's
oils, making the whole of his art newly available to viewers and to painters on every point of
the modernist spectrum. For some American artists now, it was Cézanne's late watercolor style,

Fig. 7 Paul Cézanne, *Mont Sainte-Victoire*, 1904–5. Oil on canvas. Galerie Beyeler, Basel

especially as distilled in the spare veils of pigment and patches of bare canvas that make up his evocative late oil paintings (fig. 7), that offered not only the essence of Cézanne's art but a path out of the rough-hewn aesthetic of Abstract Expressionism.[49]

In the early 1950s Helen Frankenthaler adopted a technique that was a product, at least in part, of this new alignment. Greenberg, with whom she was then romantically involved, had introduced her to Jackson Pollock's work at the Betty Parsons Gallery in 1951, where Frankenthaler was struck by Pollock's method of painting by attacking from all sides a canvas stretched across the floor. Her watershed work of October 1952, *Mountains and Sea* (fig. 8), in which she stained diluted oil pigments directly into raw canvas on the floor, represented, to Greenberg, another stage in the purified modernist lineage that privileged "flatness and all-over pictorial organization."[50] But Frankenthaler's work, the first of her fully realized stain paintings, was also painted just months after the Cézanne retrospective had closed, and followed a summer trip to

eastern Canada, in which she executed a number of oil sketches and watercolors from nature. Her gestures, traced in fluid washes of color, may well suggest not only a revision of Pollock's allover technique but memories of that Cézanne show and summer.[51] As the artist herself noted, in an often-quoted reminiscence: "I came back and did *Mountains and Sea* and I know the land-scapes were in my arms as I did it." Like Cézanne, who, in his late work, tried to capture not a fixed motif but, with controlled, rhythmic strokes and fragmentary marks of color, his animate sensations in nature, Frankenthaler suggests in her painting a telling symmetry between her supple, deliberate gestures and pulsating imagery.[52] It summons "that instant" Merleau-Ponty had described in Cézanne's painting "when . . . vision became gesture."[53] Much as in his ethe-real, late works, the diaphanous washes in Frankenthaler's mural-sized stain paintings merge the image of nature with an experience of it. Far more than just an extension of Pollock's aesthetic, the impact of Frankenthaler's new work would be considerable.

Fig. 8 Helen Frankenthaler, *Mountains and Sea*, 1952. Oil and charcoal on canvas. Collection of the Artist, on loan to the National Gallery of Art, Washington, DC

This catalogue begins with key works by Paul Cézanne that were likely seen by, and were inspiration for, the American modernists whose works follow, in alphabetical order by artists' names.

CATALOGUE

The painter must dedicate himself totally to the study of nature and try to produce paintings which enlighten. . . . Work, which brings about progress in one's art, is sufficient consolation for being misunderstood by fools.[1]

—Paul Cézanne

Featured in the Salon d'Automne in 1904, this paint-
ing was later owned by Lillie P. Bliss. It was published in
Ambroise Vollard's *Paul Cézanne* (1914) and featured in
The Museum of Modern Art's opening exhibition, *Cézanne,*
Gauguin, Seurat, van Gogh in 1929.

PAUL CÉZANNE

Cat. 1
Victor Chocquet Seated, c. 1877 (R296)
Oil on canvas
18 × 15 in. (45.72 × 38.1 cm)
Columbus Museum of Art, Ohio: Museum Purchase,
Howald Fund, 1950.024
Phoenix only

Acquired in December 1907 from the Galerie Bernheim-
Jeune, Paris, this still life was owned by Leo and Gertrude
Stein. Leo Stein referred to it as having "a unique impor-
tance to me that nothing can replace."[2]

Furthermore, this still life was greatly admired by
Morgan Russell and Andrew Dasburg, who borrowed
it from Stein in order to create works inspired by it.
Dasburg observed, in a letter of April 24, 1910:

> Yesterday and the day before I have been making
> a copy of a small Cézanne that belongs to Mr. Stein.
> Have two copies that are much better than what I
> expected to get. . . . For me the original is infinitive.
> It will rest in my mind as a standard of what I want
> to attain, i.e. the qualities which it contains to such
> a great degree.[3]

In a letter of June 26, 1910, to Morgan Russell, Leo Stein
observed:

> I noticed at Rome that nowhere on the ceiling has
> Michelangelo attained to the sheer expression of
> form that is often achieved in his drawings. I believe
> that nowhere is it as complete as in those apples of
> Cézanne's. Cézanne must for the . . . general public
> always remain a painter of still life because there
> only could he "realize" in the ordinary sense of the
> word without sacrificing his aesthetic conscience.[4]

PAUL CÉZANNE

Cat. 2
Five Apples, 1877–78 (R334)
Oil on canvas
4¾ × 10 in. (12.1 × 25.4 cm)
Collection of Mr. and Mrs. Eugene V. Thaw

Exhibited at the Galerie Bernheim-Jeune in 1910, this work
was one of over thirty Cézannes owned by Egisto Fabbri,
the pioneering American collector of Cézanne's work who
lived in Paris and Florence.

PAUL CÉZANNE

Cat. 3
Still Life: Plate of Peaches, 1879–80 (R423)
Oil on canvas
23½ × 28⅞ in. (59.7 × 73.3 cm)
Solomon R. Guggenheim Museum, New York,
Thannhauser Collection, Gift, Justin K. Thannhauser,
1978, 78.2514.4

Shown at the Galerie Bernheim-Jeune in 1909, this water-
color was featured in Cézanne's first one-person exhibi-
tion in America, at the gallery 291 in New York, in 1911. It
was also exhibited at the Montross Gallery in 1916, when
it was characterized by Willard Huntington Wright as one
of the "completely beautiful works" (along with cat. 20)
in his review.[5] It is seen hanging on the walls of the Arens-
berg apartment in New York in a photograph by Charles
Sheeler (fig. 8 in Stavitsky's essay in this volume).

PAUL CÉZANNE

Cat. 4
A Forest of Standing Timber, c. 1880–85 (RWC233)
Watercolor and graphite on off-white laid paper
12¾ × 18¾ in. (31.1 × 47.6 cm)
Philadelphia Museum of Art: The Louise and Walter
Arensberg Collection, 1950, 50-134-33
Montclair only

Illustrated in an early article in English on Cézanne by
Frederick Lawton (*The Art Journal* [London] 1911, 60)
and the *Cézanne Mappe* portfolio (1912), this painting
was featured in the landmark shows of modern art in
1921 at the Brooklyn Museum and The Metropolitan
Museum of Art.

PAUL CÉZANNE

Cat. 5
Portrait of Madame Cézanne, 1885–87 (R532)
Oil on canvas
18⅛ × 15⅛ in. (46 × 38.3 cm)
Philadelphia Museum of Art: The Louis E. Stern Collection,
1963, 1963-181-6

Formerly owned by Henri Matisse, this portrait was pub-
lished in a 1920 article on Cézanne by French philosopher
Elie Faure, who was a close colleague of Walter Pach's.
It was exhibited at the Wildenstein Galleries in New York
and the Philadelphia Museum of Art in 1928.

PAUL CÉZANNE

Cat. 6
Portrait of Madame Cézanne, 1886–87 (R576)
Oil on canvas
18 7/16 × 15 5/16 in. (46.8 × 38.9 cm)
Philadelphia Museum of Art: The Samuel S. White 3rd
and Vera White Collection, 1967, 1967-30-17

One of the earliest known studies of the Bibémus Quarry, this watercolor was exhibited at the Montross Gallery in 1916. Its subject and subtle balance of the material and immaterial exemplifies the kind of innovative aesthetic approach that appealed to American artists.

PAUL CÉZANNE

Cat. 7
Rocks at Bibémus, c. 1887–90 (RWC306)
Watercolor and graphite on off-white laid paper
18 1⁄16 × 12 1⁄2 in. (45.9 × 31.8 cm)
The Henry and Rose Pearlman Foundation, Inc.; on long-term loan to the Princeton University Art Museum
Phoenix only

Acquired from the Armory Show of 1913 by The Metro-
politan Museum of Art, this landscape, known at the time
as *La Colline des Pauvres (The Hill of the Poor)*, was the
first painting by Cézanne to enter an American museum
collection.

PAUL CÉZANNE

Cat. 8
View of the Domaine Saint-Joseph, 1888–90 (R612)
Oil on canvas
25 ⅝ × 32 in. (65.1 × 81.3 cm)
Lent by The Metropolitan Museum of Art, New York,
Catharine Lorillard Wolfe Collection, Wolfe Fund, 1913 (13.66)

This watercolor was exhibited in New York at 291 in 1911 and at the Montross Gallery in 1916.

PAUL CÉZANNE

Cat. 9
Trees and Rocks, c. 1890 (RWC328)
Watercolor and graphite on off-white wove paper
17⅝ × 11⁷⁄₁₆ in. (44.8 × 29.1 cm)
Philadelphia Museum of Art: The Samuel S. White 3rd
and Vera White Collection, 1967, 1967-30-19
Phoenix only

When it was reproduced in *The Arts* magazine in 1925, this work was mentioned as a "small but very rare still life by Cézanne" which "tells with convincing clarity why this unhappy man has come to be considered the greatest master of still life that ever lived."⁶ It was exhibited in Paris at the Galerie Vollard in 1895 and the Galerie Blot in 1909, in New York at the Wildenstein Galleries in 1928, and at the Fogg Art Museum, Cambridge, Massachusetts, in 1929.

PAUL CÉZANNE

Cat. 10
Fruit and a Jug on a Table, c. 1890–94 (R741)
Oil on canvas
12¾ × 16 in. (32.4 × 40.6 cm)
Museum of Fine Arts, Boston. Bequest of John T. Spaulding, 48.524

Exhibited at the Galerie Bernheim-Jeune, Paris, in 1907, 1909, and 1910, this watercolor was characterized as reaching "the very consummation of [Cézanne's] development in this medium" when it was exhibited at the Galerie Druet in 1920.[7]

PAUL CÉZANNE

Cat. 11
In a Forest (Fontainebleau?), 1892–94 (possibly later)
(RWC451)
Watercolor on paper
17¾ × 23 in. (45.1 × 58.4 cm)
Private Collection

This painting was acquired by Leo and Gertrude Stein at
an unknown date, presumably from Vollard; it is illustrated
in Georges Rivière's *Le maître Cézanne* (1923), as well as
Elie Faure's *P. Cézanne* (1926).

PAUL CÉZANNE

Cat. 12
Man with Pipe, 1892–96 (R711)
Oil on canvas
10¼ × 8 in. (26 × 20.3 cm)
National Gallery of Art, Washington, DC, Gift of
the W. Averell Harriman Foundation in memory
of Marie N. Harriman, 1972.9.3

This watercolor was exhibited at the Galerie Bernheim-Jeune, Paris, in 1909; in the *Second Post-Impressionist Exhibition* at the Grafton Galleries, London, in 1912; and at the Montross Gallery, New York, in 1916.

PAUL CÉZANNE

Cat. 13
House on the Hill, Near Aix, 1895–1900 (RWC464)
Watercolor and graphite on paper
18¾ × 22½ in. (47.6 × 57.1 cm)
Philadelphia Museum of Art: The Louis E. Stern Collection,
1963, 1963-181-7
Baltimore only

This watercolor was featured in Cézanne's first solo show in America at the 291 gallery in 1911. It was singled out by critic James G. Huneker of the *New York Sun* (March 12, 1911) as "worth close attention." This work was also exhibited at the Montross Gallery in 1916 and the Museum of French Art in 1921.

PAUL CÉZANNE

Cat. 14
Edge of Lake Annecy (Boat in Front of Trees), 1896
(RWC472)
Watercolor and graphite on paper
12⅛ × 18¾ in. (30.6 × 47.6 cm)
Collection of The Honorable and Mrs. Joseph P. Carroll, New York

An impression of this lithograph was owned by the Steins in Paris, and one was exhibited at Alfred Stieglitz's gallery, 291, in 1910, as part of the exhibition of *Lithographs by Manet, Cézanne, Renoir, and Toulouse-Lautrec, Drawings by Rodin, and Paintings and Drawings by Henri Rousseau.* Elisabeth Luther Cary described it in her review:

> We may as well admit straightway that Cézanne's powerful white bathers lifting their big, gleaming bodies against a background suffused with color by a few marks of blue and green chalk has to us every appearance of superb, vital, normal art, sound and vigorous as that of the early Greeks.[8]

Impressions of this print were acquired by Lillie P. Bliss, Walter Arensberg, and John Quinn from the Armory Show in 1913.

PAUL CÉZANNE

Cat. 15
Large Bathers, 1896–98
Crayon transfer and brush and tusche color lithograph on paper
16 × 19⅞ in. (40.6 × 50.5 cm)
Private Collection

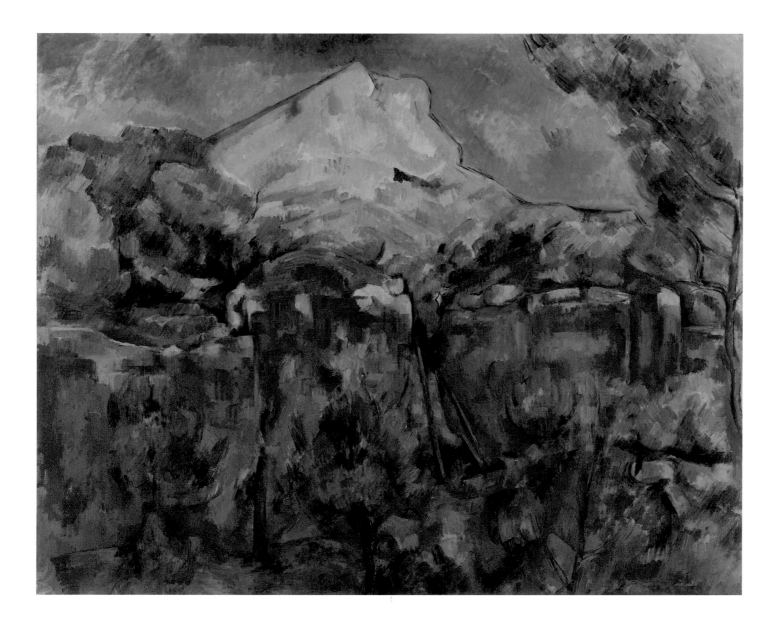

Featured in Cézanne's memorial exhibition of 1907 at the Salon d'Automne, held at the Grand Palais, Paris, this painting was acquired by the Baltimore collector Claribel Cone in 1925 for the highest price that either she or her sister would pay for a work in their collection.

Excerpt from "The Mountain and the Reconstruction" by Marsden Hartley
And it was the spring of Provence, and of the RECONSTRUC-
TION. . . .
A new Mountain to ourselves . . . a very noble one. . . .
Calm fires warmed its shadows, and there was the quality of revela-
tion contained in it . . . for the body, the mind and the spirit . . . the
sweet old man appeared in vision—a man who had evolved some
of the clearest principles for himself, a new metaphysic—a new
logic—a new, inviolable conviction, a new law for the artist with
ambitions toward truth, a belief in real appearances, and a desire
toward expression, without the HYPOCRISIES.[9]

PAUL CÉZANNE

Cat. 16
Mont Sainte-Victoire Seen from the Bibémus Quarry, c. 1897
(R837)
Oil on canvas
25⅛ × 31½ in. (65.1 × 80 cm)
The Baltimore Museum of Art: The Cone Collection, formed by Dr. Claribel Cone and Miss Etta Cone of Baltimore, Maryland, BMA 1950.196

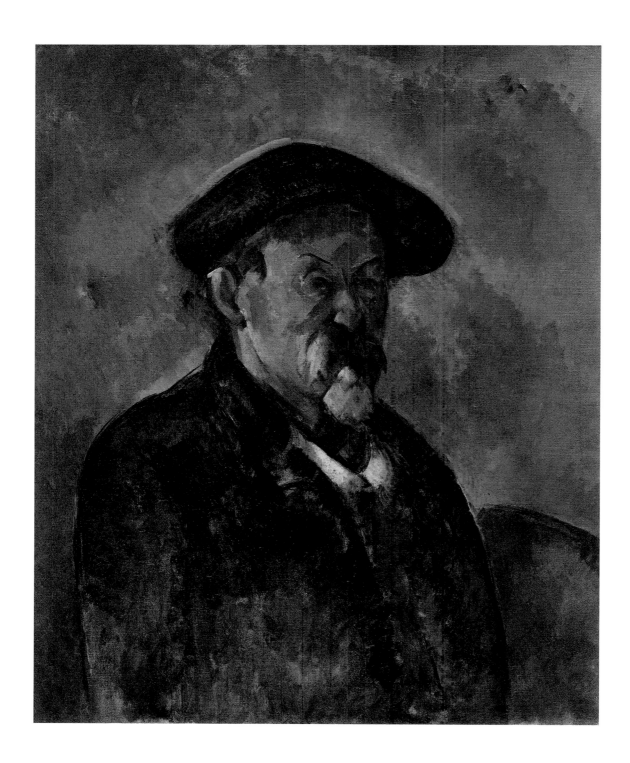

One of Cézanne's last self-portraits, this work was owned by Egisto Fabbri, reproduced in Julius Meier-Graefe's *Paul Cézanne* (1910), and featured in *Cézanne, Gauguin, Seurat, van Gogh* at The Museum of Modern Art in 1929.

PAUL CÉZANNE

Cat. 17
Self-Portrait with a Beret, c. 1898–99 (R834)
Oil on canvas
25¼ × 21 in. (64.1 × 53.3 cm)
Museum of Fine Arts, Boston, Charles H. Bayley Picture and Painting Fund and Partial Gift of Elizabeth Paine Metcalf, 1972.950

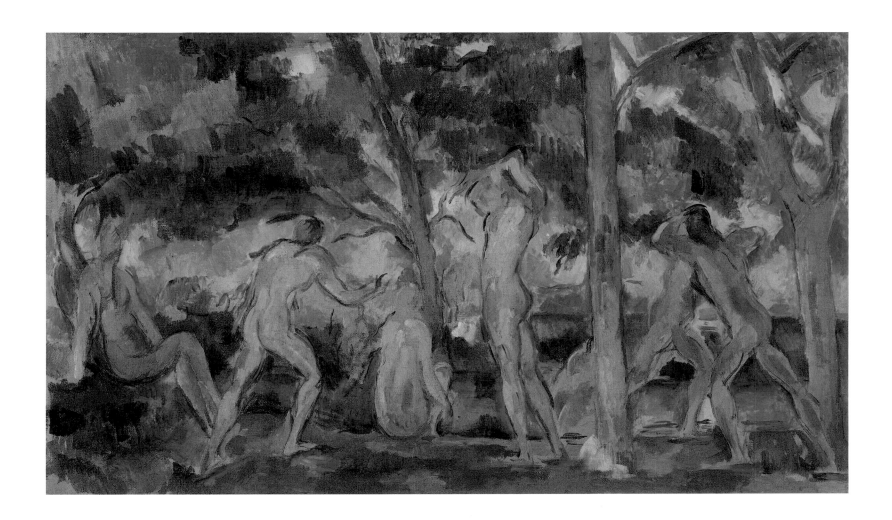

This work was one of two compositions of Bathers that entered Leo and Gertrude Stein's collection in October 1904, and was thus seen by the many painters and writers who frequented their salons. In 1926 Gertrude Stein sold it to her friend Etta Cone.

PAUL CÉZANNE

Cat. 18
Bathers, 1898–1900 (R861)
Oil on canvas
10⅝ × 18⅛ in. (27 × 46 cm)
The Baltimore Museum of Art: The Cone Collection, formed by Dr. Claribel Cone and Miss Etta Cone of Baltimore, Maryland, BMA 1950.195

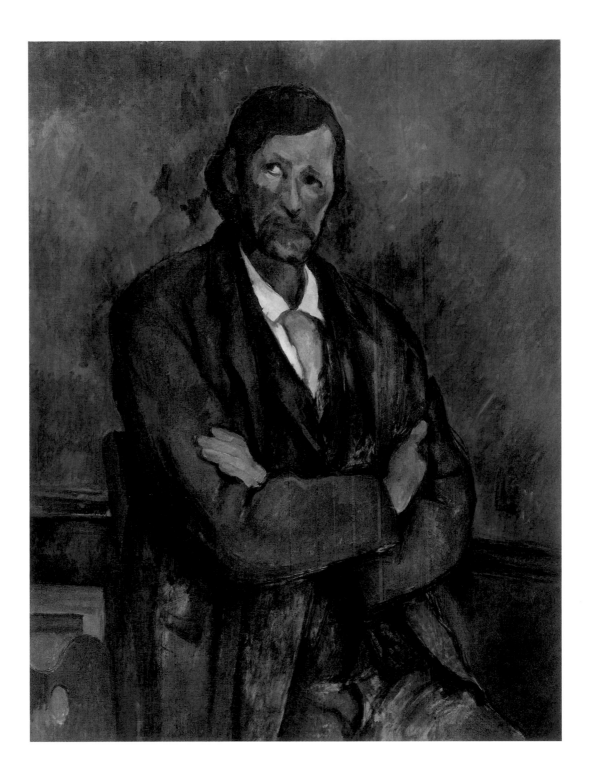

This painting was featured in the Salon d'Automne in 1904
and published in Ambroise Vollard's *Paul Cézanne* (1914).

PAUL CÉZANNE

Cat. 19
Man with Crossed Arms, c. 1899 (R851)
Oil on canvas
36¼ × 28⅝ in. (92 × 72.7 cm)
Solomon R. Guggenheim Museum, New York, 54.1387
Montclair and Baltimore only

Exhibited at the Galerie Bernheim-Jeune, Paris, in 1907, this watercolor was referred to by Willard Huntington Wright in his review of a 1916 New York exhibition as one of the "completely beautiful works" (see cat. 4). It was also exhibited in group shows at the Pennsylvania Academy of the Fine Arts, Philadelphia, in 1920; the Museum of French Art, New York, in 1921; and The Brooklyn Museum in 1926.

PAUL CÉZANNE

Cat. 20
House Among Trees, c. 1900 (RWC509)
Watercolor and graphite on paper
11 × 17⅛ in. (27.9 × 43.5 cm)
The Museum of Modern Art, New York. Lillie P. Bliss
Collection, 1934 (15.1934)
Montclair only

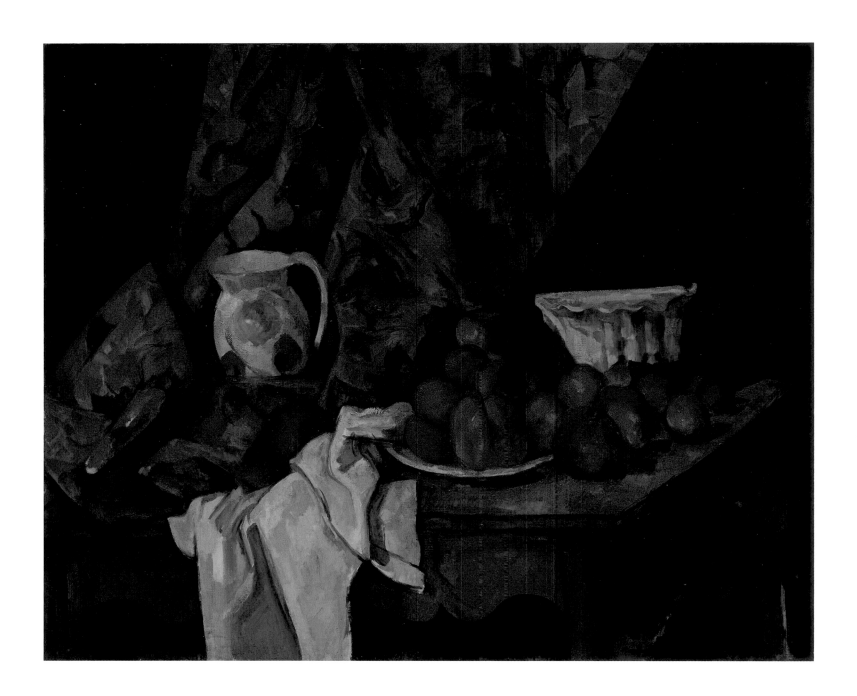

This late work was acquired by the pioneering collectors Agnes and Eugene Meyer in 1912 on the recommendation of Edward Steichen, who deemed it to be "the finest still life Cézanne ever painted."[10] It was exhibited in New York at The Metropolitan Museum of Art in 1916 and 1921, and at the Pennsylvania Academy of the Fine Arts in 1920.

PAUL CÉZANNE

Cat. 21
Still Life with Apples and Peaches, c. 1905 (R936)
Oil on canvas
31⅞ × 39⁹⁄₁₆ in. (80.9 × 100.5 cm)
National Gallery of Art, Washington, DC, Gift of Eugene and Agnes E. Meyer, 1959.15.1
Montclair and Baltimore only

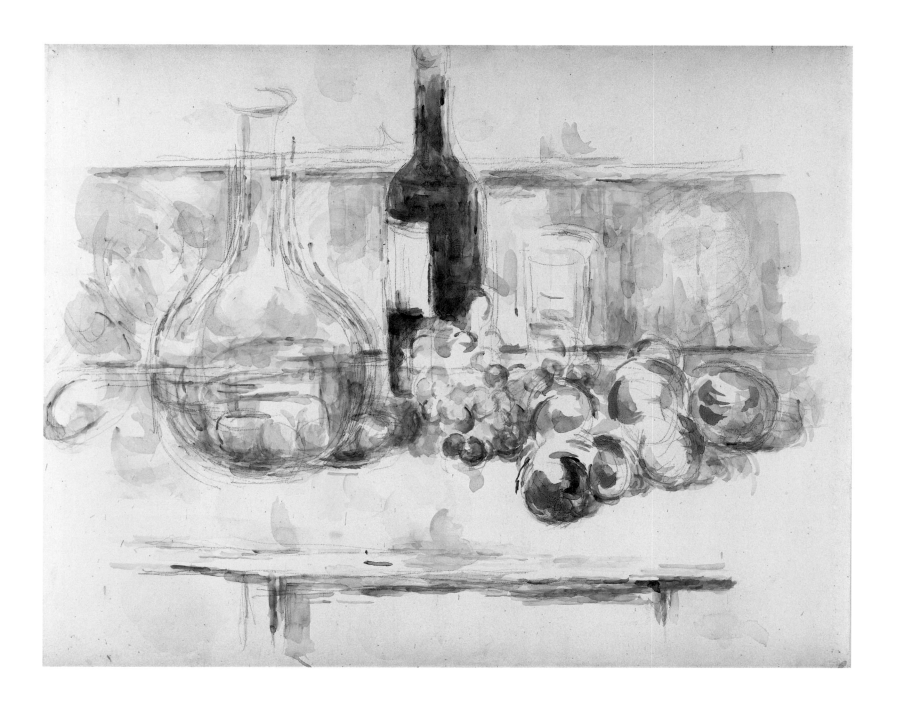

This watercolor was exhibited in Cézanne's retrospective of 1907 at the Grand Palais in Paris and published in Georges Rivière's *Le maitre Cézanne* (1923).

PAUL CÉZANNE

Cat. 22
Still Life with Carafe, Bottle, and Fruit, 1906 (RWC642)
Watercolor and soft graphite on pale buff wove paper
18⁷⁄₈ × 24⁵⁄₈ in. (48 × 62.5 cm)
The Henry and Rose Pearlman Foundation, Inc.; on long-term loan to the Princeton University Art Museum
Montclair only

1. Paul Cézanne, quoted in Émile Bernard, *L'Occident* (July 1904), from *Conversations with Cézanne,* ed. Michael Doran, trans. Julie Lawrence Cochran (Berkeley and Los Angeles: University of California Press, 2001), 39.

2. Leo Stein, *Journey into the Self* (New York: Crown Publishers, 1950), 57.

3. Sheldon Reich, *Andrew Dasburg, His Life and Art* (Lewisburg, PA: Bucknell University Press, 1989), 27, 29n71.

4. Leo Stein to Morgan Russell, June 26, 1910, Morgan Russell Archive and Collection, Montclair Art Museum.

5. Willard Huntington Wright, "Paul Cézanne," *The International Studio* 57 (February 1916): CXXX.

6. Forbes Watson, "American Collections No. 2—The John T. Spaulding Collection," *The Arts* (December 1925): 321, 334.

7. H.L. van Doren, "Some Little Known Cézannes," *The Touchstone,* December 1920, 188.

8. Elisabeth Luther Cary review, reprinted in *Camera Work* 33 (January 1911): 49.

9. Marsden Hartley, "The Mountain and the Reconstruction" (1928), in *On Art,* ed. Gail Scott (New Haven, CT: Yale University Press, 1982), 75-76.

10. Quoted in John Rewald, *Cézanne and America: Dealers, Collectors, Artists and Critics 1891-1921* (Princeton: Princeton University Press, 1989), 158.

CITATIONS FOR QUOTES ON SUBSEQUENT PAGES

Page 166
11. Paul Cézanne, in a letter to "a young artist friend of Joachim Gasquet's (Gustave Heriries?)," in John Rewald, ed., *Paul Cézanne: Letters* (New York: Hacker Art Books, 1984), 255.

Page 193
12. Letter from Paul Cézanne to Émile Bernard, from "Memories of Paul Cézanne," *Mercure de France* (October 1 and 16, 1907), quoted in Elie Faure, *Cézanne* (New York: Association of American Painters and Sculptors, 1913), 52.

Page 212
13. Paul Cézanne quoted in Willard Huntington Wright, *Modern Painting, Its Tendency and Meaning* (New York: John Lane, 1915), 162.

Page 250
14. Paul Cézanne to Roger Marx, January 23, 1905, quoted in John Rewald, ed., *Paul Cézanne: Letters* (New York: Hacker Art Books, 1984), 309.

Page 318
15. "A Tape Recorded Interview with Abraham Walkowitz," conducted by Abram Lerner and Bartlett Cowdry, December 8 and 22, 1958, *Archives of American Art Journal* 9 (January 1969): 12-13.

Page 336
16. Paul Cézanne, quoted in Émile Bernard, *L'Occident* (July 1904), in *Conversations with Cézanne,* ed. Michael Doran (Berkeley and Los Angeles: University of California Press, 2001), 38.

Perhaps I came too soon. I was a painter of your generation more than my own. . . . You are young, you have vitality, you will imbue your art with a force that only those with true feelings can manage. As for me, I'm old. I won't have time to express myself. . . . The reading of a model and its realization are sometimes very slow in coming."

—Paul Cézanne

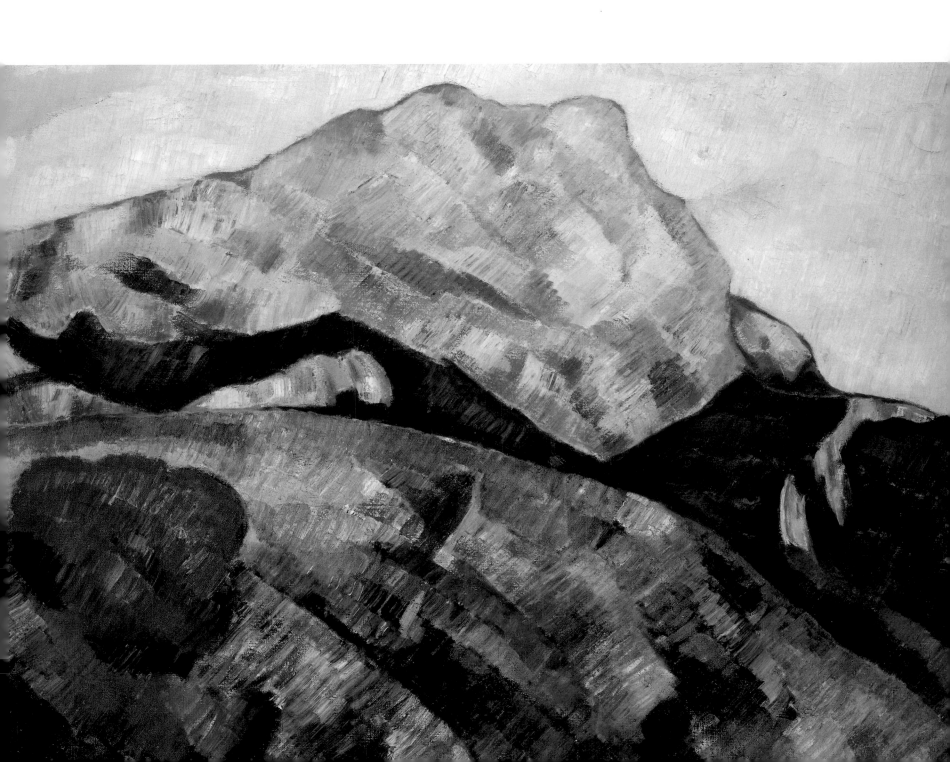

JÓZEF BAKOŚ (1891–1977)

In 1921 Józef Bakoś founded *Los Cinco Pintores* (The Five Painters), the first group of modernist artists to exhibit in Santa Fe, New Mexico.[1] The idealistic painters, all under the age of thirty, were afforded the opportunity to display their work in the recently opened Fine Arts Museum, and they filled three galleries with almost forty paintings. None of the artists had yet traveled to Europe, and all learned of modernism through second-hand sources. The influence of Cézanne is apparent in the structural qualities of building a composition through faceted planes of color in Bakoś's canvases of this time. His landscapes impressed a local critic, "for they present something of the massiveness and solidity of the mountains and foothills. It is almost as if one could feel the skeleton of granite beneath the contour of rolling foothills, shimmering mesas and huge gashes of canyons and arroyos."[2]

Initially trained at the Albright School of Art in Buffalo, New York, he gained knowledge of Post-Impressionism through private lessons with John Edward Thompson, who had recently returned to Buffalo from Europe. Bakoś and his childhood friend Walter Mruk followed Thompson west to Colorado in 1918, and Bakoś taught for a time at the University of Colorado in Boulder. He took part in Colorado's so-called mini-Armory Exhibit of 1919, organized by Thompson. One critic recognized Bakoś's paintings as particularly modern and unflatteringly described them as appropriate for "a permanent place on the walls of a mad house."[3] In 1920 Bakoś moved to Santa Fe, where

"the surrounding country surpassed my wildest romantic dreams," he recalled.[4] In addition to exhibiting with *Los Cinco Pintores*, which disbanded in 1926, he was also a member of the progressive New Mexico Painters. They were founded in 1923 by Ernest Blumenschein of the Taos Society of Artists after the more conservative organization failed to include modern artists.[5]

Bakoś learned of Cézanne through instruction by Thompson and conversation with other artists, particularly the tutelage of Andrew Dasburg; he would have had access only to reproductions. However, he adopted a similar treatment of surfaces and a break from traditional perspective while flattening space in his paintings, all informed by Cézanne. This is evident in *Still Life* (cat. 23), which features one of Cézanne's favorite motifs of a still life on a table. The items displayed are shown from varying angles, yet instead of presenting what appears as a constructed still life as would Cézanne, Bakoś's image is more personal and autobiographical, suggesting a simple meal in a southwestern setting.[6] The Sangre de Cristo mountain range seen through the open window can be appreciated as an homage to Cézanne and Mont Sainte-Victoire. Other still-life paintings are more direct in their appropriation, including one painting aptly titled *Still Life with Cézanne's Pears* (c. 1926, private collection).

Bakoś's favored motif was the landscape. Like Cézanne, he was interested in finding the structure of a given place. "I've always been more concerned in painting the weight of a mountain

than its atmospheric condition," he said.[7] His friend Dasburg further encouraged his interest in formal organizations based on nature. *Pine Tree and Road, Santa Fe Canyon* (c. 1930, cat. 24) was inspired after Cézanne's *Bibémus Quarry* in the Barnes Foundation, which had been reproduced in the April 1930 issue of *Art Magazine*.[8] The finished painting is a collaborative effort between Bakoś and Dasburg, Dasburg having made alterations to the nearly finished painting during a studio visit.[9] Dasburg's contributions smoothed out the sharper edges of forms to create a more uniform appearance.

JERRY N. SMITH

1. The other members of *Los Cinco Pintores* were Fremont Ellis, Walter Mruk, Willard Nash, and Will Shuster.

2. "Los Cinco Pintores," *El Palacio* 11, no. 11 (December 1, 1921): 139.

3. Organized by John Thompson, the 25th Annual Exhibition of the Denver Art Association featured several works by moderns, earning it ridicule from area critics as a mini-Colorado "Armory Exhibit." See Stanley L. Cuba, *Józef Bakoś: An Early Modernist* (Santa Fe: Museum of Fine Arts, Museum of New Mexico, 1988), unpaginated.

4. Ibid.

5. Other founding members included Frank Applegate, Gustave Baumann, William Penhallow Henderson, Victor Higgins, B. J. O. Nordfeldt, and Walter Ufer. See "The New Mexico Painters," *El Palacio* 15, no. 2 (July 16, 1923): 32. See also Robert R. White, ed., *The Taos Society of Artists* (Albuquerque: University of New Mexico Press, 1998), 84.

6. Joan Carpenter Troccoli, *Painters and the American West: The Anschutz Collection* (Denver: Denver Art Museum; New Haven, CT: Yale University Press, 2000), 47.

7. Edna C. Robertson, *Los Cinco Pintores* (Santa Fe: Museum of New Mexico, 1975), 12.

8. Cézanne's *Bibémus Quarry* had been reproduced on four occasions in European publications, but the first time in America was in the April 1930 *Art Magazine,* which is likely the year the Bakoś/Dasburg collaborative painting was created. See John Rewald, *The Paintings of Paul Cézanne: A Catalogue Raisonné* (New York: Harry N. Abrams, 1996), 1:500.

9. Dasburg's alterations to Bakoś's painting were prompted, in part, by the drinking of whiskey. "We sipped a little at a time," Bakoś explained, "and we got more courageous every minute—*on my painting!*" Quoted in Cuba, *Józef Bakoś,* 6.

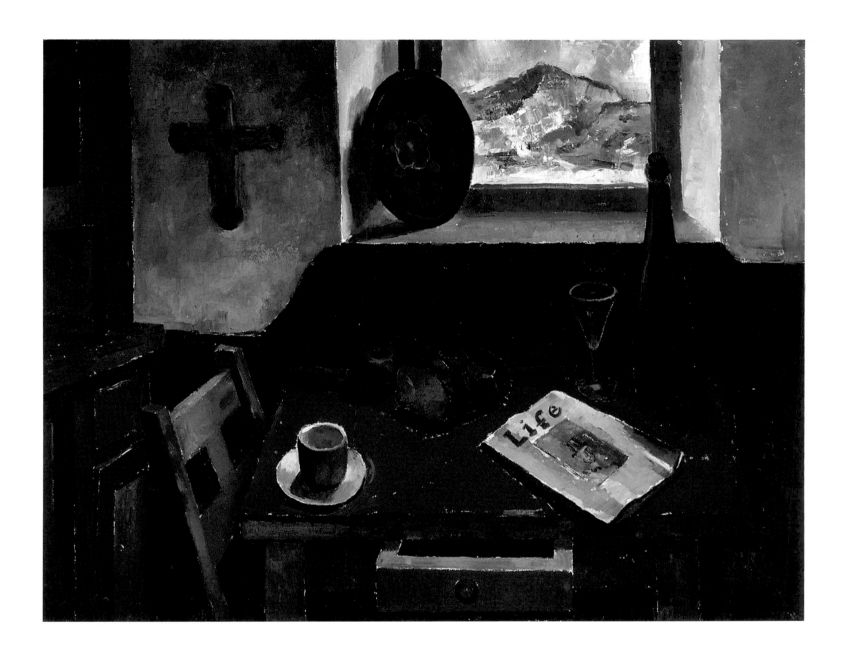

JÓZEF BAKOŚ

Cat. 23
Still Life, c. 1922
Oil on canvas
26 × 34 in. (66.56 × 87.04 cm)
Fred Jones Jr. Museum of Art, The University of Oklahoma,
Norman; Museum purchase, 1920s

JÓZEF BAKOŚ

Cat. 24
Pine Tree and Road, Santa Fe Canyon, c. 1930
Oil on canvas
30 × 24 in. (76.2 × 61 cm)
Collection of Gilbert and Nancy Waldman

OSCAR BLUEMNER (1867–1938)

During the first decades of the twentieth century, as knowledge of Paul Cézanne's art was gradually expanding in America, Oscar Bluemner was self-consciously transforming himself from an architect into a painter. The artist's copious notes on his readings and exhibition visits reveal a history of personal engagement with Cézanne that moved from avid perusal of early commentaries to thoughtful encounters with the master's work at some of the most important exhibitions in America and abroad.[1] The keen structural sense engendered by Bluemner's German architectural education, his obsessively analytic habits of mind, and his near-mystical response to nature made him especially receptive to the strengths and complexities of Cézanne's art. Although his early knowledge of the artist was limited to critical essays and grainy black-and-white reproductions, he did not have to await English translations to assimilate the writings of Théodore Duret, Émile Bernard, and Julius Meier-Graefe.[2]

Bluemner's meeting with Alfred Stieglitz catalyzed his turn from architecture to painting, and the March 1911 exhibition of watercolors at 291 supplied his first direct encounter with Cézanne's artwork.[3] According to Stieglitz this "brilliant young architect from Chicago walked into 291 . . . looked upon the wine that was Cézanne, and went away a new man."[4] "Cézanne," Bluemner observed, "dismisses what is not essential to the unity of the idea: the inherent is necessary, the incidental is not wanted."[5] Profound empathy for Cézanne's constant struggle to harmonize all the pictorial elements and natural observations into "that larger, total thing, the artistic whole," was evident when Bluemner embarked on his own first oil paintings a few months later.[6] A newly acquired copy of Julius Meier-Graefe's monograph on Cézanne (cat. 135) became a guidebook for his new endeavor; in the following years he added underlinings and marginal notes to nearly every page of the text, and he regularly enclosed notes, clippings, and annotated exhibition catalogues in an envelope pasted into the back of the book. Meier-Graefe's commentary reinforced Bluemner's growing conviction that the expressive power of a painting stemmed from its pictorial means rather than from its subject matter,[7] and that the arts of both the past and the present achieved their highest ends through the harmony of their formal elements.[8]

An extended trip to Europe in 1912 expanded Bluemner's first-hand experience of Cézanne's artwork exponentially. His first view of Cézanne's oil paintings, at the progressive Berlin gallery of Paul Cassirer, left him dazzled by the "beautiful shading of colors" and the way every element was subordinated to "the unity and homogeneity of the whole."[9] Europe provided Bluemner with a feast of both historical and contemporary art. As he filled his notebooks with observations and sketches, he was continually drawn to the formal and tectonic qualities that had been emphasized in his readings of Meier-Graefe. The group exhibition of the Berlin Secession yielded more Cézannes, but the richest feast of new art was laid out at the *Sonderbund* exhibition in Cologne. Reviewing this exhibition for the *Kölner Tageblatt,* Bluemner responded most enthusiastically to the works of van Gogh and Gauguin, but still commended Cézanne for the completeness and coherence of his formal vision, and extolled him as a fundamental bridge to modern expression.[10] Bluemner's ardent art education took him on to Paris (where he saw more Cézannes at the Bernheim-Jeune Gallery) and then down through the south of France and on to Italy, Belgium, Holland, and London, where he concluded his crash course in European modernism at Roger Fry's second Post-Impressionist exhibition, at which Cézanne's works were surrounded by a variety of Cubist and Fauvist paintings. After careful perusal of the many works of Braque, Picasso, Matisse, and other progressive modernists, Bluemner concluded: "All of this is Cézanne enlarged or broadened."[11]

Bluemner returned to the United States in time to submit five works to the Armory Show, including *Hackensack River* (cat. 25),[12] and to write an extensive review of the exhibition for *Camera Work.* In it, he faulted the critics who failed to recognize "the real and fundamental achievements of Cézanne's genius in painting" and who overlooked his "rapid and universal influence to this day, all over Europe, with those painters who are not slaves to the mechanical perpetuation of dead rule, but who feel the pulse of our time and dip their brushes in modern thought and not the ink of academic superstition."[13] He criticized

the selection and organization of the exhibition's planners, citing as one of their greatest failures the inadequate representation of Cézanne and van Gogh in "the number as well as the quality of their pictures."[14] His final comments stress again the importance of Cézanne in bringing about "the new vision of nature and with it new possibilities of expression."[15]

In the years following the Armory Show, Bluemner worked to transform his own painting practice, seeking to assimilate the new elements he had seen and studied in Europe into his own distinctive vision. Aspiring to impart Cézanne's sense of the pictorial whole to portrayals of "America's grand sceneries," he began a bold new series of oil paintings, determined "to begin a picture at all parts and corners simultaneously, in order to balance tone, color, mass," and to "proceed, pictorially . . . never seeing the things or phenomena separate but each under the radiation of all."[16] The powerful geometric planes of the paintings exhibited in his first solo American exhibition (at 291 in 1915) suggest the grids and facets of Cubism, but the evidence of Bluemner's published writings and private journals indicates that he "arrived at this hallmark of cubism through a shared regard for Cézanne."[17]

On the heels of his new experiments, the paintings executed before his European trip (including *Jersey Silkmills (Paterson)* [cat. 26] and *Hackensack River*) must have seemed tentative and unresolved. Determined to give them greater formal clarity and expressiveness, he scraped down the canvases, "soap-washed them, and made new charcoal and color studies in order to make a . . . bigger and simpler impression."[18] While reworking these pictures during 1916 he seized the opportunity to closely analyze new works by Cézanne at the Montross and Modern Galleries (cats. 146, 147).[19] His notes on these exhibitions range from workmanlike analyses of compositions and precise lists of pigments in both oil and watercolor to intensely poetic responses.[20]

Clearly, Bluemner's ongoing internal dialogue with Cézanne provided an important foundation for the labored transformation of *Jersey Silkmills, Hackensack River,* and other early works from their 1911 appearance—Impressionism tempered by awareness of Japanese prints with color schemes strongly tied to direct observations from nature—to the formal concision, tectonic composition, and intensified expressive color of the revised versions of 1916 and 1917.[21] When the newly transformed paintings were featured in a 1918 exhibition at the Bourgeois Gallery, New York, Bluemner's catalogue essay concluded with a tribute to the durable legacy of Cézanne.[22] That legacy would remain a foundation of Bluemner's art throughout his career.[23]

ROBERTA SMITH FAVIS

OSCAR BLUEMNER

Cat. 25
Hackensack River, 1911 (repainted 1914 and 1916–17)
Oil on canvas
20 × 30¼ in. (50.8 × 76.8 cm)
Naples Museum of Art, Naples, Florida (2000.15.011)
Baltimore only

OSCAR BLUEMNER

Cat. 26
Jersey Silkmills (Paterson), 1911 (repainted 1917)
Oil on canvas
19¾ × 29¾ in. (50.2 × 75.6 cm)
Private Collection

ANNE BRIGMAN (1869–1950)

Anne Brigman's subjects rather than her style are what associate her most nearly with Cézanne, but in fact, her work's most significant relationship to Cézanne is triangulated through Alfred Stieglitz's perception of her work. Indeed, her connection to modernism in any form was primarily through Stieglitz. A Californian working far from artistic circles in Europe and the East Coast, and not a student of art history, she operated as a frontier maverick rather than a dedicated avant-gardist. Brigman's characteristic subject was the female nude in the landscape. Most of her photographs were made high in the mountains where she hiked and camped, as well as setting up poses for the camera, and serving as her own model. This made a dramatic departure from the well-developed tradition of American western landscape photography based on nineteenth-century exploratory surveys, which were straightforward in their informational approach, crisply detailed in style, and grand in scope. Brigman's work, by contrast, featured soft-focus nudes in moderate close-up as allegorical figures. Her *Dryads* of 1913 (cat. 27) represents two female nudes reclining on a rocky escarpment beneath the tangled branches of a wind-blasted pine. What in painting might seem an Arcadian allusion can, in photography, have an element of incongruity, and many of Brigman's photographs seem more notable today for their naiveté than for their artistic purity.

Although a near-contemporary of Stieglitz's, Brigman nonetheless always occupied the role of a protégé under his tutelage, and he habitually signed his letters to her "as ever, your old War-Horse."[1] As Kathleen Pyne has chronicled, Stieglitz repeatedly sought for an idealized feminine presence in art, a process which culminated in his discovery of Georgia O'Keeffe, and successively replaced one incumbent in this priestess/muse role with another.[2] Brigman, she says, was Stieglitz's replacement for the painter Pamela Colman Smith, one of the least felicitous of his discoveries. Like Smith, Brigman excelled more as a symbol of feminized creativity than as a sharer in Stieglitz's increasingly modernist aesthetic.

Utterly faithful to her subjects and full-blown Pictorialist style, her work remained consistent over decades, changing only in subtle points of technique and printing. The athletic, energetic Brigman—who daringly hiked with friends in the Sierra Nevada in trousers when not posing nude for her own camera as a nymph of the mountains—was a reader of Edward Carpenter and a free spirit. High in the mountains of the West she breathed a different air from that of New York's art world. More an untouched Cézanne bather herself than a potential candidate for the role that O'Keeffe was eventually so perfectly to fill in Stieglitz's art and life, she nonetheless held his attention from afar over decades. Brigman's 1949 book *Songs of a Pagan* paired her poems with her photographs, and opened with a facsimile of an autograph letter to her from Stieglitz which proclaimed that:

In her particular field she has done pioneer work. She is a woman expressing herself through her camera, her mountains, and her strangely struggling striving trees—herself recording a strangely fascinating romantic spirit. I have watched her development for many years. I deeply respect her as a worker.[3]

Though a projected exhibition of her prints at 291 somehow never transpired, Stieglitz faithfully included Brigman's work in three issues of *Camera Work*, January 1909, April 1912, and October 1913—precisely the period during which his awareness of Cézanne was highest. If he saw echoes of Cézanne's Bathers in her work, it would help explain how he maintained this regard for her work at a time when he otherwise rejected Pictorialist soft focus, and distanced himself from former associates in the Photo-Secession.

ELLEN HANDY

1. The most comprehensive source regarding Brigman is Susan Ehrens, *A Poetic Vision: The Photographs of Anne Brigman* (Santa Barbara, CA: Santa Barbara Museum of Art, 1995).

2. Kathleen Pyne, *Modernism and the Feminine Voice: O'Keeffe and the Women of the Stieglitz Circle* (Berkeley and Los Angeles: University of California Press, 2008).

3. Anne Brigman, *Songs of a Pagan* (Caldwell, ID: Caxon, 1949), 6.

ANNE BRIGMAN

Cat. 27
Dryads, 1913
Plate III from the journal *Camera Work* (No. 44, October 1913)
Photogravure
7⁹⁄₁₆ × 11 in. (19.2 × 27.9 cm)
The Baltimore Museum of Art: Gift of Cary Ross,
BMA 2007.176.37

PATRICK HENRY BRUCE (1881–1936)

Patrick Henry Bruce was deeply affected by Cézanne for virtually his entire career, perhaps longer than any American artist of his generation.[1] Bruce studied art from an early age and by mid-1902 was in New York, where he studied under Robert Henri. Like his fellow Virginian Thomas Jefferson, Bruce understood culture to be French and classical by definition, and its center in Paris, and there Bruce settled by early 1904. For almost three years, he was content to continue in a realist vein, while studying old masters in the Louvre. By mid-1906, however, his painting began to show an awareness of Impressionism. At about the same time, he first attended the salons of Leo and Gertrude Stein, where he met Matisse, through whose eyes he began to absorb the lessons offered by Cézanne. Bruce would have absorbed the two great Cézanne exhibitions of 1906 and 1907, pivotal events for any emerging artist. With the Steins and Max Weber, Bruce was a founding member of Matisse's school when it began in January 1908, a crucial point in American art, for it joined France and America on a path to a new, abstracting phase of color painting that has continued to this day.

Cézanne, as seen through Matisse's eyes, also became Bruce's artistic father, until the end of his life. By mid-1910 Bruce was deeply immersed in adopting Cézanne's methods of color construction, strokes of paint made palpable through varying densities of materiality, thus following Cézanne's dictum that when color is at its richest, form is at its fullest. Bruce painted some landscapes (such as cat. 28) emulating the broad, open planes of Cézanne's walls that formed strong horizontals and verticals, a kind of protogrid that lay at the heart of the Cubist-based abstractions Bruce did from 1912 to 1914.[2] Yet for all its planarity, the landscape has the look and feel of a Cézanne watercolor, rather than an oil, such as *House Among Trees* (c. 1900, cat. 20), and *Rocks at Bibémus* (1887–90, cat. 7). Bruce's color in his early works was generally lighter and higher keyed than Cézanne's, telling us of the intervening example of Matisse, a mediation seen often in American art of the time.

However, Bruce paid far more attention to Cézanne's still lifes and their myriad formats, then and later. Often, as in works of 1911 (cats. 29, 30), Bruce left portions of the canvas unpainted, as Cézanne had, the better to focus on the single, few, or multiple objects carefully arranged on a tabletop, seen from any number of angles and points of view. For both, it was as if the painter—and the viewer—were walking around the table, arranging, rearranging the disposition of a few, several, or multiple objects in a continuing process of what Meyer Schapiro famously termed the painter's activity in still life as a "solitary pictorial chess."[3] The off-whites of the canvas surface became colors in themselves that also contrasted and heightened the intense colors of the palette, a lesson learned from Cézanne's "unfinished" paintings. Bruce's endless search paralleled Cézanne's unending quest, which indicated the ultimately incomplete process of art and of life itself. Paint could be thicker (as in cat. 29), denser, more sculptured, and in close-knit, parallel strokes—a Cézanne staple of color construction—organized along a diagonal axis moving from the lower right to the upper left; or it could be looser, more open, each area of color seemingly going its own, almost arbitrary way, as in cat. 30, but with a final harmony established by the fusion of table, objects, and wall.

By 1912, Bruce's fascination with color led him into the orbit of Robert and Sonia Delaunay, who were painting large-scale Orphist-Synchromist related canvases that captured the sights and kaleidoscopic rhythms of modern Paris. In 1916, Bruce did a series of abstracting Compositions that focus on the rhythms of the popular dance hall the Bal Bullier using pure color areas in triads and chords that we can trace to Cézanne. In these paintings, we find a veritable history of the shift from pre– to post–World War I art. By mid-1916 as the horrific war dragged on, artists, critics, authors, and poets saw that the old world of prewar optimism was over, and that they needed to prepare a new kind of art for a new world, built on old values, classical values based on a solid foundation that would change and rebuild the world and the society. Bruce's Compositions embody this shift, for they move from loose, open, multiple shapes to more clarified, architectural, and geometric forms, toward a more classical harmony.

By 1917 or early 1918, Bruce had distilled from the Compositions his first still lifes in a quasi-geometric, Precisionist style, the mode in which

he worked until his early death by suicide in 1936. Bruce's geometric still lifes predate the Purism of Le Corbusier and Ozenfant, contrary to standard accounts, although they should be seen as part of the same drive, part of the larger "call to order." While Bruce's post-1918 paintings looked to the future of painting, their realization depended on a return to the myriad still-life formats of Cézanne. Bruce clearly held Cézanne as an exalted master, as great as any of the old masters he had studied in the Louvre. For Bruce, Cézanne embodied the classical order and stability long associated with the history of French art since Poussin, and the ideals of Jeffersonian thought.

Bruce's post-1918 paintings were forerunners of another wave of Cézannism, part of a new classicism that developed in response to the chaos of World War I and extended well into the 1920s and even 1930s. Although Bruce would not have seen it, the great 1916 Cézanne show at the Montross Gallery in New York heralded this revival in America. Bruce revisited Cézanne, modifying his still lifes into new formats, etched with the linear exactitude of Andrea Mantegna, an artist of the highest order for Bruce, in a kind of "visionary reconstruction of art history."[4] At first Bruce depicted the still life close-up with relatively few objects, with the table top pressed up-front and against the picture plane; some may suggest Cézanne's *Still Life: Plate of Peaches* (1879–80, cat. 3) or *Fruit and a Jug on a Table* (c. 1890–94, cat. 10). But as Bruce gained more confidence in the possibilities of his format, his work became

larger and far more complex. Forms appear to tumble down the radically tilted table, calling to mind Cézanne's late, monumental still lifes such as *Still Life with Apples and Peaches* of about 1905 (cat. 21). In these, Bruce's goal of a classical serenity seemed out of reach, giving way to a sheer joyousness in color and multiple shapes orchestrated with remarkable control. But they went unnoticed in Paris, and were neglected in America until the 1960s, when artists such as Al Held, Frank Stella, and Ron Davis responded to them in their abstract illusionist pictures.

But by 1927–28, Bruce found again a more controlled and simplified balance and harmony, as in *Painting* (c. 1929–30, cat. 31), the model he used until 1936, when he took his own life. Forms are few, exactingly placed: here, a glass with a straw at center, anchoring the color triad of the primaries, yellow, various gradations of blues and reds, enriched by grays and whites, recalling Cézanne's more controlled and classical still lifes. In these canvases, Bruce had found a harmony of balance and equilibrium we connect with the classical past of the Mediterranean world, a balance between conception and observation, the key to much of Cézanne's art. Bruce was well aware of their classicism, for he wrote a friend on March 17, 1928, that "you should be well prepared to appreciate my paintings after Greece."[5]

WILLIAM C. AGEE

1. See William C. Agee and Barbara Rose, *Patrick Henry Bruce, American Modernist: A Catalogue Raisonné* (New York: The Museum of Modern Art, 1979), for all facts of his life and reproductions of all his known work.

2. The likely Cézanne sources for Bruce's *Landscape* (1910) are *Turning Road* (1900–1906, R930), and *Turning Road in the Woods* (1902–6, R889)—reproduced in color in William Rubin, *Cézanne's Late Work* (New York: The Museum of Modern Art; 1977): 278, 283—which Bruce could have seen at Vollard's. Conversation with Gail Stavitsky, September 17, 2008.

3. See Agee and Rose, *Patrick Henry Bruce,* 31, for full discussion and citation for quote.

4. David Smith, "Second Thoughts on Sculpture," *College Art Journal* 13, no. 2 (Winter 1954): 203–7.

5. Patrick Henry Bruce to Henri-Pierre Roché, March 17, 1920. Reprinted in Agee and Rose, *Patrick Henry Bruce,* 222.

PATRICK HENRY BRUCE

Cat. 28
Landscape, c. summer 1910
Oil on canvas
28 × 18¼ in. (71.1 × 46.4 cm)
Collection of The Honorable and Mrs. Joseph P. Carroll,
New York

PATRICK HENRY BRUCE Cat. 29
Still Life (with Flower Pot and Fruit), c. summer 1911
Oil on canvas
23¼ × 19½ in. (59.52 × 49.92 cm)
Collection of Mrs. Henry M. Reed

ARTHUR B. CARLES (1882–1952)

A respected artist and teacher, Arthur Beecher Carles brought European modernism back from Paris to the rather academically oriented and conservative Philadelphia in the beginning of the twentieth century. His role in the promotion of modernism, as defined by the work of Cézanne and Matisse, during that time can hardly be overstated. As Barbara Wolanin noted, "Carles' paintings span turn-of-the-century academic impressionism, early American modernism, and the mid-century emergence of Abstract Expressionism."[1] Carles was active in the art scene in New York, but it was in Philadelphia that he left his most indelible mark. He taught at the Pennsylvania Academy of the Fine Arts from 1917 to 1925. In 1920, Carles and William Yarrow organized the exhibition *Representative Modern Masters,* which featured work by Cézanne and, as Wilford Wildes Scott noted, this "established Carles as the acknowledged leader of the avant-garde in Philadelphia."[2]

Carles studied with William Merritt Chase at the Pennsylvania Academy. He spent six and a half years there, from 1900 to 1907, and he excelled as a student and won numerous prizes and fellowships. It was through the Cresson Traveling Scholarship—which Carles was awarded twice—that he was able to travel to Europe. His second grant, received in 1907, was for a full two years in Europe, which he extended to 1910. His arrival in Paris coincided with the Cézanne retrospective at the Salon d'Automne of 1907. Carles associated with other young American artists in the city, including John Marin and Alfred Maurer.[3] Carles and Maurer shared an address, and it was probably through Maurer that Carles was first introduced to the Steins. Carles was part of the New Society of American Artists in Paris.[4] Fellow member Edward Steichen brought Carles into the Stieglitz circle.

Though Carles chose to live and teach in Philadelphia rather than New York, his work was shown at Stieglitz's 291 and at the Montross Gallery in that city. *Still Life with Compote* (1911, cat. 32), was initially exhibited in 1912 at his first solo show at 291. A review of the exhibition in *American Art News* praised Carles's landscapes and portraits, noting his obvious academic training and fine draftsmanship, but concluded, "It would seem that this artist is playing with Post Impressionism as with a new toy. With his knowledge and ability it is to be hoped he will soon tire of said toy."[5] Carles was in Paris again from July to November of 1912, and *Still Life with Compote* was exhibited that year in the Salon d'Automne.

Still Life with Compote, like much of Carles's painting, reveals the influence of Cézanne—more specifically, Cézanne filtered through Matisse. The parallel brushwork, cropped composition, and flattened space are all reminiscent of Cézanne. Carles created form with color, an idea derived from the French painter. The vibrant palette points to the influence of Matisse, whom Carles met in Paris.[6] The dynamic composition of the work, set in motion by the shock of color and decorative patterning of the wallpaper, is grounded by the brilliantly white bowl in the center of the table. Of *Still Life with Compote,* William H. Gerdts noted the "Fauve-like sensuousness in the enjoyment of color and paint . . . combined with a solidity of form and an application of brushstroke that derives very much from Cézanne."[7] Though clearly inspired by Cézanne and Matisse, Carles retained traces of his academic training in Philadelphia, and he created a style distinct from both European masters.

EMILY SCHUCHARDT NAVRATIL

1. Barbara A. Wolanin, *Arthur B. Carles (1882–1952): Painting with Color* (Philadelphia: Pennsylvania Academy of the Fine Arts, 1983), 15.

2. Wilford Wildes Scott, "The Artistic Vanguard in Philadelphia (1905–1920)," Ph.D. diss., University of Delaware, 1983, 233.

3. Henry G. Gardiner, "Arthur B. Carles: A Critical and Biographical Study," *Philadelphia Museum of Art Bulletin* 64, no. 302/303 (January–June 1970): 144.

4. Barbara Haskell, *The American Century: Art & Culture, 1900–1950* (New York: Whitney Museum of American Art in association with W. W. Norton, 1999), 35.

5. "Carles at Photo-Secession," *American Art News* 10 (January 27, 1912): 6.

6. Gardiner, "Arthur B. Carles," 145.

7. William H. Gerdts, *Painters of the Humble Truth: Masterpieces of American Still Life, 1801–1939* (Tulsa: Philbrook Art Center; Columbia: University of Missouri Press, 1981), 244.

ARTHUR B. CARLES

Cat. 32
Still Life with Compote, 1911
Oil on canvas
24 × 25 in. (61 × 63.5 cm)
Collection of The Newark Museum, Bequest of
Miss Cora Louise Harshorn, 1958, 58.171
Montclair only

ANDREW DASBURG (1887–1979)

Andrew Dasburg was one of the few American artists to incorporate elements of Cubism in his work prior to the Armory Show of 1913, the result of European travel and seeing the latest developments in modernism and Cézanne's paintings firsthand. As his biographer Van Deren Coke observed, "Dasburg would be the first to say that his life as an artist can be divided neatly into two parts: before and after the day he encountered Cézanne's work in Paris in 1910."[1] He appreciated what he called the "gravitational weight" of Cézanne's break from tradition.[2] "To me," he wrote, "Cézanne is sublime, each contact with his art fills me with new life."[3]

French born, Dasburg grew up in New York City and studied under the academician Kenyon Cox at the Art Students League. His initial encounter with nontraditional painting methods came from Robert Henri, who taught night classes at the New York School of Art. Henri encouraged his students to paint directly from nature, which Dasburg did while at the League's summer sessions in Woodstock, New York. In the summer of 1907, he rented a house there with two other students, including Morgan Russell, who had begun annual travel to Paris in 1906 and would settle there in 1909.

Russell excited Dasburg with his tales of the artistic environment in France, and wrote frequent letters when in Paris, encouraging his friend to join him. In one letter of 1908, Russell conveyed the excitement of meeting the sculptor Rodin, of seeing numerous paintings by Monet at the Durand-Ruel Gallery, and of "drinking in wonderful art—getting intoxicated as it were" by what he saw, adding, "Monet is not the only one: wait till you get acquainted with Gauguin, Cézanne and the younger men Matisse, etc., and then there is Renoir."[4] It is likely the first time Dasburg had heard about Cézanne.

Convinced of its importance to his own development, Dasburg traveled to France in April 1909 and met up with Russell and the American sculptors Arthur Lee and Jo Davidson. Although Russell had written to him of Cézanne, Dasburg claimed to have been taken by surprise when he first saw several of Cézanne's paintings at Ambroise Vollard's gallery, recalling years later that the encounter was completely by chance. "I was overwhelmed. Something happened like a bright light coming on," he recalled.[5] Dasburg immersed himself in the contemporary art scene, visited Matisse's studio, and frequented with Russell and Lee the avant-garde salons of Leo and Gertrude Stein, where Dasburg was first introduced to Picasso. From Leo Stein, Russell and Dasburg borrowed a small painting of apples by Cézanne, from which they made copies (see cats. 2, 94).[6] Dasburg wrote, "To me the original is infinitive. It will rest in my mind as a standard of what I want to attain in my painting, i.e., the qualities which it contains to such a great degree."[7]

Returning to Woodstock in August 1910, Dasburg conveyed the modernist ideas learned in Europe, especially those of Cézanne, to other artists and students, including Henry Lee McFee.

"I was at that time an evangelist," explained Dasburg.[8] The German-born artist Konrad Cramer arrived there early the following year, bringing direct knowledge of Wassily Kandinsky, Franz Marc, and *Der Blaue Reiter* group of Expressionists. Cramer helped Dasburg lead Woodstock's "Sunflower Club," an avant-garde group of painters. Dasburg's paintings became infused with the sharp angles and fractured perspective of Cubism, and he went through a brief Synchromist period of brilliant color as practiced by Russell and fellow American Stanton Macdonald-Wright. This is evident in Dasburg's *Floral Still Life* (1912, cat. 34). The following year, Dasburg was included in the Armory Show, where he showed three paintings and a sculpture.[9] He briefly explored nonrepresentational paintings, but soon realized that, like Cézanne, he preferred to draw his inspiration from nature.

A major shift in the artist's career came in 1918 when he visited Taos, New Mexico, at the invitation of Mabel Dodge. He greatly admired the open expanses and rugged terrain of the Southwest's high desert. Dasburg stayed for five months and, beginning in 1920, spent part of each year in northern New Mexico before settling permanently in Santa Fe in 1930. Although portraits by him are relatively rare, his greatest interest in this subject came during the 1920s, and he pursued it in New Mexico and back in Woodstock. The paintings show stoic and aloof sitters, and feature an inanimate quality found in portraits by Cézanne. His portrait of fellow Woodstock

artist Judson Smith (c. 1923, cat. 35) retains these traits, with elements demonstrating his interest in Cubism. Smith is seated before a severe gray backdrop; his features are simplified to largely straight lines and harsh angles, and his shirt is composed of abstracted, geometric lines. The harsh light on Smith's exaggerated right cheekbone recalls the brutal lines of Dasburg's Armory Show sculpture. Of the sitter, Dasburg stated, "for me, he's always had a Satanic look."[10]

Dasburg's first decade in New Mexico coincided with his maturation as an artist, as he distilled his knowledge of European modernism into a personal style, with Cézanne's influence always remaining in the fore. *My Gate on the Camino* (1928, cat. 36) depicts the neighborhood on Camino del Monte Sol, where he lived near other artists, including his student Willard Nash. Adobe houses appear like building blocks of color set within the landscape, while rectangular brushwork and bold colors describe the land and undulating mountains in the distance. The flattened composition includes multiple perspectives, most notably the wall in the foreground, which is shown frontally and from above simultaneously. Dasburg's interest in simplification, of distilling nature to its vital forms, would continue through the years and, following John Marin's visits to the region in 1929 and 1930, he expressed a greater interest in watercolor.

Few artists had as great a role in the spread of Cézanne's innovations and European modernism in the Southwest as Dasburg, as evidenced in the work of his many students. Among those who studied with him were Nash, Ward Lockwood, Kenneth Adams, Barbara Latham, Howard Cook, and Cady Wells, all recognized as dedicated modernists who worked, to varying degrees, in a structural, Cézannesque, or Cubist manner. As Lockwood exclaimed, "I know of no single artist in the Southwest who has influenced, or does influence, the work of younger painters more than Andrew Dasburg."[11]

JERRY N. SMITH

1. Van Deren Coke, *Andrew Dasburg* (Albuquerque: University of New Mexico Press, 1979), 2.

2. Andrew Dasburg, "Cubism: Its Rise and Influence," *The Arts* 5, no. 5 (November 1923): 280.

3. Quoted in Coke, *Andrew Dasburg*, 26; and in Sheldon Reich, *Andrew Dasburg: His Life and Art* (Lewisburg, PA.: Bucknell University Press; London: Associated University Presses, 1989), 33.

4. Morgan Russell to Andrew Dasburg, August 1908. Photocopy of letter, Andrew Dasburg Artist File, New Mexico Museum of Fine Art Research Library.

5. Despite the letter from Russell mentioning Cézanne, Dasburg recalled stumbling onto Vollard's gallery by accident while wandering the streets of Paris, having "never heard of Cézanne." See Paul Cummings, "Interview with Andrew Michael Dasburg," March 26, 1974, Archives of American Art, Smithsonian Institution.

6. None of Dasburg's copies survives.

7. Quoted in Coke, *Andrew Dasburg*, 16.

8. Dasburg interview.

9. Dasburg's sculpture was a rare experiment in carved plaster, and was selected for one of the official postcards sold during the exhibition. See Milton W. Brown, *The Story of the Armory Show* (n.p.: Joseph H. Hirshhorn Foundation with the New York Graphic Society, Greenwich, CT, 1963), 70.

10. Dasburg interview.

11. Quoted by Jerry Bywaters in *Andrew Dasburg* (New York: American Federation of Arts, 1957), 23. See Charles C. Eldredge, *Ward Lockwood, 1894–1963* (Lawrence: University of Kansas Museum of Art, 1974), 25.

ANDREW DASBURG

Cat. 34
Floral Still Life, 1912
Oil on canvas
20 × 16 in. (50.8 × 40.6 cm)
Collection of Curtis Galleries, Minneapolis, Minnesota

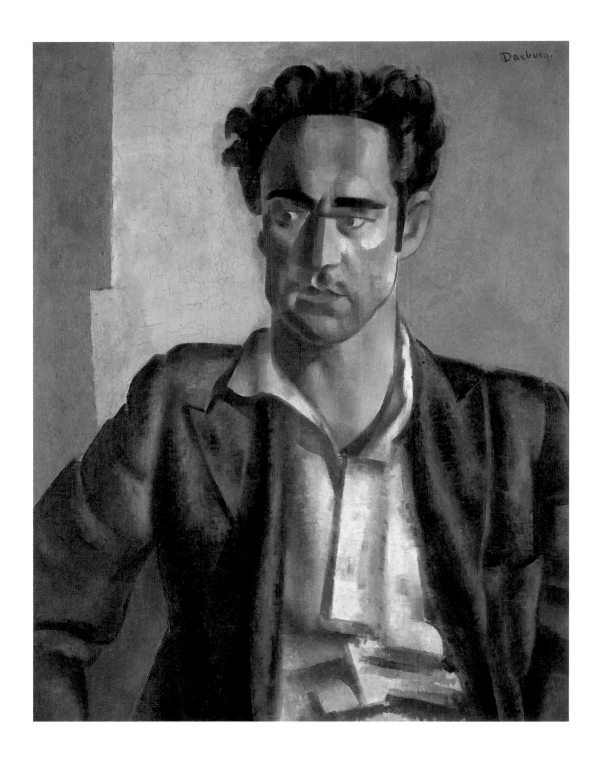

ANDREW DASBURG

Cat. 35
Judson Smith, 1923
Oil on canvas
29⅞ × 24 in. (75.9 × 61 cm)
Dallas Museum of Art, Gift of Mrs. A. Ronnebeck, 1957.21

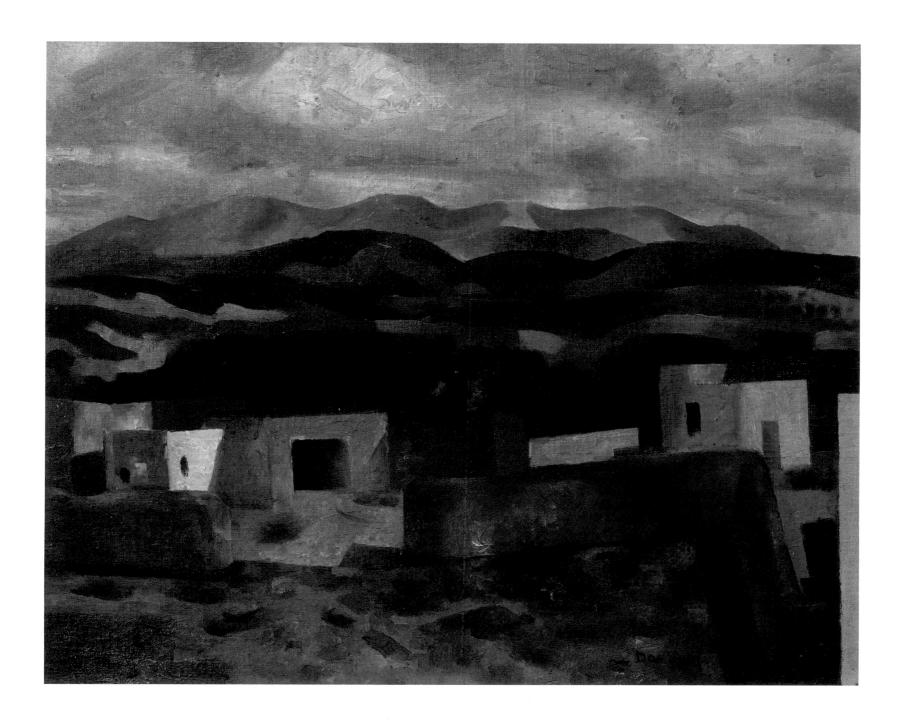

ANDREW DASBURG

Cat. 36
My Gate on the Camino, 1928
Oil on canvas mounted on masonite
13 × 16 in. (33 × 40.6 cm)
Collection of the New Mexico Museum of Art,
Gift of Mrs. R. J. Erickson, 1964 (1473.23P)

To paint from nature is not to copy what is objective; it is to realize one's sensations.[12]

—Paul Cézanne

ARTHUR B. DAVIES (1862–1928)

Arthur B. Davies was among the most knowledgeable and effective promoters of Cézanne and modern art in America during the early twentieth century. He played a variety of instrumental roles as an organizer of seminal exhibitions, as an advisor to galleries and collectors, and as an artist who was deeply inspired by Cézanne, whose works he would acquire for himself as well. As president of the anti-academic Association of American Painters and Sculptors, Davies set about with his own plan for what would become the 1913 Armory Show, which prominently featured the then little-known work of Cézanne and other European modernists. Already an admirer of Cézanne, whose works he had seen firsthand in the H. O. Havemeyer collection, Davies purchased impressions of his large and small color lithographs of Bathers during the run of the Armory Show, adding them to a collection of the French artist's work he had begun a few years earlier. He eventually collected at least seven works, primarily watercolors and drawings of landscapes and nudes.[1]

Davies' original interest in Cézanne had been fueled by the enthusiasm of artist-friends like Maurice Prendergast, whose participation Davies secured for the landmark exhibition of the Eight, in New York in 1908. When Prendergast returned from Paris in 1907, he spoke constantly of "old Paul," and had nothing but praise for his work.[2] The following year Davies' appreciation of Cézanne was further advanced by Walter Pach's groundbreaking introduction to the artist in *Scribner's Magazine*. Davies and Pach later

co-organized Cézanne's show of watercolors at the Montross Gallery in 1916.[3] In his lively correspondence with Pach, Davies praised the "classic beauty" of Cézanne's art, referring specifically to *The Road* (c. 1871, R169).[4] Featured in the Armory Show, this painting was purchased, through Pach, at Davies' behest for his patron Lillie P. Bliss.

Davies had confirmed his admiration for Cézanne in 1911 when he purchased one of his watercolors for $375 at the master's exhibition at 291. Recounting that event, Stieglitz recalled: "Arthur B. Davies came in. He wanted one of the [Cézanne] watercolors. He was the only buyer."[5] Davies' acquisition—*The Well in the Park of Château Noir* (1895–98)[6]—may have been the single watercolor, lent anonymously, represented in the Armory Show. Davies' fascination with Cézanne's casual, sketchy watercolor technique prompted him to purchase three additional examples of the Frenchman's work in this medium, all of which focused on trees. This subject exemplifies Davies' concern with the backgrounds of Cézanne's compositions of nude female and male figures in his Bather compositions.

The stylized figures of *Clothed in Dominion* (c. 1912, cat. 37) are arranged in a rhythmic, friezelike presentation reminiscent of Cézanne's compositions. There are also Cézannesque suggestions of broken contours which allow for the broadly brushed landscape to partially penetrate the figures. The awkward quality of the individual figures evokes Cézanne's response to this subject. Their almost choreographed poses suggest Davies'

longtime interest in modern dance, especially that of the figure to the far left, evocative of Nijinsky in his electrifying performance of *L'Après-midi d'un faune* (1912).[7] Resembling each other, the young men were all evidently based on Davies' primary male model, a muscular Algonquin Indian named Tahamet. While the architectonic structure of Davies' composition particularly evokes Cézanne's influence, the gracefully posed figure types also suggest his admiration for the work of Puvis de Chavannes.[8]

By the time *Clothed in Dominion* was featured at the Macbeth Galleries in 1918, Davies was acclaimed as one of the foremost artists in America. At the time of his one-man show at the Modern Gallery in 1920, Davies was praised for his use of Cézanne's "plastic distortion of form" to attain "splendid, lyrical and rhythmic qualities."[9] Cézanne's impact was also noted on the occasion of the 1923 Carnegie International in Pittsburgh, where Davies won First Prize. His art, "while disclosing the influence of Cézanne," was regarded as being "of a robust, full-blooded and decidedly American type."[10] Thus Davies played pivotal roles in the appreciation of Cézanne and modern art, both in terms of his own work and also as an ardent proselytizer who cultivated influential friendships with a generation of American artists and collectors, including John Quinn and two of the founders of The Museum of Modern Art in New York, Lillie P. Bliss and Abby Aldrich Rockefeller.[11]

BENNARD B. PERLMAN

1. Milton Brown, *The Story of the Armory Show* (New York: Abbeville Press, 1988), 252ff. For Cézannes owned by Davies, see John Rewald, *Paul Cézanne, The Watercolors: A Catalogue Raisonné* (Boston: Little, Brown, 1983), nos. RWC361, RWC397a, RWC399, RWC428; and *The Arthur B. Davies Collection* (New York: American Art Association, 1929), lots 72, 73, 377 (two studies, double-sided), 385, 393 (two studies, double-sided). See also Adrien Chappuis, *The Drawings of Paul Cézanne: A Catalogue Raisonné* (Greenwich, CT: New York Graphic Society, 1973), 1: no. 96, possibly nos. 1158 and 1211, however, the locations suggest otherwise.

2. Walter Pach, *Queer Thing, Painting: Forty Years in the World of Art* (New York: Harper & Brothers, 1938), 224.

3. Judith Zilczer, "'The World's New Art Center': Modern Art Exhibitions in New York City 1913–1918," *Archives of American Art Journal* 14, no. 3 (1974): 5.

4. Bennard Perlman, *American Artists, Authors, and Collectors, The Walter Pach Letters, 1906–1958* (Albany: State University of New York Press, 2002), 139.

5. Dorothy Norman, *Alfred Stieglitz: An American Seer* (New York: Aperture, 1973), 106.

6. RWC428.

7. The author wishes to acknowledge this observation of Maureen O'Brien, letter of July 9, 2008.

8. Patricia C.F. Mandel, *Selection VII: American Paintings from the [Rhode Island School of Design] Museum's Collection, c. 1800–1930* (Providence: Museum of the Rhode Island School of Design, 1977), 211–12. Davies' title for his composition is typically confusing, for his repetitious figures of Tahamet are all near-nudes. Is it possible that the title is intended to suggest that the men, though unclothed, are "clothed in authority"?

Perhaps Davies himself was unsure, since written in pencil across the top of the stretcher are several alternative titles scratched out: "Crying (?) of the Water. / Smooth. Cross Water / Dominion Clothed." A pair of alternate titles not scratched out are here too: "Clothed in Dominion" and "Journeying Stream."

9. Peyton Boswell, "Art of Davies is Strange Mixture," unidentified clipping, February 6, 1920, Marius de Zayas Papers, Archives, Frances Mulhall Achilles Library, Whitney Museum of American Art, New York.

10. "The Twenty-Second International Exhibition of Paintings at Carnegie Institute, Pittsburgh, PA," *Outlook*, May 9, 1923, 838.

11. Judith Zilczer, "Arthur B. Davies: The Artist as Patron," *The American Art Journal* 19, no. 3 (1987): 76–7, 81.

ARTHUR B. DAVIES

Cat. 37
Clothed in Dominion, c. 1912
Oil on canvas
24⅝ × 60½ in. (61.9 × 153.7 cm)
Museum of Art, Rhode Island School of Design,
Bequest of Miss Lizzie P. Bliss

CHARLES DEMUTH (1883–1935)

The art of American modernist Charles Demuth was strongly affected by Post-Impressionism and Cubism, and he absorbed various visual lessons from a range of French artists. Of these, it was Cézanne who served as the vital intellectual touchstone that enabled Demuth to negotiate the stylistic transition to his mature work by the mid-1910s. The significance of his influence on Demuth's painting has long been recognized by critics and scholars, as Andrew Carnduff Ritchie observed: "His greatest debt is to the founder of Cubism, Cézanne."[1] Adept in the medium of watercolor, the two artists shared a passion for still life, and their firm sensitivity to structure was grounded in a strong sense of place.

Demuth had many opportunities to view work by Cézanne in both America and Europe. Philadelphia and New York were readily accessible by train from his home in Lancaster, Pennsylvania, and he was a regular visitor to Alfred Stieglitz's New York gallery, 291, where a group of Cézanne's watercolors were displayed in March 1911. Gertrude Stein owned significant paintings by him, and during Demuth's second trip to Europe, between December 1912 and spring 1914, he often stopped by her Paris apartment at 27, rue de Fleurus. By the early twenties, the artist had established a close friendship with Albert Barnes, whose impressive collection in Merion, Pennsylvania, on the Philadelphia Main Line, included important works by the French master.

Cézanne's impact is especially evident in Demuth's watercolors, the medium he favored for his Bermuda paintings and his still lifes of fruits and vegetables, the latter of which also date from the midteens. A. E. Gallatin noted in 1922 that "with Cézanne came a new tradition for the painter in water-colour, a freshness that did not hitherto exist,"[2] and in being "full of the most delicate draughtsmanship and alluring colour,"[3] Demuth's works were imbued with the spirit of the earlier French artist. Demuth's impressive technical skills with this limpid medium enabled him to create imagery that was simultaneously both flowing and crisp, and in leaving large areas of his paper untouched, his preliminary pencil lines remain clearly visible. This is true for both his Bermuda work, as in *Houses* (1918, cat. 39), and in his still life, *Fruit No. 1* (1922, cat. 42).

Demuth spent the summer of 1916 in Provincetown, Massachusetts, sharing a house with Marsden Hartley. It was in this coastal town popular with artists that he began to distill his distinctive visual vocabulary. In late December, Hartley left for Bermuda, and Demuth followed early in February 1917, and remained a month and a half.[4] Also in residence was French painter Albert Gleizes, with whom Demuth had become acquainted in New York at the Walter Arensbergs. The pair reinforced Cézanne's stylistic possibilities to Demuth, and his Caribbean sojourn permitted a formal breakthrough as he synthesized Cézanne and Cubism, producing abstracted architectural paintings of stunning structural clarity that signaled his most important work. Some watercolors, like *Trees and Barns (Bermuda)* (1917, cat. 38),

show his mastery of understatement, while *Red Chimneys* (1918, cat. 41) pairs a disciplined angular linearity with the organic curves of the trees, his muted washes counterpointed by the startlingly bright colors.

Demuth began intensively exploring still-life subjects in the midteens, but his most ambitious compositions date from the twenties, and these handsome paintings are notable for "their angular faceted definition of form and in the interplay of curves and diagonals, radiating towards the edges of the paper."[5] In *Pears and Plums* (1924, cat. 43), he concentrated his composition at the center, framing it with crisp lines and splotchy washes. Gallatin regarded his still lifes as distinctive: "These fruits and vegetables are very cool. The juiciness of a peach by Renoir or the passion which Cézanne put into an apple are not to be found here. This is not voluptuous fruit: it comes from a country whose *vin du paye* is iced water."[6] In *Apples* (c. 1925, cat. 44), the artist deftly conveys a sculptural solidity that is reinforced by the rich colors of the fruit and glass.

Demuth's Bermuda works, in contrast to his late Lancaster subjects, are not of identifiable sites, and paintings like *Housetops* (1918, cat. 40) portray a type of colonial building, one that echoes the familiar structures of Pennsylvania. As he did with his Pennsylvania architectural paintings, Demuth likely made quick pencil sketches outdoors, but made finished watercolors in his studio, as evidenced by the fact that he kept producing Bermuda subjects in 1918. He continued the formal

transition he began in Bermuda in subsequent visits to Provincetown and Gloucester, and by 1920, he had shifted to oils for his major artistic statements. His Bermuda pieces and his faceted renditions of apples, pears, and other fruit were strongly influenced by Cézanne, providing the foundation for a series of monumental architectural paintings inspired by Lancaster buildings that established Demuth as a major American Precisionist and are the great works of the last decade and a half of the artist's life. It was Cézanne who provided the initial catalyst.

BETSY FAHLMAN

1. Andrew Carnduff Ritchie, *Charles Demuth* (New York: The Museum of Modern Art, 1950), 16.

2. A. E. Gallatin, *American Water-colourists* (New York: E. P. Dutton, 1922), 17.

3. Ibid., 22.

4. See Barbara Haskell, *Charles Demuth* (New York: Whitney Museum of American Art, 1988), 124, 142n4. She documented that Demuth was in Bermuda in February 1917, not in the fall of 1916, as stated by Farnham and subsequent scholars (Marsden Hartley to Alfred Stieglitz, February 8, 1917, Yale Collection of American Literature).

5. Ritchie, *Charles Demuth*, 16.

6. A. E. Gallatin, *Charles Demuth* (New York: William Edwin Rudge, 1927), 9.

CHARLES DEMUTH

Cat. 38
Trees and Barns (Bermuda), 1917
Watercolor over graphite on paper
9 15/16 × 14 in. (25.2 × 35.6 cm)
The Baltimore Museum of Art: Purchase Fund, BMA 1950.49
Baltimore only

CHARLES DEMUTH

Cat. 39
Houses, 1918
Watercolor on paper
13¾ × 9¾ in. (34.9 × 24.8 cm)
Columbus Museum of Art, Ohio: Gift of Ferdinand Howald,
1931.121
Phoenix only

CHARLES DEMUTH

Cat. 40
Housetops, 1918
Watercolor on paper
9¾ × 13½ in. (24.8 × 34.3 cm)
Columbus Museum of Art, Ohio: Gift of Ferdinand Howald, 1931.134
Montclair and Baltimore only

CHARLES DEMUTH

Cat. 41
Red Chimneys, 1918
Watercolor and graphite on paper
10⅛ × 14 in. (25.72 × 35.56 cm)
The Phillips Collection, Washington, DC
Montclair only

CHARLES DEMUTH

Cat. 42
Fruit No. 1, 1922
Watercolor and graphite on paper
9¼ × 12¾ in. (23.5 × 32.4 cm)
Columbus Museum of Art, Ohio:
Gift of Ferdinand Howald, 1931.132
Baltimore and Phoenix only

Cat. 43
Pears and Plums, 1924
Watercolor and graphite on paper
11½ × 17¼ in. (29.2 × 43.8 cm)
Columbus Museum of Art, Ohio:
Gift of Ferdinand Howald, 1931.140
Baltimore and Phoenix only

CHARLES DEMUTH

Cat. 44
Apples, c. 1925
Watercolor on paper
11¾ × 18 in. (29.8 × 45.7 cm)
Sheldon Museum of Art, University of Nebraska-Lincoln,
UNL-F.M. Hall Collection
Montclair and Baltimore only

ARTHUR G. DOVE (1880–1946)

The nature and the extent of Cézanne's influence on Arthur G. Dove has been hardly noted in the Dove literature. Yet Dove held Cézanne, as well as Alfred Stieglitz, Rembrandt, and van Gogh, among his most cherished sources of inspiration. When Dove began his career as a painter, in New York, he worked in an Impressionist manner of soft, atmospheric color. In mid-1908, he went to France, where he stayed until late 1909 before returning to America. Little is known of his activity there, although he apparently stayed outside Paris, where he had befriended Alfred Maurer, who became his mentor and lifelong friend. Dove's stay coincided with the peak of Cézanne's fame in France, and he must have seen a considerable amount of Cézanne's art, especially under the guidance of Maurer.

By the end of the year 1908, in *Still Life against Flowered Wallpaper* (cat. 45) for example, there are abundant marks of the French artist's influence: there is a new solidity to the painting, a tactile materiality of color and thus form, for the two are coeval throughout, and are basic tenets of Cézanne's art. The color is higher keyed than his earlier work, indicating that Dove too, like Patrick Henry Bruce, was looking at Cézanne, at least in part, through the eyes of Matisse.[1] Indeed, this Dove canvas has a startling similarity in composition and feel to Matisse's *Blue Still Life* of 1907 in the Barnes Foundation (Merion, PA). Dove's painting is composed part by part, each with its own order and axis, then fused into a single mosaic of color areas in which space is compressed and the elements merge with the wall decoration, methods well established in Cézanne's art and extended by Matisse. The fruits have an almost sculptural density, in keeping with the widespread reaction to the perceived lack of structure and order in the filtered color of Impressionism, and following Cézanne's dictum to make of Impressionism something solid, like the art of the museums. The poetry of the repeated elliptical shapes of the fruits playing across the surface, responding only to the dictates of the picture itself, and thus creating their own order, reminds us of Cézanne. So, too, do the disjointed and fragmented angles of the corners of the table, helping to bind the surface. The painting is the first instance of Dove's lifelong search for, not realism, but for the real, the concrete, the believable.[2]

Cézanne's influence continued through much of Dove's life. His so-called abstractions of about 1910, for example, are surely indebted in large measure to Cézanne's late landscapes of rough-hewn rocks and hills. At least several of Dove's famous pastels of 1911–12, especially those with buildings, can be traced to the broad, flattened planes of Cézanne's late architectural work, here perhaps as experienced through the 1908–9 landscapes of Picasso and Braque.

In 1921, after a long absence from painting, Arthur Dove's art began to blossom again. Water was a source and inspiration for the artist, living on it as he did for much of his life. He concentrated on landscapes, often the sun and the water, and the natural world immediately around him, with which he had developed an intense spiritual kinship. Often he showed the sunrise, as in the 1924 painting *Sunrise* (fig. 1), here a glorious burst of light and color, the dawning of a new day,

Fig. 1 Arthur G. Dove, *Sunrise*, 1924. Oil on wood. Milwaukee Art Museum, Gift of Mrs. Edward R. Wehr, M1960.32

the constant rebirth of the self and the world. The image may remind us more of van Gogh, but the means come directly from Cézanne. The expansive bursts of light are translated into something concrete, in a carefully plotted system of color and paint application, a fusion made through contiguous, tightly knitted parallel brushstrokes that recall Cézanne's *passage*. Dove employed this technique in much of his work through the 1920s and 1930s.

WILLIAM C. AGEE

1. Is it possible that Dove observed Matisse's classes, begun in January 1908?

2. See William C. Agee, "New Directions: The Late Work, 1938–1946" in Debra Bricker Balken et al., *Arthur Dove: A Retrospective* (Andover, MA: Addison Gallery of American Art; Washington, DC: The Phillips Collection; Cambridge, MA: The MIT Press, 1997).

ARTHUR G. DOVE

Cat. 45
Still Life against Flowered Wallpaper, 1909
Oil on canvas
25⅝ × 31⅞ in. (65.1 × 81 cm)
Collection of Curtis Galleries, Minneapolis, Minnesota

We must again become classicists by way of nature, that is to say, by sensation. . . . I am old, and it is possible I shall die without having attained that great end.[13]

—Paul Cézanne

ARSHILE GORKY

Cat. 48
Still Life, c. 1927–28
Oil on canvas
30 × 36 in. (76.2 × 91.44 cm)
Private Collection

MARSDEN HARTLEY (1877–1943)

"I can make a landscape like Mr. Paul Cézanne," writer Ernest Hemingway exclaimed. "I learned how to make a landscape from Mr. Paul Cézanne by walking through the Luxembourg Museum a thousand times. . . ." He continued, "all such people [artistic predecessors] are easy to deal with, because we all know you have to learn."[1]

Some may find it curious that Hemingway turned to Paul Cézanne for creative inspiration, yet such was the special place that the French painter occupied among the pioneering generation of twentieth-century modernists. The shadow he cast was unrivaled. Picasso, to cite another revealing example, named him "my one and only master."[2] Like these two, numerous astute artists looked to Cézanne and took away discoveries that were pointedly self-serving.[3]

The painter Marsden Hartley fits squarely within the tide of admiration for the French master. His relationship to Cézanne is both fascinating and complicated. Hartley was a leading figure in the American avant-garde and prominent in Alfred Stieglitz's circle. He sought the path of a revolutionary and meaningfully contributed to modernism's new vocabularies. Born in 1877, Hartley also lived during the decades that saw two world wars. Consequently, his life and career were not always stable since he pursued artistic experimentation and traversed severe cultural dislocations.

Indeed, Hartley's art had marked twists and turns. During phases when he needed new direction, Hartley looked to Cézanne. There are three moments of obvious focus on Cézanne—in 1911 to 1912, in 1926 to 1928, and in 1935 to 1943. Yet, Hartley had a deeper, more protracted confrontation with the French painter than just these conspicuous episodes. In looking for a reliable artistic guide, Hartley could do no better than Cézanne, given his overwhelming stature.

The transcendentalist writer Ralph Waldo Emerson was Hartley's first and enduring source of inspiration.[4] Emerson championed direct encounters with verdant nature as the optimal source for spiritual revelation and artistic stimulation. Cézanne also advocated developing oneself and one's art through sustained contact with nature. This alignment made Cézanne a natural exemplar for the young artist.

In fact, Cézanne was a stimulus for Hartley before he ever laid eyes on one of his canvases. The publication of German critic Julius Meier-Graefe's 1904 *Entwicklungsgeschichte der modernen Kunst* placed Cézanne at the center of modern art.[5] By 1910, Meier-Graefe had penned an influential monograph on Cézanne, one that Hartley read in Maine. In 1911, he wrote Alfred Stieglitz: "I keep before me on the wall—Cézanne's utterance on form + book of ancient wisdom—so much significance has it—and in the black + white reproductions of Meyer-Graefe [sic] on Cézanne one sees how much this means."[6] Months later in Manhattan, the artist Arthur B. Davies engineered a visit for Hartley to the famous H. O. Havemeyer collection, where he could see eleven works by the master.[7] His reading and firsthand viewing inspired a pictorial quotation of Cézanne during a burst of experimentation, and *Still Life: Fruit* (1911, cat. 49) reveals Hartley's growing absorption of this key predecessor.

On April 12, 1912, Hartley sailed for Europe and went directly to Paris, where he quickly inserted himself into its international milieu. His entrée to the famous salon of Leo and Gertrude Stein proved advantageous. There, he was able to study the enviable modern art collection of the Stein siblings. That proximity encouraged Hartley to remain with still-life imagery and to fashion a new body of work that creatively layered the styles of Cézanne and Cubism. The strong graphic matrix in *Still Life* (1912, cat. 50) evokes the sway of Cubism, and the selection of fruit and textured fabrics suggests Cézanne.

Hartley's friendship with Gertrude Stein also contributed to his deepening regard for Cézanne. In later years, she acknowledged the pivotal role Cézanne played for her. Through apprehending his pictorial accomplishment, she was inspired to begin writing, and she replicated in text what she perceived Cézanne created in paint.[8] Hartley and Stein became friends by discussing American philosopher William James.[9] Surely, they also talked about Cézanne and their mutual respect for him. Hartley wrote often of his enthusiasm for Cézanne in these years, calling him "ever the admirable and artistic and splendid, dignified thing."[10] In 1913, he

wrote an essay linking the creative iconoclasm of Paul Cézanne and Walt Whitman.[11] Indeed, this pair represented Hartley's most ardent heroes during the 1910s and 1920s.

Hartley moved to Berlin in spring 1913 and developed some of the strongest paintings of his career.[12] While his vocabulary absorbed German Expressionism and French Cubism, he acknowledged that Cézanne provided a critical impetus. "There is something beyond intellect that intellect cannot explain—These are sensations in the human consciousness beyond reason—and painters are learning to trust these sensations and make them authentic on canvas. This is what I am working for. It has its best expression in the last work of Cézanne. . . . It is from these that I jumped off into my ideas."[13]

Hartley left Berlin in December 1915, having remained there after World War I began. Expecting accolades in the States for his recent paintings, he instead received a cold shoulder because his imagery featured the German military uniform. In the midst of war fervor, this subject matter was positively radioactive. Hartley found he had to leave behind his achievements in Berlin and entirely reinvent himself. A rehabilitative sojourn in New Mexico in 1918 to 1919 enabled Hartley to regain purpose, and here too the precedent of Cézanne helped.

In New Mexico, Hartley returned to landscape painting. Now, however, he distanced himself from subjective extrapolations and "sensations beyond reason" and fixed his sights squarely on what appeared in front of him. He was "copying nature as faithfully as possible."[14] In his shift to landscape, realism, and an empirical approach, Hartley accommodated his art to a burgeoning concern for place and nationalism between the world wars. He wrote several prescient essays about commitment to American identity and to place from 1918 to 1922.[15] In one, Hartley again cited Cézanne as a useful model to lead the way.[16]

In 1921, Hartley returned to Berlin for several years. The New Mexico landscape remained Hartley's subject along with still lifes. In Europe, where he could live inexpensively as part of an invigorating international avant-garde, he continued to wrestle with landscape and its reading of place. In Berlin, both before and now after the war, Hartley encountered an environment very supportive of French Impressionism and Cézanne and Manet especially.[17] Leading galleries exhibited Cézanne, and progressive collectors acquired his paintings. National Galerie director Hugo von Tschudi added Cézanne's work to this public collection.[18] In huddles at artist cafés as well as establishment galleries and museums, Hartley encountered respect for Cézanne. This as well as other factors would have encouraged Hartley's next step—a move to Cézanne's own territory in the south of France.

In September 1925, Hartley leased a house in Vence, outside Nice, on the Côte d'Azur. The following autumn, he shifted to Aix-en-Provence and rented lodgings outside the town in the Maison Maria, a building that was part of an estate called Château Noir. From 1887 to 1902, Cézanne had rented studio space in the main château.[19] The American had now placed himself at the very locus of his artistic guide. He remained based in Aix until winter 1927.

Cézanne was lauded as an iconoclast loner, an artist who focused on a self-defined achievement rather than public acclaim. In an era when Nietzsche's philosophy dominated cultural criticism, the model of the solitary genius had cachet.[20] Hartley considered himself misunderstood and without patrons or recognition that he deserved, and he would have appreciated Cézanne's personal choices and related them to his own artistic struggles. Hartley's isolation in Provence brought on depression. Yet, he soldiered on and stuck to his labor, which produced rich discoveries.[21]

Provence gave Hartley new terrain for his canvases. He appreciated the ruggedness of this landscape and its elevation shifts "with their austere simplicity and refined grandeur."[22] In his 1928 poem and essay on Cézanne's country, Hartley emphasized the special quality of light in this region "so admirably perceived and expressed in the landscapes of Cézanne."[23] *Purple Mountains, Vence* (1925–26, cat. 52) reveals Hartley's study of the strong southern light and the sculptural massing of landscape forms. His raking light creates shadows with heft and tangible density.

His 1927 paintings of Mont Sainte-Victoire with their high-keyed color reveal Hartley's continued exploration of the rich light in Provence (cats. 54, 55). Praising Cézanne, Hartley wrote his works "are not cold studies of inanimate things, they are pulsing realizations of living substances."[24] In Provence, Hartley began to deepen that sensitive presence in his work.

Years of location changes continued, until Hartley began a return to his native Maine in the 1930s. Several summers spent painting the glacial moraine outside Gloucester, Massachusetts—a harsh, primal scene of impressive boulders not unlike Cézanne's Bibémus quarry—aided this trajectory to greater self-knowledge. The precedent of an artist overwhelmingly committed to his native soil finally struck Hartley as salient, so much so that he advertised himself as the "Painter from Maine" after 1937.[25] Over time and with experience, Hartley also readjusted his philosophical stance.[26] He softened his rhetoric about strident empirical objectivity and accepted that "I belong naturally to the Emerson-Thoreau tradition and I know that too well. It is my native substance."[27]

These accommodations created a sustained body of work that bore rich artistic fruit in the final decade of Hartley's life. "I return to my tall timbers and my granite cliffs," Hartley clarified in 1938, "because in them rests the kind of integrity I believe in and from which source I draw my private strength."[28] Authoritative paintings of wooded forests, imposing granite cliffs, and local

Fig. 1 Marsden Hartley, *Mount Katahdin, Maine*, 1942. Oil on hardboard. National Gallery of Art, Washington, DC, Gift of Mrs. Mellon Byers

workers occupied Hartley's late canvases. All these subjects are authentic to Maine and, nonetheless, find telling parallels in Cézanne's oeuvre.

Hartley's last great series depicts Mount Katahdin, Maine's imposing mountain (fig. 1). Here too, the correspondence to Cézanne and his Mont Sainte-Victoire is clear. Hartley had learned from Cézanne the value of rootedness and the merit of pictorial "realizations of living substances." These gifts shine with mastery in Hartley's Katahdin canvases and late paintings. As Hemingway quipped, "We all know you have to learn."[29] Marsden Hartley spent a creative lifetime of looking and learning. Across those years, Cézanne proved to be a very potent source of artistic sustenance for this American modern.

PATRICIA MCDONNELL

1. Ernest Hemingway quoted in Lillian Ross, "How Do You Like it Now, Gentlemen?" *Life Stories: Profiles from the New Yorker,* ed. David Remnick (New York: Random House, 2000), 242.

2. Pablo Picasso to Christian Zervos, "Conversation avec Picasso," *Cahiers d'art* (1935): 178; as quoted in Fred Leeman, "Painting after Cézanne," in *Cézanne and the Dawn of Modern Art,* ed. Felix A. Baumann et al. (Ostfildern, Germany: Hatje Cantz, 2004), 175.

3. For distinguished analysis on the complexity of artistic sources, see Michael Baxandall, *Patterns of Intention* (New Haven, CT: Yale University Press, 1985). Pages 58–62 of this volume are particularly illuminating, as they discuss the relationship of Cézanne's "influence" on Picasso.

4. For analysis of Hartley's embrace of Emersonian transcendentalism, see Gail R. Scott, "Introduction," in Marsden Hartley, *On Art,* ed. Gail R. Scott (New York: Horizon Press, 1982), 19–57.

5. Julius Meier-Graefe, *Entwicklungsgeschichte der modernen Kunst* (Stuttgart: J. Hoffman, 1904). The book was translated into English in 1908.

6. Marsden Hartley to Alfred Stieglitz, August 20, 1911. Yale Collection of American Literature, Beinecke Rare Book and Manuscript Library, Yale University; hereafter cited as YCAL. In fact, Hartley does not identify what Meier-Graefe book he read, but Hartley scholars largely agree that it was his latest on *Paul Cézanne* (Munich: Piper Verlag, 1910). Alfred Stieglitz also exhibited Cézanne prints in a group show in New York from November 18 to December 8, 1910, and a selection of twenty watercolors March 1–25, 1911; yet Hartley missed these shows.

7. Frances Weitzenhoffer, *The Havemeyers: Impressionism Comes to America* (New York: Harry N. Abrams, 1986), 193. See also John Rewald, *Cézanne and America: Dealers, Collectors, Artists, and Critics* (Princeton: Princeton University Press, 1989), 125, 126, 128n44, list of eleven paintings and citation of letter from Hartley to Gertrude Stein in which he recalls seeing nine "very fine" Cézannes, so he may not have seen all of them.

8. Stein acknowledged that coming to understand Cézanne's *Portrait of the Artist's Wife* in her collection inspired her to write her first book, *Three Lives.* See Stein, "A Transatlantic Interview," *A Primer for the Gradual Understanding of Gertrude Stein,* ed. R. B. Haas (Los Angeles: Black Sparrow Press, 1971), 5. Stein again mentioned Cézanne as inspiration for her to start writing in "Lectures in America" (1935), *Gertrude Stein Writings 1932–1946* (New York: Library of America, 1998), 235–36. Also see Jayne L. Walker, "The Reality of Cézanne and Caliban," *The Making of a Modernist: Gertrude Stein from Three Lives to Tender Buttons* (Amherst: University of Massachusetts Press, 1984).

9. Marsden Hartley to Alfred Stieglitz, October 22, 1913, YCAL.

10. Marsden Hartley to Alfred Stieglitz, November 1912, YCAL.

11. Marsden Hartley, "Whitman and Cézanne," *Adventures in the Arts* (New York: Boni and Liveright, 1922), 30–36. In correspondence to Alfred Stieglitz dated September 20, 1913 (YCAL), Hartley mentioned that he was writing an essay on the pair, which he assumedly published in this later volume.

12. For discussion of this pivotal chapter in Hartley's career, see Patricia McDonnell, "El Dorado: Marsden Hartley in Imperial Berlin," in *Dictated by Life: Marsden Hartley's German Paintings and Robert Indiana's Hartley Elegies* (Minneapolis: Frederick R. Weisman Art Museum with DAP, 1995), 14–55; Patricia McDonnell, "'Portrait of Berlin': Marsden Hartley and Urban Modernity in Expressionist Berlin," in *Marsden Hartley,* ed. Elizabeth Kornhauser (Hartford, CT: Wadsworth Atheneum; New Haven, CT: Yale University Press, 2003), 39–67; Patricia McDonnell, *Painting Berlin Stories: Marsden Hartley, Oscar Bluemner, and the First American Avant-Garde in Expressionist Berlin* (Frankfurt-am-Main: Peter Lang Publishing, 2003).

13. Marsden Hartley to Alfred Stieglitz, September 20, 1913, YCAL.

14. Marsden Hartley to Alfred Stieglitz, August 1, 1918, YCAL.

15. See his "Tribal Esthetics," *The Dial* 65 (November 16, 1918): 399–40; "America as Landscape," *El Palacio* 5 (December 21, 1918): 340–42; "Red Man Ceremonials, An American Plea for American Esthetics," *Art and Archaeology* 18 (January 1920): 7–14; "The Scientific Esthetic of the Redman," *Art and Archaeology* 13 (March 1922): 113–19.

16. Hartley, "America as Landscape," 340.

17. Walter Feilchenfeldt, "The History of Cézanne's Reception in Germany," *By Appointment Only: Cézanne, van Gogh, and Some Secrets of Art Dealing* (London: Thames and Hudson, 2006), 123–62; Michael F. Zimmerman, "A Tormented Friendship: French Impressionism in Germany," *The Two Art Histories: The Museum and the University,* ed. Charles W. Haxthausen (Williamstown, MA: Sterling and Clark Art Institute; New Haven, CT: Yale University Press, 2002), 162–182.

18. Barbara Paul, *Hugo von Tschudi und die modern französische Kunst im Deutschen Kaiserreich* (Mainz, Germany: Verlag Philipp von Zabern, 1993); Johann Georg Prinz von Hohenzollern and Peter-Klaus Schuster, *Manet bis Van Gogh: Hugo von Tschudi und der Kampf um die Moderne* (Munich: Prestel Verlag, 1996).

19. Philip Conisbee, "Le Tholonet, Bibémus, and the Château Noir," *Cézanne in Provence* (Washington, DC: National Gallery of Art; New Haven, CT: Yale University Press, 2006), 198.

20. See McDonnell, "The American Vogue for Nietzsche," *Painting Berlin Stories,* 23–26.

21. See Townsend Ludington, *Marsden Hartley: The Biography of an American Artist* (Boston: Little, Brown, 1992), the chapter "Cézanne Country, 1924–1928," 170–85.

22. Marsden Hartley to Alfred Stieglitz, February 2, 1926, YCAL.

23. Marsden Hartley, "Impressions of Provence, from an American's Point of View," in *On Art,* 143. See also Marsden Hartley, "The MOUNTAIN and the RECONSTRUCTION," in *On Art,* 74–77.

24. Hartley, "Whitman and Cézanne," in *Adventures in the Arts,* 33.

25. Donna Cassidy, "The 'Painter from Maine' and New England Regionalism," *Marsden Hartley: Race, Region, and Nation* (Hanover, NH: University Press of New England, 2005), 17–61.

26. For analysis of Hartley's strong shifts of position regarding intuition and objectivity, see Patricia McDonnell, "Changes of Heart: Marsden Hartley's Ideas and Art," *Marsden Hartley: American Modern* (Minneapolis: Frederick R. Weisman Art Museum; Seattle: University of Washington Press, 1997), 14–72.

27. Marsden Hartley to Edith Halpert, July 12, 1933, quoted in Garnett McCoy, ed. "Letters from Germany, 1933–1938," *Archives of American Art Journal* 25, nos. 1, 2 (1985): 3–28.

28. Marsden Hartley, "Is There an American Art?," in *On Art,* 199.

29. Ernest Hemingway quoted in Ross, "Gentlemen," 242.

MARSDEN HARTLEY

Cat. 51
Landscape, Vence, 1925–26
Oil on canvas
25½ × 31⅞ in. (64.8 × 81 cm)
Lent by the Frederick R. Weisman Art Museum, University of
Minnesota, Minneapolis. Bequest of Hudson D. Walker from
the Ione and Hudson D. Walker Collection, 1978.21.256

MARSDEN HARTLEY

Cat. 52
Purple Mountains, Vence, 1925–26
Oil on canvas
25¾ × 32⅛ in. (65.4 × 81.6 cm)
Collection of Phoenix Art Museum, Gift of Mr. & Mrs. Orme
Lewis

MARSDEN HARTLEY

Cat. 53
Aqueduct in Provence (or Alpes Maritimes, Vence), 1925–27
Oil on canvas
31⅛ × 31⅛ in. (79.7 × 79.7 cm)
Collection of Curtis Galleries, Minneapolis, Minnesota

MARSDEN HARTLEY

Cat. 54
Mont Sainte-Victoire, 1927
Oil on canvas
32 × 39½ in. (81.3 × 100.3 cm)
Private Collection of Elaine and Henry Kaufman
Montclair and Baltimore only

MARSDEN HARTLEY

Cat. 57
Still Life with Leaves in Pitcher, 1928
Oil on canvas
25¾ × 32 in. (65.4 × 81.3 cm)
Montclair Art Museum, Gift of Mr. and Mrs. Edgar S. Peierls,
1959.41

MARSDEN HARTLEY

Cat. 58
Still Life with Compote and Fruit, 1928
Oil on canvas
19⅞ × 29 in. (50.5 × 73.7 cm)
Collection of Phoenix Art Museum, Gift of Richard Anderman
in honor of Lorenz and Joan Anderman
Phoenix only

WILLIAM H. JOHNSON (1901–1970)

Although best known for his images of African American life produced in Harlem in the late 1930s and early 1940s, William Henry Johnson was profoundly influenced by Cézanne and European modernism during an earlier period of his career. Born in Florence, South Carolina, Johnson was recognized for his artistic abilities at an early age. He moved to Harlem in 1918, and began his art training three years later at the National Academy of Design. He worked closely with the teacher Charles Hawthorne (1872–1930), who encouraged his students to experiment and improvise, particularly with the use of strong color.[1] Johnson quickly became one of Hawthorne's favorite students, and he participated in Hawthorne's summer program at the Cape Cod School of Art. In his fifth year at the National Academy of Design, with Hawthorne's encouragement, Johnson applied for the Pulitzer Traveling Scholarship, which provided $1,500 for the winner to travel. Perhaps due to racial prejudice at the school, Johnson's application was unsuccessful. Hawthorne began a fundraising campaign among his friends and colleagues, and soon thereafter Johnson was able to travel to Europe to complete his artistic education.[2]

Johnson arrived in Paris in the fall of 1926, and quickly acclimated to the new world around him. His earliest paintings from Paris show the strong influence of his Impressionist predecessors, with hints of Claude Monet, Alfred Sisley, Camille Pissarro, and Paul Gauguin in his brightly colored landscapes, still lifes, and interiors.[3] Within a year of his arrival in France, Johnson had come under the spell of two other modern painters— Paul Cézanne and Chaim Soutine. In 1927, Johnson abandoned the cold, gray skies of the Parisian winter and moved to Cagnes-sur-Mer, a small town made famous by the artists Soutine and Pierre-Auguste Renoir.[4] There he was free to experiment with pigment and composition, fully embracing the expressionistic tendencies that he had learned from Soutine and his contemporaries. Johnson clearly delighted in the sense of liberty in a letter to his former teacher, Charles Hawthorne: "I am painting . . . the old villages, buildings, and streets. . . . I have a big space to select from that gives me all the freedom that I need. Here the sun is everything. . . . I am not afraid to exaggerate a contour, a form, or anything that gives more character and movement to the canvas."[5]

In his Cagnes compositions, Johnson was able to paint his immediate and emotional reaction to what he saw and felt, while always retaining a clear view of the subject he was portraying. Although the expressionistic influence of Soutine was paramount during this period in Johnson's career, in late 1920, he produced a small, but powerful group of paintings that have a clear "Cézannesque" inspiration. These landscapes feature the volumetric forms and small patches of pigment typical of the French master. In *Cagnes-sur-Mer* (1928, cat. 59), for example, Johnson also employed the even-handed and controlled use of both warm and cool colors in a manner that is reminiscent of Cézanne's characteristic palette. By adding his unique sense of movement and light, however, Johnson makes this modern composition his own.

KATHERINE ROTHKOPF

1. Richard J. Powell, *Homecoming: The Art and Life of William H. Johnson* (New York: Rizzoli, 1991), 13–14. This text provides excellent information about Johnson's biography.

2. Ibid., 21.

3. Ibid., 27–30.

4. Steve Turner and Victoria Dailey, *William H. Johnson: Truth Be Told* (Los Angeles: Seven Arts Publishing, 1998), 21.

5. William H. Johnson to Charles W. Hawthorne, August 13, 1928, Charles W. Hawthorne Papers, Archives of American Art, Smithsonian Institution, quoted in Powell, *Homecoming*, 31.

WILLIAM H. JOHNSON

Cat. 59
Cagnes-sur-Mer, 1928
Oil on canvas
19⅜ × 24 in. (49.2 × 61 cm)
Private Collection, Houston

LEON KROLL (1884–1974)

As an art student in New York at the National Academy of Design from 1906 to 1908, Leon Kroll learned to appreciate the art of the past as he was forming his own personal style. He became fascinated with Rembrandt's work, and spent a month painting his mother's portrait in the Dutch master's style. He later described the process of working through another artist's approach: "If you copy directly, it's a kind of a swipe, you know. It doesn't belong to you; it's a secondhand thing. Going from an old master back to yourself through nature, I felt, was the way to register it in your own mind in a more original fashion."[1]

In 1908, Kroll won a scholarship from the National Academy of Design that allowed him to travel to Europe to study painting for two years, and he enrolled at the Académie Julian in Paris. His introduction to Cézanne's work took place in 1909, when Kroll saw a group of his paintings in a gallery window in Paris: "I looked at those two pictures in the window, and they fascinated me. A little bit like Manet, only much more sensitive in their planes, with beautiful blacks and grays. Like Manet, but much better in their subdivision of the planes."[2] He inquired about the artist, and was unfamiliar with Cézanne's name. Years later, the lack of recognition for the French master's work in New York during the first decade of the twentieth century still surprised Kroll: "But even in my National Academy days I had never heard Cézanne's or Van Gogh's names mentioned, nor even in Paris in the ateliers. That was 1908 and 1909, and people were laughing at them, even

some people who later became very modern. But I appreciated the subtle quality of the planes of color in Cézanne's work. I thought it was wonderful."[3]

Upon his return to Europe in 1910, and after subsequent trips to France and Spain in 1911 and 1914, Kroll's enthusiasm for Cézanne and his artistic colleagues persisted.[4] "I loved Cézanne's work and was fascinated by him and Van Gogh, and a little later by Gauguin. In fact, I discovered both Van Gogh and Cézanne without ever having heard their names, just through loving their pictures."[5] Despite his enthusiasm for Cézanne's work in 1909, it took several years for his influence to become apparent in Kroll's work.

In 1917, Kroll produced a group of landscapes that show Cézanne's inspiration the most vividly, with locations ranging from New York to New Mexico.[6] *Landscape—Two Rivers* (cat. 60) was painted during one of Kroll's painting forays in Eddyville, New York, in 1917. He discovered the picturesque town in 1916, and returned the following year in search of motifs. "I found this lovely place on Rondout Creek, just off the Hudson River, near Woodstock. It was between the creek and a canal and looked like a little Spanish village. It was an amazing thing, but no artist had ever been there according to the natives."[7] It is painted with a technique reminiscent of Cézanne's work, particularly in his use of volumetric form, rich color, and sense of monumentality, as Kroll later admitted: "For the period around 1915–18, I thought Cézanne was a very interesting influence

on my work. . . . I was terrifically impressed with Cézanne's works, and it really influenced me quite a bit. I painted a little under his influence for a few years. I learned a lot from him."[8]

KATHERINE ROTHKOPF

1. Nancy Hale and Fredson Bowers, eds., *Leon Kroll, A Spoken Memoir* (Charlottesville: University Press of Virginia, 1983), 11.

2. Ibid., 19.

3. Ibid., 20.

4. For more information about Kroll's development and inspiration from 1910 to 1914, see Kenneth Morton Davis, "The Life and Work of Leon Kroll with a Catalogue of His Nudes," Ph.D. diss., Ohio State University, 1993, 1:36–49.

5. Hale and Bowers, *A Spoken Memoir*, 109.

6. Davis, "The Life and Work of Leon Kroll," 1:55–56.

7. Hale and Bowers, *A Spoken Memoir*, 40.

8. Ibid., 109.

LEON KROLL

Cat. 60
Landscape—Two Rivers, 1917
Oil on canvas
33⅞ × 39¾ in. (86.1 × 101 cm)
The Baltimore Museum of Art: The Cone Collection, formed
by Dr. Claribel Cone and Miss Etta Cone of Baltimore, Mary-
land, BMA 1950.343

STANTON MACDONALD-WRIGHT (1890–1973)

Stanton Macdonald-Wright, working in tandem with Morgan Russell, conceived of Synchromism as the visual equivalent of music—a universal art form unencumbered by narrative, illustration, or the circumstances of time and place. A brash mixture of appropriation, imagination, and innovation, Synchromism was the first vanguard painting movement founded by Americans, and arguably the single greatest influence on its two founders was Paul Cézanne.

That Macdonald-Wright saw himself as the artistic progeny of Cézanne is evidenced in the 1914 portrait he made of his brother, the author and critic Willard Huntington Wright (1887–1939). Painted in Paris while the brothers were living a near-impoverished existence at 14, rue de Moulin de Beurre, the portrait (cat. 61) derives its style and composition from an 1895–96 painting by Cézanne, *Portrait of Gustave Geffroy* (fig. 1).[1] Willard is depicted seated at a table with a stack of books, his hands on an open book, and a row of books behind him. His biographer, John Loughery, explicates the Cézanne connection: "Geffroy was one of the first journalists to write in support of the Provence master, predicting that the artist, then outrageously neglected, would one day grace the Louvre. Willard, it seems, was to be the Geffroy to Stanton's Cézanne. He was being groomed for a lofty part."[2] Indeed, Wright would serve as the chief propagandist for Synchromism, beginning in 1914 and cresting in 1915 with his book *Modern Painting*, in which he lent his prose skills to Macdonald-Wright's theoretical perspectives.

In 1912, two years before the portrait of Willard Huntington Wright and just prior to the emergence of Synchromism, Macdonald-Wright explained in a letter to Thomas Hart Benton why Cézanne was the central figure to the development of modern painting: the French master was "the first to teach us what painting really was & freed us from the coloring (no matter how brightly) of black and white drawings," by which Macdonald-Wright meant all academic painting.[3] Macdonald-Wright continued in this effusive and enlightening letter:

> We have inherited from the first painter, Cézanne, a heritage which opens to us the door wide which until now has been nearly bolted. Everything is before us but—do not let us hope to equal at the ages of 22 what it took him a lifetime to do. If we go easy first and get the exact rapport between the big things; the intricacies of color & form, the enrichening of tone & plane will come of itself later & bring with it something never yet dreamed of.

Macdonald-Wright then went on to rigorously analyze a still life for Benton, explaining that it is of no artistic necessity to recognize a lemon as a lemon or to know that the pitcher depicted holds water. What matters, he explained with illustrations, is that the colors used be in the correct relationship to each other in terms of temperature, intensity, and depth. Liberated from the classical traditions of outline and tonal modeling "you

have something in which emotion and intellect balance with perfect poise" and, according to Macdonald-Wright:

> This is the modern idea, not that many have it or know it but this is what Cézanne has brought to art, the substitution of color for black & white modeling. He says it took him 40 years to learn that painting was not sculpture. The time was well spent. Painting is in its infancy, everything is ahead of it & everything is that all painting for years to come will show an influence of Cézanne. There are many who just use color for its own sake. This means nothing but pattern making. Color must express form in space before it has a *raison d'être*.[4]

This "modern idea" to create form using color alone—discovered in Cézanne—was the genesis of Synchromism. Beginning in 1912, the year of his letter to Benton, Macdonald-Wright and Russell rigorously investigated both the physics and the psychology of color. The two often worked after Cézanne still lifes, studying their formal properties with the eventual goal of losing all referents save the color itself.[5] Both artists returned regularly to still-life painting throughout their subsequent careers (cats. 63, 64) believing that abstraction was arrived at not by abandoning nature but by embracing it.[6]

The equally modern idea for Macdonald-Wright that "emotion and intellect balance with perfect poise" quickly expanded for himself

Fig. 1 Paul Cézanne, *Portrait of Gustave Geffroy*, 1895–96. Oil on canvas. Musée d'Orsay, Paris

and Russell. While studying in Paris with the Canadian Percyval Tudor-Hart (1873–1954), Macdonald-Wright and Russell embraced the possibilities of synesthesia, the physical phenomenon of experiencing one sensory mode (sight, sound, smell, taste, or touch) in terms of another, as in hearing a color. Macdonald-Wright and Russell greatly simplified the complex color systems espoused by Tudor-Hart by adopting color scales that mirrored musical scales.[7]

Macdonald-Wright's claims about the uniqueness of Synchromist painting were reported as early as 1913 in Los Angeles.[8] In the fall of 1918, Macdonald-Wright returned to his California home as something of a self-appointed prophet of and proselytizer for modern art, and he soon promoted Synchromism in the press, careful to note its relationship to Cézanne: "These color harmonies, limited in number with Cézanne, but of singular justness of vibration, we three [Russell, Macdonald-Wright, and Tudor-Hart] made precise in studying the solar spectrum, and it is now as easy for a painter to strike a perfect chord in any color scheme on his palette as for a pianist to do the same thing on the piano."[9]

Macdonald-Wright's 1918 watercolor of Santa Monica (cat. 62) flows directly from the artist's intense admiration of Cézanne's landscape, but is hardly a slavish copy. Macdonald-Wright has fused Cézanne's stylistic innovations—the spare, transparent segments of color syncopated in space—with his own brilliant Synchromist palette. True to his lofty rhetoric, the perception

of depth in Macdonald-Wright's watercolor is achieved via the placement of warm reds, yellows, and oranges in the middle-to-foreground, while skeins of primarily blue and violet define the distance. No color is muted toward gray; all retain distinct identities and intensities, orchestrated along with the empty yet charged spaces to elicit a sweeping movement through the seemingly weightless vista.

Near the end of his life, in August 1973, Macdonald-Wright briefly outlined the sources of Synchromism in an unpublished document entitled "The Roots of Synchromism." It was Cézanne—a full sixty years after his letter to Thomas Hart Benton—that Macdonald-Wright cited as most crucial: "Cézanne—first use of color as a functioning element—not for decor, not for light, not for *images chinoises*."[10] From his student years in Paris through his final paintings in Southern California, Macdonald-Wright owed his fundamental ideas about color to Cézanne.

Over his long and enormously productive career, Macdonald-Wright built upon the "modern idea" of finding balance between emotion and intellect, adding to it the necessity for the artist to balance Eastern philosophy with Western technology. This artistic ambition outgrew the ability of any one artist to fulfill, but it was nonetheless an ambition, as he had written in 1912, "never yet dreamed of," and the source of this dream may be traced in a rhythmic line back to the legacy of Paul Cézanne.

WILL SOUTH

1. Macdonald-Wright would have seen the painting on exhibition in Paris in 1912 at the *Exposition d'art moderne*, Manzi, Joyant & Cie, 1912, no. 19.

2. John Loughery, *Alias S.S. Van Dine: The Man Who Created Philo Vance* (New York: Charles Scribner's Sons, 1992), 81.

3. Stanton Macdonald-Wright to Thomas Hart Benton, Thomas Hart Benton Papers, 1906–1975, Archives of American Art, Smithsonian Institution, roll 2325, frs. 509–11.

4. Macdonald-Wright to Benton, Benton Papers, roll 2325, frs. 513–16.

5. Macdonald-Wright recalled purchasing four watercolors by Cézanne shortly after arriving in Paris: "In 1908 I bought four Cézanne watercolors and lived with them. I know Cézanne." Macdonald-Wright to Mrs. Phillips, July 26, 1973. Typescript copy in author's file, from the Estate of Stanton Macdonald-Wright, Los Angeles. Macdonald-Wright did not, however, arrive in Paris until the fall of 1909. He married in Los Angeles on January 14, 1908 according to a certified copy of their marriage license, provided to the author on July 4, 1992, by the Registrar-Recorder/County Clerk for the County of Los Angeles, State of California. The newlyweds spent most of the next year in San Francisco before leaving for Europe. In addition, Thomas Hart Benton recalled meeting Macdonald-Wright in Paris "in the late autumn of 1909" when Macdonald-Wright had "recently arrived from California." See Benton, *An American in Art* (Lawrence: University Press of Kansas, 1969), 18. Finally, it was reported by Antony Anderson that "Stanton Macdonald-Wright, a student of the Art Students League, will start for Paris this week to be gone for five years of study." See "Art and Artists," *Los Angeles Sunday Times*, June 27, 1909.

6. "We are incapable of imagining a form that is not the result of some contact of our senses with nature. Or at least the forms that issue from this contact are infinitely more expressive and varied than those born of the inventive labor of the intellect. So far as form is concerned, one must maintain a relationship with nature." Macdonald-Wright, "Individual Introduction," *Les Synchromistes: S. Macdonald-Wright et Morgan Russell* (Paris: Bernheim-Jeune & Cie., 1913), unpaginated.

7. For a detailed account of the Synchromist method, see Will South, *Color, Myth, and Music: Stanton Macdonald-Wright and Synchromism* (Raleigh: North Carolina Museum of Art, 2001).

8. Antony Anderson, "Art and Artists," *Los Angeles Times*, November 23, 1913.

9. Antony Anderson, "Of Art and Artists," *Los Angeles Sunday Times*, August 3, 1919.

10. Jan Stussy Papers, Archives of American Art, Smithsonian Institution, roll 3976, frs. 695–99, emphasis in original. For Macdonald-Wright, a fundamental difference between the Synchromists and the Orphist Robert Delaunay (1885–1941) was that "Delaunay followed the path of Gauguin—decor—Synchromists the path of Cézanne—form in space, 1912–1913."

All quoted material by Stanton Macdonald-Wright, Courtesy of Estate of Stanton Macdonald-Wright, Los Angeles

234

STANTON MACDONALD-WRIGHT

Cat. 61
Willard Huntington Wright (S. S. Van Dine), 1913–14
Oil on canvas
36¼ × 30¼ in. (92.1 × 76.8 cm)
National Portrait Gallery, Smithsonian Institution; this acquisition was made possible by a generous contribution from the James Smithson Society, NPG.86.7

STANTON MACDONALD-WRIGHT

Cat. 62
California Landscape, 1918
Watercolor on paper
15¼ × 18½ in. (38.7 × 47 cm)
Private Collection
Montclair only

JOHN MARIN (1870–1953)

John Marin had a complex relationship with Cézanne, denying early knowledge of the Frenchman's work (thus denying the possibility of influence). Yet critics nonetheless have been prone to reference relationships between their shared formal concerns. Marin lived in Europe from autumn 1905 to autumn 1910, except for one return trip to the United States of several months' duration starting in late 1909. After that he never again crossed the Atlantic. Based in Paris during much of his European sojourn, he traveled to other French cities as well as several additional countries. A quiet intimacy marks much of Marin's art from this period, affirming James McNeill Whistler's primary influence.

When Marin returned from America to Europe in mid-1910, this delicacy was overtaken by a more explosive and experimental approach, one in which his watercolors were marked by a looser paint application, brighter colors, and subjects far grander in scale: "big nature" is how critic Charles Caffin described it.[1] Exemplary are *Entrance to the Tyrol* and *Mountain, the Tyrol* (cats. 65, 66), two of approximately thirty imposing Austrian scenes from 1910 that constitute Marin's first in-depth exploration of the mountain subject he would embrace intermittently throughout his life, which culminated with the pulsating Tunk Mountain watercolors and oils of his last decade.[2]

The Tyrol watercolors, featured in Marin's February 1911 exhibition at 291, relate in subject and medium to Cézanne's riveting mountain landscape watercolors. Marin echoed his predecessor in examining a visual source from multiple vantage points, and in his sensitive balance of painted hue and white paper. Diverse views likewise mark Marin's New Mexico watercolors from 1929 and 1930, approximately one hundred in all, including *Ranchos de Taos Church* (cat. 68) and *Taos Mountain, Pueblo and Mesa* (cat. 67). Both feature the dynamic and dramatic sky characteristic of many of them, hovering above warm earthy tones and muted greens denoting land. Such fractured and pulsating surfaces of this work of the late twenties link to Cézanne as understood through the lens of Cubism. One aspect of this is the framing enclosure associated with many of Marin's paintings, which is essential to the abstracted patterning he deployed across the field.[3]

Given the verticality and flowing paint in the earlier Tyrol series, a more pointed association than Whistler or Cézanne might be Chinese landscape painting, which, like Cézanne, is associated with Marin's watercolors. In fact, a matter of scholarly controversy for decades has circled around the possibility of Cézanne having impact on Marin's European work, given that the American (supported by others close to him in Paris) denied familiarity with the Frenchman's art prior to a 1911 exhibition of his watercolors at 291.[4]

In 1935, Marin's first biographer, E. M. Benson, quoted the artist's comment that "as for Cézanne, when in this country I saw Cézannes I said to myself there's a painter, not much else. . . . I am afraid my dear fellow that now—from my point of view—that you and others have given Cézanne too much space."[5] Benson argued that Marin's apparent resentment of the admiration accorded his predecessor by "professional evangelists" was rooted in fundamental differences in the two artists' approach to nature—Cézanne's distant, cerebral, and formal, Marin's defined by spontaneity and close observation of "the relatively little things that grow on the mountain's back."[6]

Ignoring the essential need of Marin and his contemporaries to have their work rooted in ideas born in America, Benson further suggested that Marin's "self-sufficient preoccupation with his own 'seeing' [made his ignorance of Cézanne] less incredible."[7] Benson reinforced this view in his catalogue essay for Marin's 1936 Museum of Modern Art retrospective, but acknowledged there that it was "no feather in his cap" that he "could have been unaware of the many art movements which were exploding like giant firecrackers under his very nose."[8]

Cézanne's ideas were widely circulated at popular meeting places that Marin frequented while in Europe, like Paris's Café du Dôme; and subsequent writers have been less accepting than Benson of the painter's professed oblivion. MacKinley Helm, also writing during Marin's lifetime, believed that while in Europe he "could not have escaped" such conversations about Cézanne, who was much admired by young painters. Sheldon Reich, who catalogued Marin's thousands of watercolors and oils, attributed characteristics of some early works to a possible knowledge of Cézanne during those European years, but

muddied his argument by suggesting it was plausible that Marin first encountered Cézanne's art in New York.[9] It seems impossible to this writer, however, that Marin, a member of the forward-looking New Society of American Artists in Paris, would have ignored Cézanne's memorial exhibition, coinciding as it did with the 1907 Paris Salon in which his own art was represented.[10]

Cézanne is cited in commentary throughout Marin's career, and his significance to Marin is not disputed, only when it began. Helm felt that Marin's earlier familiarity with Cézanne's art was *reinforced* by the Frenchman's 1911 watercolor exhibition, immediately after which the American displayed a "growing concern for saving the flatness of paper while creating space and distance in color—not with line, as in drawing . . . laying on flat planes of color [that resembled those] of the great man from Provence."[11] (Marin would come to reinforce his color planes in watercolor with a varied and emphatic line, often in graphite, crayon, or another dry medium, or incised with the tip of a brush handle or other tool; and he employed ink lines to enhance his oils on canvas.)

Marin's contemporaries contrasted Cézanne's preference for a "motif's theoretical aspect" to Marin's approach, which was considered more raw—"interrogating nature."[12] Marin's symbols "like Chinese characters . . . [are] less arbitrarily mathematical" than Cézanne's cylinders, spheres, and cones.[13] "Marin himself would be the first to tell you he is the spiritual child of Cézanne," claimed one critic, "yet we defy anyone to find anything more American than Marin and his breathless interpretation of this mad life."[14]

Among Marin's papers are reproductions of Cézanne's two Bather paintings in the Philadelphia area—at the Barnes Foundation (Merion, PA) and the Philadelphia Museum of Art—the most pragmatic evidence we have of Cézanne's art as an inspiration for Marin's. They suggest that starting in the early 1930s, Marin was considering his early mentor's work while exploring his late symbolic sea fantasies and other compositions featuring nude figures, beginning about 1932.[15]

Irony reigns, however, in Marin's 1935 comment to Stieglitz that his reply to an inquiry about the time and effect of his first encounter with a work by Cézanne might be: "Cezanne is now up somewhere or down somewhere a trying his heaven'est—or his damnd'est whatever the vocabulary in the place he is—they use—to imitate that cuss Marin."[16]

RUTH FINE

1. Charles Caffin, *New York American*, reprinted in *Camera Work* 48 (October 1916): 37.

2. Contrary to my own view, MacKinley Helm, in *John Marin* (New York: Pellegrini and Cudahy in association with the Institute of Modern Art, Boston, 1948), 23, describes this Tyrol group as "low-keyed watercolors . . . [which] showed no advance in his style . . . more concerned with light and atmosphere than with movement and form." On Marin's lifelong interest in mountains, see *John Marin's Mountains* (New York: Kennedy Galleries, 1983), with an introduction by John I. H. Bauer.

3. See Hilton Kramer's introductory essay in *John Marin: The Painted Frame* (New York: Richard York Gallery, 2000).

4. Jill Kyle reminds us that three lithographs by Cézanne had previously been on view at 291 in a 1910 group exhibition that included work by Manet, Cézanne, Renoir, Rodin, Rousseau, and Toulouse-Lautrec. See her "Paul Cézanne, 1911: Nature Reconstructed," page 496n1, in *Modern Art and America: Alfred Stieglitz and His New York Galleries*, ed. Sarah Greenough (Washington, DC: National Gallery of Art; Boston: Bulfinch, 2001).

5. E. M. Benson, quoting Marin's August 17, 1935, letter from Cape Split, Maine, in *John Marin: The Man and His Work* (Washington, DC: American Federation of Arts, 1935), 16.

6. "John Marin, by Himself," *Creative Art* (October 1928), as quoted in Benson, *John Marin*, 19.

7. Benson, *John Marin*, 16.

8. E. M. Benson, "John Marin—'and pertaining thereto'" in *John Marin* (New York: The Museum of Modern Art, 1936), 23.

9. Sheldon Reich, *John Marin: A Stylistic Analysis and Catalogue Raisonné* (Tucson: University of Arizona Press, 1970), 30. Reich also discusses Marin's relationship to Whistler, 17–22.

10. This view previously was voiced in relation to both Marin and Matisse in Ruth Fine, *John Marin* (Washington, DC: National Gallery of Art; New York: Abbeville Press, 1990), 77.

11. Helm, *John Marin*, 27.

12. Helm, also quoting Henry McBride, 27.

13. Helm, *John Marin*, 34.

14. "Goings on about Town: The Art Galleries," *The New Yorker*, November 8, 1930. Press clipping, no author or page number noted, John Marin Scrapbook, Volume 1, National Gallery of Art, Washington, DC, library.

15. The reproductions are among the Periodical Clippings, Volume 13, John Marin Family Papers, National Gallery of Art Library, Washington, DC. The reproduction of the Philadelphia Museum of Art picture is inscribed, lower right, in Marin's hand: "Cezanne's-Bathers-/ Pennsylvania Museum of Art." The museum acquired the painting in 1937. The Barnes picture, acquired in 1932, is reproduced on the first page of an article clipped from *The Saturday Evening Post* (March 28, 1942): Carl W. McCardle's "The Terrible-Tempered Dr. Barnes." Among Marin's bathers and other nudes, are Reich, *John Marin*, vol. 2: 32.5; 35.31; 40.10; 43.18; 49.44; 51.33.

16. John Marin to Alfred Stieglitz, August 18, 1935, reprinted in Dorothy Norman, *The Selected Writings of John Marin* (New York: Pellegrini & Cudahy, 1949), 167.

JOHN MARIN

Cat. 65
Entrance to the Tyrol, 1910
Watercolor on paper
15¼ × 18¼ in. (38.7 × 46.4 cm)
Private Collection, Courtesy of Meredith Ward Fine Art,
New York

JOHN MARIN

Cat. 66
Mountain, the Tyrol, 1910
Watercolor on paper
15 9/16 × 10 3/8 in. (39.5 × 26.4 cm)
Private Collection, Courtesy of Meredith Ward Fine Art,
New York

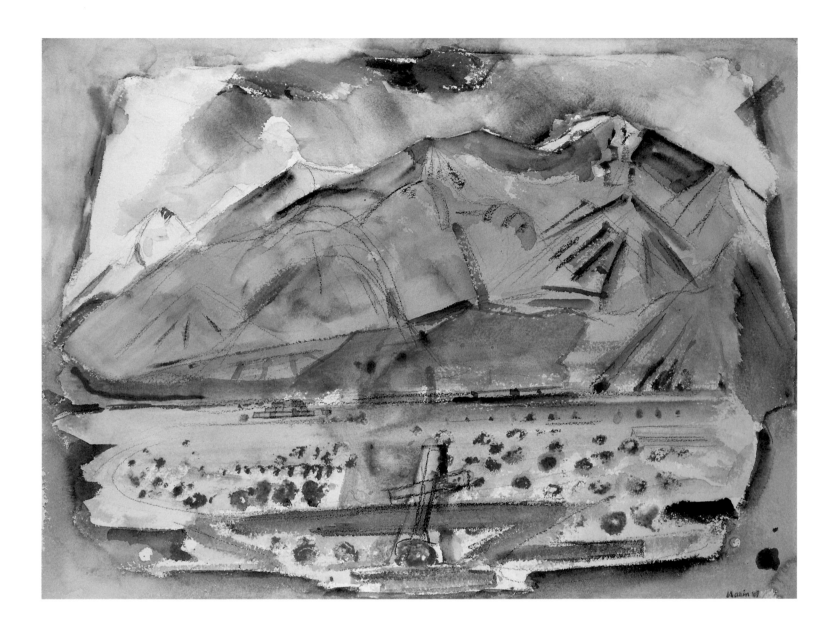

JOHN MARIN

Cat. 67
Taos Mountain, Pueblo and Mesa, 1929
Watercolor, graphite, and black crayon on paper
21¾ × 28¾ in. (55.2 × 73 cm)
Private Collection, Courtesy of Meredith Ward Fine Art,
New York

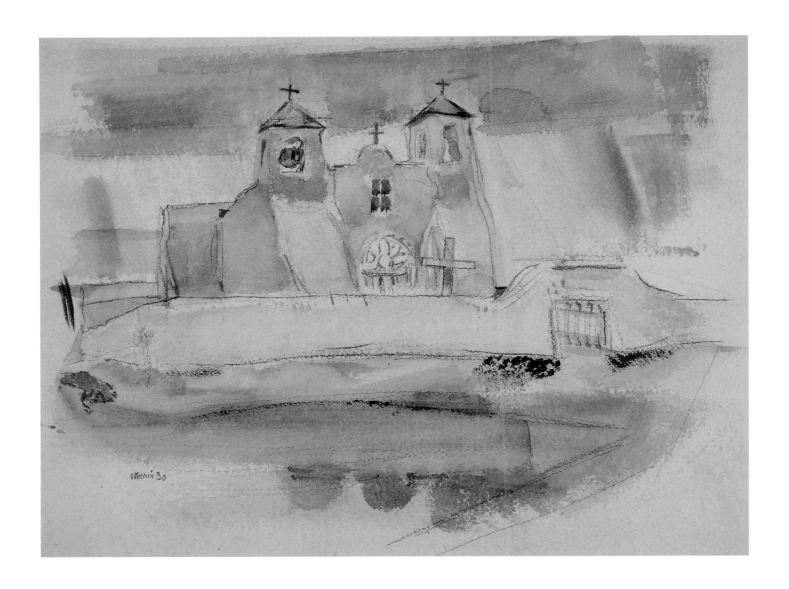

JOHN MARIN

Cat. 68
Ranchos de Taos Church, 1930
Watercolor on paper
15 × 18 in. (38.1 × 45.7 cm)
Private Collection
Phoenix only

ALFRED H. MAURER (1868–1932)

Alfred H. Maurer shook off turn-of-the-century gentility to pursue his modernist inclinations as early as 1906. In 1907 he was painting and exhibiting dynamic modern works squarely in the zeitgeist of Fauvism. By 1909 he had already showcased his own Cézanne-Matisse–inspired compositions in a landmark show with John Marin at Alfred Stieglitz's New York gallery, 291—the first of its type to present Fauve work by an American.

Maurer resided primarily in France from 1897 to 1914 and was an influential member of a community of progressive Americans abroad. Fully immersed in contemporary international art currents, he navigated the French art market, its dealers, artists, and collectors. He frequented Parisian galleries, including those of Vollard, Bernheim-Jeune, Druet, and Durand-Ruel, where such French masters as Cézanne could be seen to great effect. He was a regular at Paris Salon showings including the 1907 Salon d'Automne, which he is known to have attended, where Cézanne's influence was widely felt from over fifty oils and watercolors. Maurer participated in this important event, showing six modern landscapes.

Long before most Americans in the States came under what the critic Willard Huntington Wright labeled the Cézanne "fetish," Maurer had invested in Cézanne's radical contributions and sought to enrich the understanding of American artists and collectors alike. On September 29, 1912, Maurer wrote to the eccentric Pennsylvania collector Dr. Albert C. Barnes advising him on

the purchase of Cézanne's *Woman in a Red Striped Dress* (1892–96, R853) from the French dealer Ambroise Vollard, noting to Barnes that "it's as Cézanne as Cézanne can be."[1] Later that same year Maurer helped Barnes acquire Cézanne's *Portrait of Madame Cézanne* (1880–90, R683), a solidly rendered depiction of the artist's wife—a paean to the concept of modern portraiture.

Maurer served as artistic liaison to Barnes between 1912 and 1914, during which time Barnes relied on Maurer's "cultivated taste" and keen eye[2] to guide him in managing the details of his transatlantic art purchases. Acting as Barnes's agent, he kept the collector apprised of available works of interest, visited artist studios, and contacted him with information about public art auctions, private sales, gallery exhibitions, and other related art events. In return, Barnes paid Maurer for his services and supported his artistic endeavors. He purchased numerous works by the artist and sponsored Maurer's 1913 exhibition at the Folsom Galleries in New York.[3]

In 1912, when Maurer was involved in these Cézanne transactions, his familiarity with the artist's work was extensive. His high regard for Cézanne was borne out in his contact with Leo and Gertrude Stein. The Steins' Paris salon, to which Maurer introduced many Americans, was a sanctuary for modern art. As Gertrude Stein recalled, by 1905 Maurer was "an old habitué of the house . . . and he was among those who used to light matches to light up a little piece of a Cézanne portrait. Of course you can tell it is a finished pic-

ture, he used to explain to other American painters who came and looked dubiously, you can tell because it has a frame, now who ever heard of anybody framing a picture that isn't finished."[4]

Leo Stein and Maurer developed a close friendship in 1904, the very same year that Stein's fascination with Cézanne was first nurtured and encouraged by the art historian Bernard Berenson and the collector Charles Loeser. Along with his sister Gertrude, Leo acquired seminal examples of Cézanne's paintings over the years and frequented Vollard's gallery with Maurer and fellow Americans Mahonri M. Young and Maurice Sterne to see the works on hand. Stein's intellectual insight into Cézanne had a determining influence in shaping the direction of Maurer's modernist work. Stein hailed Cézanne as the greatest of all painters, speaking of him often with Maurer, expounding upon his innovative pictorial devices and crediting Cézanne for opening up the road to abstraction.

Maurer himself absorbed and assimilated Cézanne into his own aesthetic lexicon after earning acclaim as a successful painter of Whistlerian and Chase-inspired figurative imagery, which he executed through 1905. Following a brief period of Post-Impressionistic experimentation, Maurer emerged in 1906 as one of the first Americans to demonstrate a nuanced and intuitive understanding of Matisse and Fauvism, which, as illustrated by Maurer's *Woman with Blue Background (Portrait of a Woman)* of about 1907 (cat. 69), he filtered through the lens of Cézanne. Painted

summarily in a forceful and enlivened facture, this image plainly references Cézanne in its marriage of the concrete and ephemeral and in its modeling of form through color that vibrates against breathing white passages of the ground. It is Maurer's answer to the truly modern portrait and is simply unimaginable without such structural precedents as Cézanne's *Portrait of Madame Cézanne* (Barnes Foundation, Merion, PA) and the rich palette and field of energy that defined such Fauve depictions as Matisse's *Young Sailor (I)* of 1906 (private collection).

Maurer remained loyal to the same subjects and motifs through his career, plumbing the full potential of the figurative genre, as traced from his early elegant fin-de-siècle depictions through to the bizarrely abstracted heads of his last decade. In the mid-1920s he created a series of female nudes after moving into a new studio space, where he worked intently and rendered the model in two distinct styles. One was architectonic and Cubistic; the other was sinuous and mannered like the gouache and watercolor *Two Figures* (cat. 71), a spontaneous and fluid work that channels Cézanne's monumental nudes and bathers.

Landscapes comprise perhaps the most significant portion of Maurer's oeuvre. He returned religiously to this subject and depicted the same sites and locales over the years. In France he executed many landscapes in the Champagne region, fusing Cézanne's dynamic paint handling with rich chromatics that evoke the presence of light. In *Landscape (Autumn)*, a painting bathed in French light (1909, cat. 70), Maurer liberated color from its descriptive role and achieved what the American critic Charles Caffin called "color notes of spiritual impressions received in the presence of nature."[5] Maurer maintained his fascination with landscape painting throughout his lifetime, creating compositions anchored in nature but not bound to it.

In addition to the figure and landscape, Maurer remained faithful to the painting of still life. He developed a dialogue with this genre during his Fauve years and pushed the envelope with it during the 1920s and early 1930s with his innovative Cubist compositions. Still life afforded Maurer the opportunity to work with fixed, unchanging objects and explore new spatial possibilities, while experimenting with a variety of painting techniques. As with *Still Life with Candlestick, Brass Bowl, and Yellow Drape* (cat. 72) he offered a synthesis of both a real and an imagined space, bringing to light the realm that exists between the two. Throughout this time Maurer intensively probed the potential of the Cubist idiom, finding vital ways to reconceive the pictorial field. The objects he painted were not especially important—it was the way in which he painted them that mattered: the interpenetration of objects, the arrangement of flat planes, and the compression of space as related to Cézanne.

Cézanne's radical translation of a space and time continuum, which the Cubist artists like Picasso and Braque realized to new potential, ran through Maurer's Cubist imagery and the vast proportion of his other modern work. The French master's emancipation of art from natural phenomena, his use of nondenominative space, and his complex dialogue between figure and ground gave Maurer new points of reference for understanding the potential of modern expression and freed him to create dynamic modern work.

The lessons Maurer gleaned from Cézanne and his direct inheritors, like Matisse, his fellow Fauves, and the Cubists, formed the intellectual and aesthetic underpinnings that ran like an invisible thread through Maurer's modern work, underscoring it to the very end of his career. His early embrace of this new modernist ideology, fueled by his encounters with such modernist apostles as Stein, Edward Steichen, Stieglitz, Vollard, and Barnes, helped to guide and ground Maurer in his quest for a meaningful interpretation of the world around him and encouraged him to advocate for a new modernist narrative in art.

STACEY B. EPSTEIN

1. "Went to Paris yesterday and saw Vollard, have cabled you the total. He asks 35,000 fr. for Cézanne's woman in striped dress, which I think about the real value, it's a fine picture and Vollard tells me it was painted in 1896 Cézanne's latest manner." After discussing several other Cézannes Maurer continues "If you don't want to buy all three I would advise you to take the woman in a stripped (sic) dress. It's as Cézanne as Cézanne can be." Alfred Maurer to Alfred C. Barnes, September 29, 1912, Pont de Try Dormans, Barnes Foundation Archives, Merion, PA. Although Maurer began the negotiations on this piece in 1912 recommending it enthusiastically to Barnes, the collector did not end up purchasing it until 1915, when the French gallery Durand-Ruel was able to procure it for a better price. For detailed information on this specific transaction, see *Great French Paintings at the Barnes Foundation* (New York: Alfred A. Knopf, in association with Lincoln University Press, 1993), 301n2.

2. Barnes wrote to Maurer in Paris telling him that if the painting he was considering, but had not yet seen "meets with your approval, the probabilities are it will please my less cultivated taste." (Barnes to Maurer in Paris, undated letter, Barnes Foundation Archives). For a detailed discussion on the relationship between Maurer and Barnes see Stacey Epstein, "Alfred Maurer: Aestheticism to Modernism 1897–1916," Ph.D. diss., City University of New York, 2003, chapter 7, 237–45.

3. Barnes to Maurer, November 13, 1912, Barnes Foundation Archives. For a full account of the relationship between Maurer and Barnes, see my essay in the forthcoming exhibition catalogue *Alfred H. Maurer: At the Vanguard of Modernism,* traveling exhibition organized by the Addison Gallery of American Art, Andover, MA.

4. "Gertrude Stein in Paris, 1903–1907," in *The Autobiography of Alice B. Toklas* (London: John Lane, Bodley Head, 1933), 10.

5. Charles H. Caffin, "The Maurers and Marins at the Photo Secession Gallery," *Camera Work* 27 (July 1909): 41.

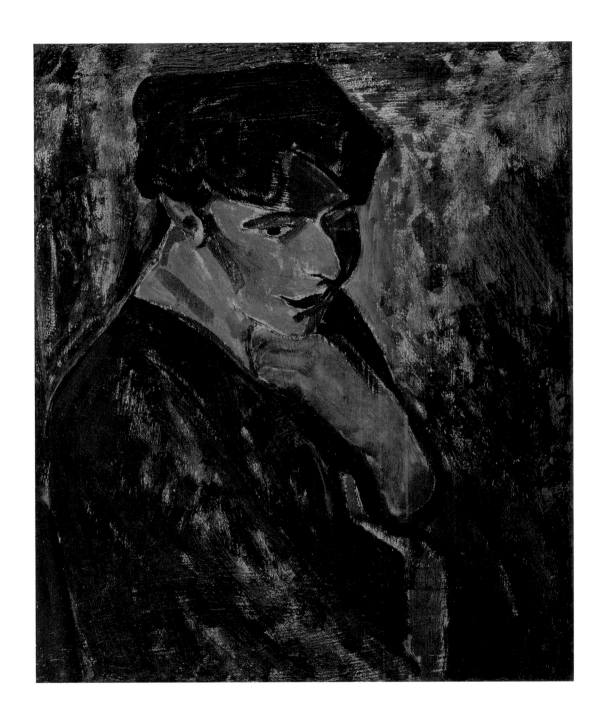

ALFRED H. MAURER

Cat. 69
Woman with Blue Background (Portrait of a Woman), c. 1907
Oil on panel
21⅛ × 17⅝ in. (53.7 × 44.8 cm)
Sheldon Museum of Art, University of Nebraska-Lincoln,
UNL-Bequest of Bertha Schaefer

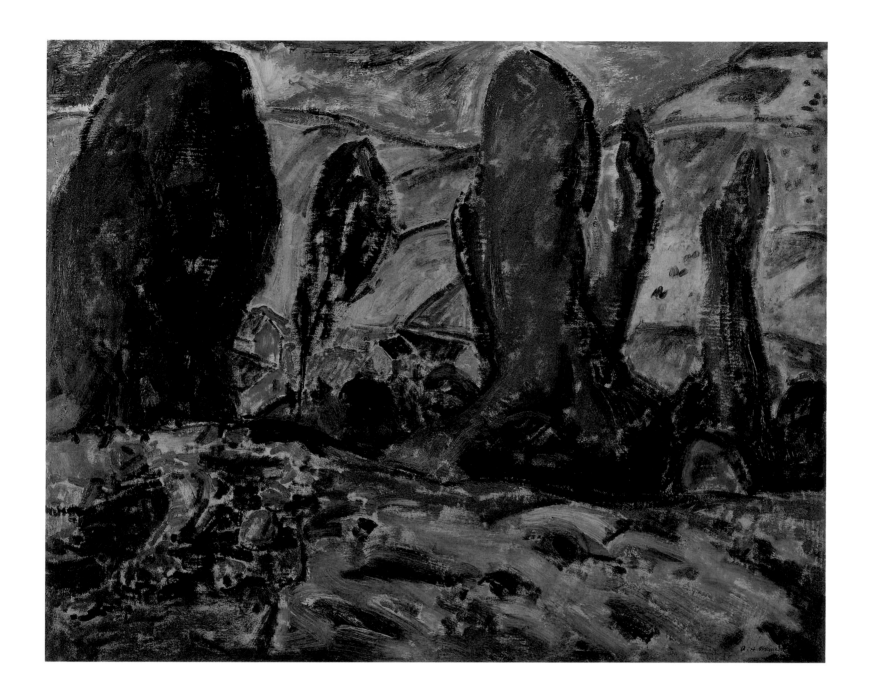

ALFRED H. MAURER

Cat. 70
Landscape (Autumn), 1909
Oil on canvas
25⅝ × 32 in. (65.1 × 81.3 cm)
Lent by the Frederick R. Weisman Art Museum, University of
Minnesota, Minneapolis. Gift of Ione and Hudson D. Walker
Collection, 1953.299

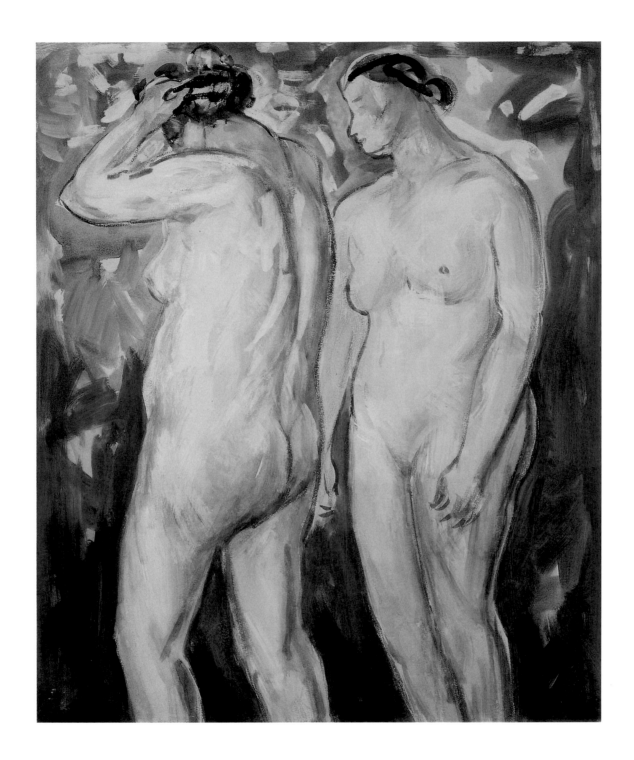

ALFRED H. MAURER

Cat. 71
Two Figures, c. 1927–28
Gouache and watercolor on paper
21½ × 18 in. (54.6 × 45.7 cm)
Lent by the Frederick R. Weisman Art Museum, University of
Minnesota, Minneapolis. Bequest of Hudson D. Walker from
the Ione and Hudson D. Walker Collection, 1978.21.145

My age and my health will never allow me to realize the artistic dream I have pursued throughout my entire life. However, I shall always be grateful to the group of intelligent art lovers who have . . . sensed what I was trying to do to renew my art . . . one does not replace the past, one only adds a further link to it.[14]

—Paul Cézanne

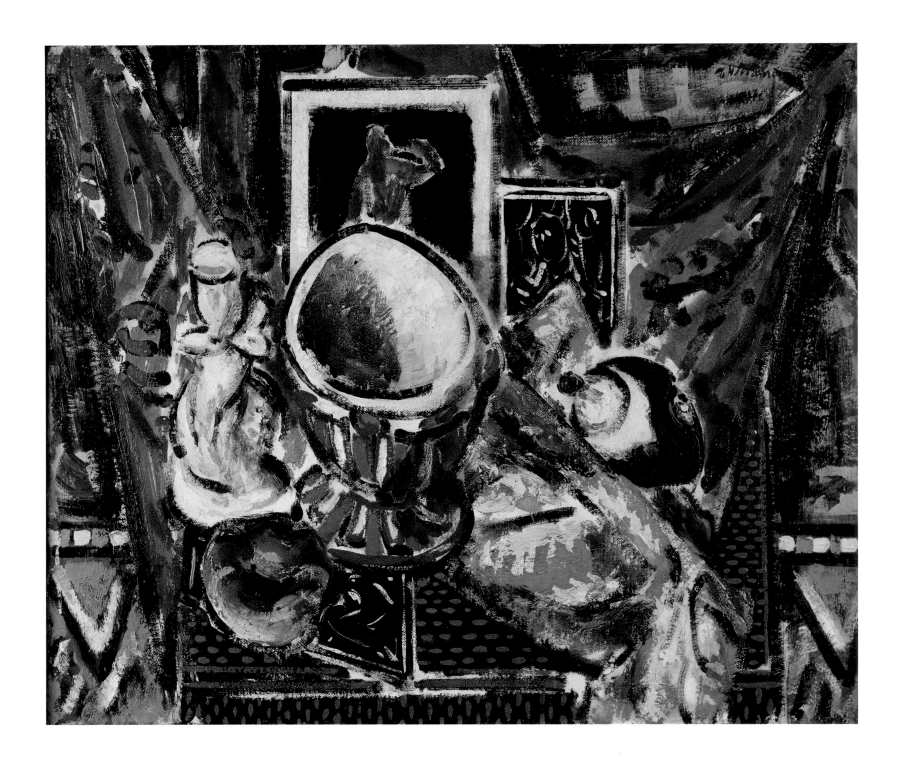

ALFRED H. MAURER

Cat. 72
Still Life with Candlestick, Brass Bowl, and Yellow Drape, c. 1928
Oil on gesso board
21¾ × 18¼ in. (55.2 × 47.6 cm)
Collection of Tommy and Gill LiPuma

WILLARD NASH (1898–1942)

Just fourteen years old at the time of the 1913 Armory Show, Willard Nash was one of the younger American devotees to the painting style of Cézanne. Working in Santa Fe, without having studied in Europe, Nash learned of Cézanne in the 1920s primarily through reproductions and the tutelage of Andrew Dasburg. So complete was Nash's interest in exploring Cézanne's handling of color and treatment of space that since the 1930s he has been referred to as an "American Cézanne" by national and local critics.[1] In 1931, he earned the admiration of Diego Rivera, who described Nash as one of the six finest artists in America.[2] Rivera exclaimed that Nash's painting was "proof that the American personality in art still exists."[3]

Born in Philadelphia, Nash attended the Detroit Art School. Seeking inspiration for a mural project, Nash first traveled to Santa Fe in 1920, where he was allowed use of a studio in the historic Palace of the Governors.[4] He settled there the following year. The change from Detroit to Santa Fe had a direct impact on his painting. A local writer observed that Nash "found a palette that is of greater brilliance," adding that in comparison to the paintings of the previous year he "brought more light into his landscapes and there is a greater feeling for the luminous colors of the southwest."[5] He trained with Dasburg, who would continue to guide Nash in his break from academic realism, and he was greatly influenced by the progressive practices of Józef Bakoś. At twenty-three, Nash was the youngest member of

Los Cinco Pintores (The Five Painters), the state's first modernist group of artists, which was headed by Bakoś. At their first exhibition in 1921 at the Museum of Fine Arts, Santa Fe, Nash's paintings were admired for their "pleasing harmony."[6] Of his landscapes it was stated, "Nash is direct and eliminates every nonessential detail, producing effects that are almost purely decorative." As a group, their paintings were praised as "modern . . . yet within the bounds of sanity." After a few short years, Nash's paintings, oils and watercolors, became bolder in color and stronger in composition and design. "I am an experimenter in art," he explained, "and have worked through many phases, going step by step deeper into the mysteries of esthetics."[7]

In Landscape with Reservoir (c. 1920s, cat. 73) Nash's debt to Cézanne-via-Dasburg is apparent. The scene is realized largely through rectangular patches of color, and natural shapes are simplified into generalized masses. In Untitled (Santa Fe Landscape) (c. 1925, cat. 75), the adobe homes are treated as blocks of contrasting earth tones, and natural formations are simplified into geometric shapes. The painting, saturated with color, is a reinterpretation of nature after Cézanne. There is a massiveness of elements and interest in the modeling of figures, combining tradition with abstraction, that indicates Nash to be much more than a mere imitator. In his search to construct paintings after nature, he considered more than the surface of objects, and claimed, "Art is not concerned

with the outer aspect of things. Art is concerned with the true inner spirit which determines the outer form."[8]

Though stoic and solidly constructed, Nash's Self-Portrait with Pipe (c. 1928, cat. 74) is more animated than Cézanne's self-portraits that informed it. Included in a five-year survey of Nash's work held in 1928, it was recognized as the finest painting in the exhibition and was described by a local critic as "intelligently conceived from the viewpoint of linear design and balanced masses."[9] It cleverly utilizes the pattern of the artist's plaid shirt to accentuate the facet-planes found in Cézanne and Cubist paintings. Nash received his largest degree of recognition in the 1930s, when he took part in prominent exhibitions in San Francisco and New York.

JERRY N. SMITH

1. Van Deren Coke, *Willard Nash: An American Cézanne* (Santa Fe: Gerald Peters Gallery, 1997), unpaginated.

2. Ina Sizer Cassidy, "Art and Artists of New Mexico," *New Mexico: The Sunshine State's Recreational and Highway Magazine* 13, no. 9 (September 1935): 48.

3. "And the Pacific is Supposed to be 'Calm,'" *Art Digest* 5, no. 17 (June 1, 1931): 6.

4. Van Deren Coke, "Cézanne's Influence on Modernistic Painting in New Mexico," *Voices in New Mexico Art* (Santa Fe: Museum of Fine Arts, Museum of New Mexico, 1996), 24.

5. "Museum Events: Paintings by Nash," *El Palacio* 11, no. 5 (September 1, 1921): 67.

6. "Los Cinco Pintores," *El Palacio* 11, no. 11 (December 1, 1921): 139–40.

7. Cassidy, "Art and Artists," 23.

8. Ibid., 23.

9. *Self-Portrait with Pipe* was featured on the cover of *El Palacio* in September 1928, and again in the November 5, 1930, issue. Nash quoted in "Exhibit by Willard Nash," *El Palacio* 25, nos. 8–11 (August 25, September 8, September 15, 1928): 165.

B. J. O. NORDFELDT (1878–1955)

An expressive use of color with the structural formations and angular brushwork learned through the study and admiration of Cézanne defines the paintings of Bror Julius Olsson Nordfeldt, particularly his work from around 1911 through the 1920s. Born in Sweden and raised in Chicago from the age of thirteen, Nordfeldt studied at the Art Institute before traveling to Paris in 1900. Intent on painting, he dropped out of the drawing classes at the Académie Julian after just two weeks, yet an interest in Japanese prints prompted him to study woodblock techniques in England the following year.[1] Initially working in a Whistlerian manner of subtle tones, over the course of the decade and additional European trips Nordfeldt's paintings dramatically brightened in color from his first-hand knowledge of Parisian modernism, particularly of Matisse and Fauvism. He merged his expressive style with a structural quality informed by Cézanne.

In late 1912, Nordfeldt exhibited paintings and prints in Chicago at the Albert Roullier and the Thurber Art Galleries and the following year at the Milwaukee Art Society. He described his work in a press interview, claiming, "I love to paint the radiance in animate life and in nature. I accomplish this in masses of pure color, sustaining the serenity of technique in drawing, although unconscious of any trite rules while I work."[2] Harriet Monroe praised the work in the *Chicago Tribune*, placing him in the "line of succession" of "Cézanne, Gauguin, and their ideas, Matisse, and other recent radicals of the autumn Salon."[3]

Louis Mayer with the Milwaukee *Free Press* noted the revolutionary nature of the images: "We feel attracted by the artist's compelling directness of line. Every canvas bespeaks mastery of draftsmanship. But the coloring is at first sight as repellant as the drawing is attractive."[4] In 1913, he traveled to Paris for further development, telling a reporter, "I am too radical for Chicago. At least, they say I am."[5] His intention to stay for five years, however, was cut short due to the escalation of war.

Settling in New York City in 1914, Nordfeldt spent summers in Provincetown, Massachusetts, where he took an active part in the small community of writers, socialites, actors, and artists there, who included Marsden Hartley, Charles Demuth, Maurice Sterne, and Marguerite and William Zorach.[6] In an article on the Provincetown Art Colony, Nordfeldt and the Zorachs were categorized as "essentially 'futurists' [whose] work is reminiscent of that famous futurist exhibition [the Armory Show with] . . . the Cézanne decorations."[7] *Figures on the Beach, Provincetown* (1916, cat. 76), is typical of Nordfeldt's painting at the time, featuring bright colors, flattened composition, a Cubist's interest in geometric shapes and prominent figures in the foreground that suggest the appearance of actors before a stage set. *Figures on the Beach* presents a day of male leisure at the Provincetown shore. The motif recalls Cézanne's many images of male bathers, particularly the arrangement and placement of figures in the foreground. The inclusion of sailboats and additional bathers in the middle ground, however, provides a

narrative or genre quality not found in Cézanne's more monumental bathers.

Nordfeldt traveled to New Mexico in 1918 on the invitation of artist William Penhallow Henderson, who had settled in Santa Fe two years earlier. Like many other visitors to the remote region, the "exotic" dances and religious ceremonies of the Pueblo Indians fascinated Nordfeldt. *Corn Dance, San Ildefonso* (1919, cat. 77) is a response to the rhythms, music, dances, and colors of the ceremonies, set within a carefully planned composition. The dancers serve largely as foils for the design, much in the way the Tahitians had for Paul Gauguin, or bathers for Cézanne.[8] Angular brushwork and Cézanne-inspired blocks of color are used to enliven the scene. As with his *Figures on a Beach*, the action is in the foreground, while an homage to Mont Sainte-Victoire serves as the backdrop. *Corn Dance* was included in *The Exhibition of Paintings and Drawings Showing the Later Tendencies in Art* held in 1921 in Philadelphia, which illustrated the impact of European modernism on American art since the Armory Show of 1913.[9]

Initially attracted to the Pueblo Indians, in the 1920s Nordfeldt grew increasingly interested in the Hispanic population of Santa Fe, who inspired several genre and portrait paintings. Often shown indoors, or in shallow, outdoor settings, the sitters continue to serve primarily as a means to a compositional end rather than explorations of the individuals. In *Covered Wagon* (c. 1920, cat. 78), a stiff and solid couple stares forward, framed

beneath a thickly painted canvas cover.[10] Behind them, colorful swatches energize the landscape. Nordfeldt remained in New Mexico until moving to Texas in 1941.

JERRY N. SMITH

1. Nordfeldt studied woodblock techniques under Frank Morley Fletcher at the Oxford Extension College at Reading, England. He would later make single-block, multicolored prints, which became known as Provincetown prints. See Sam Hunter, *B. J. O. Nordfeldt: An American Expressionist* (Pipersville, PA: Richard Stuart Gallery, 1984), 81.

2. H. Effa Webster, "Nordfeldt to Show Chicago on Canvas," *Chicago Examiner,* October 31, 1912, in Van Deren Coke, *Nordfeldt The Painter* (Albuquerque: University of New Mexico Press, 1972), 37.

3. Harriet Monroe, "Nordfeldt Pictures Monday," *Chicago Tribune,* November 3, 1912, in B. J. O. Nordfeldt Papers, Archives of American Art, microfilm roll D-167, fr. 58.

4. Quoted in Coke, *Nordfeldt the Painter,* 39–40.

5. "Olson Nordfeldt's Portrait of Katherine Dudley Radical, but Not Reaching that of Cubist," *Chicago Examiner,* April 10, 1913, quoted in ibid., 42.

6. Nordfeldt was a founding member in 1917 of the Provincetown Players theater troupe, where he created set designs, built furniture, and acted, on at least one occasion alongside Charles Demuth. The troupe was the first to perform the plays of Eugene O'Neill. See Steven Watson, *Strange Bedfellows: The First American Avant-Garde* (New York: Abbeville Press, 1991), 216–17.

7. A. J. Philpott, "Biggest Art Colony in the World at Provincetown," *Boston Daily Globe,* August 27, 1916, 9.

8. John Carpenter Troccoli compares the placement of figures in Nordfeldt's *Corn Dance, San Ildefonso* with Gauguin's *Where Do We Come From? What Are We? Where Are We Going?,* 1897, noting that Nordfeldt had opportunities to see Gauguin's work, including at the Armory Show. See Joan Carpenter Troccoli, *Painters and the American West: The Anschutz Collection* (Denver: Denver Art Museum; New Haven, CT: Yale University Press, 2000), 62–65.

9. It is possible that another, similarly titled work was submitted, although this is unlikely. *Corn Dance, San Ildefonso,* now in the Anschutz collection, was included in additional exhibitions around the same time. Sylvia Yount and Elizabeth Johns, *To Be Modern: American Encounters with Cézanne and Company* (Philadelphia: Museum of American Art of the Pennsylvania Academy of the Fine Arts, 1995), 71.

10. Like most of Nordfeldt's works created before the mid-1930s, this painting is not dated. *Covered Wagon* can be dated to the early 1920s, as it was one of seven paintings by the artist purchased by Mayett Evans of Chicago in 1923, according to family records maintained by the artist's niece, Emily Lundquist. See B. J. O. Nordfeldt Files, Special Collections, Phoenix Art Museum Research Library.

PAUL OUTERBRIDGE (1896–1958)

Paul Outerbridge was a highly ambitious commercial photographer of the Jazz Age, specializing in advertising still lifes. His slick, sophisticated work represents a translation of European avant-garde thinking to a very different arena. The connection between his work and Cézanne's is not an obvious one of visual parallelism, but rather indirect assimilation of the semi-abstract composition that the Clarence H. White School derived from Cézanne, and other sources. Outerbridge began his artistic studies in sculpture at the Art Students League, New York, in 1915, then enrolled at the White School in 1921.[1] Originally a stage designer and illustrator, he became one of the most stylish commercial photographers of the 1920s, specializing in edgy modern still-life compositions. These began to be reproduced in publications such as *Vanity Fair* and *Vogue* as early as 1922, and perfectly represent the White School's teachings about design and space-filling (in the manner of Arthur Wesley Dow) as the foundation for successful commercial imagery. Or we could say that they demonstrate Cézannesque compositional aesthetics put to work to earn a living on Madison Avenue.[2] The characteristically American pragmatism of this application makes a radical disjunction with more typical avant-garde art practice.

In 1925, Outerbridge moved to France to open his own studio and work for French *Vogue* for a period. While there, he surely saw the full range of modern painting, already familiar to him from Weber's lectures. At that time, he also became acquainted with Edward Steichen, then the most successful commercial photographer in the world, and another successful adapter of European modernism to American advertising ends. The urbane suavity of Outerbridge's aesthetic is interestingly at odds with the more homespun Pictorialism of much of the White School's work; when he returned to the school around 1933 as an instructor, he no doubt brought a new sharpness to the curriculum.[3]

Outerbridge's pictorial tensions are typically created between one object and the next, particularly via diagonal elements, rather than through a merging of objects and space, or through distortions of contour and drawing. Outerbridge combined a residual delicacy of printing technique and small scale with extremely bold compositions. His images are never as precariously composed as Paul Strand's Twin Lakes still lifes, but they are always dynamic, frequently employing angled objects as graphic elements.[4] Unlike much commercial photography, they are surprisingly powerful in aesthetic effect, largely as a result of their Cézanne-inspired compositional sophistication. His occasional practice of preparing preliminary pencil sketches for his photographs is highly unusual, and seems to indicate the connections between these images and the development of compositions in fine art, particularly painting. They are thoroughly planned, developed, composed images.

Whether his characteristic style derives more from assimilation of Cézanne's example itself, or from Max Weber's Cézanne-saturated design precepts, Outerbridge was a typical product of the Clarence H. White School. In still lifes like *Cheese and Crackers* (1922, cat. 79), the dynamically positioned knife and shadowy cutting board generate spatial tensions which use properties of the photographic medium to emphasize composition and the relations of objects and space. Less purely abstract than some of his famous advertising designs, like the 1922 *Ide Collar* and *Cracker Box,* it retains elements of a classical still life, precisely as Cézanne's paintings do, despite its very modern hints at the destabilization of form.

ELLEN HANDY

1. David Travis in *Photography Rediscovered* (New York: Whitney Museum of American Art, 1979), 169–70.

2. Bernard Barryte, Graham Howe, and Elaine Dines, *Paul Outerbridge: A Singular Aesthetic* (Laguna Beach, CA: Laguna Beach Museum of Art, 1981).

3. Marianne Fulton, ed., *Pictorialism into Modernism: The Clarence H. White School of Photography* (New York: Rizzoli, 1996), 197.

4. They are thoroughly planned, developed, composed images. John Pultz compared Outerbridge's work to that of Stieglitz, Strand, and Sheeler, but concluded that it more closely resembled that of Morton Schamberg. In John Pultz and Catherine B. Scallen, *Cubism and American Photography* (Williamstown, MA: Sterling and Francine Clark Art Institute, 1981), 45.

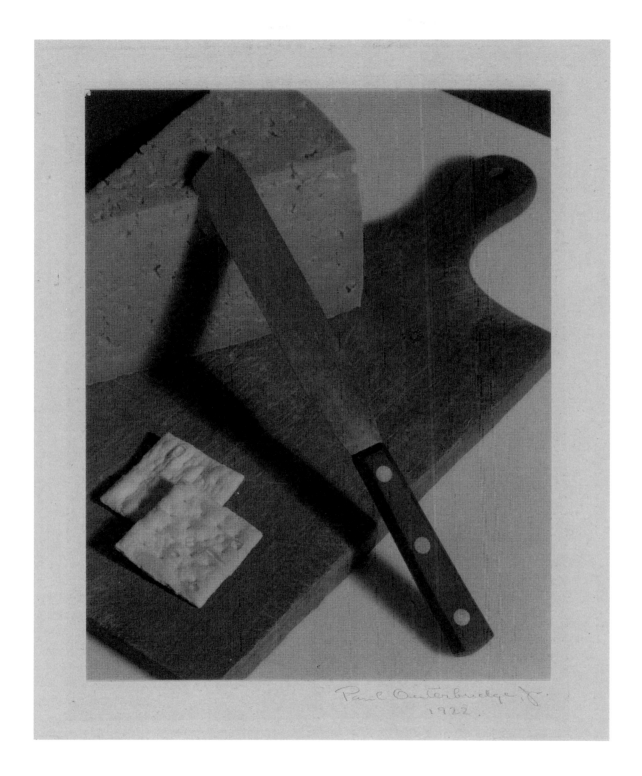

PAUL OUTERBRIDGE

Cat. 79
Cheese and Crackers, 1922
Platinum print
4⁹⁄₁₆ × 3⁵⁄₈ in. (11.6 × 9.1 cm)
Prints & Photographs Division, Library of Congress,
Washington, DC

5. On Pach's translation of Faure's essay for Stieglitz's show, see John Rewald, in collaboration with Walter Feilchenfeldt and Jayne Warman, *The Paintings of Paul Cézanne: A Catalogue Raisonné* (New York: Harry N. Abrams, 1996), 363. Elie Faure, *Cézanne*, trans. Walter Pach (New York: Association of American Painters and Sculptors, 1913).

6. Elie Faure, *History of Art: Modern Art*, trans. Walter Pach (New York: Harper & Brothers, 1924).

7. For Pach's appointment to Berkeley, see Walter Pach to Paul Sachs, October 26, 1939, Paul J. Sachs File, Harvard Art Museums Archives, Cambridge, MA (hereinafter Sachs File); and *American Artists, Authors, and Collectors: The Walter Pach Letters, 1906–1958*, ed. Bennard B. Perlman (Albany: State University of New York Press, 2002), 347; Pach, *Queer Thing, Painting*, 281; and Laurette E. McCarthy, "Walter Pach: Artist, Critic, Historian, and Agent of Modernism," Ph.D. diss., University of Delaware, Newark, 1996, 211–12. For Pach's appointment to teach in Mexico City, see Pach to Sachs, October 26, 1939, Sachs File; Perlman, *American Artists, Authors, and Critics*, 347; Pach, *Queer Thing, Painting*, 281–88; and Margarita Nieto, "Mexican Art and Los Angeles, 1920–1940," in *On the Edge of America: California Modernist Artists, 1900–1950*, ed. Paul J. Karlstrom (Berkeley and Los Angeles: University of California Press, 1996), 123. For Pach's appointment to teach for New York University in New York and Paris, see Pach to Sachs, October 26, 1939, Sachs File; and Perlman, *American Artists, Authors, and Critics*, 347.

8. Pach, "Cézanne—An Introduction."

9. For Pach's friendship with Elie Faure, see Pach, *Queer Thing, Painting*, 261–67.

10. Pach, "Cézanne—An Introduction," 768.

11. Pach, "The Point of View of the 'Moderns,'" 851–52.

12. Ibid., 862.

13. In April 1911, Loeser wrote to Pach, who was in Paris, "Vollard dropped in on me about 10 days ago. He had brought with him a big & most beautiful Cézanne that I had much admired in his rooms in Paris, but which I had no thought of ever possessing at his price 30,000 frcs. Still I had suggested that we might effect an exchange. This we finally agreed upon here. I giving him no less than four Cézannes in exchange for the one. . . . One of these exchanged pictures is 'Costa's.'" Charles Loeser to Walter Pach, April 28, 1911, Pach Papers, reel 4217, frs. 23–25. For this transaction see also Arthur B. Davies to Walter Pach, June 19 and October 1, 1912, Pach Papers, reel 4217, frs. 83, 95; and Perlman, *American Artists, Authors, and Collectors*, 139–40. See also John Rewald, *Cézanne and America: Dealers, Collectors, Artists, and Critics, 1891–1921* (Princeton: Princeton University Press, 1989), 169–70.

14. Because Pach arranged the sale of Georges Seurat's *Study for "A Sunday on La Grande Jatte"* to Adolph Lewisohn, through Stephan Bourgeois and Félix Fénéon of Bernheim-Jeune, it is highly probable that he introduced the collector to Bourgeois. For the sale of the *Study for "A Sunday on La Grande Jatte"* to Adolph Lewisohn see Félix Fénéon to Walter Pach, May 19, 1919, Pach Papers, reel 4217, fr. 466.

15. For Pach's connection with the Bartletts, see Douglas W. Druick and Gloria Groom, "'Almost by a Miracle': *La Grande Jatte* at the Art Institute of Chicago," in *Seurat and the Making of "La Grande Jatte"* (Chicago: Art Institute of Chicago in association with University of Chicago Press, 2004), 15.

16. Harry Bakwin was originally from Utica, New York, and Ruth Bakwin was of the Morris family of Chicago. They were pediatricians, and Ruth initially met Pach through her mother, Helen Swift Morris, and her stepfather, Francis Nielson. The relationship between Walter Pach and the Bakwins is discussed in the "Unpublished Memoirs of Ruth Bakwin." I wish to express my sincere appreciation to Mr. Gregg Selch for providing me with a copy of this writing. For the introductions to Vollard and Lebel, see "Memoirs," 56, 68, 104. For their acquisition of *Italian Woman at a Table*, see "Memoirs," 80.

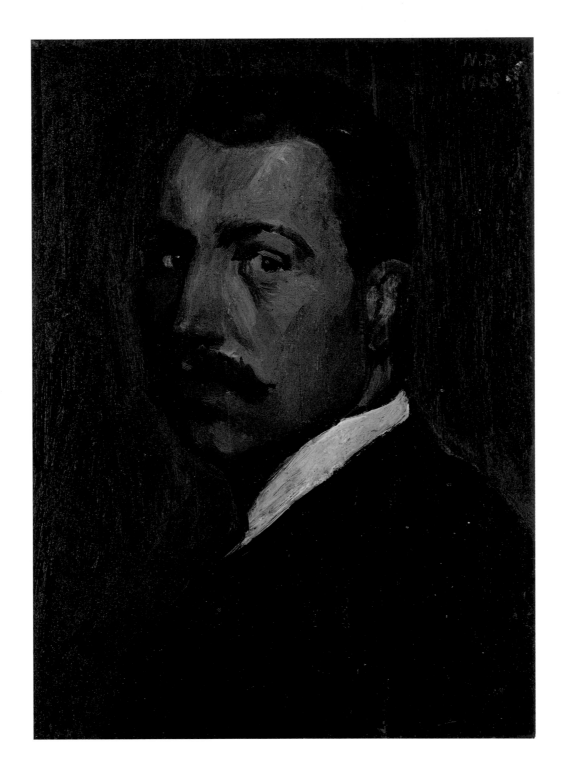

WALTER PACH

Cat. 80
Self-Portrait, 1908
Oil on board
14¾ × 10½ in. (37.5 × 26.7 cm)
High Museum of Art, Atlanta, Georgia; Gift of
Ruth and Raymond Pach, 1985.24a-b

MAURICE PRENDERGAST (1858–1924)

The influential Walter Pach thought of Maurice Prendergast as pivotal in the American art world's embrace of Cézanne. Not only did Pach state that Prendergast was "probably the first American to realize the importance of the master of the modern school,"[1] but he honored Prendergast's zealous promotion of Cézanne's art and ideas to his colleagues, as he played a crucial role in bringing about an appreciation of Cézanne in this country.[2]

Like many of the other artists in this study, Prendergast was at the peak of his enthusiasm for Cézanne when he just returned from Paris, where he could see a significant number of the works themselves.[3] At a studio party in New York soon after his trip in 1907, his friends remembered that he "was talking to all, of Cézanne; and the high point of the evening was a stentorian demand, loud above the noise of conversation, 'Prendergast, who is this man, Cézanne?'"[4] As one of the first American modernists to return from Paris with this special knowledge, Prendergast provided for many other artists their first hint of the legendary master who would be credited for transforming art itself in the twentieth century.

Given his role in the introduction of Cézanne to American artists, one would expect to see strong Cézannesque elements in Prendergast's art. And indeed, he produced nude figures in landscapes, such as *Eight Bathers in a Cove* (cat. 83), *Bathers at Passamoquoddy Bay* (cat. 81), *Rocky Shore with Bathers* (cat. 84), and *Bathers by the Sea* (cat. 82); strong still lifes, such as *Still Life: Fruit and Flowers*

(cat. 85); and experimental portraiture, such as *Woman in Brown Coat* (cat. 86) and *Woman in Green Dress* (cat. 87), paying clear homage to Cézanne in the years immediately after 1910. Prendergast's own copy of the 1912 *Cézanne Mappe*,[5] a set of black-and-white plates of Cézanne's paintings (cat. 137), is proof of his knowledge of these by-now famous motifs.

In all three cases, Prendergast was trying something new, since nudes and still life were unknown in his art until this time and portraiture was very rare. This departure might be viewed in the spirit of discovery that was held to be the essence of Cézanne's approach to art. Called by James Huneker in 1910 "a fumbler and seeker,"[6] he was admired for his lengthy studies of familiar subjects and for his patient labor. Writers on Cézanne such as Huneker told the story of his return again and again to the "The Motive": "There, facing Mount Sainte-Victoire, he painted every afternoon in the open."[7] While still life and portraiture did not find a permanent place in Prendergast's art, the frieze of nudes or partially dressed figures did; and he returned faithfully to his own "Motive" for years to come.

But as clearly Cézannesque as is this episode in Prendergast's art, it is important to understand that Prendergast and his contemporaries felt that the lessons of the great modern master underlay *all* of Prendergast's art after 1907, whether it had the outward appearance of Cézanne or not. Walter Pach noted that "Nowadays, when Cézanne is so very much in fashion and so widely imitated,

a casual observation may not reveal what he has meant to Mr. Prendergast."[8] He stressed that, unlike the shallow Cézanne followers who merely copied externals, Prendergast had absorbed Cézanne's principles and displayed them in "every stroke he makes."[9]

Prendergast's discovery of Cézanne is first documented in a letter to Esther Williams, an amateur artist, patron, and neighbor in Winchester, Massachusetts. Prendergast had spent the summer and fall of 1907 in Paris and St. Malo preparing canvases for the upcoming exhibition of the Eight, which was scheduled to open in New York the following spring, and he was thrilled with the new art movements that enlivened the Paris exhibitions. He wrote of the "delightful fall exhibitions . . . they have all Paul Cezannes, Berthe Morisot and Eva Gonzales. Cezanne gets the most wonderful color, a dusty kind of a grey and he had a water color exhibition late in the spring which was to me perfectly marvelous. He left everything to the imagination, they were great for their simplicity and suggestive qualities." He also admired the Fauve approach to color that he saw in the exhibitions, and he went on to confess, "I was somewhat bewildered when I first got over here but I think Cezanne will influence me more than the others . . . I think so now."[10]

The studies of St. Malo that Prendergast submitted to the exhibition of the Eight would not today be seen as influenced by Cézanne in the same sense that the nudes, the still lifes, and the portraits of 1910–13 clearly are. Yet at least one

writer at the time noticed his "after-Cezanne style" and his "Cézanne technique," which has made him the "storm centre of criticism." Noting the theoretical underpinning of Prendergast's work, the writer makes the crucial modernist distinction: "The pictures are worth what they represent, and not what they reproduce; the emotion, not the landscape."[11]

Cézanne's art theories were best known from the publications by Émile Bernard, including his first article in *L'Occident* from 1904,[12] a handwritten translation of which has survived in the Prendergast papers (cat. 124). Prendergast patiently transcribed this article, interspersing the text with lists of vocabulary words and visibly grappling with Bernard's vague and convoluted sentences. Taking this article as a touchstone for Prendergast's understanding of Cézanne, much more of Prendergast's art, including the St. Malo paintings, can be seen, as the Newark critic put it, as "after-Cézanne."

The Cézanne that emerges in Bernard's 1904 essay is a colorist, an artist of sensations, and an expressionist. One finds constant advice to the painter to be open to nature but to think with paint: "Sensation requires that one's methods be constantly transformed, in order to be capable of intense expression."[13] The term "decorative" is found more often in this essay than in later writings about Cézanne, which emphasize Cézanne's interest in abstract form. Here, an almost Neo-Impressionist aesthetic can be detected when "sculptural form" is compared with "decorative form." The former "is servile, the other free; in one, contour prevails, in the other, brilliance, color, and spontaneity dominate."[14]

This could not have been more meaningful to Prendergast. Already established as a colorist with a background in Impressionism from his first trip to Paris (1891–94) and Venetian color theory from his recent trip to Italy (1898–99), Prendergast was always open to new ways of thinking about his art. By 1904, the *New York Times* critic Charles de Kay had pegged him a neo-Impressionist with the greatest indifference for "the vulgar yearning for realism."[15] His color was associated with emotions like joyousness and was the basis for an original decorative effect. For Prendergast to find his well-established tendencies theorized so persuasively in the words of Cézanne and his interpreter Bernard must have been exhilarating at such a crucial time in the establishment of modern art in America.

Not long after Bernard's article, the liberating force of color would be adopted by Matisse and the Fauves, causing Prendergast to be associated more closely with Matisse than Cézanne in that regard. Stieglitz's exhibition of Matisse drawings in 1908, for instance, caused an immediate association with Prendergast: "His color work, like that of Maurice Prendergast's, in the recent display of 'The Eight,' would seem to be simply spots of paint daubed on here and there, perhaps with some idea of form or composition, not at first recognizable."[16] And as time went on, Prendergast's color was associated with Cubism and Futurism, as in the 1914 Boston Watercolor Club: "This year the 'Cubist' and 'Futurist' vaccination has evidently 'taken' well, the show being made more exciting by the admission of work by Arthur B. Davies and others of that ilk. Boston's own spotty Prendergast they have with them, and he fairly outdoes himself with square-set blobs of color and twinkling high lights."[17]

Spotty Prendergast's "blobs" of color, liberated through the theorizing of Cézanne's work (and Prendergast's loving translation of it), were also signs of the personality of the true artist that emerged in the literature about Cézanne. The true artist values work above all else, laboring tirelessly at his sensations to create great art. He submits completely to the model in order to go beyond it; "then in deeply meditative sessions, heightening the color sensations and elevating form into a decorative concept and color to its most harmonious register. Thus, the more the artist works, the further his work distances itself from the objective," as Bernard said of Cézanne.[18] The work, the repetitious application of spots of paint, becomes an end in itself. Cézanne withdrew to Aix; Prendergast withdrew through his deafness. Neither was thought to pursue commercial success or fame. And both achieved through their purity as artists a kind of authority. James Huneker described Cézanne as a king and a gallery of his work, sacred ground.[19] At the start of World War I, Cézanne was called the "Kaiser of all Europe" because he had been singled out by Kaiser Wilhelm for inspiring the "gutter-art" of the day.[20] Prendergast

too was crowned: "Maurice Prendergast is king at the Montross Gallery." Although his connection to Cézanne was lost to many observers in the welter of styles dominating New York in the teens, the color theory and method that Cézanne had inspired in him remained: "Prendergast's color fairly fills the big gallery, the beautiful, 'sane' color of an ever-modern artist, whose message is one of clean and clear joy."[21] As Walter Pach would later explain it, Cézanne kept him to the idea that art is best when it holds light, space, and solidity together in a "living design" in which "one cannot say that a given touch is there to give form or to give color." He quoted Prendergast, who simply said: "It is painting—that's what it is."[22]

NANCY MOWLL MATHEWS

1. Walter Pach, "Maurice Prendergast," *Shadowland* 6, no. 2 (April 1922): 74.

2. Pach inscribed a copy of Gerstle Mack's *Paul Cézanne* (New York: Alfred A. Knopf, 1935) to Maurice's brother Charles Prendergast "in recognition of what he and his brother did to bring about an appreciation of Cézanne." Prendergast Archive and Study Center, Williams College Museum of Art, Williamstown, MA (hereinafter Prendergast Archive).

3. For a thorough study of Prendergast and Cézanne, see Nancy Mowll Mathews, "Prendergast and the Influence of European Modernism," in Carol Clark, Nancy Mowll Mathews, and Gwendolyn Owens, *Maurice Brazil Prendergast, Charles Prendergast: A Catalogue Raisonné* (Williamstown, MA: Williams College Museum of Art; Munich: Prestel, 1990), 35–45. In the intervening years, very little new documentary evidence has emerged to flesh out the connection between Prendergast and his master; yet a broader view of Prendergast as an artist and how he thought about Cézanne can be proposed from a deeper reading of the stylistic terminology that came to the fore in this period.

4. William M. Milliken, "Maurice Prendergast, American Artist," *The Arts* (April 1926): 186.

5. *Cézanne Mappe* (Munich: R. Piper & Co., 1912), Prendergast Archive.

6. James Huneker, *Promenades of an Impressionist* (New York: Charles Scribner's Sons, 1910), 17.

7. Huneker, *Promenades,* 13.

8. Pach, *Shadowland,* 74.

9. Ibid.

10. Maurice Prendergast to Esther Williams [Mrs. Oliver Williams], October 10, 1907, Esther Baldwin Williams and Esther Williams papers, 1892–1984, Archives of American Art, Smithsonian Institution.

11. The first phrase is in "Widely Shown Exhibition of 'The Eight': American Artists at the Public Library," *Newark Evening News,* May 1, 1909; and all the others in "The Eight Stir Up Many Emotions," *Newark Evening News,* May 8, 1909.

12. Émile Bernard, "Paul Cézanne," *L'Occident* (July 1904): 17–30; Prendergast's manuscript translation, Prendergast Archive. This transcription is undated, but was most likely made c. 1907.

13. Michael Doran, ed., *Conversations with Cézanne,* trans. Julie Lawrence Cochran (Berkeley and Los Angeles: University of California Press, 2001), 42. Prendergast's translations, while similar, are less concise.

14. Ibid., 38.

15. Charles de Kay, "French and American Impressionists," *The New York Times,* January 31, 1904.

16. "Work by Henri Matisse," *American Art News* 6, no. 26 (April 11, 1908): 6.

17. "Boston," *American Art News* 12, no. 14 (January 10, 1914): 7.

18. Doran, *Conversations with Cézanne,* 36.

19. Huneker, *Promenades,* 3.

20. James Britton, "Art: A Revolutionary Painter of France—Cézanne, Wealthy Vagabond, is Kaiser of All Artistic Europe," *Hartford Courant,* November 1, 1914.

21. "Americans at Montross's," *American Art News* 17, no. 14 (January 11, 1919): 2.

22. Pach, *Shadowland,* 74.

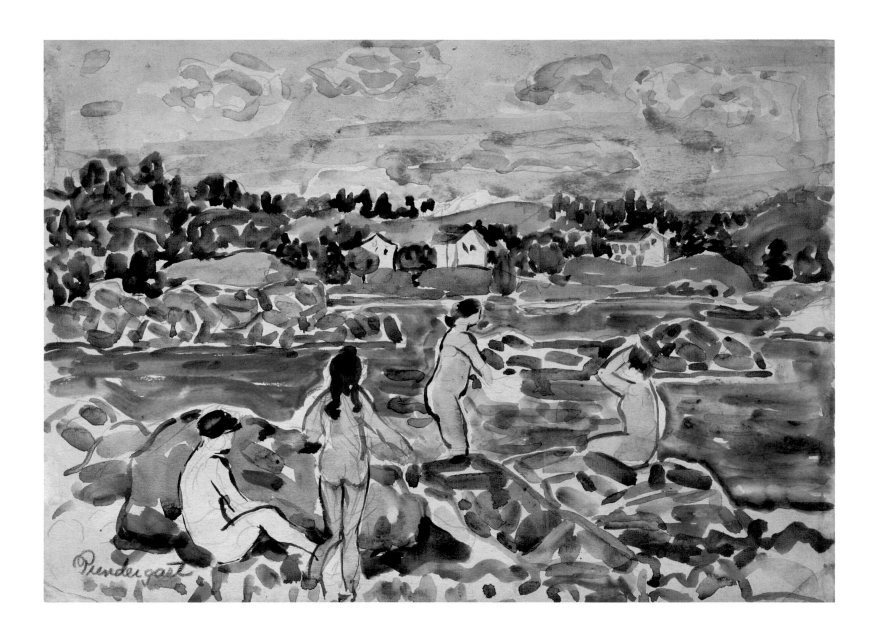

MAURICE PRENDERGAST

Cat. 81
Bathers at Passamaquoddy Bay, c. 1910–13
Watercolor and graphite on paper
9⅝ × 13⅝ in. (24.4 × 34.6 cm)
Williams College Museum of Art, Bequest of
Mrs. Charles Prendergast, 95.4.66
Montclair only

MAN RAY (1890-1976)

Man Ray saw his first original works by Cézanne in March 1911, at Alfred Stieglitz's 291. At the time, Man Ray—who was then an aspiring young painter enrolled in classes at the Art Students League and the National Academy of Design in New York—took breaks from his work as an illustrator for a map-and-atlas publisher in midtown Manhattan to visit various galleries in the area. Years later, he recalled what impressed him most about the Cézanne exhibition (which happened to be the very first show he saw at 291): "I admired the economical touches of color and the white spaces which made the landscapes look unfinished but quite abstract, so different from any watercolors I had seen before."[1] It seems to have taken Man Ray about a year to fully absorb the impact of this exhibition. By then he had enrolled in classes in the Modern School of the Ferrer Center, the leading anarchist center in New York, located on 107th Street in Harlem. In the winter of 1912–13, he showed a painting called *A Study in Nudes* in a group exhibition of artists associated with the center, a painting whose subject—nude female figures in an outdoor setting—recalls pictures from the Bathers series of Cézanne.[2] Exactly which pictures from this series Man Ray was familiar with at the time is difficult to say; he might have seen photographs of paintings by Cézanne that were brought back from Europe by the American painter Max Weber (cats. 128–33), a friend and fellow painter who was also taking classes at the Ferrer Center, or he might have seen the lithographs of Bathers by Cézanne that Stieglitz had in his gallery (see cat. 15), which he

had placed on display in an earlier exhibition but which he might have taken out to show Man Ray during the time of his visit to the Cézanne watercolor exhibition.[3]

Within a few weeks after this show closed, Man Ray attended the Armory Show, where he had ample opportunity to view major works by Cézanne. As with virtually everyone who attended that exhibition, Man Ray found the many examples of vanguard European painting and sculpture overwhelming. "I did nothing for six months," he told an interviewer a few years later. "It took me that time to digest what I had seen."[4] By the summer of 1913, Man Ray was ready to begin painting again. At the time, he was living in Ridgefield, New Jersey, an artists' colony located across the Hudson River from Manhattan (where he resided for approximately three years: from the fall of 1912 to December of 1915). When he first moved out there, he shared rent on a small cottage with Samuel Halpert (1884–1930), an American painter who had recently returned from Europe, where he had studied for a brief period at the so-called Matisse Academy. Halpert and Man Ray went on weekend excursions in the surrounding countryside and painted side-by-side, so it is natural that their approach to the subject was similar. Indeed, Man Ray's *Ridgefield Landscape* (cat. 88) resembles the style and subject of several paintings by Halpert from this same period. Like Halpert, Man Ray had a tendency of outlining the periphery of elements within the landscape, from foliage and houses in the immediate foreground, to the distant trees, rolling hills,

and mountains in the background. Both Man Ray and Halpert would soon come under the sway of Cézanne, Halpert going so far as to make a watercolor comprising only elements derived from Cézanne's Bather series.[5] The influence of Cézanne on Man Ray is suggested by the simplified forms, flattened planes, areas of unpainted canvas, and parallel constructive brushstrokes of *Ridgefield Landscape.*

In September of 1913, Man Ray went with some friends on a three-day camping trip to Harriman State Park in northern New Jersey, an excursion designed for relaxation and pleasure, but an occasion that would have far-reaching consequences for his career as a painter. Man Ray was accompanied by Adon Lacroix, a Belgian poet and painter whom he had met only a few weeks earlier (they would marry in March 1914) and two other couples. On the last day of the trip, possibly while making a sketch of distant mountains, he declared that he would no longer seek inspiration directly from nature, which, he felt, only hindered his creativity. From that point onward, he would create his compositions from memory, in the privacy of his studio back in Ridgefield. One of the most vivid memories of his camping trip was when he and one of his companions awoke one morning to find the women in their group bathing in a nearby stream. "We watched the nude figures moving about through the branches," he recalled. "I thought of Cézanne's paintings, and made a mental note of the treatment of figures in a natural setting, for future works."[6] Indeed, the sketch and painting he later produced of this

Fig. 1 Man Ray, *Still Life,* 1913. Oil on canvas.
Courtesy Sotheby's

scene (cats. 90, 91) do bear a casual resemblance to Cézanne's Bathers, particularly *Four Bathers* (1877–78, R363), a painting of nude female figures emerging from a stream, that was on display in the Armory Show. In terms of style, however, the Man Ray sketch is fluid and curvilinear, while, by contrast, the figures in his painting are cold and geometric, neither one resembling, in particular, any specific work by Cézanne. Yet it could be argued that certain formal contrivances within Man Ray's picture—such as the tree in the background seemingly responding to the void left above the distant hills, or the pointed knee of the recumbent figure in the foreground that echoes

the spread legs of the woman directly behind her—derive from lessons taught to all painters by the Master of Aix.

Man Ray displayed his closest affinity to Cézanne in the various still lifes that he painted during the years he worked in Ridgefield (e.g., fig. 1). One still life is painted with repetitive, staccato brushstrokes similar in appearance to what has been referred to as the "modulated brush" of Cézanne. This is especially evident in the articulation of the brilliant blue vase holding fruit, with its reflection cast on the surface of the table below. In this picture, Man Ray also adopted an elevated viewpoint, generating a sense of instability to objects gathered on the table, a feature common to many paintings by Cézanne. In another still life from this period (cat. 89), Man Ray devised a spatial composition that is, by contrast, more confined. Here a banana, ceramic jug, small rectangular bowl, and plate occupy no more than a few inches of space, the whole seemingly placed on the edge of a long shelf against the backdrop of red-orange patterned wallpaper. Over time, this tendency of compressing spatial dimensions would increase, so much so that it would eventually culminate in abstraction. This was exactly what Man Ray intended, for he would soon go on to develop the basic tenets of a remarkably early formalist theory, one wherein the flat surface is established as a common vehicle of expression for all the arts.[7]

FRANCIS M. NAUMANN

1. Man Ray, *Self Portrait* (Boston: Atlantic-Little, Brown, 1963), 18; 2nd expanded ed. (Boston: Little, Brown and Company, 1988), 25.

2. Reproduced in Francis M. Naumann, *Conversion to Modernism: The Early Work of Man Ray* (Montclair: Montclair Art Museum; New Brunswick: Rutgers University Press, 2003), 23.

3. This was Stieglitz's first show of modern European art, and was held at his gallery from November 18 through December 8, 1910; on this and the exhibition of Max Weber's photographs of paintings by Cézanne there, see the Chronology in this volume.

4. Quoted in C. Lewis Hind, "Wanted a Name," *Christian Science Monitor,* newspaper clipping, date unknown (likely November–December 1919), scrapbooks of Katherine S. Dreier, Beinecke Rare Book and Manuscript Library, Yale University, reprinted in Hind, *Art and I* (New York: John Lane Company, 1920), 180–85; for this reference, see 181.

5. Reproduced in Diane Tepfer, *Samuel Halpert: Art and Life, 1884–1930* (New York: Millennium Partners, 2001), 37.

6. Man Ray, *Self Portrait,* 51–52 (second edition, 50).

7. Man Ray, *A Primer of the New Art of Two Dimensions* (privately printed, 1916); for a discussion of this publication, see Francis M. Naumann, "Man Ray's Early Paintings 1913–1916: Theory and Practice in the Art of Two Dimensions," *Artforum* 20, no. 9 (May 1982): 37–46; and Naumann, *Conversion to Modernism,* 148–51.

MAN RAY

Cat. 88
Ridgefield Landscape, 1913
Oil on canvas
20 × 24 in. (50.8 × 61 cm)
Montclair Art Museum, Gift of Naomi and David Savage,
1998.13

MAN RAY

Cat. 89
Still Life, 1913
Oil on canvas
9⅞ × 11⅞ in. (25.1 × 30.2 cm)
Lent courtesy of the Ackland Art Museum, the University of
North Carolina at Chapel Hill

MAN RAY

Cat. 90
Study for Departure of Summer, 1913
Pen and ink on paper
7⅞ × 9⅞ in. (20 × 25.1 cm)
Marion Meyer Gallery, Paris, France

MAN RAY

Cat. 91
Departure of Summer, 1914
Oil on canvas
32½ × 35½ in. (82.5 × 90.2 cm)
The Art Institute of Chicago, Through prior gift of the
Mary and Leigh Block Collection, 1992.653
Baltimore only

ANNE ESTELLE RICE (1879–1959)

Anne Estelle Rice found early success as an illustrator in Philadelphia. Though less well known in this country, she gained acclaim as a painter in Paris and London in the early part of the twentieth century. In all of her paintings one can see the constant play between the influences of Matisse and Cézanne, tempered by the curving lines which hint at her illustrative beginnings.

Rice entered the School of Industrial Art of the Pennsylvania Museum (now the Philadelphia Museum of Art) in 1894. In 1899, she enrolled at the Pennsylvania Academy of the Fine Arts. Rice started her career as an illustrator; her work appeared in *Collier's, Harper's Bazaar, Ladies Home Journal, Metropolitan Magazine,* and the *Saturday Evening Post.* In 1905, Rice was sent to Paris by the *North American,* a Philadelphia newspaper owned by Thomas Wanamaker, to illustrate the fashion commentary of Elizabeth Dryden. Rice's circle in Paris included the Scottish painter John Duncan Fergusson (1874–1961) and the contributors to the journal *Rhythm,* a publication focused on art, music, and literature.[1] She would have seen the Cézanne memorial exhibition at the 1907 Salon d'Automne, on account of her relationship with Fergusson, who also exhibited there that year. Though Fergusson knew the Steins he was not "an habitué," and there is no evidence of Rice having visited the Stein apartment.[2]

Fergusson taught at the Académie de la Palette in Paris, and it was through his encouragement and perhaps even under his instruction that Rice began painting. She debuted at the Salon d'Automne in 1908. In 1910 she was elected a *Sociétaire* of the Salon d'Automne, and her painting *Egyptian Dancers* was given the Place d'Honneur.[3] Rice had her first solo show at the Baillie Gallery in London in 1911; she moved permanently to that city in 1913.[4]

In *Ajaccio, Corsica* (1913, cat. 92) the influence of Cézanne is clear. Rice used parallel brushstrokes to define the undulating hills and trees in the foreground. A tree on either side of the painting frames the scene, a common element in Cézanne's landscapes. The hills open out, drawing the viewer back through the maze of trees to the stacked, compressed buildings in the middle ground. The brilliant blue sea and mountains in the background are pushed to the very edge of the canvas. The subdued pinks and greens of *Ajaccio, Corsica,* create a marked contrast to much of Rice's oeuvre, which is done in a more brilliant, Fauve-like palette. That Rice never abandoned her early training can be seen in her use of thick dark lines that outline certain elements in the painting. Here, Rice perfectly fused the structure of Cézanne and color of Matisse with the lyricism of her own curving line.

EMILY SCHUCHARDT NAVRATIL

1. Carol A. Nathanson, *The Expressive Fauvism of Anne Estelle Rice* (New York: Hollis Taggart Galleries, 1997), 7.

2. Ibid., 9.

3. Ibid.

4. O. Raymond Drey, *Anne Estelle Rice* (Hull, UK: University of Hull, 1969), unpaginated.

ANNE ESTELLE RICE
Cat. 92
Ajaccio, Corsica, 1913
Oil on canvas
21¼ × 25½ in. (54 × 64.8 cm)
Private Collection

MORGAN RUSSELL (1886–1953)

As an American expatriate painter residing in Burgundy during the mid-1930s, Morgan Russell stopped to reflect, at midcareer, on the artistic debt he owed to his French predecessor, Paul Cézanne. Paraphrasing Cézanne's dictum that a painter should be adept at perceiving certain elemental forms—"the sphere, the cone, and the cylinder"—in nature, Russell now confidently responded, "One needs to know *how* to paint cones, cylinders, etc., before being able to *sing form* in the elevated language [of abstraction]."[1]

Russell's rejoinder was not merely clever, as learning how to "sing form" in oil pigments signified virtually everything he had aspired to upon completing his artistic training, in New York, at the Art Students League (and briefly in the Manhattan studio of Robert Henri) in early 1909, and promptly moving to Belle Époque Paris.[2] Like so many of his restless colleagues, Russell soon found his way to the already legendary salon of Gertrude and Leo Stein, where he would be introduced to Matisse, Picasso, and Apollinaire, among many others. All of these visitors found themselves frequently playing audience to Leo's windy ruminations on Cézanne's "sheer expression of form"—a pictorial quality evident even in the Impressionist master's unprepossessing still life, *Five Apples* of 1877–78 (cat. 2), which hung easily within eyeshot.[3]

It was doubtless at Leo's direct urging that Russell eventually borrowed this picture for extended study, which in 1909 led to a host of related pencil and watercolor sketches, as well as

several highly accomplished oil paintings (e.g., *Three Apples* of 1910, cat. 94). Unlike his fellow expatriate Andrew Dasburg, who also benefited by this singularly generous loan (there is no evidence that the Steins ever repeated the gesture), Russell was hardly seeking to "copy" Cézanne's example but attempting to assimilate the lessons implied in its "plastic," or material construction.[4] Russell was especially taken by Cézanne's seemingly systematic juxtaposition of multiple color patches for rendering form sculpturally, a technique that also functioned, for Russell, as an apt metaphor for light itself (see *Still Life Color Study,* c. 1915, cat. 99). Russell would come to refer to this effect as *profondeur,* meaning the rendering of not only form but space itself as two equally "palpable" entities. As is reflected in his studio notes of the period, *profondeur* lent itself to Russell's development of a purely "presentative" painting idiom, that is, one that largely dispensed with referencing everyday subject matter—human figure, landscape, still life—in favor of foregrounding the work's own tangible, material constitution.[5]

Russell's high regard for Cézanne had always been qualified, however, by his own ambitious agenda. This is attested by certain passages found in his more than seventy extant notebooks, in which Russell's admiration for various vanguard masters (Monet, Renoir, and Rodin rounded out his list of favorites) is often tempered by a conviction that he would eventually surpass their collective achievement.[6] Seeking to establish a progressive principle of picture construction,

Russell complemented his study of Cézanne's still life with a sketching session after Picasso's *Three Women* (1907–8), which similarly hung in the Stein apartment (now in the State Hermitage Museum, St. Petersburg). Russell's loose transcription (Montclair Art Museum) is frequently cited by historians as evidence of Picasso's growing influence over a whole generation of vanguard painters working in prewar Paris.[7] Less appreciated is how Russell's study of Cézanne and Picasso represents a proactive, syncretic means of arriving at a new principle of picture construction in the marrying of dissimilar sources. This is attested by a hitherto unknown drawing dating from the same period, in which a four-square, prismatic schema that Russell derived from Picasso's proto-Cubist *Women* is limned alongside a thumbnail sketch (on the same sheet of paper) of a small crate of apples. This unlikely pictorial collision aptly demonstrates what Russell would refer to, by about 1911, as *serré,* by which he meant an "intensity of expression . . . [resulting from] . . . the greatest state of tension and interpenetration of [the painting's] parts."[8]

Russell's notebook entries from 1909 through 1912 thus attest to his continual referencing of Cézanne while he sought to arrive at entirely abstract, yet always *sculptural* configurations of colored light in rhythmic and "interminable" metamorphosis.[9] *Battle of the Filaine* (1909, cat. 93) attests to Russell's understanding of this sculptural interdependence of form and color, as well as his faith in its making fea-

sible a new "musical" idiom of complete color abstraction (the latter was what Russell and Stanton Macdonald-Wright would come to call Synchromism—meaning "with color"—at the time of their formal debut together in Munich in the summer of 1913).[10]

As though seeking to update Cézanne's typically triangular and centripetal organization of figures-in-landscape, Russell has his own figurative ensemble in *Battle* project collectively outward from the picture's center, the orgy of combative forms pivoting laterally in either direction away from a specific locus along the river embankment. These figures collectively mirror, in reverse manner, the summit of the distant mountain, thereby lending a lozenge- or diamond-like structure to the entire canvas, one that virtually collapses the implied space of extension (in depth) into a shallow, emotion-charged envelope.[11] Russell's appreciation for Claude Monet is apparent in this painting's quasi-Impressionist facture; nevertheless, Russell was primarily quoting Cézanne in experimenting with such a mock history picture. As Cézanne had counseled Émile Bernard in a letter of 1905 from Aix, "Go ahead and draw, but remember, it is reflected light that is enveloping. Lighting by reflection in general: *that* gives the envelope. . . . Into our vibrations of light . . . we need to introduce sufficient blues *to make one feel the air*." Russell evidently reiterates Cézanne's counsel in a notebook entry of about the same time he executed this painting:

Fig. 1 Paul Cézanne, *Self-Portrait*, 1879–82. Oil on canvas. Pushkin State Museum of Fine Arts, Moscow (3338)

Large nude of Cézanne—Truth and solid building up of color—that renders the mass and compactness and force as well as the envelopment in air and space— water greenish, land violetish, sky greenish again—bits of warmth.[12]

If such examples make clear that Russell frequently quotes—and cribs from—Cézanne, he almost invariably does so through an aesthetic scrim provided by a contemporary intermediary. This was Henri Matisse, whose Paris *académie*

Russell all but certainly frequented as early as 1908.[13] Russell's notes from 1908 to 1912 speak eloquently to the Fauve master's fundamental contributions to his artistic development.[14] The progression from Fauvist experimentation to American Synchromism is perhaps nowhere more evident than in Russell's oil copy after Cézanne's *Self-Portrait* of 1879–82 (fig. 1). Cézanne's own contention that drawing has no real place in painting, in that all modeling after nature may be accomplished by the juxtaposition of discrete color patches in lieu of *chiaroscuro* was adopted verbatim by Russell, who achieved here the illusion of three dimensions by reducing entire sections of Cézanne's own Impressionist facture to nearly opaque, discrete color units (cat. 96). Russell's "Cézanne" takes shape by way of variegated color zones—each color patch emerging from, or receding into the picture by virtue of its juxtaposition with others of equal intensity. Recording his "Impressions of C[ézanne]," in November of 1911, Russell writes,

The completeness of continuity of form in depth. The variety of the light and "shade . . ." Also gradation of the light and variety in same as tint and tone. Sharp brusque contrasts of same running off into insensible gradations. . . . Large rhythmic order of whole canvas.[15]

If Russell's appreciation for Cézanne underwent subtle modification during his study with Matisse, this was most in evidence in the

evolution of his philosophy—from about 1908 to 1912—regarding a painting's composition or structure.[16] At virtually any time in 1910 and well into early 1911 (when he was sketching and painting after Cézanne's still-life, portrait, or Bather pictures in the Stein collection), whatever might constitute a given painting's apparent motif was subject to integration into a larger composite whole, the "strength and directness of expression" of which—as Russell notes on a drawing of about 1912 after Cézanne's 1877–78 *Bather with Outstretched Arms* (cat. 97)—depended upon every portion of the canvas pulling its own weight in a greater optical array, or visual "envelope."[17]

While Russell never abandoned this holistic principle of picture construction, his regard of its primacy underwent distinct revision under the close tutelage of Matisse. In this respect Russell is exemplary of an entire generation coming of age in the decade leading up to World War I, for whom a set of long-popular mechanistic metaphors began to give way to analogies borrowed from the realm of musical composition. Painting was now to embody a single or "dominant" emotional impact, as well as entirely dispense with visually negligible details. Russell's own dogged pursuit of a mode of "musical" color abstraction—one that might ideally lead to choreographed performances of colored light, or what Russell called *synchromies lumières*—is evident as early as 1910, when he notes:

The composing of a whole, of a "melodie" as it were—or a symphonie *morceau* that holds together and is capable of standing and living alone before every preoccupation [with] form, mass, or anything else— these latter are the result of the *moyen* [i.e. "core" or "viscera"] of one's emotion.[18]

This was Matisse's territory. As it turns out, Russell made the transition almost seamlessly, handily converting his early reverence for Cézanne into a more thoughtfully reasoned appreciation. It is possible to detect this in Russell's quasi-Fauvist *Still Life with Bananas* of c. 1912–13 (cat. 98), in which the influence of Cézanne meets the keyed-up colorism of Matisse in a tense—if intermittently lyrical—standoff. Nothing about this picture elicits the gradually additive or analytical mien of Cézanne, which by that time Russell was quietly criticizing. Visiting the exhibition of Impressionist pictures at the gallery of Durand-Ruel in May of 1912, for instance, Russell proceeded much as an art critic, jotting in disjunctive fashion in his own graph-papered notebook:

In looking at the Renoirs or Cézannes [there is a] lack of an easily grasped rhythm or melodie of ensemble. *This is terribly significant.*[19]

Suddenly Monet was looking all the more relevant, the Impressionist master having achieved "an intelligent representation of things, and light . . .

seen chromatically or as color." Three years hence, Russell would find himself again comparing and contrasting paintings by Renoir and Cézanne, the latter's work constituting an "intense study and meditation of a fragmentary kind."[20]

By 1915 Russell had indeed come a great conceptual distance from his early grounding in American Tonalism, the Ashcan School, and French Impressionism.[21] Not unlike the art critic and connoisseur Bernard Berenson, Russell was ultimately pulled squarely into the twentieth century by a very "modern" old master.[22] It was Paul Cézanne who had essentially shown Russell—as he had similarly shown Matisse—how to see in color, form, and light a single entity, something to be registered thoroughly by the attentive retina and converted joyfully into the expressive and ecstatic syntax of painting.[23]

GREGORY GALLIGAN

1. Russell is referring to a statement by Cézanne that originally appeared in an article by Émile Bernard in the Paris journal *L'Occident* in July of 1904. Cézanne's statement there reads, "Everything in nature is modeled after the sphere, the cone, and the cylinder. If the artist learns to paint according to these simple figures, he will then be able to do all he desires"; see Michael Doran, ed., *Conversations with Cézanne,* trans. Julie Lawrence Cochran (Berkeley and Los Angeles: University of California Press, 2001), 39. A reprint of that article, which also included a letter by Cézanne that expanded slightly upon his original, appeared in the *Mercure de France,* on October 1 and 16, 1907. Russell was not in Paris on either occasion, but in a letter to the painter Andrew Dasburg of October 27, 1907—written notably within days of the newspaper's second installment—Russell speaks of achieving a breakthrough in his rendering of color after he had "read over Cézanne's letters," which indicates his close familiarity with Bernard's tribute (the letters themselves were not to be published in book form until 1912); see the Andrew Dasburg and Grace Mott Johnson Papers, 1833–1980 [bulk 1900–1980], Archives of American Art, Smithsonian Institution, reel 2803.

2. At that moment the City of Light was the site for many of the most heated discussions over recent developments in continental philosophy, atomic physics, and behavioral psychology, as well as physiological aesthetics and painting and sculpture. Russell compiled a representative reading list in an artist's notebook of late 1911 that suggests he review the works of the American psychologist William James, the German physiologist Gustave Fechner, and the French psychologist and philosopher Henri Bergson—no less the literary masterpieces of Dante, Ibsen, and Petrarch; see Morgan Russell, Notebook 4.2.12 [1911–12], Morgan Russell Archives, Montclair Art Museum (hereinafter Russell Archives). On the assimilation of the experimental principles of physiological aesthetics by artists from the late 1880s through the 1930s in Britain, France, and the United States, see Gregory Galligan, "The Cube in the Kaleidoscope: The American Reception of French Cubism, 1918–1938," Ph.D. diss. Institute of Fine Arts, New York University, 2007, esp. chapter 3, "Quickening Vision: Albert E. Gallatin and the Advent of an American Cubism," 127–261.

3. Leo Stein initially gained his appreciation of Cézanne by way of a conversation with Bernard Berenson in the spring of 1904; see Leo Stein, *Appreciation: Painting, Poetry and Prose* (New York: Crown, 1947), 154; see also *Four Americans in Paris: The Collections of Gertrude Stein and Her Family* (New York: The Museum of Modern Art, 1970), 24; and Ernest Samuels, *Bernard Berenson: The Making of a Legend* (Cambridge, MA: Harvard University Press, 1987), 5–48. Both Stein and Russell saw in early Italian Renaissance painting certain "precursors" to Cézanne, and their writings suggest that both men may have been viewing Cézanne originally through lenses colored by a comprehensive study of Italian Renaissance pictures. The point was prob-

ably not lost on Russell, who as early as 1909 studied Berenson's publications closely; see Russell, Notebooks 4.2.3 (1909–10), 4.2.4 [1909–10], and 4.2.6 (Early 1909–10), Russell Archives.

4. Dasburg himself noted a distinct difference between his own quotidian use of the Cézanne still life and Russell's more carefully reasoned approach to it; see Paul Cummings, Andrew Dasburg Interview, March 26, 1974, Archives of American Art, Smithsonian Institution. On Russell and Dasburg's use of this picture, see also John Rewald, *Cézanne and America: Dealers, Collectors, Artists and Critics* (Princeton: Princeton University Press, 1989).

5. At the same time, Russell's ideal was no proto-Constructivism. Indeed, Russell distinctly saw himself as extending Cézanne's Impressionist legacy, writing, "Aim entirely now at a purely 'musical' form of expression of reality, not dramatic but rhythmic and plastic—in painting it is the treatment, the feeling and expressing of *chromatic light* in this manner. In sculpture the expressing of having forms as rhythmic and esthetic values and not representational ones—but don't get away from reality by theorizing on *color* and *form*—it is light and organic life"; Russell, Notebook 4.2.9 (1910–11), Russell Archives; see also Richard Shiff, *Cézanne and the End of Impressionism: A Study in the Theory, Technique, and Critical Evaluation of Modern Art* (Chicago: University of Chicago Press, 1984). For an informative discussion of the term "plastic" as utilized by Cézanne's artist-admirers and critics for referring to "the physical, that which is rooted in matter," as well as the term's frequently evoking "non-physical assumptions," see the essay in this volume by Jill Anderson Kyle as well as her 1995 dissertation; I am grateful to Gail Stavitsky for bringing this study to my attention. Émile Bernard's understanding of Cézanne's "mystical" concentration on the plastic, or material qualities of painting over its superficial subject matter speaks to this subject: "Cézanne is a painter with a mystical nature because of his purely abstract and aesthetic vision of things. Where others busy themselves trying to create a subject, in order to express themselves, Cézanne is satisfied with some harmonies of line and tonality taken from random objects without worrying about the objects themselves. *He is like a musician who, disdainful of elaborating upon a libretto, is content instead with chord sequences whose exquisite nature would unerringly immerse us in a transcendent art inaccessible to his able colleagues*"; see Doran, *Conversations with Cézanne,* 40; emphasis added.

6. As early as the spring of 1915, notably within two years of making his professional debut in Paris, Russell had boasted to himself that, in historical and aesthetic terms, just as Stravinsky had been to Debussy, he would be to Picasso; see Russell, Notebook 4.2.36 [c. May 1915], Russell Archives.

7. For the most recent example, see Michael FitzGerald, *Picasso and American Art* (New York: Whitney Museum of American Art, in

association with Yale University Press, New Haven, CT, 2006) (Russell's drawing is reproduced on page 21).

8. The dual sketch occurs in an artist's notebook of 1910–11 that documents Russell's intense search at this juncture for the means to render natural forms via color, light and shadow, implied movement, the illusion of "form in depth" (over flat line drawing), and the perfection of a painting as a vital "organism," in which every part contributes indispensably to the success of the whole; see Russell, Notebook 4.2.11 (June–August 1911), Russell Archives. There is evidence that Cézanne appreciated a similar plastic, abstract quality (in the rendering of form and color as mutually dependent properties) in the late pastels of Jean-Baptiste-Siméon Chardin, and that Russell took this as a cue to study Chardin closely at the Louvre; see Doran, *Conversations with Cézanne,* 31.

9. Russell found himself seeking a "movement that has [a sense of] beginning, middle, and end" while implying "dramatic action" in a state of "interminableness"; see Russell, Notebook 4.2.9 (1910–11), Russell Archives. For a comprehensive discussion of Synchromism as conceived by Russell and Stanton Macdonald-Wright for designating an idiom of painting that might serve as a visual equivalent to music, see Marilyn S. Kushner, *Morgan Russell* (Montclair, NJ: Montclair Art Museum, 1990); see also Will South, *Color, Myth, and Music: Stanton Macdonald-Wright and Synchromism* (Raleigh: North Carolina Museum of Art, 2001).

10. The narrative subject of this picture is apparently based on a legendary clash between the inhabitants of France's Loire Valley and the occupying Romans circa 52 BCE. Russell was a lifelong student of Italian culture, as well as ancient Greek and Mediterranean history. As is the case for a great number of Russell's figurative pictures throughout his career, such subjects tend to serve him as "pegs" on which to hang his more abstract, or formal interests. This particular example dates from Russell's second trip to Paris and his introduction to the Stein salon in early 1908 (prior to his relocation). Russell may have derived this picture in part from Cézanne's *Group of Seven Bathers,* of 1898–1900, which also occupied an honored place in Gertrude and Leo's apartment. Gertrude made a point of having herself photographed while seated beside it, back to the canvas, as though she were steadying herself before its combustive energies; for a reproduction of the photograph—which notably prefigures Pablo Picasso's *Portrait of Gertrude Stein,* of 1906—see *Four Americans,* 53.

11. It is entirely possible that Russell conceived this picture along the lines of the shallow relief (*bas relief*) of Roman sarcophagi, which he is known to have studied closely at the Louvre. It should also be noted that Russell's early study of Cézanne's Bather pictures resurfaces in his return to figuration in the interwar period, and reaches a peak in a series of male bather pictures dating from the mid-1930s. The full implications of this subject in regard to Russell's development and

complete oeuvre await further, comprehensive study; for an introduction, see Kushner, *Morgan Russell*.

12. I have taken the liberty here of juxtaposing two closely related quotes of Cézanne pertaining to the rendering of form and color that he made separately in letters to Bernard dating from 1904 and 1905; see Doran, *Conversations with Cézanne*, 29 and 47. Russell's quote occurs in a notebook of 1909–10; see Russell, Notebook 4.2.4 [1909–10], Russell Archives.

13. While initially pursuing a career in architecture after the example of his deceased father and working as a studio model for the sculptor James Earle Fraser at the Art Students League, Russell made two "student" tours of Europe. The first, of France and Italy, was undertaken in the spring and summer of 1906, at the end of which Russell visited the Salon d'Automne, where he rendered an oil sketch after Gauguin's *Nave Nave Mahona* (1896); he doubtless also studied the ten canvases by Cézanne that were included in that year's exhibition. During the second European tour in the summer of 1908, Russell likely visited Matisse's class as a guest (perhaps courtesy of Andrew Dasburg). He also attended the grand exhibition by Claude Monet (numbering over fifty works) at the galleries of Durand-Ruel; see the chronology provided by Kushner, *Morgan Russell*, 187–88.

14. Shortly after settling in Paris in mid-April of 1909, Russell formally matriculated with Matisse, doubtless seeking firsthand correction of his figurative sculpture. The Russell Archives contain several photographs of Russell's efforts in this realm, their shiny gelatin surfaces bearing Matisse's own matted, ink revisions that insist on a given plaster figure's maintaining the top-down, progressively diminishing proportions of Egyptian statuary. This compositional bias would prevail in Russell's drawing, *Study after Cézanne's "Smoker"* (c. 1910, cat. 95), in which the upward thrust of the sitter's blazer fans out into a portrait in three-quarter profile. The same vertical and progressively expanding composition would ultimately characterize Russell's Synchromist abstractions in about 1913; for a representative history, see Gail Levin, *Synchromism and American Color Abstraction, 1910–1925* (New York: Whitney Museum of American Art, 1978).

15. See Russell, Notebook 4.2.9 [1910–11], Russell Archives. As Russell had already noted only several pages preceding this entry, he was seeking in his own painting "a feeling as if kneading in a plastic material . . . a constant vision of the whole as an organism which is continually moving and changing form as a result of touching it in one place or another."

16. In about 1911 Russell would complement his studies with Matisse with color studies under the expatriate color theorist Percyval Tudor-Hart, who taught that color could serve as a visual equivalent for musical tone, or sonority); see South, *Color, Myth, and Music*. It is not known whether Russell attended the Matisse exhibition at Alfred Stieglitz's Gallery of the Photo Secession [a.k.a. 291] in April 1908. Cézanne's work was not shown in a solo exhibition at 291 until March of 1911, that is, when Stieglitz and Edward Steichen brought to New York a representative selection of his celebrated watercolors.

17. The work of art was thus a kind of distilled afterimage, as it were, of visual perception, its composite parts adding up to the most salient and striking aspects of the observed subject (as Russell learned from his studies with Matisse, who repeatedly stressed such qualities with the students of his academy). Russell probably saw Cézanne's *Bather with Outstretched Arms* in the private collection of Auguste Pellerin, in Paris, in October of 1912; see Russell, Notebook 4.2.19 (September 1912), Russell Archives. Pellerin began collecting Cézanne from Ambroise Vollard in 1898; his collecting intensified between 1907 and 1913, when he secured twenty-nine canvases (although the *Bather* picture cited here was obtained directly from the galleries Bernheim-Jeune); see Françoise Cachin et al., *Cézanne* (Philadelphia: Philadelphia Museum of Art; New York: Harry N. Abrams, 1996), 278–80, 573.

18. See Russell, Notebook 4.2.9 (1910–11), Russell Archives. I have taken the liberty, for the sake of clarity, of reversing two entries in this sample quotation, given Russell's own characteristic shifting back and forth between ideas in these notebooks, as well as the disjunctive nature of his creative revelations. The actual passages are in fact neighboring entries; only their sequence has been reversed here.

19. Russell, Notebook 4.2.15 (Spring 1912), Russell Archives; emphasis added.

20. Russell, Notebook 4.2.37 (1915), Russell Archives.

21. On the matter of his Tonalist background, Russell had spent part of the summer of 1907 at Woodstock, New York, visiting the painter Andrew Dasburg, who was studying with the American Tonalist Birge Harrison. At about that time Russell produced his first oil painting, *My First Painting, Old Westbury, Long Island,* where he loosely recalls the legacy of George Inness; see Cummings, Dasburg Interview, AAA. It is also worth noting that Russell's exposure to American Tonalism and French Impressionism all but certainly occurred as early as the summer of 1904, during a trip to St. Louis, where Russell probably studied much recent and contemporary painting in the American and French sections of the spectacular Louisiana Purchase Exposition (which included work by Edgar Degas, Stanislas Lepine, Claude Monet, Auguste Renoir, and Auguste Rodin). Notably, Cézanne's single submission—a landscape submitted at the urging of the art critic Roger Marx— had been rejected by the jury; see *Official Handbook: Illustrations of Selected Works in the Various National Sections of the Department of Art,* intro. by Halsey C. Ives (St. Louis: Louisiana Purchase Exposition Company, 1904); see also Cachin, *Cézanne*, 563.

22. Passages from Berenson's celebrated studies of Venetian, Florentine, and Central Italian painters of the Renaissance (published in 1894, 1896, and 1897, respectively) were quoted verbatim by Russell between 1909 and 1910; see Russell, Notebooks 4.2.3 (1909–10), 4.2.5 [1909–10], and 4.2.6 (Early 1909–10), Russell Archives.

23. In Russell's case, one might argue that Michelangelo was Cézanne's only equal, although the two obviously occupy separate, if complementary categories—one an old master, the other a modern mentor.

MORGAN RUSSELL

Cat. 93
Battle of the Filaine, 1909
Oil on board
10 × 13 in. (25.4 × 33 cm)
Courtesy Lori Bookstein Fine Art, New York

MORGAN RUSSELL

Cat. 94
Three Apples, 1910
Oil on cardboard
9¾ × 12⅞ in. (24.6 × 32.5 cm)
The Museum of Modern Art, New York. Given anonymously, 1949 (349.1949.2)

MORGAN RUSSELL

Cat. 95
Study after Cézanne's "Smoker," c. 1910
Graphite on paper
12 3/8 × 9 in. (31.4 × 22.9 cm)
Montclair Art Museum, Morgan Russell Archives and Collection,
Gift of Mr. and Mrs. Henry M. Reed, 1985.172.231

MORGAN RUSSELL

Cat. 96
Portrait of Cézanne, c. 1910
Oil on board
15¾ × 13⅞ in. (40 × 35.2 cm)
Collection of The Honorable and Mrs. Joseph P. Carroll,
New York

MORGAN RUSSELL

Cat. 97
Study after Cézanne's "Bather with Outstretched Arms,"
c. 1912
Graphite and ink on paper
5⅛ × 8¼ in. (13 × 21 cm)
Montclair Art Museum, Morgan Russell Archives and Collection, Gift of Mr. and Mrs. Henry M. Reed, 1985.172.147

MORGAN RUSSELL

Cat. 98
Still Life with Bananas, c. 1912–13
Oil on canvas
10¾ × 14 in. (27.3 × 35.6 cm)
Montclair Art Museum, Morgan Russell Archives and Collection, Gift of Mr. and Mrs. Henry M. Reed, 1985.172.2

MORGAN RUSSELL

Cat. 99
Still Life Color Study, c. 1915
Watercolor on paper
5¾ × 8½ in. (14.6 × 21.6 cm)
Montclair Art Museum, Gift of Mr. and Mrs. Henry M. Reed,
1988.116

CHARLES SHEELER (1883–1965)

Charles Sheeler's enduring penchant for architectonic structure and underlying, essential forms was nurtured by his early appreciation of the work of Cézanne. He saw his first examples during a trip abroad in 1908–9 with his colleague Morton Schamberg. They initially toured Italy, where the works of Giotto, Masaccio, Piero della Francesca "brought to [their] consciousness that . . . forms must be placed with primary consideration for their relation to all other forms . . . if the picture . . . is to achieve an architectural-like structure."[1] These valuable precedents helped to prepare them for the bewildering experience of encountering the work of Cézanne, Picasso, Matisse, and others in Paris who were "opening up new territory . . . and revivifying the past by directing attention to that which is intrinsic."[2] After seeing Cézanne's work during his short trip at the Durand-Ruel and Druet galleries as well as the apartment of Michael Stein, Sheeler returned to Philadelphia and immersed himself in the lessons of the master. Turning away from the bravura style of his teacher at the Pennsylvania Academy of the Fine Arts, William Merritt Chase, Sheeler methodically pursued a new approach based on the Cézanne-inspired realization that "a picture might be assembled arbitrarily, with a primary consideration of design, that would be outside of time, place, or momentary [atmospheric] conditions."[3]

One of only a few known paintings that he created in 1910, *Peaches in a White Bowl* (cat. 101) epitomizes the new Cézannesque direction of

Sheeler's work.[4] The choice of subject and plastic rendition of closely massed, simplified forms within a seemingly unbalanced, asymmetrical composition based on a tilted perspective typify Sheeler's empathy with the highly controlled, finely tuned aspects of Cézanne's oeuvre. The broad, modulated strokes of vibrant, contrasting colors that firmly construct the shapes of the peaches, plate, tablecloth, and shadows recall Cézanne's often quoted belief in making "of Impressionism something solid and durable like the art of the museums."[5] The refined quality of this work, consistent with Sheeler's aspirations toward a more timeless, classical, universal style based on "the elimination of the unessentials," is evident in the series of other modest table-top still lifes that Sheeler would concentrate on creating for the next few years.[6] In 1914 in a review of a show at the Montross Gallery, Sheeler was grouped as being among "the younger painters . . . who have learned much worth learning from Cézanne and his adapters. . . . [H]is understanding of passing from one color into another that makes his vase of small asters altogether a work of great beauty."[7]

This tendency toward "an intensive and selective realism" was observed as a critical aspect of Sheeler's photography as well as his paintings.[8] Reviewing a show in 1917 at the Modern Gallery in New York that included Sheeler's then little-known, sharply focused photographs, Henry McBride observed that his "photograph of a New York building has the . . . inevitableness

of Cézanne's 'Bouquet de Fleurs' [c. 1900–1903, National Gallery of Art, Washington, DC, R893]."[9] This highly publicized Cézanne had been shown at the Modern Gallery in 1916 (where Sheeler was working as a photographer of artworks) and has been credited with possibly inspiring Sheeler's photography from this time onward.[10] Sheeler's photographs, on view in a show at the Modern Gallery in December 1917, were again discussed in this context:

> In fact these prints of Sheeler's represent the testimony of photography to the truth and value of the modern evolution in painting. What Cézanne stands for in the structural use of colors is here certified to as being true to nature. So, too, are the directions of Picasso and others in the direction of abstraction . . . underlying the surface beauty of nature. . . . It is this abstract, organic beauty that the camera has revealed to Sheeler.[11]

Furthermore, around this time, Sheeler became close with the New York collectors Walter and Louise Arensberg, whose collection he photographed and from whom he borrowed a small Cézanne still life for closer examination of its "primary classicism" in his own studio.[12] In a later interview, he exclaimed, "That picture was painted by one of the Angels . . . Incredible!"[13] Sheeler's earlier photograph of his studio, made around 1913, presents compelling evidence of his admiration for Cézanne, whose *Smoker* (c. 1891,

Fig. 1 Charles Sheeler, *Studio Interior,* c. 1913. Gelatin silver print. The Lane Collection, Courtesy Museum of Fine Arts, Boston

Hermitage Museum, St. Petersburg, R757) is featured in a matted and framed reproduction in the center of the wall (fig. 1).[14]

The impact of Cézanne continued to be a factor in Sheeler's style, including his abstractions of 1915–17 in which he synthesized the structural approaches of the Post-Impressionist master and such successors as Picasso and Braque.[15] These efforts were likely encouraged by discussions in the Arensberg circle centering on Cézanne and Cubism. Sheeler's architectonic *Barn Abstraction* (1917, Philadelphia Museum of Art) has been cited as an example of the artist's appreciation of Cézanne's watercolors because of the predominance of the white ground.[16] Even Sheeler's later, Precisionist works, especially his still lifes, have been linked to the abiding influence of Cézanne

in the 1920s in terms of their pure forms, geometric structures, and complex, tilted compositions. It was during this era that Sheeler wrote an unpublished essay on still-life painting, in which he summarized the groundbreaking accomplishments of Cézanne, who had played such a major role in his development of the reductive, structural analysis of form that would define his style for the remainder of his career:

> With the advent of Cézanne still life turned toward a complete detachment from human association as a quality pertinent to visual expression. It is true that objects of association continued to serve Cézanne . . . but their selection is based upon preferences in the matter of shapes, surfaces, and quantities related to a geometric structure. Since Cézanne still-life as a vehicle for the expression of aesthetic principles has been elevated to the plane of genre.[17]

GAIL STAVITSKY

1. Charles Sheeler, "Autobiographical Notes," Charles Sheeler Papers, Archives of American Art, Smithsonian Institution (hereafter AAA), reel NSH-1, frs. 60–61.

2. Ibid., fr. 62. See also Jill Anderson Kyle, "Cézanne and American Painting, 1900 to 1920," Ph.D. diss., University of Texas at Austin, 1995, 257. See also 130–31 for Sheeler's trip to Paris and his assertion to Pach in a letter of October 26, 1910 (Sheeler Papers, reel 4216, fr. 846) that his knowledge of Cézanne's work was limited to only one canvas and reproductions. Therefore, it is unlikely that he visited the apartment of Gertrude and Leo Stein.

3. Sheeler Papers, reel NSH-1, fr. 61.

4. For a discussion of this work as the earliest known dated work to follow Sheeler's decisive trip abroad, see John Driscoll, "Charles Sheeler's Early Work: Five Rediscovered Paintings," Art Bulletin 60 (March 1980): 125–28.

5. Quoted by Maurice Denis, L'Occident, September 1907, translated by Roger Fry, "Cézanne I—by Maurice Denis," Burlington Magazine 16 (January 1910): 213.

6. Sheeler quoted in Garnett McCoy, "Charles Sheeler: Some Early Documents and a Reminiscence," Archives of American Art Journal 5 (April 1965): 2. For the series of still lifes, see Carol Troyen and Erica E. Hirshler, Charles Sheeler: Paintings and Drawings (Boston: Museum of Fine Arts; Little, Brown, 1987): 4–6, 52–57. See also Sandra Phillips, "Cézanne's Influence on American Art, 1910–1930," Masters thesis, Bryn Mawr College, PA, 1969, 96–98, 114–15nn43–44.

7. "Art Notes," Forbes Watson Papers, AAA, reel D48, fr. 24.

8. Quotation from Charles Sheeler, unpublished essay on still-life painting, Forbes Watson Papers, AAA, reel D56, fr. 1094. See also Rick Stewart, "Charles Sheeler, William Carlos Williams, and the Development of the Precisionist Aesthetic," Ph.D. diss., University of Delaware, Newark, 1981, 25, 67n24, 68n26. For more on Sheeler's career as a photographer, see Theodore E. Stebbins Jr. and Norman Keyes Jr., Charles Sheeler: The Photographs (Boston: Museum of Fine Arts; Little, Brown, 1987). See also Theodore Stebbins Jr., Gilles Mora, and Karen E. Haas, The Photography of Charles Sheeler: American Modernist (Boston: Bulfinch Press, 2002); and Charles Brock, Charles Sheeler Across Media (Washington, DC: National Gallery of Art in association with University of California Press, Berkeley and Los Angeles, 2006).

9. Henry McBride, New York Sun, April 8, 1917, quoted in Stebbins and Keyes, Sheeler: The Photographs, 7. Cézanne's Bouquet of Flowers was owned by the collectors Agnes and Eugene Meyer and referred to by Sheeler as among "their four very outstanding Cézannes. . . . They're always reproduced in any of the big books that are supposed to be definitive ones; with Cézanne, no book can be definitive." Quoted in Martin Friedman, Interview with Charles Sheeler, June 18, 1959, AAA, 13.

10. Stebbins and Keyes, Sheeler: The Photographs, 7.

11. Review in New York American, December 25, 1917, quoted in Marius de Zayas, How, When, and Why Modern Art Came to New York, ed. Francis M. Naumann (Cambridge, MA: The MIT Press, 1996), 39. For Sheeler's similar statement of his artistic goals at this time, see his statement on art "as perception . . . of universal [underlying] order" in the catalogue of The Forum Exhibition of Modern American Painters (New York: Anderson Galleries, 1916), unpaginated.

12. Constance O'Rourke, Charles Sheeler, Artist in the American Tradition (New York: Harcourt, Brace, 1938), 39, 46–47, 99. O'Rourke (38) refers to Sheeler's "extraordinary fidelity" of approach in his early still lifes (at a time when there were "no Cézannes to be seen publicly") indicating that one of them "approached Cézanne closely enough to be studied in photographic reproduction with some care, as an unknown Cézanne, by an expert student who came upon it in a group of photographs of modern French paintings." O'Rourke also quotes Sheeler as observing that "our early Bingham . . . found his words in Webster—that is, in a common source and the result is essentially commonplace—while Cézanne made his dictionary to suit his needs." For Sheeler's photographs of the Cézannes in situ in the Arensberg collection, see Francis Naumann, "Walter Conrad Arensberg: Poet, Patron, and Participant in the New York Avant-Garde 1915–20," Philadelphia Museum of Art Bulletin 76 (Spring 1980): 8–9 (see also fig. 8 in Stavitsky's essay in this volume).

13. Interview with William Lane, 1958, cited in Martin Friedman et al., Charles Sheeler (Washington, DC: National Collection of Fine Arts, 1968), 68.

14. See Carol Troyen in Troyen and Hirshler, Sheeler: Paintings and Drawings, 5, and also Morgan Russell's drawing based on this theme (cat. 95 herein).

15. See Troyen and Hirshler, Sheeler: Paintings and Drawings, 62, for a discussion of Landscape (1915, The Lane Collection).

16. Rick Stewart, "Charles Sheeler," 95. See Willard Huntington Wright, "Modern American Painters—And Winslow Homer," The Forum (December 1915): 662, "Sheeler is now passing through a stage which gives promise of good work. In him one may trace various European influences [including] generalizing lines delineating volumes, which might have been inspired by Cézanne's watercolors." See also Friedman, Charles Sheeler, 31.

17. Sheeler, essay on still-life painting. See Troyen and Hirshler, Sheeler: Paintings and Drawings, 94; and Kyle, "Cézanne and American Painting," 261.

CHARLES SHEELER Cat. 101
Peaches in a White Bowl, 1910
Oil on canvas
10 × 13¼ in. (25.4 × 33.7 cm)
Private Collection

EDWARD STEICHEN (1879–1973)

In his autobiography, Edward Steichen wrote approvingly that Cézanne was the painter "who consciously took the first step toward the complete elimination of the literal representation of objects in modern art."[1] Steichen's response to Cézanne's work is most obviously apparent in his advocacy for Cézanne exhibitions at 291. Of the many advisors bringing Cézanne to Stieglitz's attention, Steichen's was probably the best informed and most persuasive voice. His efforts to acquire an important painting by Cézanne on behalf of his friends, the Meyers, also demonstrate affinities with Cézanne. As a painter himself before he finally decided to devote himself exclusively to photography, Steichen responded to the chromatic and spatial effects in Cézanne's work. His frequent sojourns in Paris during the first two decades of the century familiarized him with the work of all the key modernist figures, many of whom (like Rodin and Matisse) he met by offering to make their photographic portraits. Although he appreciated Cézanne's work with a painter's eye, his own paintings of the time are characterized by flatness more in the mode of Matisse more than spatial manipulation; little immediate influence of Cézanne is apparent in them. Surprisingly, it is in one particular group of still-life photographs made at a moment of crisis and stylistic transformation in Steichen's career that we see most evidently his absorption and assimilation of Cézannesque compositional devices.

Steichen's biographer Penelope Niven quoted him as saying that "art is the taking of the essence of an object or experience and giving it a new form so that it has an existence of its own," and she noted that "while he did not fully appreciate the radical new forms expressed in Picasso's Cubism, Steichen had immediately comprehended the essence of Cézanne's work—his superb use of color, light, and form to reveal the complicated contours of the world, its mysterious depths and jagged edges as well as its smooth skin."[2] Those mysterious depths and smooth skin are precisely the elements most apparent in Steichen's still lifes of about 1921, such as *Three Pears and an Apple* (cat. 102), while the tight cropping, spatial complexity, and tipping planes are reasonable analogs to the unstable arrays of objects Cézanne paradoxically delineated as emblems of timeless, classical order. This photograph is one of the series of elegiac still lifes of fruit Steichen made in 1921 shortly before deciding to leave his studio in Voulangis, France.

Following his return from France and his break with Stieglitz in the 1920s, Steichen renounced fine-art photography in favor of advertising and glamour portraiture; in so doing, he achieved fame, wealth, and success.[3] So paradoxically, it was just as he turned away from the paths of avant-garde art to begin his commercial career that he most clearly expressed the influence of Cézanne in his photography.

Three Pears and an Apple recalls Cézanne's *Five Apples* (cat. 2), which Steichen would have seen on his visits to the Steins years before. It is even closer in appearance to Morgan Russell's *Three Apples* of 1910 (cat. 94). Is this the characteristic look of Cézanne recapitulated in the hands of Americans? Perhaps, though Demuth's sparklingly faceted apples and pears of the later 1920s are utterly unlike these weighty still lifes, and perhaps found their model in very different still lifes by Cézanne than those admired by Russell and Steichen. In any case, Steichen photographed in this manner only for a brief period, but it represented a path for him away from Pictorialism and toward the flashier Jazz Age magazine photography which was to bring him wealth and fame for the next twenty years, as well as a way to leave behind the sometimes claustrophobic Stieglitz circle. Later, in another *volte face,* he was to retreat completely from commerce and the city, instead making repetitive studies of a particular shadblow tree on his property in rural Connecticut, while simultaneously diligently working to breed the perfect delphinium. This retreat to the country and serial portrayal of that single favored tree are both faintly reminiscent of Cézanne's customary seclusion in Aix, and devotion to Mont Sainte-Victoire as a subject.[4]

ELLEN HANDY

1. Edward Steichen, *A Life in Photography* (New York: Bonanza, 1984), unpaginated.

2. Penelope Niven, *Steichen: A Biography* (New York: Crown, 1997), 348.

3. This period of his work is effectively discussed in Patricia Johnston, *Real Fantasies: Edward Steichen's Advertising Photography* (Berkeley and Los Angeles: University of California Press, 1997).

4. Steichen's later years are best chronicled by his third wife, Joanna Steichen, who shared them with him. Joanna Steichen, *Steichen's Legacy: Photographs 1895–1973* (New York: Knopf, 2000).

EDWARD STEICHEN

Cat. 102
Three Pears and an Apple, c. 1921
Gelatin silver print, printed by Rolf Peterson, early 1960s
16¾ × 13½ in. (42.5 × 34.3 cm)
The Museum of Modern Art, New York. Gift of the
photographer, 1964 (368.1964)

ALFRED STIEGLITZ (1864–1946)

Alfred Stieglitz constituted himself leader of any group in which he participated, and wrestled throughout his life with problems of artistic autonomy and influence, almost wholly unable to acknowledge those figures whose work shaped his own. Yet he was acutely attuned to the work of other artists, and much in Cézanne's example was valuable to him in his formation of his own innovations and avant-garde strategies in photography. If he remained reticent about Cézanne's influence upon himself, he was not at all hesitant to embrace and promote Cézanne's work through his roles as gallery proprietor, editor, and impresario of the arts, and by lobbying to promote the idea of a museum exhibition of Cézanne's work. Stieglitz's *Camera Work* journal and 291 gallery were the two most important institutions in the introduction of Cézanne's work to American audiences. Cézanne, like Picasso, Rodin, and Matisse became an emblem of modernism for Stieglitz, and arguably the one he most thoroughly internalized in his own work.

In 1919, Stieglitz photographed Strand as part of a series depicting his closest associates.[1] The portrait shows him as far less mercurial than in Kreymborg's description (see my essay in this volume), an oddly short tie hanging awkwardly above his belted trousers.[2] The body language is not unlike that of Cézanne's *Man with Crossed Arms* (cat. 19) with head cocked slightly against the torsion of shoulders, hinting at dynamic tension even in repose. Strand's highly conscious, watchful participation in the portrait transaction was shared by another Stieglitz portrait subject,

Marsden Hartley (cat. 104), who was photographed with muffled throat and tenebrous hat above luminous eyes, recalling Cézanne's *Portrait of the Artist in Wide Brim Hat* (1879–80, R415).[3] In these portraits Stieglitz somewhat uncharacteristically adopted Cézanne's reserve, in this case depicting Strand as an uneasy acolyte of art, or perhaps of modernity, without attempting greater psychological penetration.[4]

Stieglitz insistently placed himself at the center of the American art world for almost fifty years, and participated in the formulation of histories of the era, but was reluctant to characterize his art in relation to any of the models whose examples may have influenced him. Most comfortable in the roles of patron, prophet, and arbiter, he willingly acknowledged his own part in bringing Cézanne's work to America, but preferred not to discuss the debt to Cézanne which might exist in his own work.[5] By 1921, he impatiently dismissed Cézanne as an outmoded talisman of modernism. Writing in the catalogue he printed for his exhibition at the Anderson Galleries:

PLEASE NOTE: In the above STATEMENT the following, fast becoming "obsolete," terms do not appear: ART, SCIENCE, BEAUTY, RELIGION, every ISM, ABSTRACTION, FORM, PLASTICITY, OBJECTIVITY, SUBJECTIVITY, OLD MASTERS, MODERN ART, PSYCHOANALYSIS, AESTHETICS, PICTORIAL PHOTOGRAPHY, DEMOCRACY, CEZANNE, "291," PROHIBITION.[6]

How quickly Cézanne joined Pictorialism as an impediment to aesthetic progress in Stieglitz's view! Yet his inclusion in this list implicitly demonstrates a prior place of importance in Stieglitz's thought.

Earlier, however, Cézannes served as a touchstone of modernity for him. Stieglitz recounted an anecdote about the arrival of a customs inspector ("a fine fellow") to review the Cézanne watercolors borrowed from Bernheim-Jeune in Paris for 291's 1911 show. Stieglitz had previously found these works puzzling, but recognized his destiny to present them to American audiences for the first time. As he told it,

The box of framed Cézannes was opened, and lo and behold, I found the first one no more or less realistic than a photograph. What happened to me? The custom house man looked up: 'My Lord, Mr. Stieglitz,' he said, 'you're not going to show this, are you—just a piece of white paper, with a few blotches of color?' . . . Are you trying to hypnotize me into saying something is there that doesn't exist? . . . Do you mean that people will pay good money for these?' I answered, 'These pictures will become the fashion. People won't like them any more than you do, but they will pay thousands for them."[7]

This tale establishes several rhetorical points near to Stieglitz's heart. He plays the role of the enlightened viewer, with a less appreciative foil to establish the vanguard qualities of the work

he is promoting. He redeems himself from the uncomfortable situation of his visit to Bernheim-Jeune a year before with Steichen, when he failed to appreciate the Cézannes. He separates himself from the philistines who buy, but do not love modern art, but also affirms that he has the power to make them buy what he chooses to present. And he raises the idea of artist as nearly shamanistic mesmerist, drawing the viewer into the work by uncanny means, prefiguring a trope he was to invoke again ten years or so later when he was making and explaining his purely abstract sky photographs, the Equivalents. It was in these photographs, his iterations of loose organic form, lambent contours of cloud, and unbounded space that he explored the radical subjectivity of emotion, rather than Cézanne's hard-won, faithful seriality in the face of the motif, finally assimilating but transforming the message he'd first found in the painter's work more than a decade before.

ELLEN HANDY

1. Stieglitz's continuing attempts to generate an intellectual-artistic community were as heartfelt as they were destined for failure, given his gigantic need to dominate and control all associates. He was, serially, more successful at accomplishing the fusion of art and fellowship in love than in masculine camaraderie, and particularly with O'Keeffe, who tersely, and fondly if also irritatedly, referred to her husband's band of followers, critics, and fellow artists as "the men."

2. Alfred Kreymborg, *Troubadour: An Autobiography* (New York: Boni and Liveright, 1925), 164.

3. A photograph by Eugène Druet of this painting, cat. 129 herein, was one of the images displayed at 291 in 1910.

4. Stieglitz, an expressionist artist by temperament and inclination, in a sense used these portraits to express his own place on the emerging American modernist cultural scene, *primus inter pares*, more than to limn his sitters and explore their souls. As O'Keeffe put it, whatever his artistic subject, he was always fundamentally after himself: "His eye was in him, and he used it on anything that was nearby. Maybe that way he was always photographing himself." Quoted in Alfred Stieglitz, *Georgia O'Keeffe: A Portrait* (New York: The Metropolitan Museum of Art, 1978), unpaginated.

5. Biographical accounts of Stieglitz's life and work are numerous; of these, one of the most complete is Richard Whelan, *Alfred Stieglitz: A Biography* (Boston: Da Capo, 1995).

6. Catalogue statement quoted in Dorothy Norman, *Alfred Stieglitz: American Seer* (New York: Aperture, 1970), 129.

7. Quoted in Norman, *Alfred Stieglitz: American Seer*, 81.

ALFRED STIEGLITZ

Cat. 103
Ellen Koeniger, 1916
Gelatin silver print (chloride)
3½ × 4⅝ in. (8.9 × 11.8 cm)
The Museum of Modern Art, New York. Gift of Miss Georgia
O'Keeffe, The Alfred Stieglitz Collection, 1950 (24.1950)

ALFRED STIEGLITZ

Cat. 104
Marsden Hartley, 1916
Gelatin silver print
9½ × 7 3⁄16 in. (24.2 × 18.3 cm)
The Baltimore Museum of Art: Gift of David Warnock and
Deidre Bosley, Baltimore, BMA 2008.117

ALFRED STIEGLITZ

Cat. 105
John Marin, 1921–22
Gelatin silver print
9⁷⁄₁₆ × 7½ in. (24 × 19 cm)
The Museum of Modern Art, New York. Gift of
Edward Steichen, 1961 (554.1960)

ALFRED STIEGLITZ

Cat. 106
Charles Demuth, 1923
Gelatin silver print
9⅝ × 7⅝ in. (24.4 × 19.3 cm)
The Museum of Modern Art, New York. Gift of Miss Georgia
O'Keeffe, The Alfred Stieglitz Collection, 1950 (64.1950)

PAUL STRAND (1890–1976)

Paul Strand is the American photographer of the early twentieth century whose work most immediately reflects a study of Cézanne's compositions and pictorial construction. In a brief period during the summer of 1916, Strand labored to construct what are essentially photographic versions of Cézanne still-life paintings, and the still-life photographs by Strand in this exhibition all belong to this group (cats. 107–11). Whether this series grew out of a design exercise from the Clarence White School, a passionate response to first-hand experiences with Cézanne, a reading of Caffin's and other writers' praise for Cézanne, or some kind of combination of these causes, is unknown. But at the moment that he produced these Twin Lakes, Connecticut still lifes and abstractions, Strand stepped dramatically from artistic apprenticeship to mastery. His attempts to find his own voice in photography flowed seamlessly into the effort to make a new, modern, American, photographic kind of art based on what was learned from European avant-garde painting. This moment in Strand's career was short-lived, but decisive.

As Maria Morris Hambourg observed, "Unlike Cézanne, who never tired of his ordinary materials because his sensitivity to the problems they posed was limitless, Strand, who needed to make photographs that would connect with the essence of things, found boxes and bowls ultimately too empty to sustain his attention."[1] Ultimately, his need for connection to the world governed his choices of pictorial subjects and prevented him from extending this body of images further in future work. Strand wrote of what he called "the problem of Cézanne, the essential problem of those whom we choose to call the greatest artists of all times, whose expressiveness and livingness is in direct proportion to their having achieved complete organisms."[2] That organic sense of completeness may also have had its roots in Strand's early education as a product of the teachings of Friedrich Froebel, Felix Adler, Lewis Hine, and Friedrich Nietzsche, imbibed through the progressive Ethical Culture School (where Charles Caffin and Lewis Hine were teachers of art) as much as through his absorption in modern art as revealed to New Yorkers by Stieglitz.[3]

Strand mentioned Cézanne occasionally in his early writings, usually in connection with others of the European modernists introduced to America by Stieglitz, and sometimes in relation to old-master painters as well. But he didn't specifically attribute his Twin Lakes series to Cézanne's influence, or speak much of his own motivations. Virtually all authors who have written about Strand's artistic formation have noted his debt to Cézanne, however, although recognition of this relationship as broadly characteristic of other photographers of the time and place is almost unknown.[4] Reviewing his career as an older man, Strand said of his early abstractions:

> These beginnings were like something that grows out of seed. You come back to them. All through your life they remain important, enabling you to solve the problems posed by what you've undertaken to do. . . . After the so-called purely abstract

Fig. 1 Paul Strand, *Portrait, Five Points Square, New York,* 1916. Platinum print. Museum of Fine Arts, Boston, Sophie M. Friedman Fund, 1977.776

photographs that I made in 1915 (not purely abstract but abstract in intention), I never did such things again. I felt no desire and no need to photograph shapes per se. I learned from these photographs what the painters were doing . . . and that no matter what is included, that unity must be there and must be continuous. I went next very naturally towards trying to apply the method that I had worked out in pictures, like the shadows of the porch railing and the bowls, to what I tackled thereafter in landscape."[5]

Strand, like Stieglitz, photographed portrait subjects much as Cézanne famously painted Vollard ("like an apple"), that is, as nearly inscrutable still-life objects.[6] In Strand's *Portrait, Five Points Square, New York* (1916, fig. 1) the subject's gaze is locked on a point above and beyond the camera, and thus above the viewer's gaze. The downturned arc of his compressed lips and the irregularly upward wandering line of the facings of his buttoned overcoat animate the image, and as in the most powerful of Cézanne's portraits, emotional contact between sitter and artist is severely muted. Portraiture (so traditional, so tied to its subject matter) at first would seem one of the artistic genres least immediately susceptible to the transformations of modernist practice. But by 1920, an American mode of photographic portraiture that was fluently conversant with Cézannesque portrait aesthetics was emerging.

ELLEN HANDY

1. Maria Morris Hambourg, *Paul Strand, Circa 1916* (New York: The Metropolitan Museum of Art, 1998), 34.

2. Paul Strand, "American Watercolors at the Brooklyn Museum," *The Arts*, December 2, 1921, 148.

3. Hambourg, *Paul Strand, Circa 1916*, 32.

4. Interestingly, many of the contributors to the 1990 volume *Paul Strand: Essays on His Life and Work* describe Strand's work throughout his subsequent career as reflecting Cézanne's influence, despite changes in form and subject matter from the seminal 1916 series. See, for instance, in *Paul Strand: Essays on His Life and Work*, ed. Maren Stange (New York: Aperture, 1990): Steve Yates, "The Transition Years: New Mexico," 87–99; Estelle Jussim, "Praising Humanity: Strand's Aesthetic Ideal," 87–99; and Edmundo Desnoes, "Paul Strand, Dead or Alive," 249–55.

5. *Paul Strand: Sixty Years of Photographs* (New York: Aperture, 1976), 145.

6. These still lifes represent the zenith of abstraction in American photography, and the point at which Strand's work most evidently approximates Cézanne's example as still life allows subject matter to fall away, and pure form to dominate, calling attention to its own qualities rather than what is represented. Following Roger Fry, Clive Bell said, "a work of art is like a rose. A rose is not beautiful because it is like something else. Neither is a work of art. Roses and works of art are beautiful in themselves." Clive Bell, *Since Cézanne* (New York: Bibliobazaar, 2006, first published in 1922), 32. Strand's Twin Lakes still lifes have precisely the *Ding an sich* quality of which Bell speaks.

PAUL STRAND

Cat. 107
Abstraction, 1916
Photogravure
8⅞ × 6½ in. (22.6 × 16.6 cm)
The Museum of Modern Art, New York. Anonymous gift,
1966 (234.1966)

PAUL STRAND

Cat. 108
Abstraction, Porch Shadows, Connecticut, 1916
Gelatin silver print, Artist's Proof from *On My Doorstep:*
A Portfolio of Eleven Photographs, 1914–1973, 1976,
printed 1976 in collaboration with Richard Benson
13⅛ × 9⅟₁₆ in. (33.3 × 23 cm)
The Museum of Modern Art, New York. Gift of
Arthur M. Bullowa, 1978 (693.1978.2)

PAUL STRAND

Cat. 109
Bottle, Book, and Orange, 1916
Silver-platinum print
10 ⁹⁄₁₆ × 11 ⁵⁄₈ in. (26.8 × 29.5 cm)
The Baltimore Museum of Art: Purchase with exchange funds from
the Edward Joseph Gallagher III Memorial Collection; and partial
gift of George H. Dalsheimer, Baltimore, BMA 1988.577
Baltimore only

PAUL STRAND

Cat. 110
Pears and Bowls, 1916
Silver-platinum print
10⅛ × 11⁵⁄₁₆ in. (25.7 × 28.8 cm)
Lent by The Metropolitan Museum of Art, New York, Gilman Collection, Purchase, Ann Tenenbaum and Thomas H. Lee Gift, 2005
(2005.100.137)
Montclair only

ABRAHAM WALKOWITZ (1878–1965)[1]

Among the first to appreciate the work of Cézanne, in 1906 Abraham Walkowitz traveled to Paris, where he befriended Max Weber; he attended the Salon d'Automne of 1907, and later recalled the impact of seeing the master's paintings draped in black. Walkowitz arrived "just a week after . . . Cézanne died.[2] Pronouncing him to be "the father and mother of modern art," Walkowitz recalled that the "whole town was mad about Cézanne. It was Cézanneitis. . . . The American artists began to ape Cézanne, and that was a disease."[3] Asserting that he "never did that," Walkowitz nevertheless was profoundly influenced by the French master of whom he "was proud."[4] Recalling that he "did not find [Cézanne] strange," Walkowitz "could not see what people had found so revolutionary in his work. I felt at home with his pictures. To me they were simple and intensely human experiences."[5]

In Paris, fleeing the constraints of his academic education, Walkowitz was fortunate to encounter Max Weber, who provided an entrée into modernist circles, including that of Leo and Gertrude Stein. The two artists also traveled together to Italy, where their studies of the Italian Renaissance masters reinforced their appreciation of Cézanne and modern art. Walkowitz's landscapes painted in Anticoli Corrado were the first of his works to reflect the impact of the French master in their structural reduction of pictorial elements to broadly brushed, simplified forms.[6] After Walkowitz returned to the United States in 1907, he corresponded with Weber, who shared his enthusiasm for Cézanne and responded to his friend's requests for reproductions of the master's work.[7]

Like Cézanne, Walkowitz explored subjects in serial form, especially the theme of figures in a landscape setting, which occupied him from 1908 to 1945.[8] His idyllic Bathers series were associated by critics of the era with Walkowitz's "remembering the lesson of the great Cézanne."[9] Walkowitz's approach to this Cézannesque subject was mediated by his appreciation for the warm palette, horizontal format, friezelike composition and elemental, simplified, flattened forms of Rodin's drawings, and especially for the work of Matisse, whom he had met in Paris. The constructive strokes of limpid color, broken, multiple contour lines, areas of *passage,* and broad, cropped rendition of the trees as framing devices all typify the impact of Cézanne's *Bathers* ([see cat. 18], which Walkowitz likely saw at the Steins' apartment). The use of the ground to define the volumes and surfaces of the figures and to suggest the impact of light on the water can also be related to the work of Cézanne. The critic Willard Huntington Wright made a related comparison in his observation that Walkowitz's "simplest drawings . . . are, like the water-colors of Cézanne, very often the most complex in their statement of structural principles."[10] Furthermore, Walkowitz's detached, nonacademic approach to the figures, rendered from memory and imagination rather than direct observation, is rooted in the example of Cézanne's work.

Two Nudes Reclining on Grass (cat. 112) dates from the period of Walkowitz's close involvement with Alfred Stieglitz and his gallery 291. Through Marsden Hartley, Walkowitz met Stieglitz in 1912 and was closely associated with him until the closing of 291 in 1917. In reviews of his first show at 291, in 1912, the influence of Cézanne was cited "as in the work of many another seeker for truthful and convincing expression."[11] In a special issue of *Camera Work* published in March 1914 highlighting Walkowitz, Oscar Bluemner observed that the artist "carries forth Cézanne's standard consciously, and like him, conscientiously," in terms of "the pictorial metamorphosis that reality undergoes in his vision."[12]

GAIL STAVITSKY

1. The date of Walkowitz's birth is variously cited as 1878 or 1880. According to Martica Sawin, he claimed that his mother falsified the date of his birth, hoping that he would evade being conscripted into the Russian Army. Therefore Sawin used the 1878 date in "Abraham Walkowitz: The Years at 291, 1912–1917," Master's thesis, Columbia University, New York City, 1967, 80.

2. "A Tape Recorded Interview with Abraham Walkowitz," conducted by Abram Lerner and Bartlett Cowdry, December 8 and 22, 1958, *Archives of American Art Journal* 9 (January 1969): 12.

3. Ibid.

4. Ibid., 13.

5. Alfred Werner, "Abraham Walkowitz Rediscovered," *American Artist* 43 (August 1979): 59. See also Martica Sawin, *Abraham Walkowitz 1878–1965* (Salt Lake City: Utah Museum of Fine Arts, University of Utah, 1975), 10–13.

6. Theodore Wayne Eversole, "Art and the Struggle for an American Modernism," Ph.D. diss., University of Cincinnati, 96ff; and Sawin, "Abraham Walkowitz: The Years at 291," 10–11. E-mail from Martica Sawin, January 25, 2008. She recalls that Walkowitz also made a very accurate copy (location unknown) of a Cézanne Bathers lithograph shown at 291. See also Carol Ann Nathanson, "The American Response, in 1900–1913, to the French Modern Art Movements After Impressionism," Ph.D. diss., The Johns Hopkins University, Baltimore, Maryland, 1973, 126–27.

7. Max Weber to Abraham Walkowitz, November 15, 1907, and January 5, 1908, Whitney Museum of American Art Papers, Archives of American Art, Smithsonian Institution, quoted in Nathanson, "The American Response," 127–28, 265, 291nn146–49. See also Jill Anderson Kyle, "Cézanne and American Painting 1900 to 1920," Ph.D. diss., University of Texas at Austin," 1995, 135, 274–5.

8. See Kent James Smith, "Abraham Walkowitz: A Study and a Critical Appraisal Based on the Long Beach Museum of Art Abraham Walkowitz Collection," Master's thesis, California State University, Long Beach, 1983, 2–4, 25–32.

9. Charles Vildrac, "Introduction," *One Hundred Drawings by A. Walkowitz* (New York: B. W. Huebsch, 1925), 8. On the topicality of the theme as reflecting Walkowitz's social liberalism and Walkowitz's sources, including Cézanne's watercolors at the 1907 Salon d'Automne, see Kent Smith, *Abraham Walkowitz: Figuration, 1895–1945* (Long Beach: Long Beach Museum of Art, 1982), 20–25; and Sawin, *Abraham Walkowitz*, 27–28.

10. Willard Huntington Wright, "Introduction," *One Hundred Drawings by A. Walkowitz* (New York: B. W. Huebsch, 1925), 12. Related to this is Wright's observation that "in several of his pictures he has approached volume from the point of view of Cézanne." For a more detailed discussion of Cézanne sources for Walkowitz's Bather works, see Sawin, *Abraham Walkowitz*, 39–40. She refers to a small watercolor labeled by Walkowitz as being a copy of a Cézanne watercolor belonging to a New York collector and states that it "is a version of *La Lutte d'amour* . . . amazingly fluent for a copy." Upon Sawin's suggestion, the author contacted Janet Broske, Curator of Collections, University Museums, University of Delaware, to see if perhaps the artist's heirs donated this work along with others from the estate. It is not, however, among the many depictions of Bathers (e-mails of March 27, 2008).

11. Samuel Swift in the *New York Sun*, reprinted in *Camera Work* 41 (January 1913): 27, as quoted in Eversole, "Art and the Struggle for an American Modernism," 120.

12. Oscar Bluemner, "Walkowitz," *Camera Work* 44 (October 1913 [but published in March 1914]): 25.

In 1906 when I came to Paris Cézanne died, not on account of me. He was a modern who was the father and mother of modern art. . . . The whole town was mad about Cézanne . . . the American artists began to ape Cézanne and that was a disease. I called it Cézanneitis.[15]

—Abraham Walkowitz

ABRAHAM WALKOWITZ

Cat. 112
Two Nudes Reclining on Grass, c. 1912–14
Pastel on canvas
16 × 22 in. (40.6 × 55.9 cm)
Collection of The Honorable and Mrs. Joseph P. Carroll, New York

MAX WEBER

Cat. 114
Portrait of Abraham Walkowitz, 1907
Oil on canvas
25 × 20⅛ in. (63.5 × 51.1 cm)
Brooklyn Museum, Gift of Abraham Walkowitz (44.65)

MAX WEBER

Cat. 115
Still Life from Paris, 1907
Oil on canvas
23½ × 28 in. (59.7 × 71.1 cm)
Private Collection, South Dakota

HALE WOODRUFF (1900–1980)

Hale Woodruff is best known today for his murals depicting African American life painted in the 1930s and 1940s, and his interaction with Cézanne's work in the 1920s played an essential role in his development as an artist. Born in Cairo, Illinois, and raised in Nashville, Tennessee, Woodruff was a talented artist at a young age. Upon graduating from high school, he moved to Indianapolis, where he began to take classes at the Herron Art School. He was most interested in painting landscapes, and he frequently produced views of the Indiana countryside.[1] In the early 1920s, Woodruff supplemented his income by drawing political cartoons for the local African American newspaper, the *Indianapolis Ledger.* He also worked at the Senate Avenue YMCA, a cultural hub for African American life in Indianapolis, where he met many prominent artists, writers, and intellectuals.

In 1926 Woodruff submitted five paintings to the newly formed Harmon Foundation, an organization created to present achievement awards to African Americans. The foundation is best known today for providing one of the only venues for African American artists to show their works in the late 1920s and 1930s. Woodruff received national acclaim for receiving the bronze award and one hundred dollars in the first Harmon Foundation competition. This grant, along with other gifts raised by local supporters, provided Woodruff with enough funds to travel to France to continue his education.[2]

Woodruff left for France on September 3, 1927.[3] At first he took art classes in Paris, but he found the teachers to be uninspiring. He became friendly with the philosopher and art critic Alain Locke, and the two young men spent time studying and buying African art at flea markets in Paris.[4] One of Woodruff's primary goals while in Europe was to meet Henry Ossawa Tanner (1859–1937), an accomplished African American painter who had studied with Thomas Eakins before leaving the racially divided world of the United States for the artistic freedom of France.[5] Woodruff traveled to Normandy in the spring of 1928 to meet Tanner, and the two artists spent an afternoon together discussing painting and life.[6] In the summer of 1928, Woodruff returned to the region and produced *Normandy Landscape* (cat. 123). Clearly influenced by artists such as Paul Cézanne, Woodruff relishes the medium of paint itself in this subtle and modern work, exploring the numerous textures produced by palette knife and brush with a subtle range of color. He has carefully structured the composition, applying the jewel-like pigments in deliberately delineated strokes reminiscent of the facetlike patches of paint that Cézanne preferred. A screen of well-formed willow trees in the foreground is set against an overcast sky, evoking the character and mood of the northern French countryside.

In 1929, Woodruff left Paris, and moved to Cagnes-sur-Mer, a small town on the Mediterranean coast that had been home to such artistic luminaries as Pierre-Auguste Renoir and Chaim Soutine.[7] While there, Woodruff traveled to Aix-en-Provence and Arles, soaking in the landscape that inspired Cézanne and Vincent van Gogh.[8] He later credited his trip to France for providing him with an important foundation to his understanding of modern art. Recalling his experience of first seeing Cézanne's work and understanding its relationship to African art, he stated:

On seeing the work of Paul Cézanne I got the connection. Then I saw the work of Picasso and I saw how Cézanne, Picasso, and the African had a terrific unique sense of form. The master I chiefly admired at that time was Paul Cézanne; then Picasso, who was certainly bolder and more courageous in his Cubist work. . . . I studied the works of these men and, as I said earlier, I was associated largely with a group of younger artists. We used to sit around and talk about art and then go off to our studios and paint. My painting consisted largely of figures and landscapes. They were done in a manner of the structural style of the African sculptor and of Cézanne, who was a forerunner of Picasso. I was painting more or less this way.[9]

KATHERINE ROTHKOPF

1. Winifred L. Stoelting, "Hale Woodruff, Artist and Teacher: Through the Atlanta Years," Ph.D. diss., Emory University, 1978, 5–6.

2. Ibid., 9–12.

3. Ibid., 12.

4. Ibid., 28.

5. Ibid., 2.

6. Ibid., 31–36.

7. Ibid., 41. William H. Johnson also chose to live in Cagnes-sur-Mer during his stay in France in the 1920s, but the two artists did not meet until fifteen years later in New York. See Richard J. Powell, *Homecoming: The Art and Life of William H. Johnson* (New York: Rizzoli, 1991), 34. Also see Johnson entry in this catalogue for more information.

8. Stoelting, "Hale Woodruff," 54.

9. Al Murray, Interview with Hale Woodruff, Nov. 18, 1968, 8. Archives of American Art, Smithsonian Institution, Washington, DC.

HALE WOODRUFF
Cat. 123
Normandy Landscape, 1928
Oil on canvas
21¼ × 25⅝ in. (54 × 65.1 cm)
The Baltimore Museum of Art: Edward Joseph Gallagher III
Memorial Fund, BMA 2002.279

SELECTED CHRONOLOGY
1895–1930

Emily Schuchardt Navratil

As much information as is known is listed for each item, some of which may be incomplete. Items lacking documented date or month are placed when thought to occur or, if unknown, placed at the end of the list for that year.

All of the exhibitions featuring Cézanne's work are listed in Jayne Warman, "List of Exhibitions," in *Paul Cézanne: The Watercolors: A Catalogue Raisonné* (Boston: Little, Brown, A New York Graphic Society Book, 1983), cited as "Warman 1983"; and Jayne Warman, "List of Exhibitions," in John Rewald et al., *The Paintings of Paul Cézanne: A Catalogue Raisonné* (New York: Harry N. Abrams, 1996), cited as "Warman 1996"; or Jill Anderson Kyle, "Cézanne and American Painting, 1900–1920" Ph.D. diss., University of Texas at Austin, 1995, cited as "Kyle." Additional information from Rewald et al. *The Paintings of Paul Cézanne: A Catalogue Raisonné,* is cited as "Rewald 1996"; while John Rewald, *Cézanne and America: Dealers, Collectors, Artists and Critics 1891–1921* (Princeton: Princeton University Press, 1989) is cited as "Rewald 1989"; and Rebecca A. Rabinow, *Cézanne to Picasso: Ambroise Vollard, Patron of the Avant-Garde* (New York: The Metropolitan Museum of Art; New Haven, CT: Yale University Press, 2006) is cited as "Rabinow."

1895

Exhibitions/Auctions
NOVEMBER–DECEMBER
Paris, Galerie Vollard, *Paul Cézanne*. (Warman 1996, 562)

DECEMBER
Aix-en-Provence, Société des Amis des Arts, *Salon Aixois, première exposition*. (Warman 1996, 562)

Acquisitions
The Gulf of Marseille Seen from L'Estaque (1878–79) [R390] and *Yard of a Farm* (c. 1879) [R389] enter the Musée de Luxembourg, Bequest of Gustave Caillebotte. (Rewald 1989, 16; Rewald 1996, 259)

1896

Exhibitions/Auctions
Paris, Galerie Vollard, *Les Peinteurs-Graveurs*. (Rabinow, 306)

Acquisitions
JANUARY
Egisto Fabbri purchases three works by Cézanne from Vollard. (Rewald 1989, 29n23)

MARCH, MAY, AND SEPTEMBER
Fabbri purchases a total of four works in these months. (Rewald 1989, 29n23)

JUNE
Charles Loeser acquires works by Cézanne from Vollard. His first work was acquired in December 1894. (see Warman's essay in this volume, 82)

JULY 16
John O. Sumner acquires *The Harvesters* (c. 1880) [R454] from Vollard. (Rewald 1996, 306)

1897

Acquisitions
JANUARY
Charles Loeser acquires three more works by Cézanne from Vollard. (Rewald 1989, 29n21)

DECEMBER
Fabbri purchases another Cézanne from Vollard. (Rewald 1989, 29n23)

1898

Exhibitions/Auctions
MAY 9-JUNE 10
Paris, Galerie Vollard, *Exposition Cézanne.* (Warman 1996, 562)

Acquisitions
MAY
Fabbri purchases another Cézanne from Vollard. (Rewald 1989, 29n23)

Charles Loeser acquires two works by Cézanne from Vollard. (Rewald 1989, 29n21, Warman's essay in this volume, 81)

Notes
1898-99
Maurice Prendergast travels to Paris, and visits Vollard's gallery, where he may have seen works by Cézanne. (Rewald 1989, 32)

1899

Exhibitions/Auctions
MAY 1
Paris, sale of Sisley's studio, includes a landscape by Cézanne. (Rewald 1989, 37)

MAY 4-5
Paris, Galerie G. Petit, sale of the Doria Collection, includes *Melting Snow in Fontainebleau* (1879-80) [R413], which is purchased by Monet. (Rewald 1996, 274)

JULY 1, 3
Paris, Galerie G. Petit, sale of the Victor Chocquet estate, which contained thirty-one Cézanne works, including *Victor Chocquet Seated* (c. 1877) [R296] (cat. 1). (Rewald 1989, 34; Rewald 1996, 194-99)

OCTOBER 21-NOVEMBER 26
Paris, *15e Exposition des artistes indépendants.* (Warman 1996, 562)

NOVEMBER
Paris, Galerie Vollard, *Paul Cézanne.* (Warman 1996, 562; Rabinow, 312)

Acquisitions
FEBRUARY
Fabbri purchases another Cézanne from Vollard. (Rewald 1989, 25, 29)

The National Gallery of Berlin acquires *The Mill on the Banks of La Couleuvre near Pontoise* (1881) [R483]. (Rewald 1989, 156; Rewald 1996, 326)

1900

Exhibitions/Auctions
APRIL-OCTOBER
Paris, Grand Palais, *Centennale de l'art français de 1800 à 1899.* (Warman 1996, 562)

MAY 9-10
Paris, Hôtel Drouot, Auction of Eugène Blot Collection, five Cézanne paintings [R134, R351, R498, R675, R741], all bought in except [R134]. (Kyle, 621; Rewald 1996, 114, 235-36, 333, 432, 456)

NOVEMBER 2-DECEMBER 1
Berlin, Bruno and Paul Cassirer, [Group exhibition]. (Warman 1996, 562)

First exhibition of Cézanne paintings in Germany.

Acquisitions
FEBRUARY 10
Fabbri acquires a landscape [R717] from Vollard. (Rewald 1989, 49)

Notes
B. J. O. Nordfeldt travels to Paris.

1901

Exhibitions/Auctions
JANUARY 20-FEBRUARY 20
Paris, Galerie Vollard. (Warman 1996, 562)

MARCH 1-31
Brussels, Salon de la Libre Esthétique. (Kyle, 621)

APRIL 20-MAY 21
Paris, Grandes Serres, *Indépendants.* (Warman 1996, 562)

MAY 9-JUNE 12
The Hague, Villa Boschoord (Bezuidenhout), *Eerste Internationale Tentoonstelling.* (Warman 1996, 562)

Acquisitions
The Havemeyers acquire seven Cézannes from Vollard in April. (see Warman's essay in this volume, 83)

Notes
Etta Cone travels to Europe, tours Italy with Leo Stein, then travels to Paris.

1902

Exhibitions/Auctions
MARCH 29-MAY 5
Paris, Grandes Serres, *Indépendants.* (Warman 1996, 562)

MARCH-APRIL
Paris, Galerie Vollard, *Paysages de Cézanne.* (Warman 1996, 563)

JUNE 16
Aix-en-Provence, Société des Amis des Arts, *Salon Aixois, quatrième exposition.* (Warman 1996, 563)

1903

Exhibitions/Auctions
JANUARY-FEBRUARY
Vienna, [Secession], *Entwicklung des Impressionismus in Maleri u. Plastik.* (Warman 1996, 563)

SPRING
Berlin, Kantstrasse 12, *Siebente Kunstaustellung der Berliner Sezession.* (Warman 1996, 563)

MARCH 9-13
Paris, Hôtel Drouot, Émile Zola, Médan sale, includes [R75, R90, R116, R121, R122, R136, R150]. (Kyle, 621; Rewald 1996, 84, 91, 106, 108-9, 115-16, 125-26).

Paris, Galerie Bernheim-Jeune, *Oeuvres de l'école impressioniste.* (Kyle, 621)

Books
Mauclair, Camille. *The French Impressionists.* London: Duckworth; New York: E. P. Dutton, 1903.

Mauclair, Camille. *The Great French Painters and the Evolution of French Painting from 1830 to the Present Day.* New York: E. P. Dutton, 1903.

Acquisitions
MAY
The Havemeyers make Cézanne purchases, *The Abduction* (1867) [R121], and *A Portrait of the Artist in a Cap* (c. 1875) [R219] from Vollard. (Rewald 1989, 30n34, Warman's essay in this volume, 83)

Notes
Etta and Claribel Cone meet Gertrude Stein in Florence. Gertrude then moves in with Leo Stein in Paris.

1904

Exhibitions/Auctions
FEBRUARY 15-MARCH 5
Paris, Galerie des Collectionneurs (L. Soullié), *Exposition des tableaux par Paul Cirou et quelques autres.* (Warman 1996, 563)

FEBRUARY 25-MARCH 29
Brussels, Salon de la Libre Esthétique, *Peintres impressionistes.* (Warman 1996, 563)

APRIL-JUNE
Berlin, Galerie Paul Cassirer, [*Cézanne*?]. (Warman 1996, 563)

OCTOBER-NOVEMBER
Dresden, Galerie Emil Richter, [Impressionist Exhibition]. (Kyle, 622)

OCTOBER 15-NOVEMBER 15
Paris, Petit Palais, *Salon d'Automne.* (Warman 1996, 563)

Articles/Reviews

Bernard, Émile. "Paul Cézanne," *L'Occident* (July 1904): 17–30.

Huneker, James G. "Autumn Salon Is Bizarre," *New York Sun,* November 27, 1904.

Acquisitions

EARLY 1904
Leo Stein acquires his first Cézanne from Vollard, *The Conduit* (c. 1879) [R406]. (Rewald 1989, 53)

OCTOBER 28
Leo Stein acquires *Group of Bathers* (c. 1892–94) [R753] and *Bathers* (1898–1900) [R861] (cat. 18). (Rewald 1996, 460).

DECEMBER
Leo and Gertrude Stein acquire *Portrait of the Artist's Wife* (begun 1878, reworked 1886–88) [R606]. (Rewald 1996, 402, Warman's essay in this volume, 84)

Notes

The Cone sisters are again in Europe, spending time with Leo and Gertrude Stein.

Leo Stein and Alfred H. Maurer become friends.

1905

Exhibitions/Auctions

JANUARY–FEBRUARY
London, Grafton Galleries, *Pictures by Boudin, Cézanne, Degas, Manet, Monet, Morisot, Pissarro, Renoir, Sisley.* Exhibition organized by Durand-Ruel. (Warman 1996, 563)

THROUGH JUNE 17
Paris, Galerie Vollard, [*Aquarelles de Cézanne*]. (Warman 1983, 469, Rabinow, 317)

OCTOBER 18–NOVEMBER 25
Paris, Grand Palais, *Salon d'Automne.* (Warman 1996, 563)

Notes

SEPTEMBER
Max Weber arrives in Paris.

AUTUMN 1905–AUTUMN 1910
John Marin lives in Europe, save for a trip back to the United States late 1909–May 1910.

WINTER 1905-6
Etta Cone rents an apartment in Paris.

1906

Exhibitions/Auctions

JANUARY
London, New Gallery, *Exhibition of the International Society.* (Warman 1996, 563)

MID-FEBRUARY–MID-MARCH
Bremen, Kunstverein, *Internationale Kunstausstellung.* (Warman 1996, 563)

FEBRUARY 20-MARCH 14
Berlin, Galerie Paul Cassirer. (Kyle, 622)

MARCH
Paris, Galerie Vollard, [Twelve paintings by Cézanne]. (Warman 1996, 563)

MARCH 10
Paris, Hôtel Drouot, Auction of Eugène Blot Collection, four paintings [R187, R351, R498, R675]. (Rewald 1996, 146, 235–36, 333, 432)

SUMMER
Aix-en-Provence, Société des Amis des Arts, *Salon Aixois, cinquième exposition.* (Warman 1996, 563)

OCTOBER 6-NOVEMBER 15
Paris, Grand Palais, *Salon d'Automne.* (Warman 1996, 563)

Articles/Reviews

[James G. Huneker], "Paul Cezanne," *New York Sun,* December 20, 1906.

Acquisitions

Etta Cone purchases a Cézanne lithograph, *Small Bathers* (BMA 1950.12.605).

APRIL 19
Mrs. Montgomery Sears buys *The Deep Blue Vase II* (c. 1880) [R473] and *Bottle of Liqueur* (c. 1890) [R681] from Vollard. (Warman's essay in this volume, 83)

Notes

Abraham Walkowitz travels to Paris.

1907

Exhibitions/Auctions

MARCH–APRIL
Vienna, Galerie Miethke, *Paul Gauguin and Others.* (Warman 1996, 563)

MARCH 2-APRIL 2
Paris, *Exposition d'art français contemporain.* (Kyle, 623)

JUNE 17-29
Paris, Galerie Bernheim-Jeune, *Les aquarelles de Cézanne.* (Warman 1983, 469)

Prendergast, Steichen, and Stieglitz see the show at Bernheim-Jeune. (Nancy Mowll Mathews, "Maurice Prendergast and the Influence of European Modernism," *Maurice Brazil Prendergast, Charles Prendergast: A Catalogue Raisonné* [Williamstown, MA: Williams College Museum of Art; New York: Prestel, 1989]: 36–41; Rewald 1989, 111)

SEPTEMBER–OCTOBER
Berlin, Galerie Paul Cassirer, *Cézanne aquarelles.* (Kyle, 623)

OCTOBER 1-22
Paris, Grand Palais, Salon d'Automne, *Retrospective de Cézanne.* (Warman 1996, 563)

Weber, Pach, Prendergast, and Maurer attend. (Rewald 1989, 112–14; Epstein's essay in this volume, 244)

OCTOBER–NOVEMBER
Prague, Pavilion Manes, *Tableaux modernes.* (Kyle, 623)

NOVEMBER 14-30
Paris, Galerie Bernheim-Jeune, *Fleurs et natures mortes.* (Kyle, 623)

DECEMBER 10-31
Paris, Galerie Eugène Blot, Group exhibition. (Kyle, 623)

DECEMBER 15, 1907-JANUARY 4, 1908
Paris, Galerie Bernheim-Jeune, *Portraits d'hommes.* (Kyle, 623)

1907–11

Amsterdam, Rijksmuseum, Long-term loan: *Vase of Flowers and Apples* (1883–87) [R660]. (Kyle, 623)

Articles/Reviews

Denis, Maurice. "Cézanne," *L'Occident* 12 (September 1907).

Bernard, Émile. "Souvenirs de Paul Cézanne," *Mercure de France* (October 1, 1907).

Bernard, Émile. "Souvenirs de Paul Cézanne," *Mercure de France* (October 16, 1907).

Acquisitions

DECEMBER
Leo and Gertrude Stein acquire *Five Apples* (1877–78) [R334] (cat. 2) from Bernheim-Jeune. (Rewald 1989, 56)

Note

Maurice Prendergast returns from Paris.

1907–13

Pach is living in Paris.

MID-1908 TO LATE 1909

Arthur Dove is in France.

JANUARY 1907-11
Matisse class in Paris; over its course, Patrick Henry Bruce, Morgan Russell, Walter Pach, Maurice Sterne, and Max Weber attend. (John Cauman, "Matisse and America, 1905–1933," Ph.D. diss., City University of New York, 2000, 96n45)

1908

Exhibitions/Auctions

FEBRUARY 3-15
New York, Macbeth Galleries, *The Eight Exhibition.* Includes work by Arthur B. Davies and Maurice Prendergast.

SPRING
Berlin, *Ausstellung der Berliner Sezession.* (Kyle, 623)

APRIL 6–25
New York, Little Galleries of the Photo-Secession—hereafter "291"—Matisse's first one-person show in New York.

APRIL 18–MAY 24
Moscow, *La toison d'or.* (Warman 1996, 563)

MAY–JUNE
Paris, Galerie Durand-Ruel, *Exposition de natures mortes par Monet, Cezanne, Renoir.* (Kyle, p 623)

JULY
London, New Gallery, *Exhibition of the International Society.* (Kyle, 624)

OCTOBER 15–NOVEMBER 8
Berlin, Galerie Paul Cassirer, *Ausstellung.* (Kyle, 624)

DECEMBER 21, 1908–JANUARY 16, 1909
Paris, Galerie Druet, Group exhibition. (Kyle, 624)

Articles/Reviews
De Kozmutza, Ottilie. "The Art of Paul Cezanne," *Burr Mc'Intosh Monthly,* March 1908, unpaginated.

"Paintings on view at the Academy of the Fine Arts," *Philadelphia Public Ledger,* March 8, 1908.

Pach, Walter. "Cézanne—An Introduction." *Scribner's* 44, no. 6 (December 1908): 765–68.

Books
Meier-Graefe, Julius. *Modern Art; Being a Contribution to a New System of Aesthetics.* London: W. Heinemann; New York: G. P. Putnam's Sons, 1908.

Notes
In Paris, Edward Steichen co-organized the New Society of American Artists, which included Weber, Maurer, and Marin.

Morgan Russell visits Paris. (Rewald 1989, 66)

Leon Kroll wins a scholarship from the National Academy of Design which allows him to travel to Europe for two years. In Paris, Kroll enrolls at the Académie Julian.

1908–9

Charles Sheeler and Morton Schamberg in Europe.

1909

Exhibitions/Auctions
SPRING
Berlin, *Ausstellung der Berliner Sezession.* (Kyle, 624)

MARCH 30–APRIL 17
New York, 291, Paintings by Maurer and watercolors by Marin. (Homer, *Alfred Stieglitz and the American Avant-Garde,* 296)

APRIL 22–MAY 18
New York, Haas Gallery, *Paintings and Drawings by Max Weber.* Catalogue for the show includes excerpts from Cézanne's letters to Émile Bernard, published in 1904 and 1907 (cat. 127).

MAY 3–15
Paris, Galerie Bernheim-Jeune, *Aquarelles et pastels.* (Kyle, 624)

NOVEMBER 12–DECEMBER 4
Paris, *Natures mortes et fleurs.* (Kyle, 624)

Cat. 127

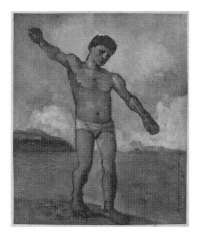
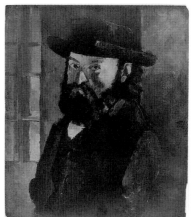

Cats. 128–33. Eugène Druet photographs of Cézanne paintings, taken c. 1907–8, which were purchased in Paris by Max Weber and exhibited at 291.

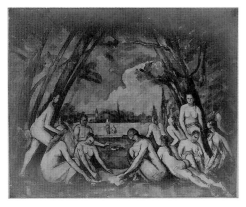

NOVEMBER 17–DECEMBER 12
Berlin, Galerie Paul Cassirer, Group exhibition. (Warman 1996, 563)

Articles/Reviews
"Art Notes Here and There." *The New York Times,* May 2, 1909.

Caffin, Charles H. "Alfred Maurer [and] John Marin," *Camera Work* 27 (July 1909): 41–42.

Notes
JANUARY
Anne Brigman's work first appears in *Camera Work.*

JANUARY–FEBRUARY
Sheeler is in Paris. (Rewald 1989, 77)

Weber returns to New York with 18 high-quality black-and-white photographs of Cézanne paintings taken by Eugène Druet, the Paris gallery owner-photographer. (Carol Gruber, "The Reminiscences of Max Weber," Columbia University, New York, Oral History Project, vol. 1, 1958, 249)

SPRING
Morgan Russell settles in Paris.

FALL
Stanton Macdonald-Wright arrives in Paris.

1909–10
Andrew Dasburg is in France.

1910

Exhibitions/Auctions
JANUARY 10–22
Paris, Galerie Bernheim-Jeune, *Paul Cézanne.* (Warman 1996, 563)

FEBRUARY 7–19
New York, 291, John Marin watercolors, etchings, and pastels. (Homer, *Alfred Stieglitz and the American Avant-Garde,* 296)

FEBRUARY 23–MARCH 8
New York, 291, Matisse exhibition of drawings and reproductions of paintings. Weber's Druet photographs of Cézanne paintings are possibly shown. (see Stavitsky's essay in this volume, 29)

MARCH 9–MARCH 21
New York, 291, *Younger American Painters,* included work by Carles, Dove, Hartley, Marin, Maurer, Steichen, and Weber. (Homer, *Alfred Stieglitz and the American Avant-Garde,* 301)

SPRING
Berlin, *Ausstellung der Berliner Sezession.* (Kyle, 624)

APRIL 20–MAY 15
Florence, Lyceum Club, *Prima mostra Italiana dell'impressionismo.* (Warman 1996, 563)

JUNE–AUGUST
Brighton, Public Art Galleries, *Modern French Artists.* (Kyle, 624)

JUNE 27–JULY 23
Paris, Galerie Vollard, *Figures de Cézanne.* (Warman 1996, 564)

OCTOBER–NOVEMBER
Leipzig, *Ausstellung französischer Kunst des 18, 19, und 20 Jahrhunderts.* (Kyle, 625)

NOVEMBER 8, 1910–JANUARY 15, 1911
London, Grafton Gallery, *Manet and the Post-Impressionists.* (Warman 1996, 564)

NOVEMBER 18–DECEMBER 8
New York, 291, *Lithographs by Manet, Cézanne, Rodin, and Toulouse-Lautrec, Drawings by Rodin, and Paintings and Drawings by Henri Rousseau.* Show includes 2 Bather and 1 self-portrait lithographs and Weber's Druet photographs.

Articles/Reviews
Denis, Maurice. Trans. Roger Fry. "Cézanne—I." *Burlington Magazine* 16, no. 82 (January 1910): 207–19.

Denis, Maurice. Trans. Roger Fry. "Cézanne—II." *Burlington Magazine* 16, no. 83 (February 1910): 275–80.

"News and Notes of the Art World." *The New York Times,* February 20, 1910.

Du Bois, Guy Pène. "Exhibitions . . ." *New York American,* March 21, 1910.

Du Bois, Guy Pène. "Great Modern Art Display Here April 1," *New York American,* March 17, 1910.

Cary, Elisabeth Luther. "Post Impressionist 'Art,'" *The New York Times,* November 27, 1910.

Weber, Max. "The Fourth Dimension from a Plastic Point of View," *Camera Work* 31 (1910): 25.

Weber, Max. "Chinese Dolls and Modern Colorists," *Camera Work* 31 (1910): 51.

Books
Duret, Théodore. *Manet and the French Impressionists.* London: Grant Richards; Philadelphia: J.B. Lippincott, 1910.

Huneker, James G. *Promenades of an Impressionist.* New York: Charles Scribner's Sons, 1910.

Meier-Graefe, Julius. *Paul Cézanne.* Munich: R. Piper, 1910.

Notes
Kroll returns to Europe.

JULY 4–5
Steichen visits Vollard's gallery (Rabinow and Warman, 284)

Cat. 135

1911
Exhibitions/Auctions
JANUARY 11–31
New York, 291, Weber show. (Homer, *Alfred Stieglitz and the American Avant-Garde,* 301)

FEBRUARY
New York, 291, Marin show features Tyrol watercolors. (Homer, *Alfred Stieglitz and the American Avant-Garde,* 301)

MARCH
Berlin, Galerie Paul Cassirer, Group exhibition. (Warman 1996, 564)

MARCH 1–25
New York, 291, *Watercolors by Cézanne.* Man Ray attends. (Rewald 1989, 151)

Paris, Galerie Bernheim-Jeune, *L'eau.* (Kyle, 625)

Munich, Alte Pinakothek, *Collection Nemes.* (Kyle, 625)

MAY 20–JULY 2
Düsseldorf, Städtische Kunsthalle, *Ausstellung des Sonderbundeswestdeutscher Kunstfreunde und Kunstler.* (Kyle, 625)

JUNE 8
Paris, Hôtel Drouot, Sale of the Bernstein collection, which includes [R521, R538, R573, R617, R951]. (Rewald 1989, 159)

OCTOBER 6–NOVEMBER 5
Amsterdam, Stedelijk Museum, *Moderne Kunst Kring.* (Warman 1996, 564)

NOVEMBER
London, Stafford Gallery, *Cézanne and Gauguin.* (Warman 1996, 564)

NOVEMBER
Berlin, Ausstellung der Berliner Sezession XXIII, *Graphics.* (Kyle, 625)

NOVEMBER
Berlin, Galerie Paul Cassirer, Group exhibition, II. (Warman 1996, 625)

Articles/Reviews
"Watercolors by Cézanne," *The New York Times,* March 12, 1911.

Caffin, Charles. "A Note on Paul Cézanne," *Camera Work* 34–35 (April–July 1911): 47–51.

"Cézanne Exhibition," *Camera Work* 36 (October 1911): 30.

Lawton, Frederick. "Paul Cézanne," *The Art Journal* (London) 1911, 55–60.

Books
Caffin, Charles H. *The Story of French Painting.* New York: The Century Co., 1911.

Hind, C. Lewis. *The Post Impressionists.* London: Methuen, 1911.

Acquisitions
Davies acquires *The Well in the Park of Château Noir* (1895–98) [RWC428] from Stieglitz.

Notes
Kroll travels to France and Spain.

LATE 1911–EARLY 1912
Davies takes Marsden Hartley to Mrs. Havemeyer's house to see her collection, which at the time contains eleven Cézannes. (Rewald 1989, 125)

1912
Exhibitions/Auctions
St. Petersburg, L'Institut Français, *L'exposition centennale.* (Warman 1996, 564)

JANUARY–FEBRUARY
Vienna, Galerie Miethke. (Kyle, 625)

JANUARY 17–FEBRUARY 3
New York, 291, Arthur B. Carles's first solo show.

FEBRUARY
New York, Murray Hill Gallery, Max Weber solo show.

APRIL
Berlin, Galerie Paul Cassirer, Group exhibition, VIII. (Warman 1996, 564)

MAY 21–22
Amsterdam, F. Muller & Cie, Partial sale of the Cornelis Hoogendijk collection includes [R132, R816], and one watercolor. (Rewald 1989, 269; Rewald 1996, 113–14, 491)

MAY 25–SEPTEMBER 30
Cologne, Städtische Ausstellungshalle, *Sonderbund.* (Warman 1996, 564)

JULY
Hagen, Germany, Folkwang Museum, *Moderne Kunst.* (Kyle, 626)

JULY 18–SEPTEMBER 30
Frankfurt, Ausstellung Frankfürter Kunstverein, *Die klassische Malerei frankreichs im 19. Jahrhunderts.* (Kyle, 626)

AUGUST
Paris, Manzi, Joyant & Cie, *Exposition d'art moderne.* (Warman 1996, 564)

OCTOBER–NOVEMBER
Berlin, Galerie Paul Cassirer, Group exhibition, XV. (Warman 1996, 564)

OCTOBER 1–NOVEMBER 8
Paris, Salon d'Automne, *Exposition de portraits du XIXe siècle.* (Warman 1996, 564)

OCTOBER 5–DECEMBER 31
London, Grafton Galleries, *Second Post-Impressionist Exhibition.* (Warman 1996, 564)

Düsseldorf, Städtische Kunsthalle, *Collection Nemes.* (Kyle, 626)

NOVEMBER
Chicago, Roullier's Gallery, *Exhibition of Paintings by Bror J. Olsson Nordfeldt*. Critic Harriet Monroe places Nordfeldt in the "line of succession" of "Cézanne, Gauguin and their ideas, Matisse, and other recent radicals of the autumn salon." (Harriet Monroe, "Nordfeldt Pictures Monday," *Chicago Tribune,* November 3, 1912, B.J.O. Nordfeldt Papers, Archives of American Art, Smithsonian Institution, roll D-167, frame 58)

DECEMBER 9-12
Paris, Galerie Manzi-Joyant, Sale of the Henri Rouart collection, five Cézanne works [R127, R216, R330, R342, R364]. (Rewald 1989, 162; Rewald 1996, 158)

DECEMBER
Munich, Modern Galerie, Heinrich Thannhauser. (Warman 1996, 564)

DECEMBER 28, 1913–JANUARY 15, 1913
Milwaukee, Milwaukee Art Society, *Exhibition of Paintings by Bror. J. Olsson Nordfeldt.*

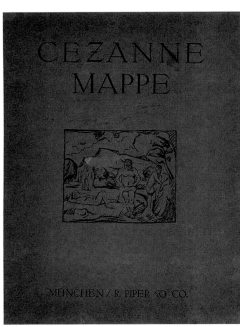

Cat. 137

Articles/Reviews
Monroe, Harriet. "What Are Post-Impressionists? Expressionists More Appropriate," *Chicago Daily Tribune,* March 3, 1912.

Books
Cézanne Mappe portfolio, 1912.

Acquisitions
Eugene and Agnes Meyer acquire *Still Life with Apples and Peaches* (c. 1905, cat. 21) [R936] through Steichen. (Rewald 1989, 158–59; Rabinow and Warman, 285–86)

FEBRUARY 28
William Glackens purchases *Toward Mont Sainte-Victoire* (1878–79) [R397] from Bernheim-Jeune on behalf of Albert C. Barnes. (Rewald 1989, 161)

DECEMBER
Barnes purchases three Cézannes from the Rouart sale: *Five Bathers* (1877–78) [R364], *Two and One-Half Apples* (1878–79) [R330], *Grapes and a Peach on a Plate* (1877–79) [R342]. (Rewald 1989, 162)

DECEMBER 10
Barnes acquires three Cézanne paintings from Vollard: *Portrait of Madame Cézanne* (1889) [R607]; *Four Bathers* (1876–77) [R362]; *Plate of Fruit on a Chair* (1885) [R335]. (Rewald 1989, 162, Warman's essay in this volume, 85)

Notes
Oscar Bluemner travels from the US to Europe.

JANUARY 12
Davies is named president of the Association of American Painters and Sculptors.

APRIL
Hartley travels to Paris.

APRIL
Brigman's work appears in *Camera Work.*

DECEMBER 1912–SPRING 1914
Demuth is in Europe (his second trip).

1913

Exhibitions/Auctions
JANUARY
New York, Folsom Galleries, Alfred Maurer show. Catalogue includes excerpted statements by Roger Fry and Clive Bell, from the 1912 Grafton show in London. (Stacey B. Epstein, "Alfred H. Maurer: Aestheticism to Modernism, 1897–1916." Ph.D. diss., The City University of New York, 2003, 39)

JANUARY 19
Berlin, Galerie Paul Cassirer, *Sammlung Reber.* (Warman 1996, 564)

JANUARY–FEBRUARY
Vienna, Galerie Miethke. (Kyle, 626)

FEBRUARY 17–MARCH 15
New York, Armory of the Sixty-Ninth Regiment, *International Exhibition of Modern Art, Armory Show.* Includes sixteen works by Cézanne, as well as work by Bluemner, Bruce, Carles, Dasburg, Davies, Hartley, Kroll, Marin, Maurer, Pach, Prendergast, Russell, Schamberg, Sheeler, Walkowitz, and Weber. (Warman 1996, 564; Stavitsky's essay in this volume, 32)

MARCH 8–APRIL 13
Brussels, Salon de la Libre Esthétique, *Interpretations du Midi.* (Warman 1983, 470)

MARCH 24–APRIL 16
Chicago, The Art Institute of Chicago, *Armory Show.* (Warman 1996, 564)

Cat. 139. Postcard, Cézanne, *Portrait of Gustave Boyer,* from the International Exhibition of Modern Art, February 17–March 5, 1913, New York, Armory of the Sixty-Ninth Regiment

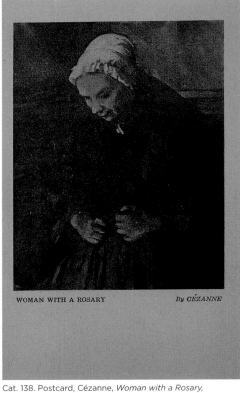

Cat. 138. Postcard, Cézanne, *Woman with a Rosary,* from the International Exhibition of Modern Art, February 17–March 5, 1913, New York, Armory of the Sixty-Ninth Regiment

APRIL 28–MAY 19
Boston, Copley Society of Boston, Copley Hall, *Armory Show*. (Warman 1996, 564)

SPRING
Berlin, Secession Ausstellungshaus, *Ausstellung der Berliner Sezession*. (Warman 1996, 564)

MAY–OCTOBER
Stuttgart, Kunstgebäude, *Grosse Kunstausstellung*. (Kyle, 626)

MID-MAY–MID-JUNE
Darmstadt, Mathildenhöhe, *Sammlung G. F. Reber*. (Warman 1996, 564)

JUNE 1–30
Munich, Der Neue Kunstsalon, *Ausstellung der Synchromisten Morgan Russell, S. Macdonald-Wright*.

SUMMER
Berlin, Galerie Paul Cassirer, *Sommerausstellung*. (Kyle, 626)

SUMMER–FALL
Newark, NJ, Newark Museum, Max Weber one-person exhibition.

OCTOBER–NOVEMBER
Cologne, Kunstverein Gemäldegalerie, *Eröffnungausstellung*. (Kyle, 627)

OCTOBER 27–NOVEMBER 8
Paris, Galerie Bernheim-Jeune, *Les Synchromistes: Morgan Russell et S. Macdonald-Wright*.

NOVEMBER
Portland, Oregon, exhibition organized by Frederic C. Torrey featuring lithographs by Cézanne, Renoir, and Denis, as well as Duchamp's *Nude Descending a Staircase [2]* (1912, Philadelphia Museum of Art), at the Portland Art Association. Torrey delivers a lecture on "The Significance of Certain Tendencies in Recent Art" in which he observes that Cézanne was "obsessed with the problem of volume," simplifying forms and achieving a "monumentality" to be found among the greatest examples of historical, international art. Torrey remounted the show a few months later in his San Francisco gallery, Vickery Atkins & Torrey. (Francis M. Naumann, "Frederic C. Torrey and Duchamp's *Nude Descending a Staircase*," in *West Coast Duchamp*, ed. Bonnie Clearwater [Miami Beach: Grassfield Press, 1991], 15–16)

Rome, *Prima Esposizione internazionale d'arte della Secessione*. (Kyle, 627)

NOVEMBER–DECEMBER
Paris, Galerie Eugène Blot, [Aquarelles de Cézanne]. (Kyle, 627)

NOVEMBER 30
Berlin, Galerie Paul Cassirer, *Degas—Cézanne*. (Warman 1996, 564)

Articles/Reviews
Bell, Clive. "Post-Impressionist and Aesthetics," *Burlington Magazine* 22, no. 118 (January 1913): 226–30.

Arts & Decoration Special Edition Number (March 1913).

Camera Work Special Number (June 1913).

Bluemner, Oscar. "Audiator Et Altera Pars: Some Plain Sense on the Modern Art Movement," *Camera Work* Special Number (June 1913): 30, 31.

Anon [W. H. Wright]. "Art at Home and Abroad," *The New York Times*, July 6, 1913.

Wright, Willard Huntington. "Impressionism to Synchromism," *The Forum* (December 1913): 766–67.

Books
Faure, Elie. *Cézanne*. Trans. Walter Pach. New York: Association of American Painters and Sculptors, 1913.

Zayas, Marius de, and Paul B. Haviland. *A Study of the Modern Evolution of Plastic Expression*. New York: "291," 1913.

Acquisitions
By 1913, Stephan Bourgeois acquires *Portrait of Madame Cézanne* (c. 1885) [R580] and *Self-Portrait with Bowler Hat* (1885–86) [R584], which he lends to the Armory Show. (Rewald 1996, 390–91)

JANUARY
John Quinn acquires *Madame Cézanne in Striped Dress* (1883–85) [R536], from Vollard, which is exhibited in the Armory Show. (Rewald 1989, 165)

Lillie P. Bliss acquires two Cézanne lithographs from the Armory Show. (Rewald 1989, 203)

Walter Arensberg acquires a Cézanne print from the Armory Show. (Rewald 1989, 203)

The Metropolitan Museum of Art, New York, acquires *View of the Domaine Saint-Joseph* (1888–90) [R612] (cat. 8), from the Armory Show.

Notes
SPRING 1913–DECEMBER 1915
Hartley in Berlin.

OCTOBER
Brigman's work appears in *Camera Work*.

Congress rescinds the existing 15 percent duty on the importation from abroad of works of art less than 20 years old (Tariff Act of 1909), thereby encouraging the rise of more American galleries dealing in modern European art, including Cézanne.

1914

Exhibitions/Auctions
JANUARY 6–17
Paris, Galerie Bernheim-Jeune, *Paul Cézanne*. (Warman 1996, 564)

FEBRUARY 1–MARCH 31
Bremen, Kunsthalle, *Internationale Ausstellung*. (Warman 1983, 470)

FEBRUARY–JUNE
Rome, *Secessione, II Internazionale*. (Warman 1983, 470)

MARCH 19–APRIL 5
Cincinnati, Cincinnati Art Museum, *Special Exhibition, Modern Departures in Paintings: "Cubism," "Futurism," etc.*

APRIL–MAY
Dresden, Galerie Ernst Arnold, *Französische Malerei des 19 Jahrhunderts*. (Warman 1983, 470)

APRIL–SEPTEMBER
Berlin, *Ausstellung der Freie Sezession*. (Kyle, 627)

MAY 15–JUNE 30
Copenhagen, Statens Museum for Kunst, *Fransk Malerkonst d. 19 Jahrhunderts*. (Warman 1996, 566)

SUMMER
London, Grosvenor House, *Art français, Exposition d'art décoratif contemporain 1800-1885*. (Warman 1996, 566)

SUMMER
Berlin, Galerie Paul Cassirer, *Sommerausstellung*. (Warman 1983, 470)

Paris, Galerie Ambroise Vollard, *Paul Cézanne*. (Kyle, 627)

San Francisco, Exhibition of Cézanne lithographs remounted by Torrey.

Exhibition of art by American Cubists, Futurists, and Post-Impressionists at the Detroit Museum of Art (organized by Davies, with the assistance of Pach).

Books
Vollard, Ambroise. *Paul Cézanne*. Paris: Galerie A. Vollard, 1914.

Eddy, Arthur Jerome. *Cubists and Post-Impressionism*. Chicago: A. C. McClurg, 1914.

Acquisitions
Musée de Louvre acquires five Cézanne paintings, from the Count Isaac de Camondo Bequest [R202, R223, R675, R714, R847]. (Kyle, 627; Warman 1996, 574)

Notes
Kroll travels to France and Spain.

Clarence White School of Photography founded in New York City (operates 1914–42); Weber is a founding faculty member, and leading proponent of Cézanne. (see Handy's and North's essays in this volume, 108, 324)

SUMMER
Margaret Watkins studies at the White School.

1915

Exhibitions/Auctions
FEBRUARY 15–MARCH 6
New York, Carroll Galleries, *Maurice B. Prendergast: Paintings in Oil and Watercolors*.

FEBRUARY 20–DECEMBER 4
San Francisco, Panama-Pacific International Exposition, including one painting by Cézanne, and portions of which travel to Buffalo and Pittsburgh.

Berlin, Galerie Paul Cassirer. (Kyle, 628)

Paris, Galerie Manzi, Joyant & Cie, *Exposition d'art moderne.* (Kyle, 628)

DECEMBER
New York, Montross Gallery, *Modern American Painters.* Includes works by Pach and Sheeler.

DECEMBER 14–28
New York, Montross Gallery, Max Weber, paintings and sculptures.

New York, 291, Bluemner's first solo show in America.

Articles/Reviews
Wright, Willard Huntington. "Cézanne," *The Forum* (July 1915): 39.

Wright, Willard Huntington. "Modern American Painters—and Winslow Homer," *The Forum* (December 1915): 667.

Wright, Willard Huntington. "The Truth about Painting," *The Forum* (October 1915): 450.

Gregg, Frederick James. "Paul Cézanne—At Last," *Vanity Fair* (December 1915): 58.

Books
Wright, Willard Huntington. *Modern Painting, Its Tendency and Meaning.* New York: John Lane, 1915.

Coady, Robert J. Introduction, in *Cezanne's Studio.* New York: Washington Square Gallery, 1915.

Acquisitions
March 29, Barnes purchases *Madame Cézanne in a Green Hat* (1891–92) [R700] from Durand-Ruel, who obtained the painting from Vollard. (Rewald 1989, 268)

1916

Exhibitions/Auctions
JANUARY
New York, Modern Gallery, (Marius de Zayas). (Warman 1996, 566)

JANUARY 1–31
New York, Montross Gallery, *Cézanne.* Catalogue includes statement by Max Weber on Cézanne's watercolors. (Warman 1996, 566)

JANUARY 5–29
New York, M. Knoedler Gallery, *Exhibition of Paintings by Contemporary French Artists.* (Warman 1996, 566)

JANUARY 18–FEBRUARY 12
New York, 291, John Marin watercolors.

JANUARY 25–FEBRUARY 9
New York, Modern Gallery, *Paintings by Cézanne; African Negro Sculpture.* (Kyle, 634)

FEBRUARY 12–MARCH 4
New York, Modern Gallery, *Paintings by Cézanne, Van Gogh, Picasso, Picabia, Braque. Desseignes, Rivera.* (Warman 1996, 566)

Top: Cat. 146. Montross Gallery catalogue, with annotations by Oscar Bluemner. He refers to Cézanne on another page as a "*Realist*" who, however, "does not . . . copy reality" but rather "selects from it only so much as will give on paper or canvas a *total* harmony of *enlivened* part-multiplicity."

Bottom: Cat. 147. Pamphlet from Modern Gallery exhibition of Cézanne paintings, 1916, with notes by Oscar Bluemner

MARCH 13–MARCH 25
New York, Anderson Galleries, *The Forum Exhibition of Modern American Painters.* 1916. Includes works by Bluemner, Dasburg, Dove, Hartley, Macdonald-Wright, Man Ray, Marin, Maurer, Russell, Sheeler, and Walkowitz.

APRIL
New York, Bourgeois Gallery, *Paintings, Drawings and Sculpture Arranged by a Selected Group of Americans.*

MAY 17–JUNE 15
Philadelphia, McClees Galleries, *Philadelphia's First Exhibition of Advanced Modern Art.* Includes work by Pach, Man Ray, Schamberg, Sheeler, and Weber.

OCTOBER 29–NOVEMBER 26
Winterthur, Kunstverein, *Ausstellung französischer Malerei.* (Warman 1996, 566)

NOVEMBER 27–DECEMBER 16
New York, M. Knoedler Gallery, *Foreign and American Painters.* (Kyle, 634)

Articles/Reviews
"A Representative Group of Cezannes Here." *The New York Times,* January 2, 1916.

"Some Paintings in the Reisinger Collection." *The New York Times,* January 9, 1916.

Cortissoz, Royal. "Paul Cezanne and the Cult of His Paintings," *New York Tribune,* January 9, 1916.

Mather Jr., Frank Jewett. "Paul Cézanne," *The Nation* (January 13, 1916): 57–59.

Stein, Leo D. "Cézanne," *The New Republic,* January 22, 1916, 298.

"The Cézanne Show," *Arts & Decoration* 6 (February 1916): 184.

Gregg, Frederick James. "Paul Cézanne, The Misanthropic Don Quixote of Modern Art," *Current Opinion* LX (February 1916): 121.

Wright, Willard Huntington. "The Aesthetic Struggle in America," *The Forum* (February 1916).

Wright, Willard Huntington. "Paul Cézanne," *The International Studio* (February 1916).

Gallatin, Albert Eugene. "Notes on Some Masters of the Water-Colour," *Arts & Decoration* VI (April 1916): 277.

"Two Cézannes," *Bulletin of the Metropolitan Museum of Art* 11 (May 1916): 117.

Acquisitions
JANUARY
Seventeen watercolors sold from the Montross Gallery show, New York.

Lillie P. Bliss purchases six watercolors: *Bridge* (1885–86) [RWC248], *House and Trees* (1890–95) [RWC390], *Trees among Rocks* (1895–1900) [RWC436], *Trees on the Mountain* (c. 1900) [RWC499], *Verdure* (1900–1904) [RWC551], *House*

Among Trees (c. 1900) [RWC509] (cat. 20), and *Bottle of Liqueur* (c. 1890) [R681]. (Rewald 1983; Rewald 1989, 298)

Arthur B. Davies acquires *Trees in a Ravine* (1890–95) [RWC 399]. (Rewald 1989, 298)

John Quinn purchases *White Tree Trunks* (1882–84) [RWC169], *Rocky Ridge* (1895–1900) [RWC435], and *House on the Hill, Near Aix* (1895–1900) [RWC464] (cat. 13). (Rewald 1983, 193).

JANUARY
Eugene and Agnes Meyer purchase *Bouquet of Flowers* (1900–1903) [R893] and *Château Noir* (1900–1904) [R937] from the Modern Gallery show. (Rewald 1989, 302–5)

JULY
The Meyers acquire *The Sailor* (1902–6) [R949] from Vollard through de Zayas. (Rewald 1989, 305; Warman's essay in this volume)

Notes
SUMMER
Nordfeldt, Demuth, and Hartley are in Provincetown, Massachusetts.

DECEMBER
Hartley travels to Bermuda.

1917

Exhibitions/Auctions
MARCH
New York, Arden Gallery, *Cézanne.* (Warman 1996, 566)

MARCH 20–MARCH 31
New York, 291, Stanton Macdonald-Wright paintings and sculptures.

MARCH 29–APRIL 9
New York, Modern Gallery, *Exhibition of Photographs by Sheeler, Strand and Schamberg.*

SPRING
Stockholm, Nationalmuseum, *French Art.* (Warman 1996, 566)

JUNE 14–23
Paris, Galerie Bernheim-Jeune, *Exposition de peinture moderne.* (Kyle, 628)

OCTOBER 5–NOVEMBER 14
Zurich, Kunsthaus, *Französische Kunst des XIX und XX.* (Warman 1996, 566)

DECEMBER 5–21
Poughkeepsie, NY, Vassar College, *Exhibition of Paintings by the "Moderns."* 20 paintings including works by Pach, Schamberg, Sheeler, and Weber, identified in the catalogue as "strongly influenced by Cézanne and the Post-Impressionists who believe that colors have definite spiritual values" and that "nature exists not to serve as a model to be copied but as a medium through which the artist may express an ideal or emotion."

Articles/Reviews
McBride, Henry. "Important Cézannes in Arden Galleries," *New York Sun,* March 4, 1917.

[Wright, Willard Huntington.] "Paintings by Cézanne Now on Exhibition Here," *The New York Times Magazine,* March 4, 1917, 7.

Cole, Robert J. "Studio and Gallery Cézanne's Inconvenient Variety," *New York Evening Sun,* March 9, 1917.

Notes
FEBRUARY–MARCH 1917
Demuth in Bermuda.

1918

Exhibitions/Auctions
JANUARY 3–FEBRUARY
Oslo, Kunstnerforbundet, *Den franske Utsilling.* (Warman 1983, 471)

MARCH 25–APRIL 20
New York, Bourgeois Gallery, *An Exhibition of Modern Art Arranged by a Group of European and American Artists.* Included work by Bluemner, Marin, Prendergast, and Walkowitz.

New York, Macbeth Galleries, Davies show features *Clothed in Dominion* (cat. 37).

Articles/Reviews
Du Bois, Guy Pène. "Who's Who in Modern Art—Cézanne," *The Evening Post Magazine,* July 13, 1918.

Hartley, Marsden. "America as Landscape," *El Palacio* 5 (December 21, 1918): 340–42.

Notes
SUMMER
Pach teaches a modern art course at University of California, Berkeley.

FALL
Macdonald-Wright returns to Los Angeles.

Mabel Dodge invites Dasburg to New Mexico; he remains there five months.

Nordfeldt travels to New Mexico.

1919

Exhibitions/Auctions
Paris, Galerie Crès (organized by Vollard), *Paul Cézanne.* (Kyle, 628)

APRIL 29–MAY 24
New York, Arden Gallery, *Exhibition Illustrating the Evolution of French Art from Ingres to Delacroix to the Latest Manifestations.* (Warman 1983, 471)

NOVEMBER 17–DECEMBER 6
New York, Marius de Zayas Gallery, *Exhibition of Paintings by Courbet, Manet, Degas, Renoir, Cézanne.* (Kyle, 635)

DECEMBER 18, 1919–JANUARY 20, 1920
Paris, Galerie Crès, *Les indépendants.* (Kyle, 628)

1919–20
London, Chelsea Book Club, *French Drawings and Watercolors.* (Kyle, 628)

Acquisitions

The Arensbergs acquire *Still Life with Apples and a Glass of Wine* (1877–79) [R344] and *Group of Bathers* (c. 1895) [R755] from de Zayas. (Rewald 1989, 308)

Notes

1919–23
Watkins is a member of the teaching and administrative staff at the White School.

1920

Exhibitions/Auctions

JANUARY 26–FEBRUARY 14
New York, Modern Gallery, *Paintings, Watercolors, and Aquatints by Arthur B. Davies.*

FEBRUARY 10–21
New York, Montross Gallery, *Cézanne Watercolors.* (Warman 1983, 471)

FEBRUARY 16–MARCH 4
Paris, Galerie Bernheim-Jeune, *Exposition de paysages impressionists.* (Kyle, 629)

MARCH 26–APRIL 4
New York, Colony Club, *A Selected Group of Modern French and American Paintings.* (Kyle, 635)

APRIL 17–MAY 9
Philadelphia, Pennsylvania Academy of the Fine Arts*, Paintings and Drawings by Representative Modern Masters.* (Warman 1996, 566)

APRIL 19–MAY
Paris, Galerie d'Art des Editions C. Crès, *Exposition de portraits.* (Kyle, 628)

MAY–OCTOBER
Venice, Biennale, *Mostra individuale di Paul Cézanne.* (Warman 1996, 566)

MAY 7–NOVEMBER 1
New York, The Metropolitan Museum of Art, *Fiftieth Anniversary Exhibition.* (Kyle, 636)

SUMMER
Sale of the remainder of the Cornelis Hoogendijk collection to Paul Rosenberg, Jos. Hessel, and the Durand-Ruels. (Rewald 1989, 269)

JULY
Paris, Galerie Druet, *Cézanne Drawings and Watercolors.* (Warman 1983, 471)

SEPTEMBER–DECEMBER
New York, De Zayas Gallery, *Exhibition of French and American Artists: Asiatic Arts and African Sculpture.* (Kyle, 636)

NOVEMBER
New York, De Zayas Gallery, *Cézanne Watercolors.* (Kyle, 636)

NOVEMBER
Bern, Kunsthalle, *Französische Malerei.* (Warman 1996, 566)

DECEMBER 1–18
Paris, Galerie Bernheim-Jeune, *Exposition Cézanne.* (Warman 1996, 566)

London, Victoria Art Gallery, *Exhibition of Modern Art.* (Kyle, 629)

Los Angeles, *Exhibition of Modern American Painters at the Los Angeles Museum of History, Science, and Art,* similar to *The Forum Exhibition* featuring progressive American modernism. Organized by Macdonald-Wright, included works by Hartley, Dasburg, Dove, Demuth, Bluemner, and Marin.

Articles/Reviews

Huneker, James G. "Cézanne," *New York Sun,* April 4, 1920.

Townsend, James B. "Modern Art in Philadelphia," *American Art News* 18 (May 8, 1920): 3.

Barnes, Albert C. "Cézanne: A Unique Figure among the Painters of His Time," *Arts & Decoration* (November 1920): 40.

Acquisitions

Barnes acquires thirteen Cézanne works, through Durand-Ruel, from the Hoogendijk sale: *Village at the Water's Edge* (c. 1876) [R280], *Plate with Fruits and Pot of Preserves* (1880–81) [R480], *House in the Countryside of Aix* (c. 1886) [R597], *Clay Pots and Flowers* (1891–92) [R702], *Still Life with Skull* (1896–98) [R734], *Curtain, Jug, and Dish of Fruit* (1893–94) [R739], *Apples and Tapestry* (1893–94) [R740], *Pitcher and Fruits on a Table* (1893–94) [R742], *Mont Sainte-Victoire* (1892–95) [R767], *Ginger Jar* (c. 1895) [R773], *The Large Pear* (1895–98) [R842], *Still Life* (1892–94) [R844], and *The Vase of Flowers* (1896–98) [R892]. (Rewald 1989, 270–71)

Notes

Gorky emigrates from Armenia.

1921

Exhibitions/Auctions

FEBRUARY
New York, Wildenstein Galleries, *Paintings by the Great French Impressionists from the Collection of M. Paul Rosenberg of Paris.* (Warman 1996, 566)

FEBRUARY 6–MARCH 6
Basel, Kunsthalle, *Cézanne.* (Warman 1996, 566)

MARCH 5–12
Tokyo, Galerie Hoshi-Seiyaku, Collection Shirakaba-ha. (Warman 1996, 566)

MARCH 16–APRIL 3
New York, Museum of French Art, *Loan Exhibition of Works by Cézanne, Redon, Degas, Rodin, Gaugin, Derain, and Others.* (Warman 1996, 471)

MARCH 26–APRIL 25
New York, The Brooklyn Museum, *Paintings by Modern French Masters Representing the Post-Impressionists and Their Predecessors.* (Warman 1996, 566)

MAY 3–SEPTEMBER 15
New York, The Metropolitan Museum of Art, *Loan Exhibition of Impressionist and Post-Impressionist Paintings.* (Warman 1996, 566)

JUNE–JULY
Cleveland, Cleveland Museum of Art, *French Paintings of the Latter Nineteenth Century.*

NOVEMBER 3–DECEMBER 5
Worcester, MA, Worcester Art Museum, *Paintings by Members of the Société Anonyme.*

NOVEMBER
Minneapolis, Minneapolis Institute of Arts, *An Exhibition of Modern French Paintings.*

NOVEMBER–DECEMBER
Berlin, Galerie Paul Cassirer, *Cézanne—Ausstellung.* (Warman 1996, 566)

Dallas, Adolphus Hotel, Dallas Art Association, *Second Annual Exhibition American and European Art.*

Articles/Reviews

Boswell, Peyton. "Philadelphia Sees Best in New," *American Art News* 19 (April 23, 1921): 6.

Field, Hamilton Easter. "French Show at Brooklyn Museum," *Brooklyn Eagle,* March 27, 1921.

"French Masters in Big Exhibition," *American Art News* (April 2, 1921): 1.

"The World of Art: More French Work," *The New York Times,* April 10, 1921.

Burroughs, Bryson. "Exhibition of French Impressionists and Post-Impressionists," *Bulletin of The Metropolitan Museum of Art* 16 (April 1921):70.

Field, Hamilton Easter. "The Metropolitan French Show," *The Arts* (May 1921): 2.

Stieglitz. Alfred "Regarding the Modern French Masters Exhibition," *Brooklyn Museum Quarterly* 8 (July 1921): 107–8.

Watson, Forbes. "Comment on the Arts," *The Arts* (May 1921): 34.

M[illiken], W[illiam] M. "French Paintings of the Latter Nineteenth Century," *Bulletin of the Cleveland Museum of Art* (June–July 1921): 105–7.

Watson, Forbes, "French Impressionists and Post-Impressionists at the Cleveland Museum of Art," *The Arts* (November 1921): 70–73.

Fox, W. H. "French Post-Impressionist Paintings and Other Groups at the Brooklyn Museum," *The Brooklyn Museum Quarterly* 8 (October 1921): 163–5.

Strand, Paul. "American Water Colors at the Brooklyn Museum," *The Arts* (December 1921): 148–51.

Books

Bye, Arthur Edwin. *Pots and Pans, or Studies in Still-Life Painting.* Princeton: Princeton University Press, 1921.

Hartley, Marsden. *Adventures in the Arts.* New York: Boni and Liveright, 1921.

Acquisitions
By May 1921, Lillie P. Bliss acquires *The Road* (c. 1871) [R169], *The Large Bather* (c. 1885) [R555], *Bottle of Liqueur* (c. 1890) [R681], *Pines and Rocks (Fontainebleau?)* (c. 1897) [R906], and *Still Life with Ginger Jar, Sugar Bowl, and Oranges* (1902-6) [R933], which she lends to The Metropolitan Museum of Art show.

Notes
Józef Bakoś founds the *Los Cinco Pintores,* which has its first exhibition at the Museum of Fine Arts in Santa Fe.

Hartley returns to Berlin.

1922

Exhibitions/Auctions
London, Burlington Fine Arts Club, *Pictures, Drawings, and Sculpture of the French School of the Last 100 years.* (Warman 1996, 567)

MARCH
Detroit, Detroit Institute of Arts, *Exhibition of Modern Art.*

MAY 3-JUNE 3
Paris, Paul Rosenberg, *Les maîtres du siècle passé.* (Warman 1996, 567)

New York, American Art Association, Dikran Kelekian Collection sale [R532, R686, R732, R758, R804]. (Rewald 1996, 359-60, 436, 454, 462, 482-83)

Books
Bell, Clive. *Since Cézanne.* New York: Harcourt, Brace, and Company, 1922.

Wedderkop, H. von. *Paul Cézanne.* Leipzig: Klinkhardt & Biermann, 1922.

Acquisitions
John Quinn acquires *Landscape around Aix* (1892-95) [R758] from Kelekian sale. Lillie P. Bliss acquires *Still Life* (1895-98) [R804]. Albert Barnes acquires *House in Provence* (c. 1890) [R686] and *Four Peaches on a Plate* (1980-94) [R732]. (Rewald 1996, 462, 482-83, 436, 454)

Ralph Coe acquires *The Pigeon Tower of Bellevue* (1889-90) [R692] from Vollard. (Rewald 1996, 438)

Notes
The Cone sisters return to Europe.

1923

Exhibitions/Auctions
MARCH 23-24
New York, Anderson Galleries, Auction of the Collection of Marius de Zayas, includes *Reflections in the Water* (1892-94) [R726] and *The Aqueduct and the Lock* (1895-98) [R765]. (Rewald 1996, 288)

Prague, Manes, *French Art of the 19th-20th Centuries.* (Warman 1996, 567)

Articles
Barnes, Albert C. "Some Remarks on Appreciation," *The Arts* (January 1923): 24-29.

Books
Dreier, Katherine S. *Western Art and the New Era: An Introduction to Modern Art.* New York: Brentano's Publishers, 1923.

Acquisitions
The Brooklyn Museum acquires *The Village at Gardanne* (1885-86) [R571].

Notes
1923-29
Pach teaches modern art courses at New York University.

Macdonald-Wright teaches about Cézanne, the history of art, and color theory at the Art Students League of Los Angeles. He refers to Cézanne's application of color "as a sort of mosaic, each individual facet serving its individual purpose of being a part of the form [as] fluent directions flowing almost as freely as the Chinese line." (Macdonald-Wright, "Lectures to the Art Students' League of Los Angeles [1920-25]," recorded and transcribed by Mabel Alvarez, The Museum of Modern Art Library, lecture of September 21, 1925, [3])

1924

Exhibitions/Auctions
MARCH 5-24
Paris, Galerie Bernheim-Jeune, *Exposition Paul Cézanne.* (Warman 1996, 567)

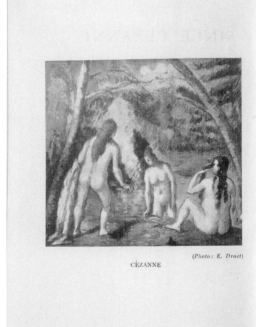

Cat. 150. Frontispiece illustration of Cézanne, *Three Bathers* (1876-77) [R360], which was owned by Henri Matisse

Books
Pach, Walter. *The Masters of Modern Art.* New York: B.W. Huebsch, 1924.

Notes
FALL
Claribel Cone travels to Aix-en-Provence and visits Cézanne's house.

1925

Exhibitions/Auctions
JANUARY 9-FEBRUARY 1
Baltimore, The Baltimore Museum of Art, *An Exhibition of Modern French Art.*

FEBRUARY 15-MARCH 15
Paris, Galerie Bernheim-Jeune, *Sola, Cézanne, Utrillo.* (Warman 1983, 471)

MARCH-APRIL
Vienna, *Die führende Meister der französische Kunst im 19. Jahrhundert (Secession).* (Warman 1996, 567)

JUNE-JULY
London, Leicester Galleries, *Paintings and Drawings by Paul Cézanne.* (Warman 1996, 567)

SEPTEMBER-OCTOBER
Berlin, Galerie Paul Cassirer, *Impressionisten.* (Warman 1996, 567)

Books
Barnes, Albert C. *The Art in Painting.* Merion, PA: Barnes Foundation Press, 1925.

Acquisitions
JUNE 26
Claribel Cone acquires *Mont Sainte-Victoire Seen from the Bibémus Quarry* (c. 1897) [R837] (cat. 16) from Galerie Bernheim-Jeune. (Rewald 1989, 342)

Notes
Hartley leases a house in Vence, France.
The gallery of The Barnes Foundation, established in 1922, opens.

1926–31

Gorky is teaching at the Grand Central School of Art, New York.

1926

Exhibitions/Auctions
Moscow, Museum of Modern Western Art, *Paul Cézanne—Vincent van Gogh.* (Warman 1996, 567)

FEBRUARY 20–MARCH 21
Paris, Grand Palais, *Trente ans d'art indépendant.* (Warman 1996, 567)

MAY
Chicago, The Art Institute of Chicago, the Birch-Bartlett collection, which includes *The Basket of Apples* (c. 1893) [R800], opens to the public.

JUNE 1–30
Paris, Galerie Bernheim-Jeune, *Rétrospective Paul Cézanne.* (Warman 1996, 567)

SUMMER
New York, Brooklyn Academy of Arts and Sciences, Summer exhibition. (Warman 1983, 471)

NOVEMBER
Cleveland, Cleveland Museum of Art, *Fifty Years of French Art.*

Articles/Reviews
Cary, Elisabeth Luther. "Art of the Moderns in a Notable Show," *The New York Times,* July 4, 1926.

Books
Dreier, Katherine S., and Christian Brinton. *Modern Art at the Sesqui-Centennial Exhibition.* New York: Société Anonyme, 1926.

Phillips, Duncan. *A Collection in the Making.* Washington, DC: Phillips Memorial Gallery, 1926.

Rutter, Frank. *Evolution in Modern Art; A Study of Modern Painting, 1870–1925.* London: G. G. Harrap, 1926.

Acquisitions
Etta Cone acquires *Bathers* (1898–1900) [R861] (cat. 18) from Gertrude Stein. (Rewald 1989, 342)

Notes
FALL
William H. Johnson is awarded a Pulitzer Traveling Scholarship, which allows him to travel to Paris.

1927

Exhibitions/Auctions
JANUARY 9–MID-FEBRUARY
Berlin, Galerie Thannhauser, *Erste Sonderanusstellung.* (Warman 1996, 567)

MAY 10–JUNE 16
Berlin, Galerie Alfred Flechtheim, *Cézanne Aquarelle und Zeichnungen, Bronzen von Edgar Degas.* (Warman 1983, 471)

DECEMBER 13, 1927–JANUARY 15, 1928
New York, Gallery of Living Art, New York University, Opening exhibition.

Articles/Reviews
Fry, Roger. "New Laurels for the Scorned Cézanne," *The New York Times,* May 1, 1927.

Books
Stein, Leo. *The ABC of Aesthetics.* New York: Liveright, 1927.

Fry, Roger. *Cézanne: A Study of His Development.* New York: Macmillan, 1927.

Acquisitions
Buffalo, Albright-Knox Gallery acquires *The Pool at Jas de Bouffan* (c. 1878–79) [R380]. (Rewald 1989, 342; Rewald 1996, 250)

Notes
New York, A. E. Gallatin founds the Gallery of Living Art, collection includes works by Cézanne, shown on a rotating basis until its closing in 1943.

Johnson moves to Cagnes-sur-Mer.

SEPTEMBER
Hale Woodruff travels to France.

1928

Exhibitions/Auctions
JANUARY
New York, Wildenstein Galleries, *Paul Cézanne.* (Warman 1996, 567)

SUMMER
Buffalo, Buffalo Fine Arts Academy–Albright Art Gallery, *A Selection of Paintings of the French Modern School from the Collection of A. C. Good-year and Other Single Loans, also Important Examples of French Art in the Permanent Collection.*

Articles/Reviews
"The 'Old Master of Aix' Comes to Fifth Avenue," *The New York Times,* January 15, 1928.

"Was Cézanne an Industrious 'Painter without Taste'?" *The New York Times Book Review,* January 22, 1928, 5.

Watson, Forbes. "New York Exhibition," *The Arts* (February 1928): 106–8.

Acquisitions
Phillips Memorial Gallery acquires *Self-Portrait* (1878–80) [R383]. (Rewald 1989, 342)

BY SUMMER
A. Conger Goodyear acquires *Peasant in a Blue Blouse* (c. 1897) [R826], which he lends to the exhibition at the Buffalo Fine Arts Academy–Albright Art Gallery.

Drs. Henry and Ruth Bakwin acquire *Italian Woman at a Table* (c. 1900) [R812] from Pach. (Rewald 1989, 342; Rewald 1996, 491–92)

Notes
Charles Loeser dies, leaving eight Cézanne paintings to the president of the United States. (Rewald 1989, 343, Warman's essay in this volume, 82)

Weber wins the Potter Palmer gold medal at The Art Institute of Chicago for a Cézannesque still-life painting.

SPRING
Woodruff travels to Normandy to meet Henry Ossawa Tanner.

1929

Exhibitions/Auctions
MARCH 6–APRIL 6
Cambridge, Fogg Art Museum, Harvard University, *Exhibition of French Paintings of the Nineteenth and Twentieth Centuries.*

NOVEMBER
New York, The Museum of Modern Art, First Loan Exhibition, New York, November 1929, *Cézanne, Gauguin, Seurat, van Gogh.* (Warman 1996, 567)

DECEMBER
Paris, Galerie Pigalle, *Cézanne.* (Warman 1983, 472)

THE MUSEUM OF MODERN ART
FIRST LOAN EXHIBITION
NEW YORK
NOVEMBER
1929

CÉZANNE
GAUGUIN
SEURAT
VAN GOGH

Cat. 151

DECEMBER 1929–JANUARY 1930
Berlin, Galerie Paul Cassirer, *Ein Jahrhundert französischer Zeichnung.* (Warman 1983, 472)

Articles/Reviews
Bulliet, C. J. "Modern Museum Launched with Show of Giants," *The Chicago Evening Post Magazine of the Art World,* November 10, 1929, 14X.

Cortissoz, Royal. "The New Museum of Modern Art/French Painting in the Opening Show," *New York Herald,* November 10, 1929, 10.

P[emberton], M[urdoch]. "The Art Galleries," *The New Yorker,* November 23, 1929, 105.

Watson, Forbes. "The Museum of Modern Art," *The Arts* (November 1929): 147–48.

Acquisitions
The Metropolitan Museum of Art acquires five Cézanne paintings from the bequest of Mrs. H. O. Havemeyer: *Mont Sainte-Victoire and the Viaduct of the Arc River Valley* (1882–85) [R511] (MMA 29.100.64); *Gustave Boyer in a Straw Hat* (1870–71) [R174] (29.100.65); *Still Life with Jar, Cup, and Apples* (c. 1877) [R322] (29.100.66); *The Gulf of Marseille Seen from L'Estaque* (c. 1885) [R625] (29.100.67); and *Rocks in the Forest* (1890s) [R775] (29.100.194).

Etta Cone purchases a second lithograph, *Large Bathers* (BMA 1950.12.681.1).

Notes
Woodruff moves to Cagnes-sur-Mer.

1929–30

Marin visits New Mexico.

1930

Exhibitions/Auctions
MARCH 13–APRIL 12
New York, The Museum of Modern Art, *Max Weber: Retrospective Exhibition, 1907–30.*

APRIL 5–MAY 3
Minneapolis, Minneapolis Institute of Arts, *Masters of Modernism: Paintings by Modern French Masters.*

SEPTEMBER 6–NOVEMBER 2
Amsterdam, Stedelijk Museum, *Van Gogh en zijn Tijdgenooten.* (Warman 1996, 567)

NOVEMBER 16–DECEMBER 14
Buffalo, Buffalo Fine Arts Academy–Albright Art Gallery, *A Group of French Paintings from Courbet down to and including the Contemporary Moderns.*

Articles/Reviews
Lane, James W. "The Moderns in America," *The Commonweal,* January 1, 1930.

McBride, Henry. "The Palette Knife—A Profoundly Impressive Museum of Modern Art," *Creative Art* (January 1930): supp. 9–11.

[Whigham, H. J.]. "The Editor's Page," *The International Studio* 95 (January 1930): 8.

Johnson, Erle Loran. "Cézanne's Country," *The Arts* (April 1930): 521–51.

Notes
Dasburg moves permanently to Santa Fe.

Hans Hofmann immigrates to America.

CONTRIBUTORS

William C. Agee is the Evelyn Kranes Kossak Professor of Art History at Hunter College, City University of New York, and has organized numerous exhibitions and written extensively in the field of modern American art, including studies on Stuart Davis, Patrick Henry Bruce, Morton Schamberg, and Arthur Dove.

Isabelle Dervaux, Curator of Modern and Contemporary Drawings at the Morgan Library & Museum, New York, has published widely on twentieth-century American art, notably on Mark Rothko, Arshile Gorky, and Philip Guston. In 2005 she organized a large exhibition on Surrealism in the United States.

Stacey Epstein, Associate Director of Modernism at Hollis Taggart Galleries, is a specialist in early American modernism and in the art of Alfred Maurer. She is writing the catalogue for *Alfred H. Maurer: At the Vanguard of Modernism,* a traveling exhibition being organized by the Addison Gallery of American Art.

Betsy Fahlman, Professor of Art History at Arizona State University, is the author, recently, of *Chimneys and Towers: Charles Demuth's Late Paintings of Lancaster* (2007), *James Graham & Sons: A Century and a Half in the Art Business* (2007), and *Guy Pène du Bois: Painter of Modern Life* (2004).

Roberta Smith Favis is Professor of Art History and Curator of the Vera Bluemner Kouba Collection at Stetson University in DeLand, Florida. She is author of *Martin Johnson Heade in Florida* (2003) and *Oscar Bluemner: A Daughter's Legacy* (2004) and of exhibition catalogues and articles on nineteenth- and twentieth-century American art.

Ruth Fine, the National Gallery of Art's curator of special projects in modern art, is compiling the catalogue raisonné of Mark Rothko's works on paper. Exhibitions she has organized focused on Romare Bearden, Mel Bochner, Helen Frankenthaler, Jasper Johns, Roy Lichtenstein, John Marin, and Georgia O'Keeffe, among others.

Gregory Galligan is an independent curator, consultant, editor, and art critic; he was the director of the *Morgan Russell Archives and Collection Enhancement Project, 2004–6,* for the Montclair Art Museum. He specializes in modern and contemporary art and writes regularly for *Art in America* and *ArtAsiaPacific.*

Ellen Handy is Associate Professor in the Department of Art at City College of New York (CUNY). She previously served as curator of photography at the Harry Ransom Humanities Research Center at the University of Texas at Austin and the International Center of Photography, New York.

Jill Anderson Kyle is an independent art historian and writer who lives in Brenham, Texas. She wrote her dissertation on "Cézanne and American Painting: 1900–1920," and she contributed the essay "Paul Cézanne, 1911, Nature Reconstructed" to *Modern Art and America: Alfred Stieglitz and the New York Galleries* (2001).

Mary Tompkins Lewis, who is visiting Associate Professor at Trinity College, is a specialist on Cézanne's work. She is the author of *Cézanne's Early Imagery* (1989), *Cézanne* (2000), and editor of *Critical Readings in Impressionism and Post-Impressionism* (2007).

Laurette E. McCarthy is an authority on Walter Pach; she wrote a dissertation entitled "Walter Pach: Artist, Critic, Historian and Agent of Modernism" (1996) and her biography on Pach is forthcoming. She is an independent scholar and curator with specialties in American modernism and historical Indiana art, and a strong interest in American sculpture before 1945.

Patricia McDonnell is Director of the Ulrich Museum of Art at Wichita State University and a specialist on the artist Marsden Hartley. She is the author of a number of publications on American modernism, including *Painting Berlin Stories: Marsden Hartley, Oscar Bluemner, and the First American Avant-Garde in Expressionist Berlin* (2003) and *Marsden Hartley: American Modern* (1997).

Nancy Mowll Mathews is the Eugénie Prendergast Senior Curator of Nineteenth and Twentieth Century Art and Lecturer in Art at the Williams College Museum of Art, Williamstown, Massachusetts. She has written and curated exhibitions on transatlantic issues in art around 1900, concentrating on Maurice and Charles Prendergast, Mary Cassatt, Paul Gauguin, and art and early film.

Francis M. Naumann is an independent scholar, curator, and art dealer specializing in the art of the Dada and Surrealist periods. He is author of numerous articles and exhibition catalogues, and has organized several museum exhibitions, including *Making Mischief: Dada Invades New York* (1996), and *Conversion to Modernism: The Early Work of Man Ray* (2003).

Emily Schuchardt Navratil, the Research Associate for this exhibition and a doctoral student in art history at the Graduate Center, City University of New York, received her BA from Trinity College and MA from Hunter College. She has worked with William C. Agee and Michael FitzGerald.

Percy North is Coordinator of the Art History program at Montgomery College, Rockville, Maryland, and an adjunct professor of Liberal Studies at Georgetown University. She has published numerous articles and exhibition catalogues on American modernism and is a specialist on the work of Max Weber.

Bennard B. Perlman, retired Professor and Chair of the Department of Fine and Applied Arts at Baltimore City Community College, is the author of *The Lives, Loves and Art of Arthur B. Davies* (1998), *The Immortal Eight: American Painting from Eakins to the Armory Show, 1870–1913* (1962), and *American Artists, Authors, and Collectors: The Walter Pach Letters, 1906–1958* (2002).

Katherine Rothkopf is Senior Curator of European Painting and Sculpture at The Baltimore Museum of Art and a specialist in late-nineteenth-century French painting. Her most recent publication is the 2007 exhibition catalogue *Pissarro: Creating the Impressionist Landscape*. She was a co-curator and contributor to *Impressionists in Winter: Effets de Neige* (1998, The Phillips Collection, Washington, DC).

Jerry N. Smith, Associate Curator of American Art at Phoenix Art Museum, specializes in pre-1950 American art, with a concentration on the art of the American Southwest. He is currently working on a study of the automobile and American painting circa 1900–1950, with a publication and exhibition anticipated in 2011.

Will South, Chief Curator for The Dayton Art Institute, has written extensively in the fields of American Impressionism and modernism, including *Color, Myth & Music: Stanton Macdonald-Wright and Synchromism* for the North Carolina Museum of Art (2001) and *California Impressionism,* with coauthor William H. Gerdts, for Abbeville Press (1998).

Gail Stavitsky is Chief Curator of the Montclair Art Museum, where, among other exhibitions, she has curated and written catalogues on *Reordering Reality: Precisionism in America 1915–1941* (1994), *Waxing Poetic: Encaustic Art in America* (1999), and *Will Barnet: A Timeless World* (2000). She co-curated *Conversion to Modernism: The Early Work of Man Ray* (2003) and *Roy Lichtenstein: American Indian Encounters* (2005).

Jayne Warman is an independent art historian and consultant who worked with John Rewald for fifteen years as a researcher for his catalogue raisonné of Cézanne's watercolors (1983) and collaborator on the oeuvre catalogue of the artist's paintings (1996).

SELECTED BIBLIOGRAPHY

Emily Schuchardt Navratil

This exhibition and catalogue are built upon the foundation of the scholarship in John Rewald's groundbreaking study, *Cézanne and America: Dealers, Collectors, Artists, and Critics* (1989), which surveyed the reception of Cézanne among dealers, collectors, artists, and critics from 1891 to 1921. Jill Anderson Kyle's dissertation, "Cézanne and American Painting, 1900 to 1920" (1995), and her complex, multifaceted approach has been a major source of inspiration. The master's thesis of Sandra Phillips, "Cézanne's Influence on American Art, 1910–1930" (1969), has also been an important source. Phillips and, later, Linda Hyman in the exhibition catalogue *American Modernist Landscapes: The Spirit of Cézanne* (1989), explored the reactions of various American artists to the works of Cézanne and their impact on the development of modern art in the United States. Also of critical importance are Carol Arnold Nathanson's dissertation, "The American Response, in 1900–1913, to the French Modern Art Movements after Impressionism" (1973); John H. Cauman's "Matisse and America, 1905–1933" (2000); and Karin Schick's seminal research in her dissertation "The Making of Cézanne—Eine Studie zur amerikanischen Cézanne-Reception" (2002).

Books and Exhibition Catalogues

Agee, William C., and Barbara Rose. *Patrick Henry Bruce, American Modernist: A Catalogue Raisonné*. New York: The Museum of Modern Art, 1979.

Agee, William C., and Bruce Weber. *High Notes of American Modernism: Selections from the Tommy and Gill LiPuma Collection*. New York: Berry-Hill Galleries, 2002.

Anderson Galleries. *The Forum Exhibition of Modern American Painters*. New York: Anderson Galleries, 1916. Reprinted, New York: Arno Press, 1968.

Association of American Painters and Sculptors, New York. *The Armory Show; International Exhibition of Modern Art, 1913*. 3 volumes: 1. Catalogues; 2. Pamphlets; 3. Contemporary and retrospective documents. New York: Arno Press, 1972.

Atkinson, D. Scott. "The First American Secession." In *The New Society of American Artists in Paris, 1908–1912*. Flushing, NY: Queens Museum of Art, 1986.

Baker, John. *Henry Lee McFee and Formalist Realism in American Still Life, 1923–1936*. London and Toronto: Associated University Presses, 1987.

Bardazzi, Francesca, ed. *Cézanne in Florence: Two Collectors and the 1910 Exhibition of Impressionism*. Milan: Electa, 2007.

Barnes, Albert C. *The Art in Painting*. Merion, PA: The Barnes Foundation Press, 1925.

Barr Jr., Alfred H. Foreword to *Cézanne, Gauguin, Seurat, van Gogh*. New York: The Museum of Modern Art, 1929.

———. *Matisse: His Art and His Public*. New York: The Museum of Modern Art, 1951.

Bell, Clive. *Since Cézanne*. New York: Harcourt, Brace, 1922.

Bluemner, Oscar. Preface to *An Exhibition of Modern Art Arranged by a Group of European and American Artists in New York*. New York: Bourgeois Gallery, 1918.

Brooklyn Museum. *Paintings by Modern French Masters, Representing the Post Impressionists and Their Predecessors*. Brooklyn, NY: Brooklyn Museum Press, 1921.

Brown, Milton. *The Story of the Armory Show*. 1963; 2nd edition. New York: Abbeville Press Publishers, 1988.

Bulliet, C. J. *Apples and Madonnas; Emotional Expression in Modern Art*. Chicago: P. Covici, 1927.

Bye, Arthur Edwin. *Pots and Pans or Studies in Still-Life Painting*. Princeton: Princeton University Press, 1921.

Cachin, Françoise, Joseph J. Rishel et al. *Cézanne*. Philadelphia: Philadelphia Museum of Art; New York: Harry N. Abrams, 1996.

Caffin, Charles H. *The Story of French Painting*. New York: The Century Co., 1911.

Cheney, Sheldon. *A Primer of Modern Art*. New York: Boni and Liveright, 1924.

Coady, Robert J. Introduction to *Cézanne's Studio*. New York: Washington Square Gallery, 1915.

Conversations with Cézanne. Edited by Michael Doran, translated by Julie Lawrence Cochran. Berkeley and Los Angeles: University of California Press, 2001.

Dale, Maud. Preface to *Loan Exhibition of Paintings by Paul Cezanne, 1839–1906, under the Auspices of Mrs. Chester Dale for the Benefit of the Building Fund of the French Hospital of New York, January, 1928*. New York: Wildenstein, 1928.

Dreier, Katherine S. *Western Art and the New Era: An Introduction to Modern Art*. New York: Brentano's, 1923.

———. Introduction to *Modern Art at the Sesqui-Centennial Exhibition*, by Christian Brinton. New York: The Société Anonyme; The Museum of Modern Art, 1926.

Duret, Théodore. *Manet and the French Impressionists; Pissarro, Claude Monet, Sisley, Renoir, Berthe Morisot, Cézanne, Guillaumin*. Philadelphia: J. B. Lippincott, 1910.

Eddy, Arthur Jerome. *Cubists and Post-Impressionism*. Rev. ed. Chicago: A. C. McClurg, 1919.

Faure, Elie. *Cézanne*. Translated by Walter Pach. New York: Association of American Painters and Sculptors, 1913.

———. *History of Art: Modern Art*. Translated by Walter Pach. New York: Harper and Brothers, 1924.

FitzGerald, Michael. *Picasso and American Art*. New York: Whitney Museum of American Art; New Haven, CT: Yale University Press, 2006.

Flam, Jack. *Matisse: The Man and His Art, 1869–1918*. Ithaca: Cornell University Press, 1986.

Flam, Jack, ed. *Matisse on Art*. Rev. ed. Berkeley and Los Angeles: University of California Press, 1995.

Four Americans in Paris: The Collections of Gertrude Stein and Her Family. New York: The Museum of Modern Art, 1970.

Fry, Roger. *Cézanne: A Study of his Development*. New York: Macmillan, 1927.

Fuller, Edmund, ed. *Journey Into the Self, Being the Letters, Papers & Journals of Leo Stein*. New York: Crown Publishers, 1950.

Gerdts, William. *Painters of the Humble Truth: Masterpieces of American Still Life 1801–1939*. Tulsa: Philbrook Art Center; Columbia: University of Missouri Press, 1981.

Gordon, Jan. *Modern French Painters*. London: J. Lane; New York: Dodd, Mead, 1929.

Greenough, Sarah, et al. *Modern Art and America: Alfred Stieglitz and His New York Galleries*. Washington, DC: National Gallery of Art; Boston: Bulfinch Press, 2001.

Hartley, Marsden. *Adventures in the Arts: Informal Chapters on Painters, Vaudeville, and Poets*. New York: Boni and Liveright, 1921.

———. "Impressions of Provence from an American's Point of View." In *On Art*. Edited by Gail Scott. New York: Horizon Press, 1982.

Henri, Robert. *The Art Spirit: Notes, Articles, Fragments of Letters, and Talks to Students, Bearing on the Concept and Technique of Picture Making, the Study of Art Generally, and on Appreciation*. Philadelphia: J.B. Lippincott, 1923.

Homer, William Inness. *Alfred Stieglitz and the American Avant-Garde*. Boston: New York Graphic Society, 1977.

Hind, C. Lewis. *The Post Impressionists*. London: Methuen, 1911.

Huneker, James G. *Promenades of an Impressionist*. New York: Charles Scribner's Sons, 1910.

Hyman, Linda. *American Modernist Landscapes: The Spirit of Cézanne*. New York: Linda Hyman Fine Arts, 1989.

Kootz, Samuel M. *Modern American Painters*. New York: Brewer and Warren, 1930.

Kuhn, Walt. *The Story of the Armory Show*. New York: W. Kuhn, 1938.

Kuspit, Donald B. *Painting in the South, 1564–1980*. Richmond: Virginia Museum of Fine Arts, 1983.

Levin, Gail. *Synchromism and American Color Abstraction, 1910–1925*. New York: George Braziller, in association with the Whitney Museum of American Art, 1978.

Mancini, J.M. *Pre-Modernism: Art-World Change and American Culture from the Civil War to the Armory Show* Princeton: Princeton University Press, 2005.

Mauclair, Camille. *The French Impressionists (1860–1900)*. New York: E. P. Dutton, 1903.

———. *The Great French Painters and the Evolution of French Painting from 1830 to the Present Day*. New York: E. P. Dutton, 1903.

McClees Galleries. *Philadelphia's First Exhibition of Advanced Modern Art*. Philadelphia: McClees Galleries, 1916.

McDonnell, Patricia. "Representation in Early American Abstraction: Paradox in the Painting of Marsden Hartley, Stanton Macdonald-Wright, and Morgan Russell." In *Over Here: Modernism, the First Exile, 1914–1919*. Providence: David Winton Bell Gallery, Brown University, 1989.

———. *Painting Berlin Stories: Marsden Hartley, Oscar Bluemner, and the First American Avant-Garde in Expressionist Berlin*. New York: Peter Lang, 2003.

Meier-Graefe, Julius. *Modern Art; Being a Contribution to a New System of Aesthetics*. New York: G.P. Putnam's Sons, 1908.

———. *Paul Cézanne*. Munich: R. Piper, 1913.

The Metropolitan Museum of Art. *Loan Exhibition of Impressionist and Post-Impressionist Paintings. The Metropolitan Museum of Art, New York, May 3 to September 15, 1921*. New York: The Metropolitan Museum of Art, 1921.

Mirbeau, Octave, et al. *Cézanne*. Paris: Bernheim-Jeune, 1914.

Morrin, Peter, et al. *The Advent of Modernism: Post-Impressionism and North American Art, 1900–1918*. Atlanta: High Museum of Art, 1986.

Mowll Mathews, Nancy. "Maurice Prendergast and the Influence of European Modernism." In *Maurice Brazil Prendergast, Charles Prendergast: A Catalogue Raisonné*, 35–45. Williamstown, MA: Williams College Museum of Art; Munich: Prestel, 1989.

Myers, Jerome. *Artist in Manhattan*. New York: American Artists Group, 1940.

Norman, Dorothy. *Alfred Stieglitz: An American Seer*. New York: Aperture, 1973.

Pach, Walter. *The Masters of Modern Art*. New York: B. W. Huebsch, 1924.

———. *Queer Thing, Painting: Forty Years in the World of Art*. New York: Harper & Brothers, 1938.

Pennsylvania Academy of the Fine Arts. *Exhibition of Paintings and Drawings by Representative Modern Masters: April 17 to May 9, 1920*. Philadelphia: Pennsylvania Academy of the Fine Arts, 1920.

Perlman, Bennard B. *American Artists, Authors, and Collectors: The Walter Pach Letters, 1906–1958*. Albany: State University of New York Press, 2002.

Phillips, Duncan. *A Collection in the Making: A Survey of the Problems Involved in Collecting Pictures, Together with Brief Estimates of the Painters in the Phillips Memorial Gallery*. New York: E. Weyhe; Washington, DC: Phillips Memorial Gallery, 1926.

Platt, Susan Noyes. *Modernism in the 1920s: Interpretations of Modern Art in New York from Expressionism to Constructivism*. Ann Arbor: UMI Research Press, 1985.

Prince, Sue Ann, ed. *The Old Guard and the Avant-Garde, Modernism in Chicago, 1910–1940*. Chicago: University of Chicago Press, 1990.

Rabinow, Rebecca A., ed. *Cézanne to Picasso: Ambroise Vollard, Patron of the Avant-Garde*. New York: The Metropolitan Museum of Art; New Haven, CT: Yale University Press, 2006.

Rewald, John. *Paul Cézanne, The Watercolors: A Catalogue Raisonné*. Boston: Little, Brown, A New York Graphic Society Book, 1983.

———. *Cézanne, the Steins, and Their Circle*. New York: Thames and Hudson, 1986.

———. *Cézanne and America: Dealers, Collectors, Artists and Critics, 1891–1921*. Princeton: Princeton University Press, 1989.

———. In collaboration with Walter Feilchenfeldt and Jayne Warman. *The Paintings of Paul Cézanne: A Catalogue Raisonné*. 2 volumes. New York: Harry N. Abrams, 1996.

Rishel, Joseph J. *Cézanne in Philadelphia Collections*. Philadelphia: Philadelphia Museum of Art, 1983.

Rishel, Joseph J., and Katharine Sachs, eds. *Cézanne and Beyond*. Philadelphia: Philadelphia Museum of Art; New Haven, CT: Yale University Press, 2009.

Rotily, Jocelyne. *Au sud d'Eden: des Américains dans le sud de la France (années 1910-1940)* (Marseille, France: Association culturelle France-Amérique, 2006).

Rubin, William, ed. *Cézanne: The Late Work*. New York: The Museum of Modern Art; Boston: New York Graphic Society, 1977.

Russell, Morgan, and Stanton Macdonald-Wright. "In Explanation of Synchromism." In *Austellung Der Synchromisten Morgan Russell, S. Macdonald-Wright*. Munich: Der Neue Kunstsalon, 1913. Reprinted in Gail Levin, *Synchromism and American Color Abstraction 1910-1925*. New York: G. Braziller, in association with the Whitney Museum of American Art, 1978, 128-29.

Rutter, Frank. *Evolution in Modern Art; A Study of Modern Painting, 1870-1925*. London: G. G. Harrap, 1926.

Shiff, Richard. "Mark, Motif, Materiality: The Cézanne Effect in the Twentieth Century." In *Cézanne: Finished, Unfinished*. Ostfildern Ruit: Hatje Cantz, 2000. Exhibitions at Kunstforum Wien, Kunsthaus Zurich.

Simonson, Lee. *Part of a Lifetime; Drawings and Designs, 1919-1940*. New York: Duell, Sloan, and Pearce, 1943.

Simpson, Fronia W., ed. *European Muses, American Masters 1870-1950*. Portland, ME: Portland Museum of Art, 2004.

Stavitsky, Gail. *Gertrude Stein: The American Connection*. New York: Sid Deutsch Gallery, 1990.

Stein, Gertrude. *The Autobiography of Alice B. Toklas*. New York: Harcourt Brace, 1933.

Stein, Leo. *The ABC of Aesthetics*. New York: Boni and Liveright, 1927.

———. *Appreciation: Painting, Poetry and Prose*. New York: Crown, 1947.

Watson, Forbes. Untitled statement in *Loan Exhibition of Works [of 19th- and 20th-Century French Art]*. New York: Museum of French Art, 1921.

Weber, Max. "Cézanne Watercolors." In *Cézanne*. New York: Montross Gallery, 1916.

Wechsler, Judith. *The Interpretation of Cézanne*. Ann Arbor: UMI Research Press, 1981.

Wedderkop, H. von. *Paul Cézanne*. Leipzig: Klinkhardt & Biermann, 1922.

Wright, Willard Huntington. *Modern Painting, Its Tendency and Meaning*. New York: John Lane, 1915.

———. "What Is Modern Painting." In *The Forum Exhibition of Modern American Painters*. New York: Anderson Galleries, 1916.

Yount, Sylvia, and Elizabeth Johns. *To Be Modern: American Encounters with Cézanne and Company*. Philadelphia: Museum of American Art at the Pennsylvania Academy of the Fine Arts, 1996.

Zayas, Marius de. *Cézanne Exhibition*. New York: Modern Gallery, 1916.

———. *Exhibition Illustrating the Evolution of French Art from Ingres and Delacroix to the Latest Modern Manifestations*. New York: Arden Gallery, 1919.

———. *How, When, and Why Modern Art Came to New York*. Edited by Francis M. Naumann. Cambridge, MA: The MIT Press, 1996.

Zayas, Marius de, and Paul B. Haviland. *A Study of the Modern Evolution of Plastic Expression*. New York: "291," 1913.

Zilczer, Judith. *"The Noble Buyer": John Quinn, Patron of the Avant-Garde*. Washington, DC: Published for the Hirshhorn Museum and Sculpture Garden, Smithsonian Institution, by the Smithsonian Institution Press, 1978.

Articles

"A Private Collection that Contains Fourteen Examples of the Art of Paul Cézanne, a Great Modern Who Already Is Placed with the Old Masters," *The New York Times,* July 6, 1913.

"Art and Artists: The Eight," *Philadelphia Press,* March 9, 1909, Pennsylvania Academy of the Fine Arts Scrapbooks, Archives of American Art, reel P54, frame 842.

"A Representative Group of Cezannes Here." *The New York Times,* January 2, 1916.

"Art at Home and Abroad; New Schools in the Berlin Exhibitions This Year—Stuck and Cézanne Paintings—German Followers of Matisse," *The New York Times,* July 20, 1913.

"Art Notes." *The New York Times,* January 6, 1916.

"Art Notes." *The New York Times,* January 29, 1916.

"Art Notes." *The New York Times,* April 13, 1916.

"Art Notes." *The New York Times,* November 26, 1916.

"Art Notes." *The New York Times,* December 7, 1916.

"Art Notes Here and There." *The New York Times,* May 2, 1909.

Bargelt, Louise James. "Art." *Chicago Daily Tribune,* May 21, 1916.

Barnes, Albert C. "Cézanne: A Unique Figure Among the Painters of His Time," *Arts & Decoration* (November 1920): 40.

Bell, Clive. "Post-Impressionist and Aesthetics," *Burlington Magazine* 22, no. 118 (January 1913): 226-30.

Bluemner, Oscar. "Audiator Et Altera Pars: Some Plain Sense on the Modern Art Movement," *Camera Work* Special Number (June 1913): 30, 31.

Boswell, Peyton. "Philadelphia Sees Best in New," *American Art News* 19 (April 23, 1921): 6.

Brinton, Christian. "Fashions in Art," *The International Studio* 49, no. 193 (March 1913): III-X.

———. "Evolution No Revolution in Art," *The International Studio* 49, no. 194 (April 1913): XXVII-XXXV.

Bulliet, C. J. "Modern Museum Launched with Show of Giants," *Chicago Evening Post Magazine of the Art World*, November 10, 1929, 14X.

Burroughs, Bryson. "Recent Accessions," *Bulletin of the Metropolitan Museum of Art* 8 (May 1913): 108.

———. "Exhibition of French Impressionists and Post-Impressionists," *Bulletin of the Metropolitan Museum of Art* 16 (April 1921): 70.

Caffin, Charles. "The New Thought which is Old," *Camera Work* 31 (July 1910): 24.

———. "A Note on Paul Cézanne," *Camera Work* 34-35 (April-July 1911): 47-51.

———. "'Cheating the Coroner' Suggested by Mr. George Moore's Verdict that Art Is Dead," *The International Studio* 62, no. 245 (July 1917): III-VII.

Camera Work Special Number (June 1913).

"Cézanne Exhibition," *Camera Work* 36 (October 1911): 30.

"The Cézanne Show," *Arts & Decoration* 6 (February 1916): 184.

"Chronological Chart Made by Arthur B. Davies Showing the Growth of Modern Art," *Arts & Decoration* Special Edition Number (March 1913): 150.

Cole, Robert J. "Studio and Gallery Cézanne's Inconvenient Variety," *New York Evening Sun,* March 9, 1917.

Cortissoz, Royal. "Paul Cézanne and the Cult of His Paintings," *New York Tribune,* January 9, 1916.

———. "The New Museum of Modern Art / French Painting in the Opening Show," *New York Herald,* November 10, 1929.

De Kozmutza, Ottilie. "The Art of Paul Cezanne," *Burr-McIntosh Monthly* (March 1908): unpaginated.

Denis, Maurice. "Cézanne." *L'Occident* 12 (September 1907).

du Bois, Guy Pène. "Great Modern Art Display Here April 1," *New York American,* March 17, 1910.

———. "Exhibitions . . ." *New York American,* March 21, 1910.

———. "The Spirit and Chronology of the Modern Movement," *Arts & Decoration* Special Edition Number (March 1913): 150.

———. "Who's Who in Modern Art—Cézanne," *The Evening Post Magazine* (July 13, 1918): 9.

Edgerton, Giles. "The Younger Painters of America; Are They Creating a National Art?" *The Craftsman* (February 1908): 512-532.

Field, Hamilton Easter. "French Show at Brooklyn Museum," *Brooklyn Eagle,* March 27, 1921.

———. "The Metropolitan French Show," *The Arts* (May 1921): 2.

Fox, W.H. "French Post-Impressionist Paintings and Other Groups at the Brooklyn Museum," *The Brooklyn Museum Quarterly* 8 (October 1921): 163–65.

"French Masters in Big Exhibition," *American Art News* (April 2, 1921): 1.

Fry, Roger, trans. "Cézanne—I." *Burlington Magazine* 16, no. 82 (January 1910): 207–19.

———. "Cézanne—II." *Burlington Magazine* 16, no. 83 (February 1910): 275–80.

———. "New Laurels for the Scorned Cézanne," *The New York Times,* May 1, 1927.

Gallatin, Albert Eugene. "Notes on Some Masters of the Water-Colour," *Arts & Decoration* VI (April 1916): 277.

———. "The Gallery of Living Art, New York University," *Creative Art* 4, no. 3 (March 1929): xl–xliv.

"The Greatest Exhibition of Insurgent Art Ever Held," *Current Opinion* 104 (March 1913): 231.

Gregg, Frederick James. "Paul Cézanne—At Last," *Vanity Fair* (December 1915): 58.

———. "Paul Cézanne, The Misanthropic Don Quixote of Modern Art," *Current Opinion* 60 (February 1916): 121.

Hartley, Marsden. "America as Landscape," *El Palacio* 5 (December 21, 1918): 340–42.

Henri, Robert. "The New York Exhibition of Independent Artists," *The Craftsman* 18 (May 1910): 160–72.

Hoeber, Arthur. "The Eight," *New York Globe and Commercial Advertiser,* February 5, 1908. Whitney Museum of American Art Papers, Archives of American Art, Smithsonian Institution, reel N655, frame 258.

Huneker, James G. "Autumn Salon Is Bizarre," *New York Sun,* November 27, 1904.

———. "Eight Painters," *New York Sun,* February 9, 1908, Macbeth Gallery Papers, Archives of American Art, Smithsonian Institution, reel NMC1, frame 144.

———. "The Case of Paul Cézanne," *New York Sun,* March 11, 1913. Reprinted in James G. Huneker, *Unicorns.* New York: Charles Scribner's Sons, 1917, 103.

———. "Cézanne," *New York Sun,* April 4, 1920. Reprinted in James G. Huneker, *Variations.* New York: Charles Scribner's Sons, 1921, 97.

"Impressionists and Post-Impressionists," *Outlook* (June 15, 1921): 280.

Johnson, Erle Loran. "Cézanne's Country," *The Arts* (April 1930): 521–51.

Knight, Christopher. "On Native Ground: U.S. Modern," *Art in America* 71, no. 9 (October 1983): 166–74.

Lane, James W. "The Moderns in America," *The Commonweal,* January 1, 1930.

Lawton, Frederick. "Paul Cézanne," *The Art Journal* (London) 1911, 55–60.

Levin, Gail. "Marsden Hartley and the European Avant-Garde," *Arts Magazine* 54 (September 1979): 158–63.

Luther Cary, Elisabeth. "Post Impressionist 'Art'" *The New York Times,* November 27, 1910.

———. "Art of the Moderns in a Notable Show," *The New York Times,* July 4, 1926.

"Mamma's Angel Child; Has a Cubist Nightmare in the Studio of Monsieur Paul Vincent Cezanne Van Gogen [*sic*] Gauguin." *Boston Daily Globe,* April 13, 1913.

Mather Jr., Frank Jewett. "The Independent Artists," *The Evening Post,* April 2, 1910.

———. "Art Old and New," *The Nation* 96 (March 6, 1913): 240.

———. "Newest Tendencies in Art," *The Independent,* March 6, 1913.

———. "Paul Cézanne," *The Nation* 102, no. 2637 (January 13, 1916): 57–59.

———. "Art," *The Nation* 102, no. 2647 (March 23, 1916): 340.

McBride, Henry. "Important Cézannes in Arden Galleries," *New York Sun,* March 4, 1917.

———. "Cézanne at the Metropolitan." *The Sun,* May 18, 1913. Reprinted in *The Flow of Art: Essays and Criticisms of Henry McBride.* New York: Atheneum Publishers, 1975, 33.

———. "Cézanne." *The Sun,* May 18, 1913. Reprinted in *The Flow of Art: Essays and Criticisms of Henry McBride.* New York: Atheneum Publishers, 1975, 96.

———. "The Palette Knife—A Profoundly Impressive Museum of Modern Art," *Creative Art* (January 1930): supp. 9–11.

McCarthy, Laurette E. "The 'Truths' about the Armory Show: Walter Pach's Side of the Story," *Archives of American Art Journal* 44, no. 3–4 (2004): 2–13.

McCoy, Garnett. "The Post Impressionist Bomb," *Archives of American Art Journal* 20, no. 1 (1980): 13–17.

"Modern Art Museum Opens in New York," *The Art News* 28, no. 6 (November 9, 1929): 3.

Monroe, Harriet. "What Are Post-Impressionists? Expressionists More Appropriate," *Chicago Daily Tribune,* March 3, 1912.

———. "Clark's Art Gains in Style and Aim." *Chicago Daily Tribune,* January 19, 1913.

———. "Bedlam in Art; A Show That Clamors." *Chicago Daily Tribune,* February 16, 1913.

———. "Art Show Opens to Freaks; American Exhibition in New York Teems with the Bizarre. All Schools Welcome. Queer Conceptions of 'Insurgents' Vie with Conservatives' Works." *Chicago Daily Tribune,* February 17, 1913.

———. "New York Has at Last Achieved a Cosmopolitan Modern Exhibit." *Chicago Daily Tribune,* February 23, 1913.

———. "International Art to Open at the Institute on March 24." *Chicago Evening Tribune,* March 16, 1913.

———. "Art Exhibition Opens in Chicago; Great Variety of Pictures of Modern Schools Shown at the Institute. Cubists There in Force. Post-Impressionists Also Have Full Sway for Displaying Their Studies." *Chicago Daily Tribune,* March 25, 1913.

"Modernism in Art." *Atlanta Constitution,* April 27, 1913.

"Museum Open Its Modernist Show," *American Art News* (May 7, 1921): 5.

Nathanson, Carol A. "The American Reaction to London's First Grafton Show," *Archives of American Art Journal* 25, no. 3 (1985): 3–10.

"News and Notes of the Art World." *The New York Times,* February 20, 1910.

Norman, Dorothy. "From the Writings and Conversations of Alfred Stieglitz," *Twice a Year* (Fall–Winter 1938): 80–83.

"The 'Old Master of Aix' Comes to Fifth Avenue," *The New York Times,* January 15, 1928.

Pach, Walter. "Cézanne—An Introduction." *Scribner's* 44, no. 6 (December 1908): 765–768.

———. "The Point of View of the 'Moderns.'" *The Century Magazine* 87 (April 1914): 851–52, 861–67.

———."Modern Art Today," *Harper's Weekly* 62 (April 19, 1916): 470–71.

———."Universality in Art," *The Modern School* (February 1918): 46–55.

———."On Cézanne's Watercolors," *The Christian Science Monitor,* February 23, 1920, 14.

———."Painting. A Modern Art Exhibition," *The Freeman* 1 (June 23, 1920): 354–55.

———. "Art. A Half-Century Celebration," *The Freeman* 1 (August 25, 1920): 568–69.

———. "Art. Paris in New York," *The Freeman* 2 (February 2, 1921): 492–94.

———. "Art. At the Pennsylvania Academy," *The Freeman* 3 (May 18, 1921): 232–33.

———. "Art. The Contemporary Classics," *The Freeman* 3 (July 13, 1921): 423–25.

———. "Les tendances modernes aux Etats-Unis." *L'amour de l'art* 1 (January 1922): 29–30.

———. "Art," in *Civilization in the U.S.: An Inquiry by 30 Americans,* edited by Harold Stearns (New York: Harcourt, Brace, 1922), an eight-part series on modern art published by *The Freeman* between July and September 1923.[delete; is next item in McCarthy's note]

———. "Modern Art Expounded in Terms of Evolution" [review of *Entwicklungsgeschichte der modernen Kunst* by Julius Meier-Graefe], *The New York Times Book Review,* December 27, 1925, 4–5.

———. *Ananias, or the False Artist* (New York: Harper and Brothers, 1928).

"Paintings on view at the Academy of the Fine Arts," *Philadelphia Public Ledger,* March 8, 1908.

P[emberton], M[urdoch]. "The Art Galleries," *The New Yorker,* November 23, 1929, 105.

Phillips, Duncan. "Revolutions and Reactions in Painting," *The International Studio* (December 1913): CXXVI–CXXVIII.

———. "Fallacies of the New Dogmatism in Art," *American Magazine of Art* 9 (December 1917): 103.

Philpott, A. J. "Marvels of Modernity in the Name of Art; Post Impressionist, Futurist and Cubist Exhibition Would Be a Joke If One Could See the Point." *Boston Daily Globe,* April 28, 1913.

——. "Biggest Art Colony in the World at Provincetown." *Boston Daily Globe,* August 27, 1916.

Quinn, John. "Modern Art from a Layman's Point of View," *Arts & Decoration* (March 1913): 155.

"Some Paintings in the Reisinger Collection." *The New York Times,* January 9, 1916.

Stein, Leo D. "Cézanne." *The New Republic,* January 22, 1916, 298.

Sterne, Maurice. "Cézanne Today," *The American Scholar* 22, no. 1 (Winter 1952–53): 40–59.

Stieglitz. Alfred. "Regarding the Modern French Masters Exhibition," *Brooklyn Museum Quarterly* 8 (July 1921): 107–8.

Strand, Paul. "American Water Colors at the Brooklyn Museum," *The Arts* (December 1921): 148–51.

Townsend, James. "The Eight," *American Art News* 17 (February 8, 1908): 6.

——. "Modern Art in Philadelphia," *American Art News* 18 (May 8, 1920): 3.

"Two Cézannes." *Bulletin of the Metropolitan Museum of Art* 11 (May 1916): 117.

"Was Cézanne an Industrious 'Painter without Taste'?" *The New York Times Book Review,* January 22, 1928, 5.

"Watercolors by Cézanne," *The New York Times,* March 12, 1911.

Watson, Forbes. "At the Art Galleries," *The Evening Post Saturday Magazine,* January 29, 1916, 18.

——. "Comment on the Arts," *The Arts* (May 1921): 34.

——. "New York Exhibition," *The Arts* (February 1928): 106–8.

——. "The Museum of Modern Art," *The Arts* (November 1929).

Weber, Max. "The Fourth Dimension from a Plastic Point of View," *Camera Work* 31 (1910): 25.

——. "Chinese Dolls and Modern Colorists," *Camera Work* 31 (July 1910): 51.

Wehle, Harry B. "Loan Exhibition of Modern French Paintings," *Bulletin of the Metropolitan Museum of Art* 16 (May 1921): 93–96.

[Whigham, H. J.] "The Editor's Page," *The International Studio* 95 (January 1930): 8.

"The World of Art: More French Work," *The New York Times,* April 10, 1921.

[Wright, W. H.] "Art at Home and Abroad," *The New York Times,* July 6, 1913.

Wright, Willard Huntington. "Impressionism to Synchromism," *The Forum* (December 1913): 766–67.

——. "Cézanne," *The Forum* (July 1915): 39.

——. "The Truth about Painting," *The Forum* (October 1915): 450.

——. "Modern American Painters—and Winslow Homer," *The Forum* (December 1915): 667.

——. "The Aesthetic Struggle in America," *The Forum* (February 1916).

——. "Paul Cézanne," *The International Studio* (February 1916).

——. "An Abundance of Modern Art," *The Forum* (March 1916): 326.

[Wright, Willard Huntington.] "Paintings by Cézanne Now on Exhibition Here," *The New York Times Magazine,* March 4, 1917, 7.

Zilczer, Judith. "'The World's New Art Center': Modern American Art Exhibitions in New York City, 1913–1918," *Archives of American Art Journal* 14, no. 3 (1974): 126–30.

——. "The Armory Show and the American Avant-Garde: A Re-Evaluation," *Arts Magazine* 53 (September 1978): 126–30.

——. "John Quinn and Modern Art Collectors in America, 1913–1924." *The American Art Journal* 14, no. 1 (Winter 1982): 56–71.

——. "Arthur B. Davies. The Artist as Patron," *The American Art Journal* 19 no. 3 (Summer 1987): 54–83.

Unpublished Sources

Cauman, John. "Matisse and America, 1905–1933." Ph.D. diss., The City University of New York, 2000.

Dr. Claribel and Miss Etta Cone Papers, Archives and Manuscripts Collections, The Baltimore Museum of Art

Epstein, Stacey B. "Alfred H. Maurer: Aestheticism to Modernism, 1897–1916." Ph.D. diss., The City University of New York, 2003.

Flood, Suzette Louise. "American Modernist Painters in France: The Decade before World War I." Master's thesis, California State University, Fullerton, 1987.

A. Conger Goodyear Scrapbook, Museum of Modern Art Archives, New York.

Gruber, Carol. "Reminiscences of Max Weber," Columbia University (New York) Oral History Project, volume 1, 1958.

Rockwell Kent Papers, Archives of American Art, Smithsonian Institution.

Knight, Christopher. "The Forum Exhibition and the Concept of an 'American' Modernism." Master's thesis, State University of New York, Binghamton, 1976.

Walt Kuhn Papers, Archives of American Art, Smithsonian Institution.

Kyle, Jill Anderson. "Cézanne and American Painting, 1900–1920" Ph.D. diss., University of Texas at Austin, 1995.

Macbeth Gallery Papers, Archives of American Art, Smithsonian Institution.

Nathanson, Carol. "The American Response, in 1910–1913, to the French Modern Art Movements After Impressionism." Ph.D. diss., The Johns Hopkins University, Baltimore, 1979.

Pennsylvania Academy of the Fine Arts Scrapbooks, Archives of American Art, Smithsonian Institution.

Walter Pach Papers, Archives of American Art, Smithsonian Institution.

Phillips, Sandra. "Cézanne's Influence on American Art, 1910–1930. Master's thesis, Bryn Mawr College, Bryn Mawr, PA, 1969.

Risatti, Howard Anthony. "American Critical Reaction to European Modernism, 1908 to 1917." Ph.D. diss., University of Illinois at Urbana-Champaign, 1978.

Morgan Russell Archives and Collection, Montclair Art Museum, Montclair, NJ.

Schick, Karin. "The Making of Cézanne—Eine Studie zur amerikanischen Cézanne-Reception." Ph.D. diss., Eberhard-Karls-Universitat Tubingen, Laupheim, Germany, 2002.

Scott, Wilford Wildes. "The Artistic Vanguard in Philadelphia (1905–1920)." Ph.D. diss., University of Delaware, Newark, 1983.

Stieglitz Archive, Beinecke Rare Book and Manuscript Library, Yale University, New Haven, CT.

Forbes Watson Papers, Archives of American Art, Smithsonian Institution.

Weber, Max. "The Matisse Class," presented at the Matisse Symposium, Museum of Modern Art, New York, November 19, 1951, Max Weber Papers, Archives of American Art, Smithsonian Institution, reel NY59-6, frames 146–63.

Max Weber Papers, Archives of American Art, Smithsonian Institution.

Whitney Museum of American Art Papers, Archives of American Art, Smithsonian Institution.

IMAGE CREDITS

IMAGE CREDITS

Courtesy of The Anschutz Collection: 259; Courtesy of the Archives of American Art, Smithsonian Institution: 354 (left); Reproduction, The Art Institute of Chicago: 208, 281; ©Artists Rights Society (ARS), New York/ADAGP, Paris: 7, 22, 208, 210, 211, 213; ©Estate of Józef Bakoś: 170, 171; ©Bates College Museum of Art: 225; Courtesy Lori Bookstein Fine Art, New York: 289; ©Estate of Arthur Carles, Courtesy of Mark Borghi Fine Arts, Inc.: 187; Christie's Images Limited (1987): 131; Photo ©Christie's Images/The Bridgeman Art Library Nationality: 132; Blair Clarke: 116, 192; Sheldan C. Collins: 331; ©Estate of Konrad Cramer: 341; Curtis Galleries, Minneapolis, MN: 190, 207, 222; ©Simone DeVirgile: Cover (bottom), Title Page (right), 289, 290, 291, 292, 293, 294, 295; Courtesy of and copyright, The Estate of Arthur G. Dove: 28, 206, 207; Thomas DuBrock: 229; Courtesy of George Eastman House: 107; Ali Elai, Camerarts, Inc.: 153, 157, 210; R. Goodbody: 187; ©2008 Helen Frankenthaler: 135; ©Galerie Beyeler, Basel, Switzerland/Lauros/Giraudon/The Bridgeman Art Library Nationality: 134; Courtesy of Estate of Yun Gee: 118; Erik Gould: 196–97, 297; Courtesy of the Richard Gray Gallery, Chicago: 85; ©2009 G. Ray Hawkins Gallery, Beverly Hills, CA: 261; Mitro Hood: 90, 94, 158, 160, 179, 184, 200, 231, 307, 314, 328, 339, 359, 360; Peter S. Jacobs, Fine Arts Photography: 7, 141, 177, 211, 226, 273, 278, 291, 293, 294, 295; ©The Willem de Kooning Foundation/Artists Rights Society (ARS), New York: 132; ©Estate of Leon Kroll: 231; ©The Lane Collection. Photograph courtesy Museum of Fine Arts, Boston: 299; Hervé Lewandowski: 22, 71, 233; ©The Estate of Roy Lichtenstein: 128; Copyrighted by the Estate of Macdonald-Wright, 2009: 234, 235, 236, 237; ©Estate of John Marin/Artists Rights Society (ARS), New York: 240, 241, 242, 243; Andrew Marinkovich-Malone and Company: 327; Image ©The Metropolitan Museum of Art: 6, 44, 150, 315; Eric Mitchell: 146, 151; Courtesy of Montclair Art Museum: 280, 351; ©2008 Museum of Art, RISD All Rights Reserved: 196–97, 297; Photograph ©2009 Museum of Fine Arts, Boston: 29, 78, 140, 152, 159, 237, 274, 310; Digital Image ©The Museum of Modern Art/Licensed by SCALA/Art Resource, NY: Cover (bottom), Title Page (right), 49, 72, 80, 100, 111 (both images), 124, 162, 185, 290, 303, 306, 308, 309, 312, 313, 352 (all), Back Cover; Image courtesy of the Board of Trustees, National Gallery of Art, Washington, DC: 135, 154, 163, 216; William J. O'Connor: 259; ©Georgia O'Keeffe Museum/Artists Rights Society (ARS), New York: 111 (both images), 306, 307, 308, 309; Courtesy of the Estate of Walter Pach: 265; Courtesy of the Gerald Peters Gallery: 224, 254 (both), 329; Courtesy of the Philadelphia Museum of Art: 16, 36, 146, 147, 148, 151, 155; Phillipi Photographi: 283; Any reproduction of this digitized image shall not be made without the written consent of The Phillips Collection, Washington, DC: 203; Dwight Primiano: 235; Courtesy of the Princeton University Art Museum: 20, 149, 164, 337; ©Man Ray Trust/Artists Rights Society (ARS), NY/ADAGP, Paris: 277, 278, 279, 280, 281; ©Reunion des Musées Nationaux/Art Resource, NY: 22, 71, 233; ©Estate of Ann Estelle Rice: 283; ©1998 Kate Rothko Prizel & Christopher Rothko/Artist Rights Society (ARS), New York: 128; Courtesy of Douglas Sandberg: 131; Scala/Art Resource: 285; Peter Schälchli, Zürich: 213; Photo ©Sheldon Museum of Art: 205, 247; Marty Snortum Studio: 240, 301; Lee Stalsworth: 33, 118; Reprinted with permission of Joanna T. Steichen: 100, 107, 303, Back Cover; Courtesy of Vera Bluemner Kouba Collection, Stetson University, DeLand, Florida: 353, 356 (both); ©The Clyfford Still Estate: 131; ©Estate of Louis Stone, Courtesy of Michael Rosenfeld Gallery: 48; Courtesy of the Paul Strand Archive/Aperture Foundation: 107, 310, 312, 313, 314, 315; ©Estate of Abraham Walkowitz, Courtesy of the Zabriskie Gallery: 319; Courtesy Meredith Ward Fine Art, New York: 241, 242; ©Estate of Margaret Watkins, Courtesy Robert Mann Gallery, New York: 321; Bruce M. White: 20, 149, 164; Estate of Max Weber, Courtesy of Gerald Peters Gallery, NY: 326, 327, 328, 329, 330, 331, 332, 333; Courtesy of Williams College Museum of Art: 269, 270, 271, 272, 275, 354 (right); Graydon Wood: 147; ©Estate of Hale Woodruff/Elnora, Inc.; Courtesy of Michael Rosenfeld Gallery, LLC, New York, NY: 339

Library of Congress Cataloging-in-Publication Data

Cézanne, Paul, 1839–1906.

 Cézanne and American modernism / Gail Stavitsky, Katherine Rothkopf.—1st ed.

 p. cm.

 Includes bibliographical references and index.

 ISBN 978-0-300-14715-5—ISBN 978-0-9824716-0-9 (pbk.)

 1. Cézanne, Paul, 1839–1906—Public opinion—Exhibitions. 2. Public opinion—United States—Exhibitions. 3. Modernism (Art)—United States—Exhibitions. 4. Art, American—20th century—Exhibitions. I. Cézanne, Paul, 1839–1906. II. Stavitsky, Gail, 1954– III. Rothkopf, Katherine. IV. Title.

 N6853.C45A4 2009b

 759.4—dc22 2009016058

Published by the Montclair Art Museum and The Baltimore Museum of Art
in association with Yale University Press

 www.artbma.org

 www.montclairartmuseum.org

 www.yalebooks.com

Front Cover: Paul Cézanne, *Five Apples* (detail, cat. 2), and Morgan Russell, *Three Apples* (detail, cat. 94)

Title Page: Paul Cézanne, *Five Apples* (detail, cat. 2), and Morgan Russell, *Three Apples* (detail, cat. 94)

Pages 6–7: Paul Cézanne, *View of the Domaine Saint-Joseph* (detail, cat. 8), and Arshile Gorky, *Landscape, Staten Island* (detail, cat. 47)

Pages 140–41: Paul Cézanne, *Fruit and a Jug on a Table* (detail, cat. 10), and Maurice Prendergast, *Still Life: Fruit and Flowers* (detail, cat. 85)

Page 167: Marsden Hartley, *Mont Sainte-Victoire* (detail, cat. 54)

Back Cover: Edward Steichen, *Three Pears and an Apple* (detail, cat. 102, see p. 303)

Edited by Joseph N. Newland, Q.E.D.

Proofread by Sherri Schultz

Designed by Jeff Wincapaw

Typeset by Brynn Warriner

Color management by iocolor, Seattle

Book production by Marquand Books, Inc., Seattle

 www.marquand.com

Printed and bound in China by Artron Color Printing, Ltd.